← WALNUT RIDGE

← PADANARUM ROAD
POLE HILL POND →

HERON MARSH TRAIL

← HERON MARSH TRAIL →

TO THE VIC ↑

STATE OF NEW YORK TRAIL MARKER '68 CONSERVATION DEPARTMENT

Entering Adirondack Park

4867-FT. ABOVE SEA
WHITEFACE MTN

NYS Department of Environmental Conservation
NPT
NORTHVILLE - PLACID TRAIL

TRAIL TRAIL

TRAIL

TRAIL ←

STATE OF NEW YORK
TRAIL MARKER DEPARTMENT
ENVIRONMENTAL CONSERVATION

JACKRABBIT TRAIL

The TRAILS of the ADIRONDACKS

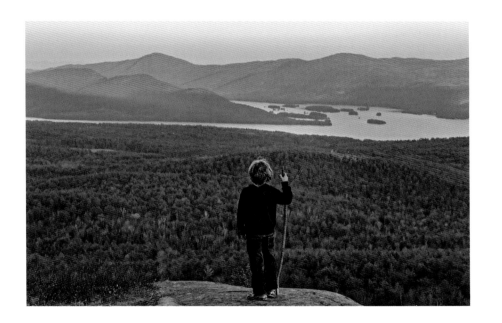

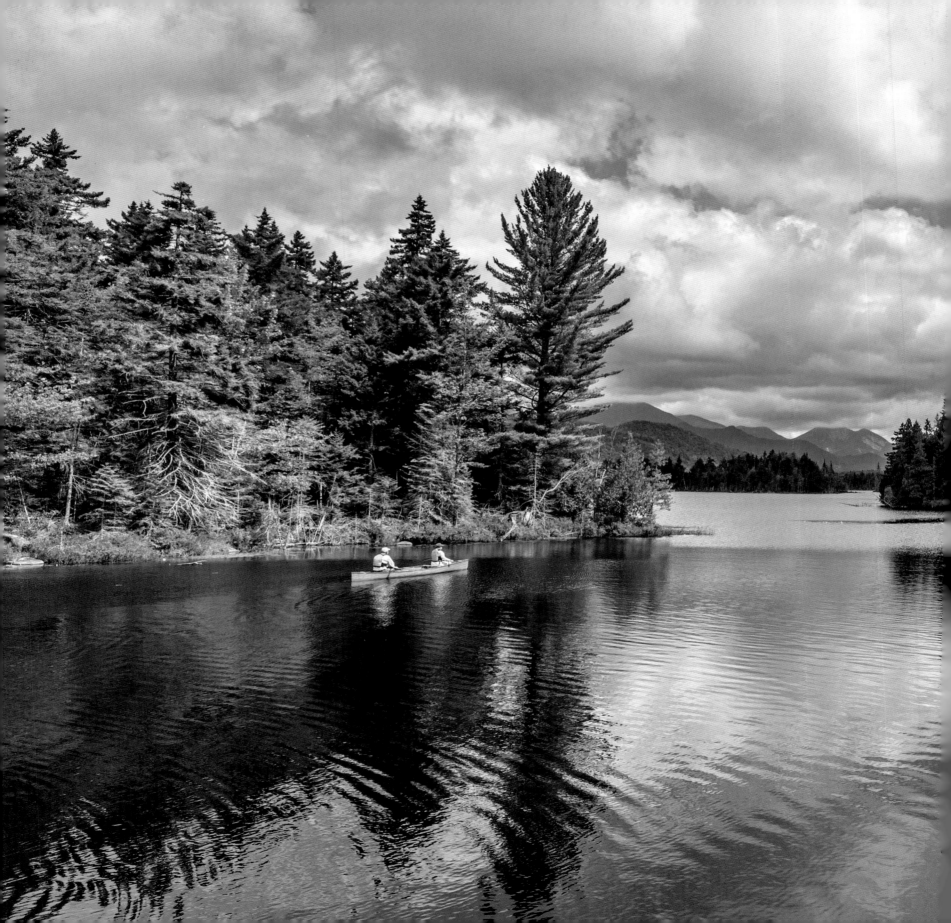

The TRAILS of the ADIRONDACKS

HIKING AMERICA'S ORIGINAL WILDERNESS

CARL HEILMAN II

Foreword by
BILL McKIBBEN

Text by
NEAL BURDICK

RIZZOLI
NEW YORK
New York · Paris · London · Milan

Adirondack
ADK
Mountain Club

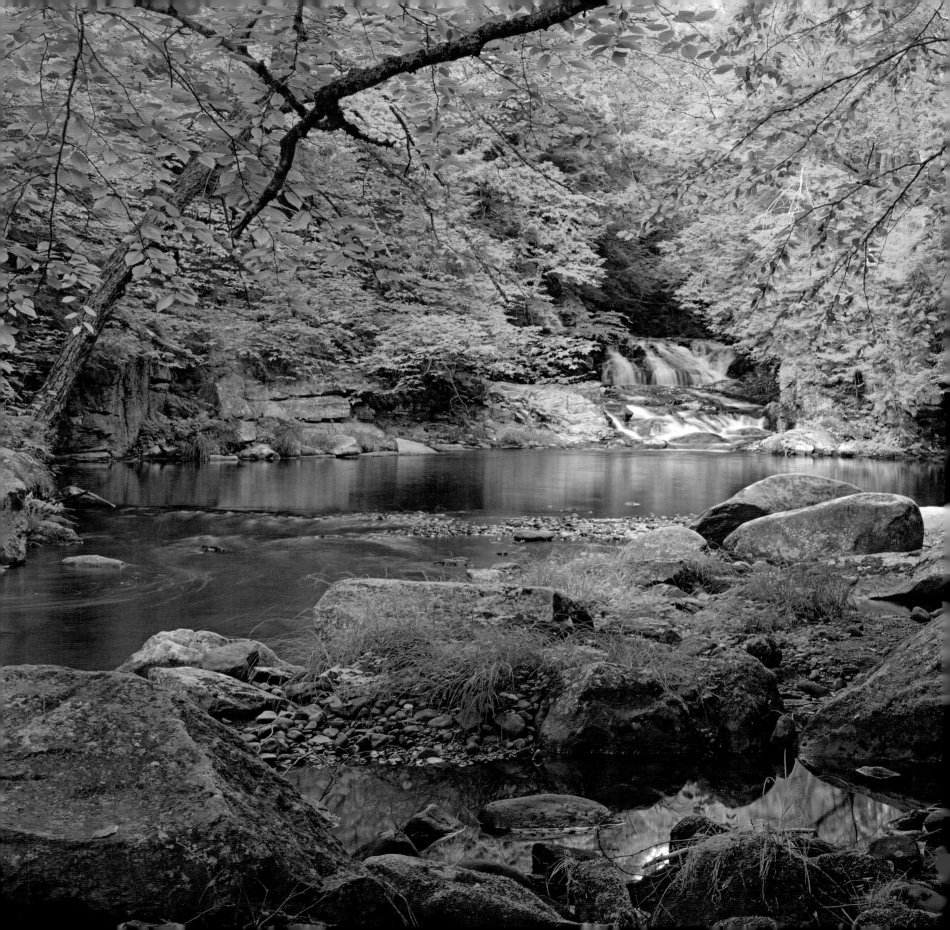

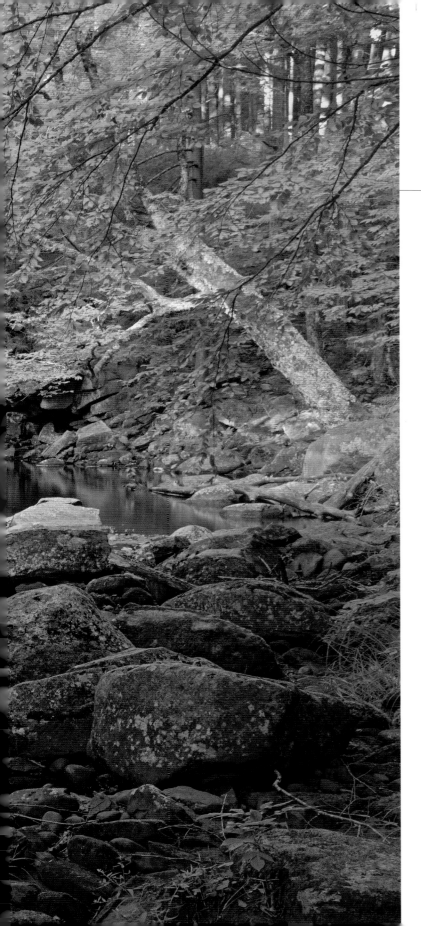

CONTENTS

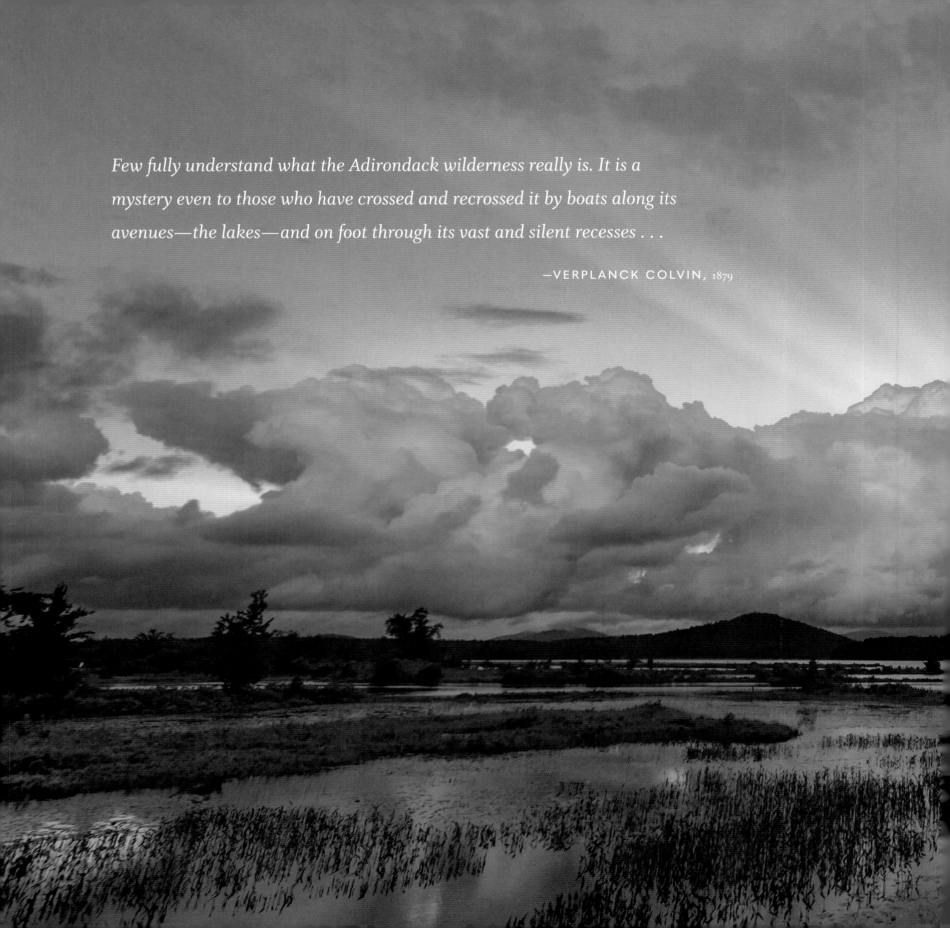

Few fully understand what the Adirondack wilderness really is. It is a mystery even to those who have crossed and recrossed it by boats along its avenues—the lakes—and on foot through its vast and silent recesses . . .

—VERPLANCK COLVIN, 1879

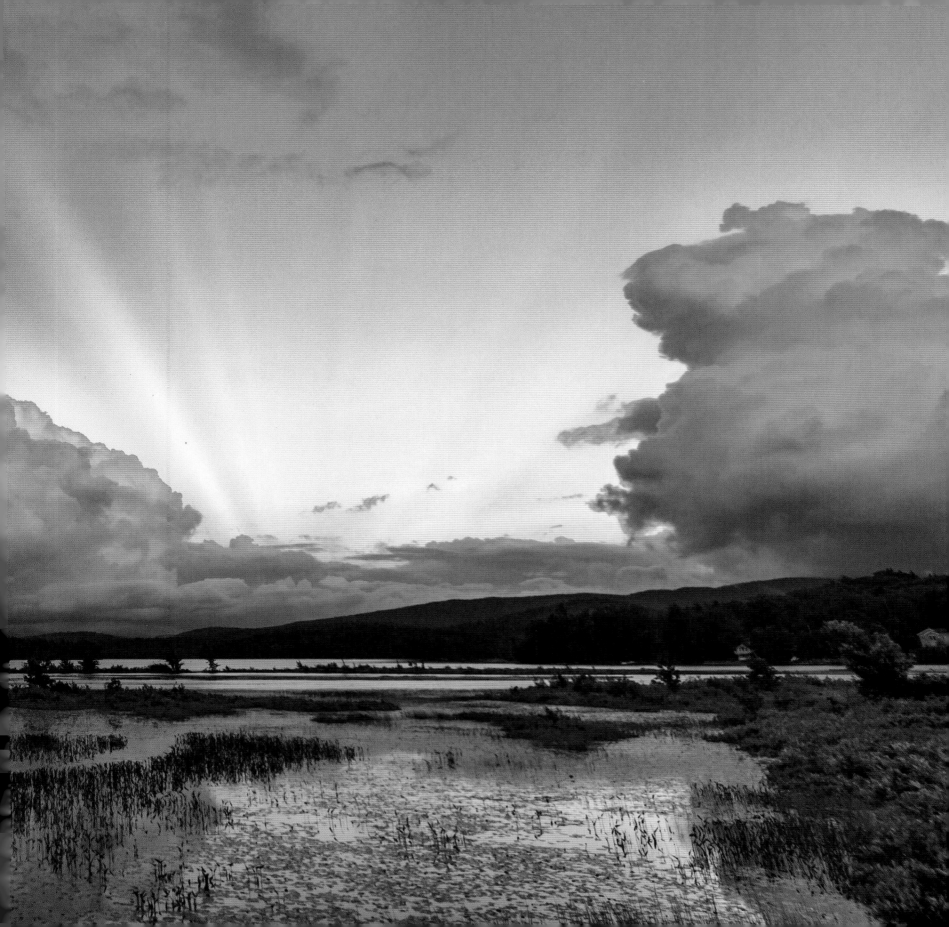

FOREWORD

BILL McKIBBEN

I was out wandering an Adirondack path recently, this one on the eastern bank of the Hudson River south of the town of Newcomb. It had been a dry summer, and so the river was low—here, near its source, you could wade across without the water topping your boots. As I clambered across, I thought of the Hudson farther south: the wide tidal estuary that borders the greatest city on earth, full of tugboats and garbage barges, ferries and cruise ships. New York City sucks up all the attention in the Empire State—it's why the greatest wilderness in the American East is able to hide in plain sight.

The Adirondacks are a miracle in many ways. One is sheer size: bigger than Glacier, Grand Canyon, Yellowstone, and Yosemite—combined. Another is integrity: where most protected areas in the country focus on spectacular granite or ice, the Adirondacks include everything, from the rocky tops of the High Peaks to the boggy lowlands and boreal stands of the other five million acres. And the Adirondacks are the best picture we have of a recovered place: a century ago most of this land was cut over, cleansed of wildlife. Now, guarded by state law, it has grown back into earth's most remarkable illustration of rehabilitation. A second-chance Eden.

All of which should be an incentive to come hike its trails. True, if you're used to easy switchbacking western climbs, you're in for a surprise. Most of the paths in these mountains take the most direct course up a hill, so be prepared to haul yourself up rocks with the roots and branches along the side of the trail. And if you're counting on sweeping views, you're going to have to work for them. The standard Adirondack trail has a high ratio of forest tunnel to exposed vista. In summertime, you usually have to reach the summit before you can see more than 50 yards. But the forest itself is more than worth the trip. I remember walking the Northville-Placid Trail, the one long Adirondack thru-hike, which manages not to top a single peak. Instead, day after day, it leads you through wet, diverse woods, past lake and pond, over stream and hummock, until you fall into a kind of deciduous trance, charmed by lichen and lake mist, loon call and bear sign.

If anyone knows this region, it's Carl Heilman, Neal Burdick, Christine Jerome, and Stuart Mesinger. I've seen Carl in every corner of the park. I remember once climbing Giant Mountain early in the morning—at least, I thought it was early, but there came Carl bounding down, having captured the sunrise shot he wanted. He's at ease in these hills, in every season—his long career as a snowshoer is evident in his winter shots—but it's his feel for the span of these mountains and the vastness of the park that makes him one of the region's finest chroniclers.

OPPOSITE: Morning light highlights the Lower Ausable Lake Valley as the full moon sets between Mount Colvin and Sawteeth Mountain.

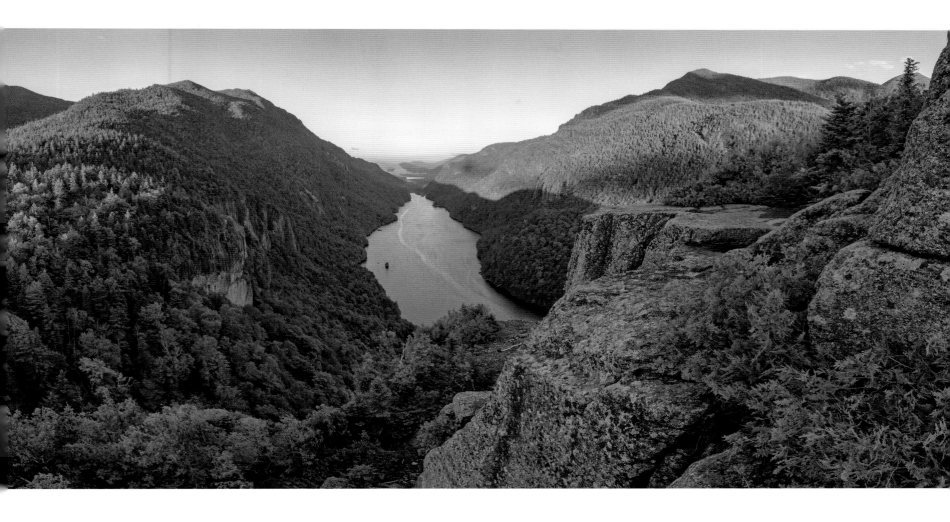

The Adirondacks have one more peculiarity that makes for fine hiking. This isn't Yellowstone or Yosemite, where there's a fence around the park. Instead, the small hamlets intersperse the wilderness, which means you can clamber down muddy and tired from a day or week of rugged hiking and make your way immediately to—well—a beer. (There are around a dozen breweries to choose from now.) You can enter a warm tavern to talk about the trek completed and plan the next one.

A very few Adirondack trails are crowded, overcrowded even, to the point where state officials have begun relocating parking lots and moving trailheads in an effort to disperse use. But all you need to do is head for one of the park's smaller towns: North Creek, Elizabethtown, Jay, Inlet, Blue Mountain Lake, Indian Lake, Star Lake, or Paradox. It's a long list, and every town is surrounded by trails that stretch and connect pretty much indefinitely, trails where you will see far more deer than people, and far more forest than you will see anywhere else on this half of the continent. It's a hiker's paradise. See you on the trail.

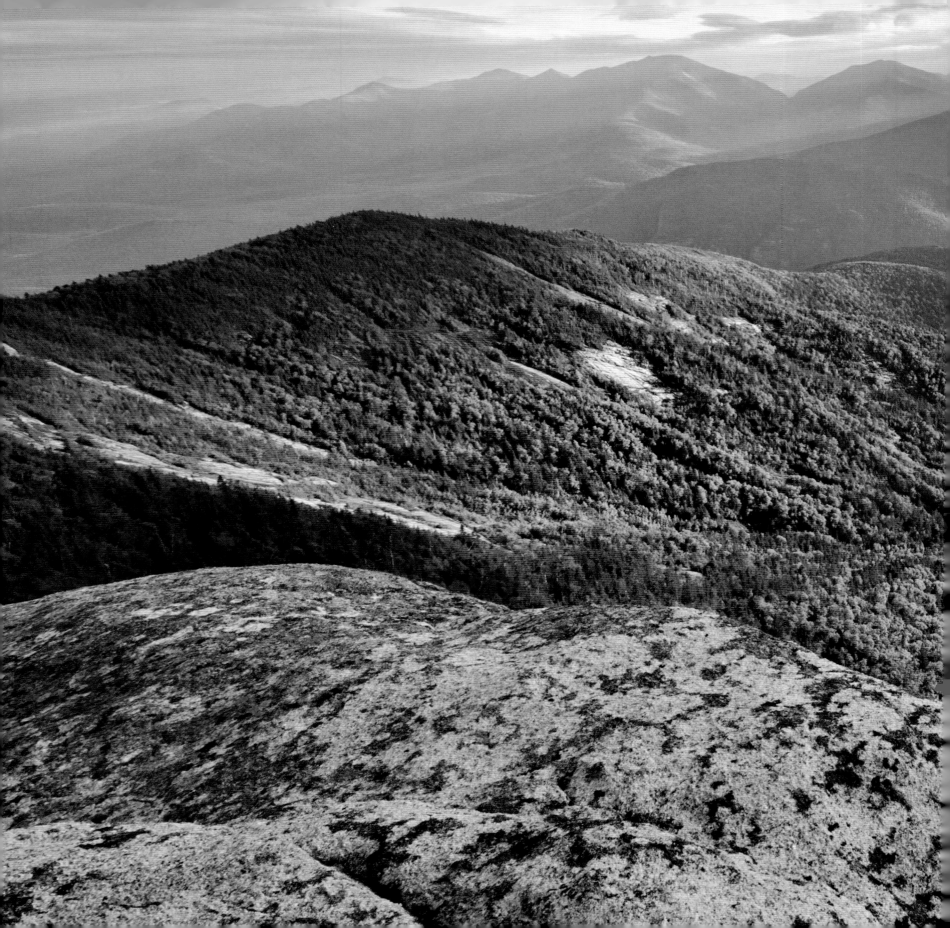

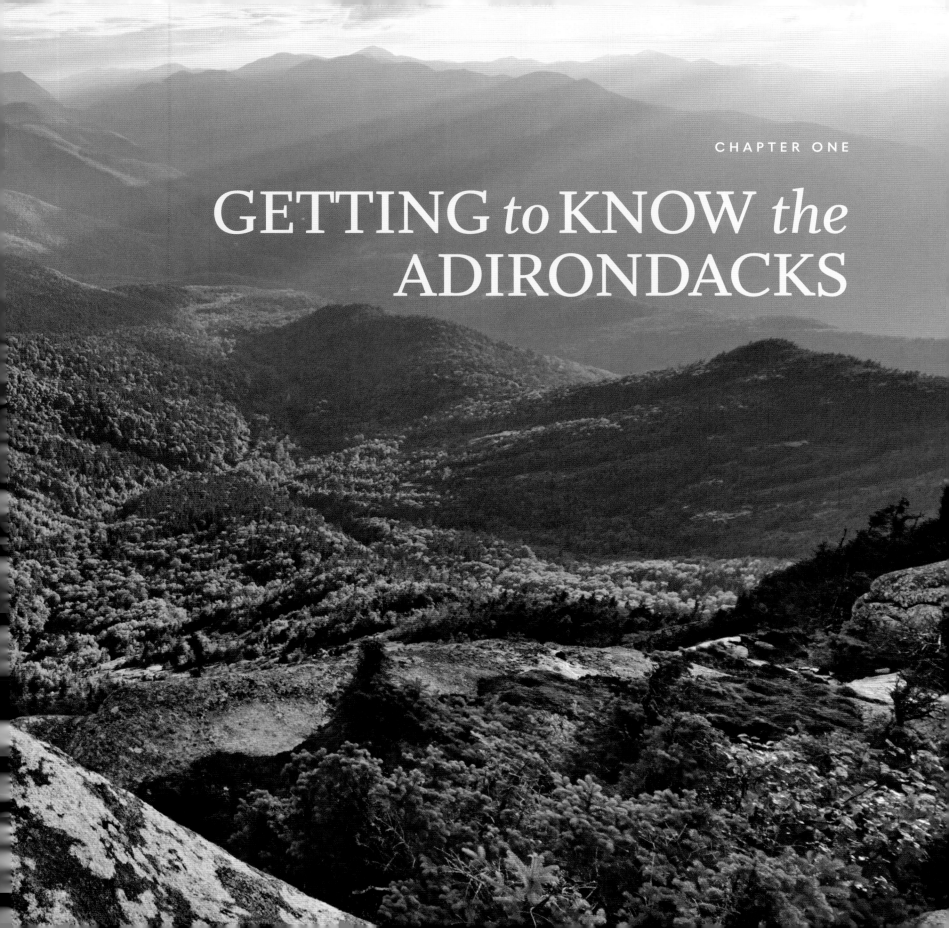

CHAPTER ONE

GETTING *to* KNOW *the* ADIRONDACKS

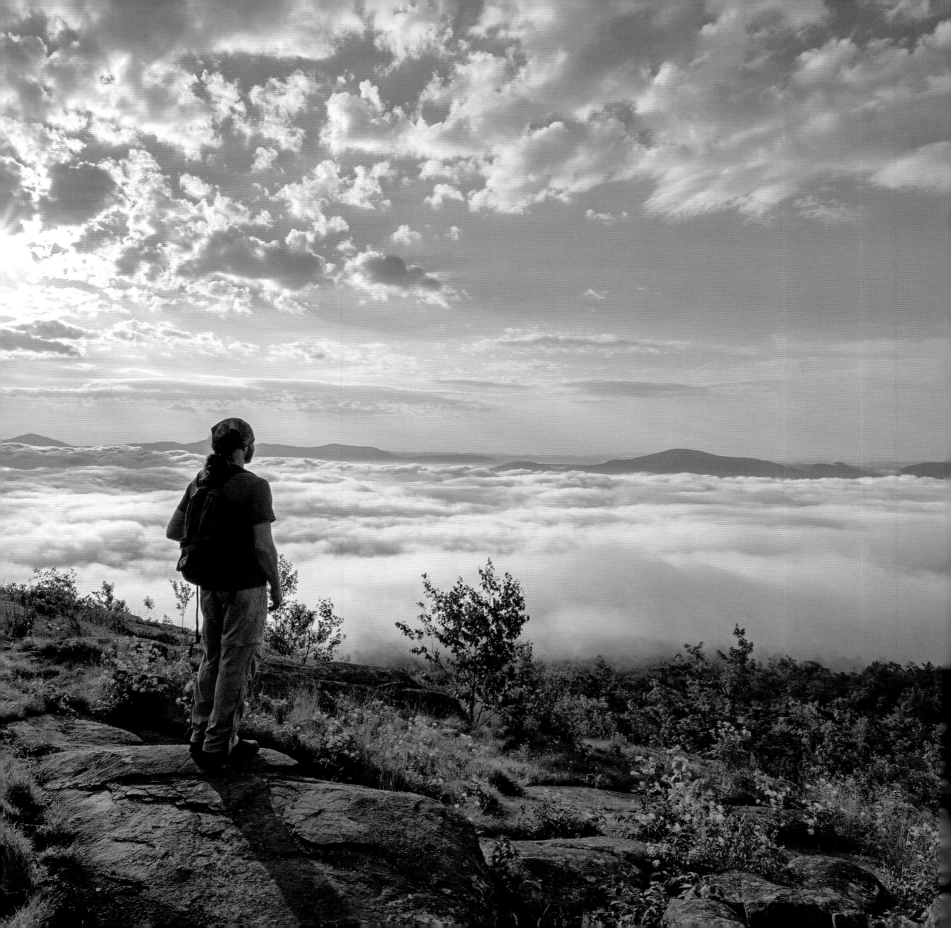

Many are those who say the Adirondacks are unique. That may be an overused word, but in numerous ways the region is distinctive, and in some cases even certifiably unique. Let's consider some of those ways.

THE ADIRONDACKS ARE BIG

Not vertically, which is what most people think of when they hear the word "big" associated with mountains, but horizontally. Consider the Adirondack Park, for all intents and purposes the most useful packaging of the region. The park is defined by its famous Blue Line, so-called because somebody drew the original line in blue pencil on a map about 125 years ago. (It has been reconfigured, usually to enlarge the park, several times since.) Inside that line are 6.1 million acres, give or take. Simply put, the park is the largest of its kind—state, national, whatever—in the Lower 48. You could put Rhode Island in it and have enough room left over for Delaware and Connecticut. Toss those three aside and you could fit Maryland in. Or New Jersey, although local self-styled comedians always ask, "Why would you want to?" You could even squeeze Vermont in if you lopped a few acres off of the Green Mountain State. Yellowstone, Glacier, and Yosemite National Parks would go in nicely as a package.

Bottom line: by any measure the Adirondack Park is huge. Think of it this way: it takes nearly four hours to drive from the northern edge of the park to the southern border (partly because you can't do that very fast most of the way, especially in the region's daunting winters). That's about the amount of time it normally requires to drive from New York City to, say, Washington, DC, or Boston. Legions of curious travelers have thought to drive around the Adirondacks for a couple of hours to get to know the area, only to realize that could actually take a couple of weeks. Or longer. The insider's answer to the uninformed tourists' question, "What does it cost to get into the Adirondack Park?" is "Lots of time."

In some sense, the park is too big. The geography, the economy, the urban orientation, the microclimate—nearly everything is different on one end than it is on the other. Adirondackers on one side display little knowledge of, or interest in, the situation on the other side. Folks in the Black River Valley on the western fringe, for example, aren't much aware of what's going on in the Champlain Valley on the east. They're too far apart: the Black River country is closer to Rochester, New York, than it is to Lake Champlain. One tries to think of the Adirondacks as a single cohesive entity, but one also lives with the gnawing possibility that it is not.

THE ADIRONDACKS ARE OLD

This is open to ongoing scrutiny by the scientific community, but most geologists consider Adirondack bedrock to be among the oldest exposed rock in the world, at somewhere beyond one billion years. It has been abused for most of that time: pushed up, worn down, pushed up again, sat on and gouged for centuries

PREVIOUS SPREAD: Late afternoon light flows across the eastern High Peaks and the St. Huberts area in this view from Giant Mountain.

OPPOSITE: A hiker enjoys the view from Cat Mountain over the cloud-filled Lake George basin.

by two-mile-thick glaciers, and eroded eternally. This bedrock—which is visible in only a few places, most notably on the higher summits—has a slightly bluish cast and is called anorthosite, a very hard granitic rock that is the southernmost extremity of the Canadian Shield. It comes from our neighbors to the north via the Frontenac Arch. Think of a cross section of a slice of the globe extending from roughly Algonquin Park in Ontario to the Adirondack Park (this, tangentially, is the route of a proposed designated wildlife corridor). The Frontenac Arch is mostly buried, but it emerges above the surface on its way to the Adirondacks in the form of the Thousand Islands and the hardscrabble, unyielding terrain that was the undoing of many optimistic pioneering farmers in parts of the St. Lawrence Valley and the northwest foothills.

Ironically, although they are old below the surface, the Adirondacks are new above. The last glaciers went back to Canada only about 10,000 years ago, the blink of an eye in geologic time. Not only did they shape the Adirondacks as they are known today—the sculpted summits, the deep narrow lakes, the sprawling wetlands of the northwest, the erratics (immense boulders) left indiscriminately here and

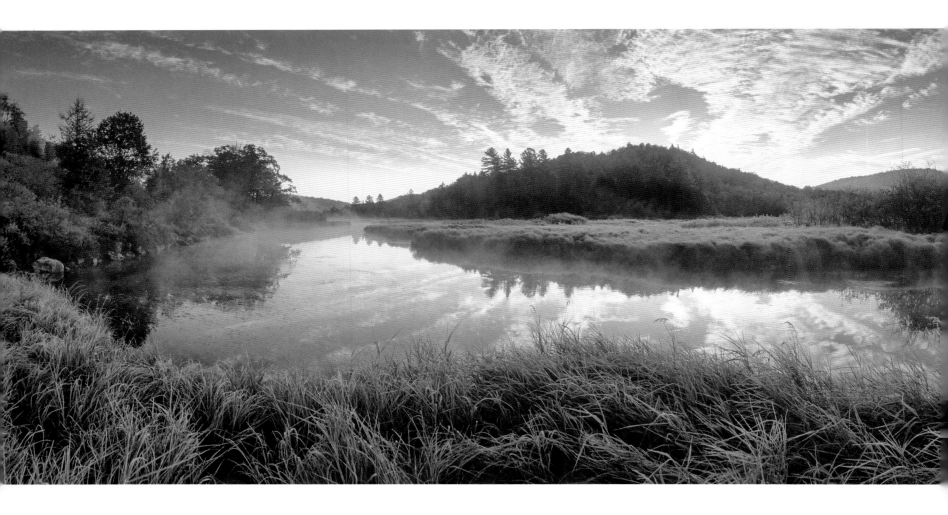

THE TRAILS OF THE ADIRONDACKS

there—they also weighed the land down so ponderously that it is still rebounding to this day, rising at the rate of a couple of millimeters a century. This revelation causes aging hikers to comment, "I thought that mountain was higher than the last time I climbed it." In truth, it is a sobering reminder that in the natural world, nothing, not even a feature as seemingly solid and immutable as the Adirondack Mountains, stays the same forever.

THE ADIRONDACKS ARE DIVERSE

Not so much sociologically (though the region is in fact less homogeneous than most people realize), but ecologically. Partly attributable to the region's size, its segments are very different from one another. Many people equate "the Adirondacks" with "the mountains," but except for a few scattered monadnocks here and there, most of the honest-to-gosh summits are sequestered in the eastern third of the park. These

BELOW: A frosty fall morning creates an enchanted landscape along the calm waters of the West Branch Sacandaga River.

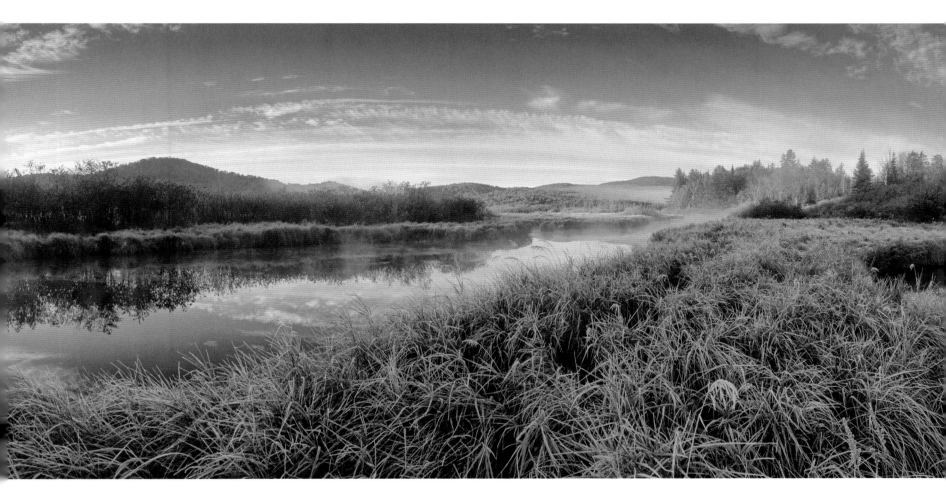

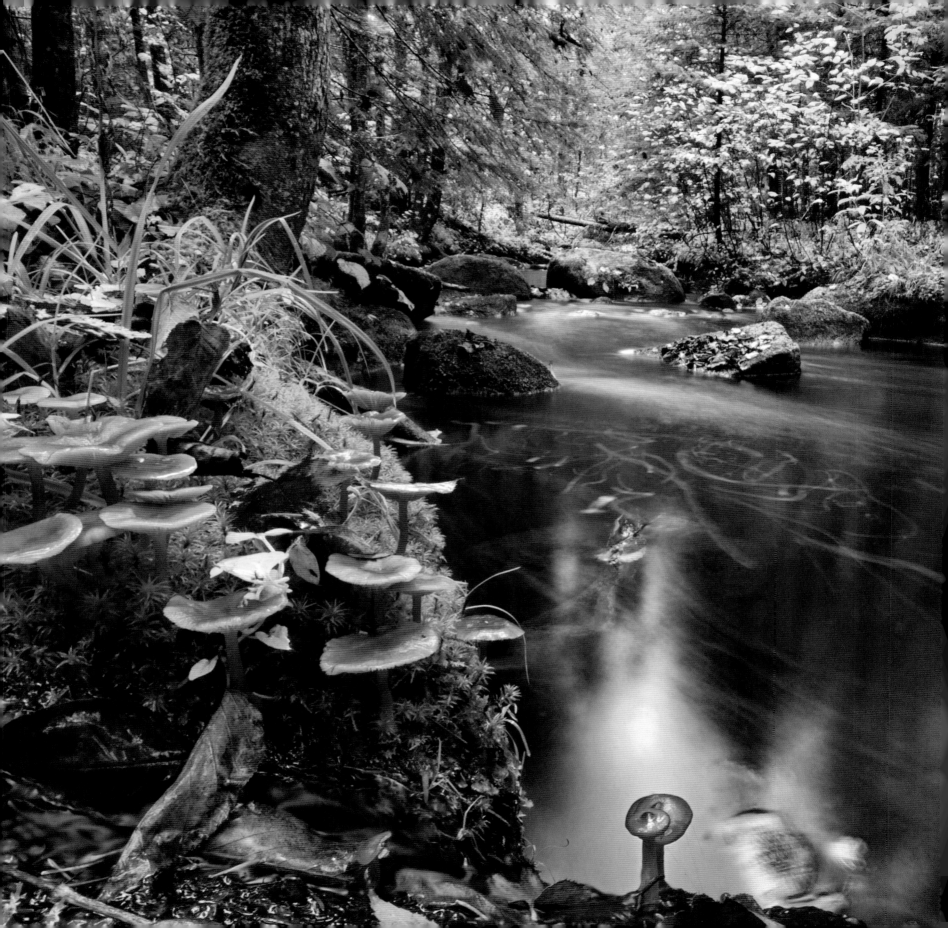

mountains are not particularly tall by many standards; only one summit, Mount Marcy, exceeds a mile above mean sea level at 5,344 feet. Any self-respecting resident of Denver, Colorado—whose downtown lies at a higher altitude than every other Adirondack mountaintop—would laugh at the notion that these are called the High Peaks. They're not even the tallest mountains in the East; the highest Great Smokies and White Mountains exceed them by a thousand feet or more. On the other hand, when you take into account the fact that the shoreline of Lake Champlain is only 95 feet above mean sea level—making it one of the lowest places not part of a coastal region east of Death Valley—you realize that from just the right spots you can see a lot of mountain in the Adirondacks. From the rare stretches on the shores of Champlain where you can peek through notches and over ridges and pick out Mount Marcy, it's almost a vertical mile from there to the summit.

Meanwhile, the majority of the Adirondack Park is anything but mountainous. Portions of it, mostly along the fringes, even feature flat, rich farmland. But farms flourish smack in the heart of the park as well. The salads you eat in those upscale resorts and dining establishments in Lake Placid and Saranac Lake consist of ingredients grown within 20 miles of those two mountain villages.

Most of the park, though, is rolling, heavily forested, and well watered. In fact, the dominant geographic features in these vast stretches of lonely territory are lakes, ponds, and rivers—wonderful for paddling—along with bogs, mires, and marshes that harbor a remarkable variety of flora and fauna— meccas for naturalists but not of much interest to peakbaggers. This is the land of nearly impenetrable forests, of hunting and fishing, of snowmobiling for mile upon mile down abandoned railroad grades, where escaped convicts from nearby maximum-security prisons can go undetected for weeks until the blackflies wear them down. It is the Adirondacks most Adirondackers and few outsiders know.

There's unusual diversity of ecosystems too. That's because the Adirondacks sit astride a fuzzy, undulating boundary between the predominantly hardwood forests of midcontinent (think beech and maple) and the more coniferous boreal, or northern, forests typical of Canada. You will find groves reminiscent of the central Appalachians sharing space with taiga-like bogs at the southern extremity of their range. You will find an intermingling of tree types not often experienced in close quarters— oaks and ashes can be neighbors with spruces, hemlocks, and spidery tamaracks. Vertical boundaries intermingle as well. Drive up the Whiteface Highway and you may as well be journeying several hundred miles northbound; watch the tree types change as you ascend.

It's said of many places, "If you don't like the weather, wait a few minutes." That cliché can apply to the Adirondacks too, but a more accurate testament might be, "If you don't like the weather, go five miles in any direction." Adirondack meteorological phenomena are as diverse as any that can be found, to the confoundment of every prognosticator within range. A blizzard can be raging on the western slopes, courtesy of their proximity to Lake Ontario (these are known in that sector—with a certain blend of respect, awe, and dread—as "lake-effect snows," and they can generate the greatest snow depths in the East), while not two miles away the sun is shining. The vicinity surrounding Old Forge is heaven on earth to snowmobilers and adherents of other forms of motorized cold-season recreation, while Nordic skiers and snowshoers also revel in annual snowfall accumulations that can exceed 300 inches and last well into April or even May once in a while.

OPPOSITE: This stream in the Lake Placid area is along a quiet footpath to Holcomb Pond.

At the same time, the southeastern corner can get pummeled by a nor'easter good for two feet of powder, while the northwest admires skies so blue it hurts to look at them. Southern Adirondackers may bask in plus-20s temperatures while northern Adirondackers congeal in the minus-20s. Mountain peaks generate their own mini-thunderstorms on muggy summer afternoons; hikers in one spot can get drenched while others, half a mile down the trail, feel nary a drop. And, as with vegetation, there's the vertical variation as well. Too many climbers have set out for the high country on a mild spring day, dressed for the valley weather, only to be blasted back one whole season once they rose above timberline. Some of these unfortunates have lost fingers or toes. Some have lost their lives. Adirondack weather is not to be toyed with.

THE ADIRONDACKS ARE BIZARRE

Management-wise, that is. The region's size and diversity, plus an organizational oddity, render it maddening to govern. Here's the oddity: unlike most other parks, the Adirondack Park contains both public and private land. The public land, known as the Adirondack Forest Preserve, is inside the park and consists of numerous detached parcels of varying acreage that are owned by the State of New York. The preserve actually preceded the park, in 1885, in an attempt to curtail out-of-control logging. The Adirondacks were the feeder of water to the Erie Canal, spinal cord of the state's billowing commerce, and careless logging practices had silted up the rivers that fed the canal, such that not much water was getting to it. Ergo, laws to stop that. It surprises some people that recreation, arguably the key benefit of the Forest Preserve today, had nothing to do with its beginnings; that it was an effect, not a cause. Creation of the preserve was a hardheaded business decision.

The Forest Preserve in 2019 accounts for only about 43 percent of the park's aforementioned 6.1 million acres. Since approval by the voters in 1894, it has been perpetually protected—under the iconic "Forever Wild" clause of the New York State Constitution—against development, incursion for human purposes, and even lowest-level forest management (in most places one must use hand tools, not chain saws, to clear blowdown from trails, for example). Only amendment of that hallowed document by the voters of the state can permit any alteration to the Forest Preserve. Such was the case in 1927 when they voted to allow construction of the Whiteface Veterans Memorial Highway. That constitutional armor is one thing about the Adirondacks that is truly unique. "Perpetually," though, is only as good as the good intentions of the voting public; they can unprotect the woods as easily as they protected them 125 years ago, though they have not seemed inclined to take that radical step.

The other 57 percent of the park is privately owned, even though it's in a park. The park was created in 1892 as an extra layer of protection for the forests because the loggers had not taken the preserve hint seven years earlier. The main drag in Lake George is inside the park, even though it's hardly wilderness (although there are those wits who say it gets pretty wild on summer Saturday nights). So is Lake Placid—lake and town and Olympic bobsled run and everything else. So are thousands of acres of managed woodlots, farms, homes, hunting camps, businesses, small factories, shops, art galleries, museums, schools, diners, tourist traps, and so on. Some 132,000 permanent residents live, work, and conduct their daily lives within the Adirondack Park.

OPPOSITE: Ice builds up quite high at the base of OK Slip Falls after a prolonged period of arctic cold.

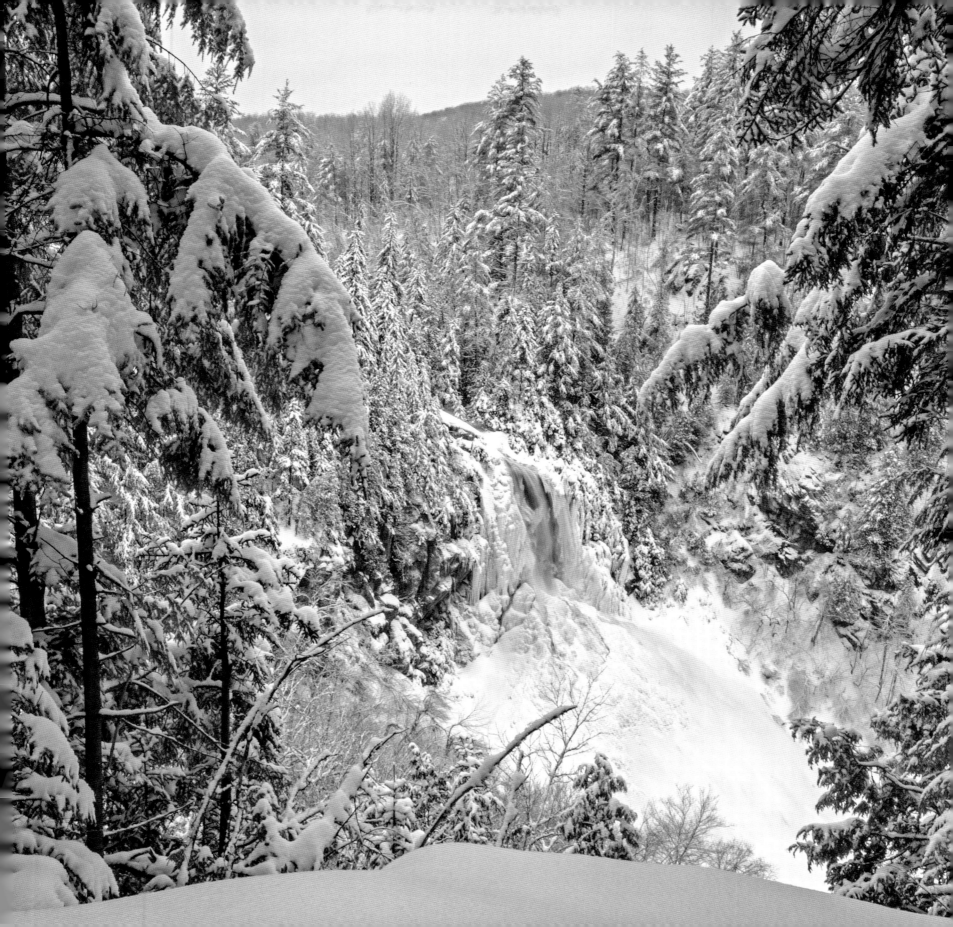

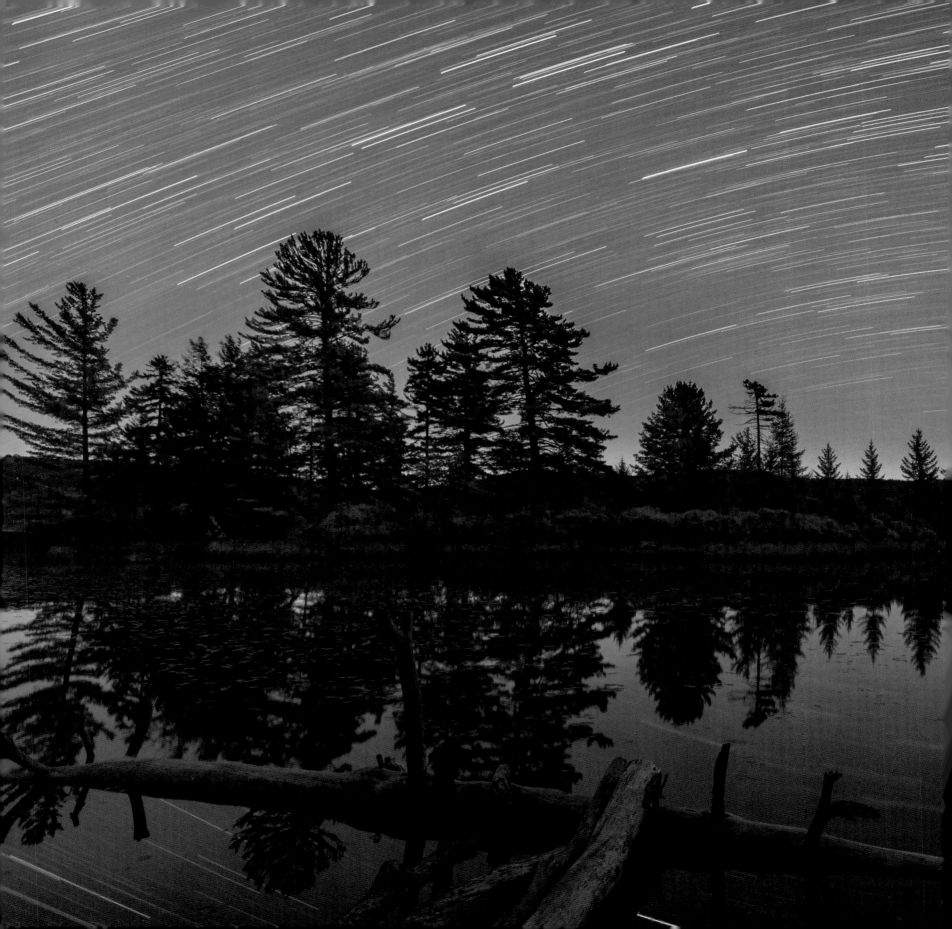

On top of that, the park sprawls over a huge chunk of northern New York, reaching its tentacles into multiple layers of overlaid jurisdictions. It encompasses 102 townships (one can obtain a guidebook with a checklist, visit all 102, and get a passport stamped if he or she can locate anyone to do it), a handful of villages, parts of 12 counties (only two, Essex and Hamilton, are wholly within the park), dozens of school districts, several state Department of Environmental Conservation management zones of assorted purpose, bushels of state and local economic development and tourism-promotion agencies, citizen advocacy groups spanning the spectrum from deep ecologists to flame-throwing libertarians, and one beleaguered Adirondack Park Agency—a megazoning board that since the 1970s has had overarching (and often overwhelming) responsibility for planning and managing land use in every square inch of the massive park, on both public and private lands.

Authority over private lands has remained controversial from the agency's beginning, at one time prompting the torching of one commissioner's barn, the dumping of a truckload of manure in the parking lot of the agency's headquarters at Ray Brook, and other malicious behavior. Tempers seem to have cooled since those dramatic days, but the contentiousness simmers underneath ongoing conversations and decisions like a fire in a coal mine. As a general rule, Adirondack landowners have never been keen on having government bureaucrats tell them what they can and can't do with their land.

THE ADIRONDACKS ARE HARD TO DEFINE

In concert with all of the above, which barely scratches the surface anyway, no one is sure what the Adirondacks are, or exactly where they are. Are they just high mountains tucked into one corner of a park? Are they the sprawling swamps and wooded hills far to the west of there? Are they the organic farms and prosperous orchards of the Champlain Valley and the decaying cores of dozens of little hamlets? Are they the abandoned mines of Lyon Mountain and Tahawus and Star Lake, the empty, echoing paper mill in Newton Falls, the struggling stores and cheesy tourist attractions? Or are they merely the great views and beautiful scenery, and nothing more? Who is to say?

Ask those questions in any tavern north of the Mohawk Valley. Ask if the Adirondacks and "the North Country" are one and the same, or whether they are separate, distinct regions, or where their boundaries are, or if they intermingle here and there. You will get as many answers as there are lumbermen and truckers and farmers and real estate agents and retirees and prison guards and town supervisors at the bar. That has been the case since those regional designations came into existence, and it will be so for time immemorial. The Adirondacks will never be defined to everyone's satisfaction.

In 1879, the surveyor Verplanck Colvin wrote, much more eloquently in this book's epigraph, that no one really knows the Adirondacks. The same can be said today. This storied, complex, magnetic, infuriating region is too big, too spread out, too schizophrenic, to be grasped in a few days, or through a few words and pictures. The best one can do is explore with an open mind, humility, and a lot of patience. Let the exploration begin.

OPPOSITE: This long exposure of stars in a clear September sky was taken along the peaceful shore of Limekiln Lake.

Adirondack FORESTS

STUART MESINGER

I often contemplate the vast green spaces on maps of the Adirondack Park, pondering where the wildest place I could go might be. I think it must be far off the beaten path, a place where people don't often intrude and natural wonders abound.

Not that long ago this exercise wasn't possible. Nearly all of the park's forests were disturbed by axe, plow, shovel, or fire. When the Adirondack Forest Preserve was created in 1885 (and in 1894 constitutionally protected as "Forever Wild"), it consisted of 681,000 acres of scattered woodland, much of it logged and then abandoned for nonpayment of taxes. The park is now 6.1 million acres, of which 2.6 million acres are wilderness where motorized uses are not allowed. In the last 50 years, 350,000 acres (that's about 540 square miles, or 15 Manhattan Islands) have been added to the Forest Preserve. An additional 765,000 acres are protected by easement (a conservation technique that allows uses such as forestry and recreation, but precludes development). The park now contains the largest protected forest in the Lower 48 and is home to 90 percent of all known plant and animal species found in the East.

The result is a forest far more wild and natural than it was 100 years ago, and it is growing more unique and wild with each passing year. After having been cut, dug, plowed, and burned, the forests are growing back together. To quote Bill McKibben, "The Park is a place of great and growing ecological integrity. It is growing more whole with each passing year—the earth's single great example of ecosystem restoration."

The restoration of the forest means that unique habitats of all kinds have been protected: thousands of acres of old growth, talus slopes and ledges, kettle bogs and ponds, pine barrens, spruce and cedar swamps, sphagnum bogs and mats where the carnivorous sundew and pitcher plant live (the latter's flower an otherworldly deep purple the color of digested blood), alder carrs and fens, floodplain forests, and, above the krummholz, rocky summits carpeted with alpine flowers—but you don't have to climb high to see them; you can also find them in ice meadows along the Hudson River.

Especially remarkable is the low-elevation boreal forest east of the St. Regis River, a rare and extensive area of spruce and fir forests and sphagnum bogs home to 19 species of birds found at the southern limit of their range. Tragically, it is doomed to disappear as the climate warms.

Nowhere is the rewilding of the park more evident than in the return of species previously extirpated. The bald eagle and peregrine falcon were extirpated but reintroduced. The moose and cougar were extirpated, but reintroduced themselves. The beaver was nearly trapped out, but has since returned in numbers, especially in the watery north. The black bear, white-tailed deer, bobcat, otter, marten, and fisher were all much reduced in numbers, but have since recovered. Of the charismatic native mammals, only the wolf and lynx haven't come home.

For many years, I thought the most remote place in the park must be deep in the Five Ponds Wilderness, where I once heard the magical call of a loon answered by the unsettling bellow of a moose. It's not. As measured by distance from the nearest road, it's deep in the High Peaks Wilderness, close to the Cold River, a few steps from the Northville-Placid Trail. However, you don't have to go that far into the woods to enjoy a wild and wondrous place; thanks to the expansion and protection of the Forest Preserve, they can be found throughout the Adirondack Park.

Opposite: Intertwined cedar roots grow along the shoreline of Lake Harris.

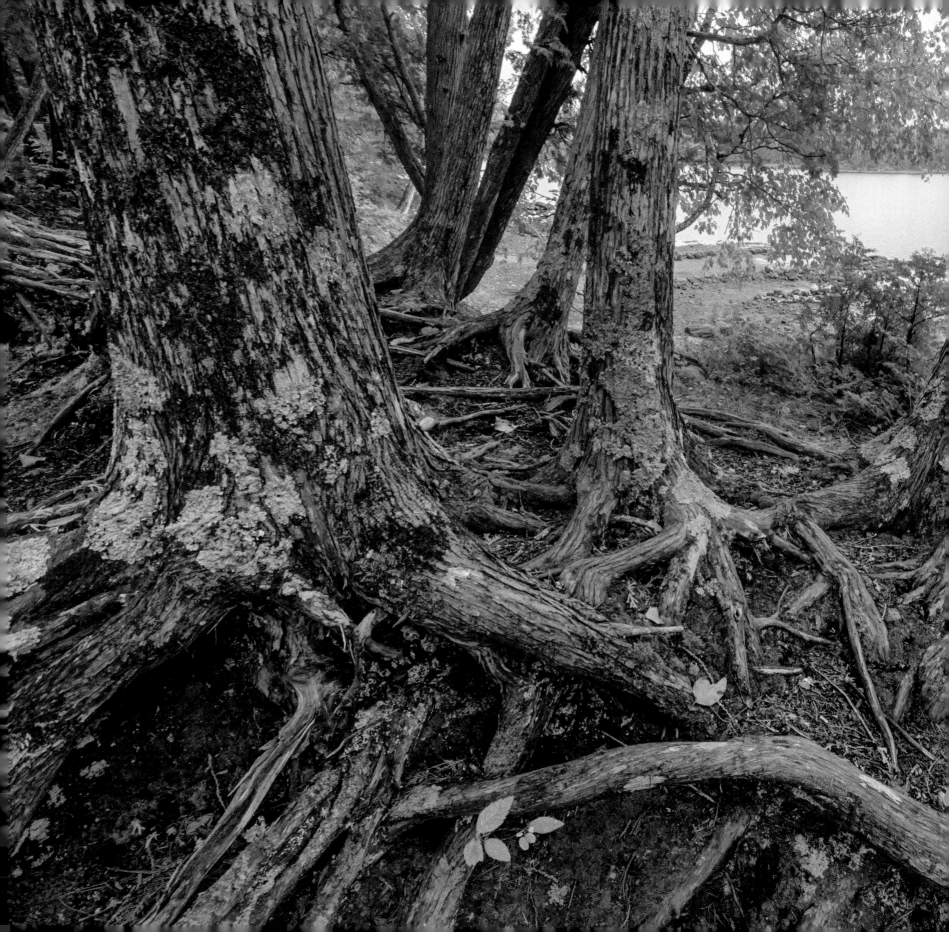

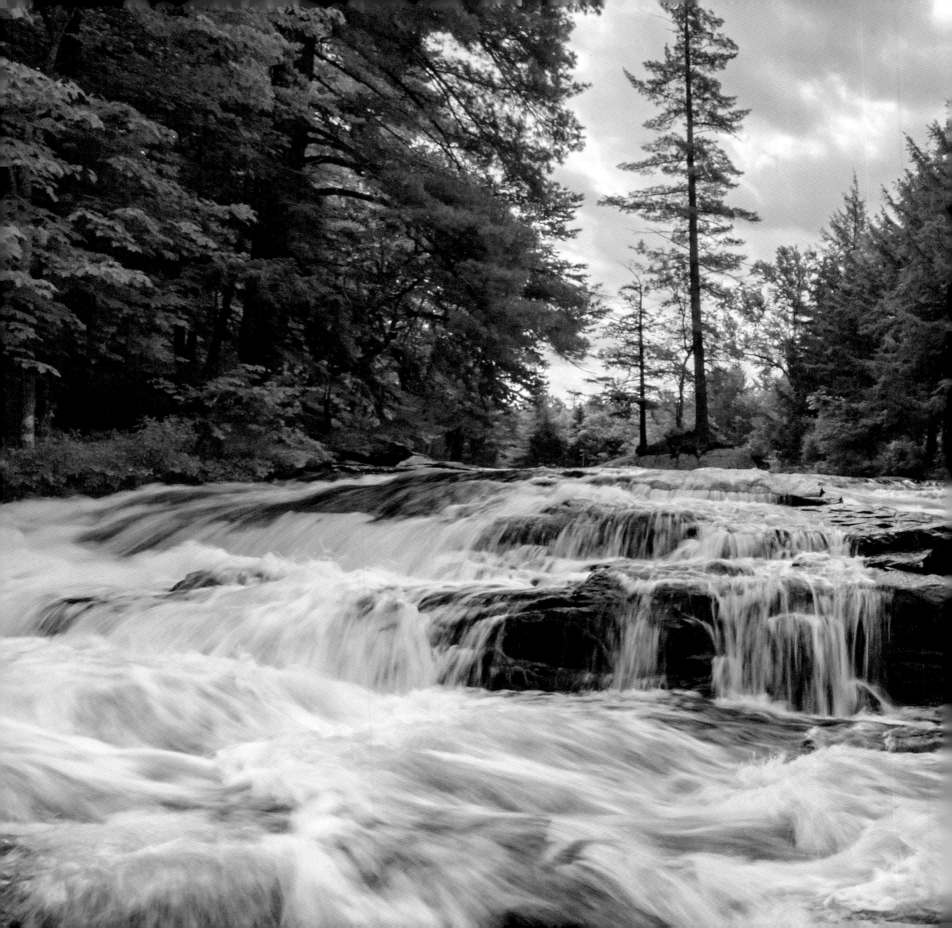

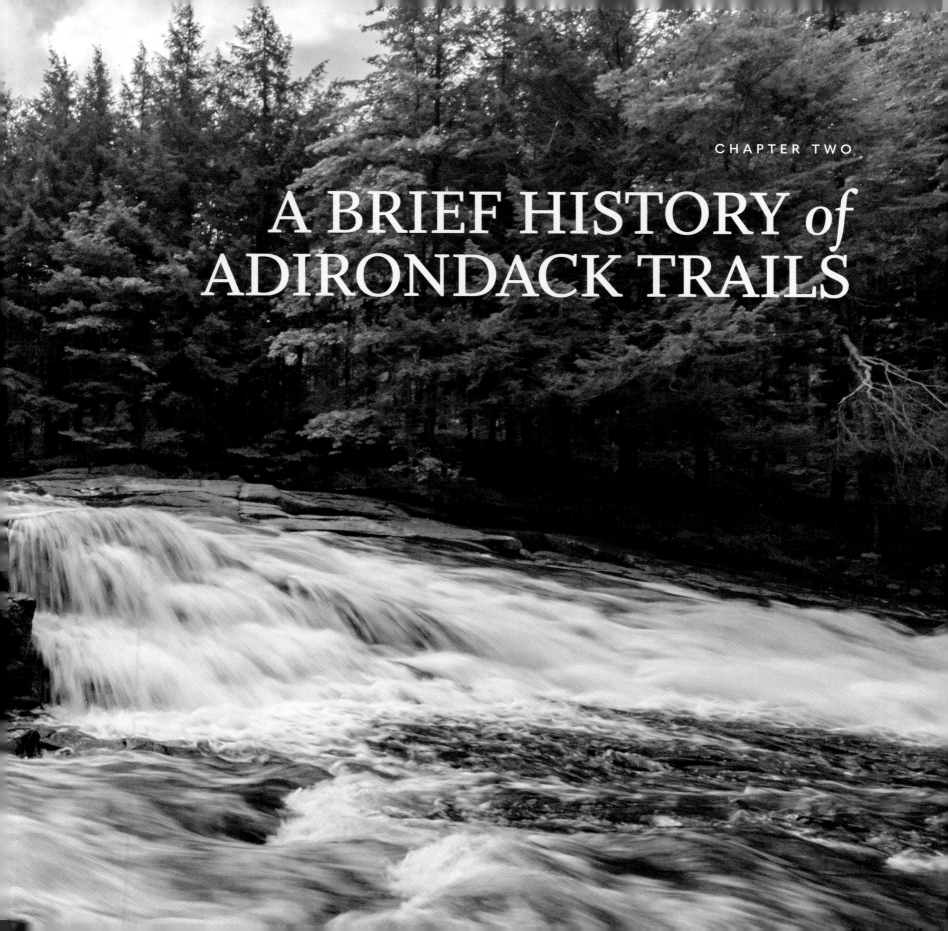

A BRIEF HISTORY *of* ADIRONDACK TRAILS

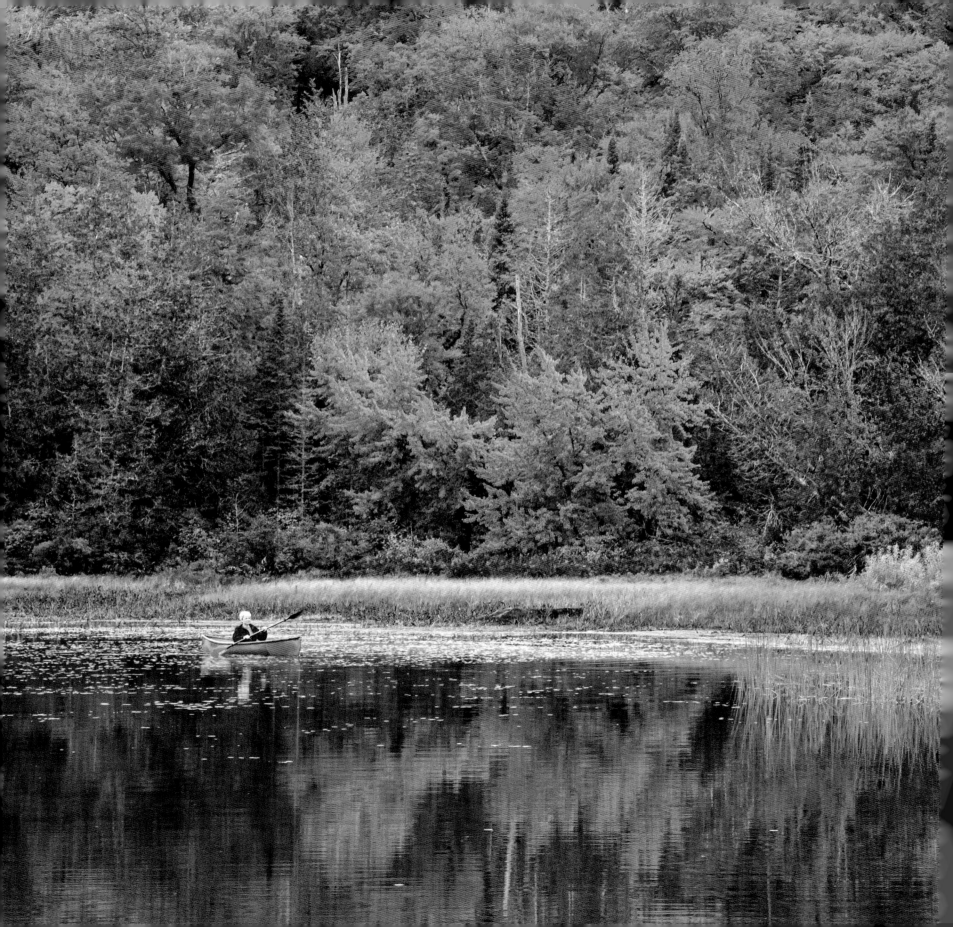

The first Adirondack trails were made of water. Nowadays, those who care about trails try to get water off of them. Such is the way the wheel of history turns.

For millennia, before Europeans arrived and pushed them aside, Native Americans used the rivers of the Adirondacks as their highways. Whether or not many of them lived in the region, only used it to hunt, fish, trade, and fight each other, or merely passed through on their way to more hospitable grounds are matters for academics to keep debating. The point is they traveled in vessels on water, with occasional short footpaths or carries, to, well, *carry* their canoes and provisions from one waterway to another.

How sensible this was can be ascertained if one looks at the Adirondacks from high in the sky. From up there, the region looks like a giant, ragged, inverted bowl, tilted up to the northeast, with water running off it in all directions, the sources of the streams not very far from one another near the top. You can demonstrate this to yourself quite easily right in your own kitchen. Take a good-sized mixing bowl and turn it upside down in your sink. Turn on the faucet—gently, or it will splatter water all over you—and see what the water does. Unless your bowl is really crooked or way off-center, it will run down all sides.

The Native Americans had this figured out, even without the benefit of aerial mapping, and were able to traverse the entire Adirondacks almost exclusively by paddling up and down its rivers and lakes. One famous southwest-northeast route took them up the Moose River through the Fulton Chain of Lakes, thence to the lakes that form the headwaters of the lengthy Raquette River watershed, and then down the Raquette (French for "snowshoe," incidentally) to the St. Lawrence Valley. Or, they could disembark at a point along the Raquette where it was but a short, level walk north to Upper Saranac Lake (a passage known to this day, though no longer politically correct, as the Indian Carry). From there, they had water access via the Saranac River system to the entire northeastern Adirondacks all the way to Lake Champlain. Today, part of this itinerary accounts for the world-famous 90-Miler, a grueling three-day canoe race that recapitulates the indigenous peoples' wisdom.

A NEW TREND AND A NEW PROFESSION

There was a time when people who went walking around in the woods for the fun of it or, even more bizarre, up mountains just to see the view were thought more than a bit daffy. One went into the woods to find land for a cabin, resources, or food—not to look at the scenery. Trees, after all, were meant for turning into lumber, not for admiring. And what sound reason could there be to scramble up to the top of a mountain, only to gaze into the distance, turn around, and come back down again?

But as the 19th century wore on, concepts of resource conservation and eventually the more radical wilderness preservation gained respectability by degrees, and the Adirondacks became one of the first places in America where some of these ideas were implemented. As part and parcel of this trend, it gradually became more acceptable to look for spiritual and not just material value in the woods. This pendulum swing

PREVIOUS SPREAD: Basford Falls along the Grasse River is one of several hiking destinations to waterfalls along Tooley Pond Road in the western Adirondacks.

OPPOSITE: A paddler enjoys a gorgeous fall day on Lake Harris near Newcomb.

Guide and Party Paul Jamieson

The bond between the guide and his patron was love of the woods and of hunting, fishing, or exploring. When this was genuine, barriers between the city-bred party (one patron or more) and the backwoodsman vanished. A friendship was formed, which sometimes lasted a lifetime.

A relationship as emotional as this attracts traditions and legends. In the 19th century especially, when guide service was more essential than today, the Adirondack guide was a celebrated figure in the nation, proverbial for woodcraft, honesty, resourcefulness, patience and good humor, and backwoods philosophy. These merits, often real enough, were enhanced in the mind of the patron, particularly if he was a writer acquainted with the myths of the age. Myth and reality combined to make the guide the most attractive figure in Adirondack life and literature.

The reality was a man who had lived all or nearly all his life in the woods, killed his first deer at 12, and operated a trap line between bouts of schooling; now in maturity, with an intimate knowledge of the woods and waters of his own area and muscles hardened by a winter's logging, he could row a boat all day, pack it and the duffel over the carries, build a shelter wherever needed, find the best spring holes, organize a hunt with dogs, or float noiselessly into shore behind a jack light. He could cook passably well, had a few picturesque oaths and other expressions not in the lexicon, and a collection of hunting stories for the campfire. Besides all this, he had an assortment of odd, ornery, or amiable traits that made him a character among characters.

in attitudes was pioneered by the transcendentalist arm of the Romantic movement. In 1858, several leading lights of that philosophy—among them Ralph Waldo Emerson, Louis Agassiz, and James Russell Lowell—camped on the shores of Follensby Pond near Tupper Lake, later praising the virtues of going to the woods just to hang out and contemplate, along with hunting, fishing, and messing about in boats. A revolution in thinking gained momentum.

After the Civil War, it became ever more permissible, even fashionable, to head for the woods just for refreshment. Glittering hotels, the five-star establishments of their day, sprang up along the periphery of the mountains in such glamorous destinations as Saratoga Springs. Lodgings cropped up as well in the interior, where at the outset they were often no more than rough shanties. Later, though, the Prospect House, overlooking Blue Mountain Lake nearly dead center in the park, became the first hotel in the world to have electricity throughout, the switch initially pulled by Thomas Edison himself. (It also had a two-story outhouse, but let's not delve further into the engineering of that feature.)

Writers who stayed in these establishments and poked around in the woods waxed eloquently, and as often as not hyperbolically, about the joys of hiking, angling, and boating (or, more precisely, being rowed around by a local woodsman looking for deer to shoot from an Adirondack invention, the guideboat). The well-to-do took up the call and plunged in, all too often woefully unprepared, intent on wilderness adventures. What had seemed nuts to practical-minded people not that many years earlier was now the "in" thing to do.

These folks needed ways to get around. Waterways often sufficed, as they had for centuries, but one can't paddle to the top of a mountain. Navigable paths were needed (keep in mind that it was not only men, typically dressed head to toe in suits and ties, who took to this climbing fad, but also independent-minded women, who normally hiked in long skirts), and local folks were on hand to provide them beginning around the time of the Civil War. They offered services ranging from campfire cooking and hauling guideboats from pond to pond to tracking down deer and telling tall tales. Thus, a new profession—guiding— was born. Not as simpleminded as they appeared or sometimes acted for the entertainment of their clients, they knew that the easier it was to get to the top of a mountain, the more customers would hire them to lead the way.

One of the most famous of these guides was Orson Schofield "Old Mountain" Phelps of Keene Valley, even then a hub of hiking fervor. It was he who conferred, or is said to have conferred, the colorful and descriptive names of numerous mountains and other prominent landmarks in the area. (Gothics, for example, was named for its triple-arched skyline, although there is some evidence that appellation may have originated with someone else.) No slouch at marketing, Phelps turned himself into a legend in the process. He and some fellow guides cut the first trail to Mount Marcy, probably in 1861. Although it was later abandoned, another trail to New York's highest peak laid out by his son, Ed, bears his family name, and a lower peak within a good shout of Marcy is named for him.

Famous summer residents of Keene Valley also got into the mountaineering mind-set and had trails named for them, a rarity in most of the Adirondacks. One of these was Dr. Felix Adler, a famous philosopher and ethicist of the later 1800s who spent many summers in "the Valley" and was a zealous

BELOW: William James Stillman's painting *The Philosophers' Camp in the Adirondacks*, 1858, depicts a camping excursion near Tupper Lake of leading naturalists, writers, and artists of the transcendentalist movement, which was considered a key turning point in American attitudes toward nature.

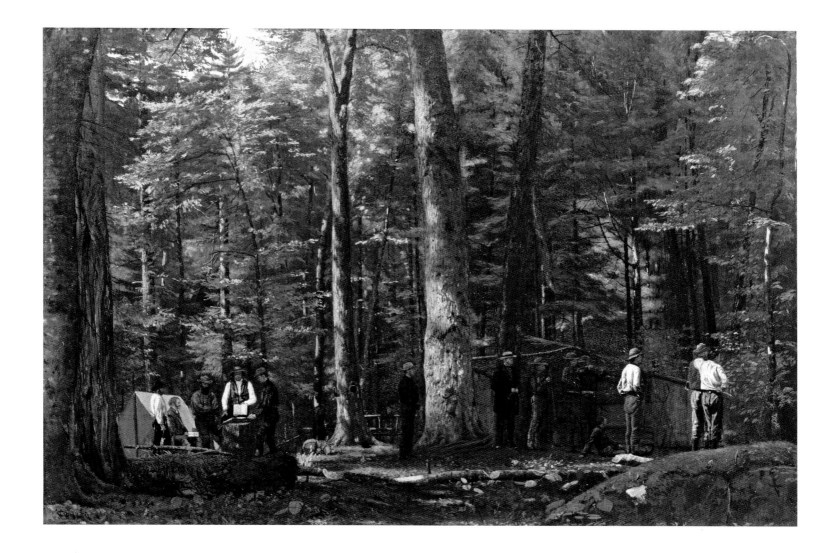

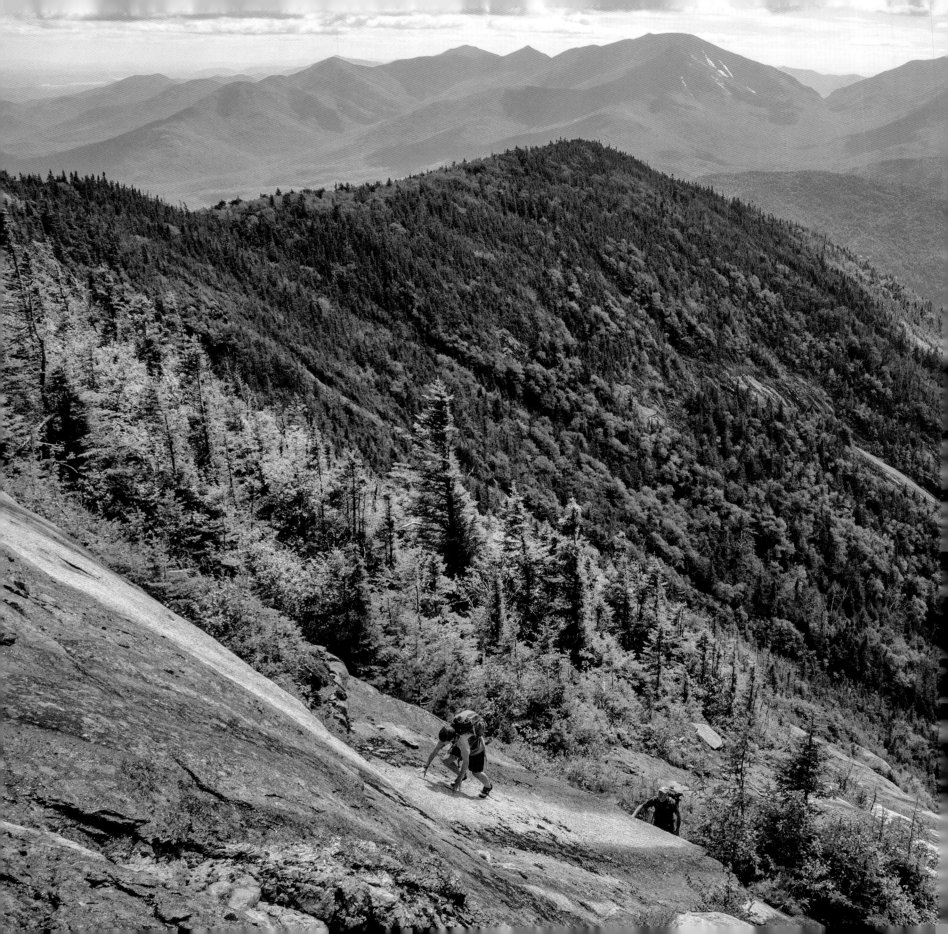

climber of the embracing peaks that were but footsteps from his cabin door. A connector trail to the summit of Noonmark Mountain, of which he was particularly fond, bears his name.

All the focus on climbing aside, it is important to remember that most early trails went not to mountaintops, but to fishing holes—the notion that the purpose of going into the woods was to extract resources was not easily displaced. Many of these spots came into being with no conscious planning or intent on anyone's part, but over time under the feet of knowledgeable guides. These guides, sometimes following the traces of longstanding "Indian trails," took their parties to places where they knew the "sports" could snag a string of hefty trout no matter how incompetent they were at fishing. Many are the Mud Ponds to which these led—and still lead. The guides, not wanting anyone else to know there was good fishing there, slyly named nearly four dozen Adirondack water bodies "Mud" in hopes of discouraging interlopers. When pressed by their wealthy big-city clients as to why they were being dragged to a spot whose name promised no fish, the guides replied, "Well, could be diff'rent today," or words to that effect.

RED HORSE: THE ADIRONDACKS' LEAST-KNOWN FAMOUS TRAIL

The history of the famous but today little-known Red Horse Trail in the western Adirondacks is representative of these early routes into the Big Woods, ancient routes that in many cases remain in use today. The trail bears the name of a chain of small lakes and ponds that were named not for a mysterious equine specimen of that hue, but for a fish. According to Edwin Wallace in his 1888 edition of *Descriptive Guide to the Adirondacks*—among the first comprehensive and trustworthy tourists' guides to the region—the name honored the redhorse suckers that inhabited one of the lakes along the route.

The trail likely existed long before Caucasian trappers pushed into the region in the early 1800s. Native Americans probably used it as a long carry, with breaks to paddle across the string of water bodies, between the west-flowing Beaver River and the extensive north-flowing Oswegatchie watershed. As Europeans penetrated the area more and more, they simply appropriated the trail for their own hunting and fishing expeditions.

And so things went along for decades. But in 1891, according to Edward Pitts—historian of the Rap-Shaw Club, a sportspersons' organization that still exists in the area—an acquisitive doctor named William Seward Webb purchased most of the forest around the headwaters of the Beaver River, including the Red Horse Chain and, with it, the trail. (He was not the last person to buy a trail; conflicts with landowners whose property is crossed by a public trail persist into the present, causing headaches for trail managers and users, not to mention the landowners themselves.) Webb intended to build a railroad across the tract—this would become the legendary "Fairy Tale Railroad" from Utica to Lake Placid that has made headlines in current times as the flashpoint of a very complex controversy over the conversion of a lengthy portion of it into a rail trail—and log the rest. But before he could start either moneymaking exploit, New York State raised its dam on the Beaver River at Stillwater, denying him the cheapest way to get his logs to lowland mills—by floating them down the river. Not pleased, he sued. The case plodded its way through the legal labyrinth for some time, but suffice it to say he ended up turning back to the state about two-thirds of his acreage, including the trail. The Red Horse Chain would henceforth not be denuded for profit.

BELOW, LEFT: In the 19th century, trails were meant to get "sports" and their guides to hunting and fishing spots—"hiking" on the trails was secondary.

BELOW, RIGHT: Trains were the main means people used to get to the mountains until the mid-20th century. Since then, they've been abandoned in favor of the automobile.

As part of the settlement, Webb was obliged to maintain the trail. This actually played into his hand. Not known for being a particularly hospitable gentleman—he built a depot on his railroad where it came abreast of his grand estate and named the station Keepawa, with a long *a* at the end—he wanted to fend the unwashed masses off of his adjoining private property. So fix up the trail he did—or rather the army of foresters, guides, and laborers in his employ did—and it soon gained popularity with the vacationing public. Further improvements occurred in the early 1920s, in one of the pioneering instances of cooperation between the New York State Conservation Department (today's Department of Environmental Conservation, or DEC) and the fledgling Adirondack Mountain Club (alias ADK, as AMC had already been claimed by the older Appalachian Mountain Club), teamwork that continues into the present throughout the park. In another instance of private-public partnering, the Red Horse Trail was maintained from 1901 until 1939 by the Rap-Shaw Club. "It's a good example of how the early

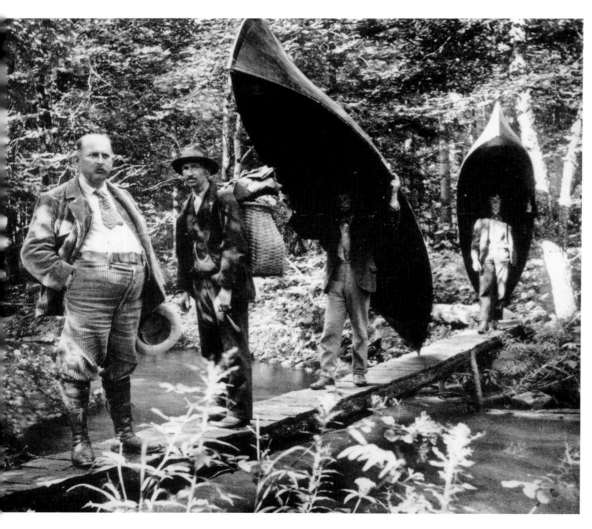

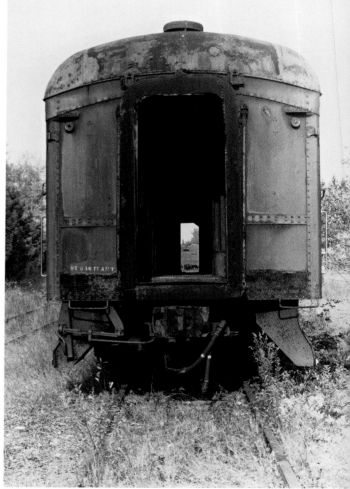

sportsmen's clubs contributed to the welfare of public hiking trails on state land," Pitts pointed out.

The trail's attractiveness was ensured by the fact that one could get to the southern trailhead, or near enough at any rate, by daily passenger train to Beaver River Station on the line that Webb built. There, parties could lay over at the remote Hotel Norridgewock, which continues to operate today, and hire a guide to transport them to the Red Horse Chain or anywhere else in the area. But train service deteriorated after World War II, as it did everywhere, and finally sputtered to an end in 1964. After that, the only way to get to the trailhead was via a long boat journey up the reservoir behind the dam. Trail use diminished precipitously, and the route faded from folks' minds. Attempts were made to keep it passable just the same, but in 1995 a rare and ferocious storm known as a microburst flung dozens of trees across it like jackstraws. If that were not enough, industrious beavers kept flooding it. Finally, the northern half of the trail, from Clear Lake to High Falls on the Oswegatchie, was formally abandoned.

The five miles from the reservoir to Clear Lake, however, remain open and in use. ADK, continuing its historic mission of nearly a century, assigns its professional and trained volunteer trail crews to the path when the need arises to build bog bridges, clear blowdown, or otherwise keep it safe and enjoyable to hike. It's just hard to get to. Those who go to the trouble are rewarded with seclusion, impressive old-growth forest, isolated glacial lakes, and a trail whose history recapitulates in its many twists and turns that of countless low-altitude trails throughout the Adirondacks.

TAKING THE CURE AND NEW MOUNTAIN TRAILS

Another instigation for the construction of trails in the latter part of the 19th century was brought on by a feared disease. Diagnosis of consumption, or tuberculosis, nearly always carried with it a death sentence in those days. It was also very contagious. A young, well-off, and at the time not highly motivated doctor named Edward Livingston Trudeau contracted it while treating his brother. The doctor loved hunting and fishing around Lower St. Regis Lake, and vowed to spend what little time he had left in those comforting surroundings.

The Voice That Launched a Thousand Guide-boats (1869) William H. H. Murray

[One] reason why I visit the Adirondacks and urge others to do so is because I deem the excursion eminently adapted to restore impaired health. Indeed, it is marvellous what benefit physically is often derived from a trip of a few weeks to these woods. To such as are afflicted with that dire parent of ills, dyspepsia, or have lurking in their system consumptive tendencies, I most earnestly recommend a month's experience among the pines. The air which you there inhale is such as can be found only in high mountainous regions, pure, rarefied, and bracing. The amount of venison steak a consumptive [tuberculosis patient] will consume after a week's residence in that appetizing atmosphere is a subject of daily and increasing wonder. I have known delicate ladies and fragile schoolgirls, to whom all food at home was distasteful and eating a pure matter of duty, average a gain of a pound per day for the round trip. This is no exaggeration, as some who will read these lines know. The spruce, hemlock, balsam, and pine which largely compose this wilderness yield upon the air, and especially at night, all their curative qualities. Many a night have I laid down upon my bed of balsam-boughs and been lulled to sleep by the murmur of waters and the low sighing melody of the pines, while the air was laden with the mingled perfume of cedar, of balsam and the water lily.

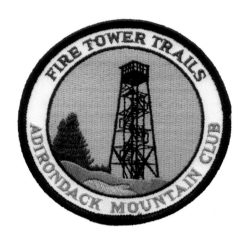

He arrived in 1873, virtually on his deathbed. His guide, who had to carry the sufferer to his hotel room, remarked, "Why, doctor, you don't weigh no more than a dried lambskin."

But Trudeau did not die. Instead, he lived for 42 more years. For him, it was a game changer: he dedicated his life to figuring out why he'd survived and to finding the cause of, and effective treatment for, that horrific illness. His heroic story is a poignant chapter in Adirondack lore, involving the discovery of the pathology of tuberculosis; the transformation of Saranac Lake from a somnolent, ragged hamlet into a world-renowned health center; and the promotion of the idea that healthful living and exercise in the conifer-cleansed air of the mountains would at the very least suppress the incurable disease to the degree that one could lead a somewhat normal life.

And that's where trails come in. As Trudeau's ideas caught on and desperately sick people flocked to the Adirondacks to "take the cure"—even though it wasn't truly a cure—the need for places to walk became acute. Many consumptives enjoyed their doctors' advice to sit for hours on the porches of the "cure cottages" of Saranac Lake, even in the coldest weather, while others took to boating on the region's array of lakes and ponds. But some wanted to hike, and trails came into being to accommodate them.

When it comes to trails up mountains, many in the region were forged in fire. In the summers of 1903 and 1908, conflagrations swept the Adirondacks. Those were dry summers. Still-careless logging—attempts to regulate it having proven difficult to enforce—had left tons of dry "slash," or the unwanted remnants of cutting operations, lying along the myriad railroad lines whose tentacles had by now penetrated most of the Adirondacks. The train locomotives belched hot coals from their smokestacks. Drought, kindling, sparks: it was a lethal combination. In both summers, thousands of acres, untold wildlife, a few buildings—including the original Adirondack Lodge at Heart Lake near Lake Placid—and even one entire community were consumed.

These disasters contributed to legislation that had nationwide implications. The railroads, the powerful megacorporations of their day, naturally denied responsibility for the fires. But attentive scrutiny of maps of the blazes, showing how closely the fires corresponded with the train tracks, gave the guilty parties away. Subsequent federal laws mandated that the railroads place spark arresters, essentially fine-mesh screens, over locomotives' smokestacks to prevent the dispersal of fire-starters. Out of twin catastrophes in the Adirondacks came changes that benefited all of America.

But first, from the ashes emerged an idea that borrowed from both east of the Adirondacks and west: fire towers. Aware that the employment of such towers in Maine had reduced the incidence, or at least the severity, of forest fires, New York State officials decided it was time to follow suit. They did so by building wooden platforms on the tops of several Adirondack (and some Catskill) summits and hiring men—not women until much later, and then rarely—to sit on them and watch for fires. Quickly ascertaining that it was not the wisest idea to strand human beings on platforms made of wood in fire-prone areas, they cast about for a more suitable material and found it in the Aermotor Company of Chicago, Illinois. The firm made steel windmills for farmers and ranchers in the Midwest and Great Plains, and the clever New Yorkers realized that by replacing the windmill blades with small huts (to this day called "cabs") they could offer fireproof lookout towers. The superstructures of many would-be windmills thus took trains east out of Chicago bound for the Adirondacks instead of west toward the wheat fields of the prairies.

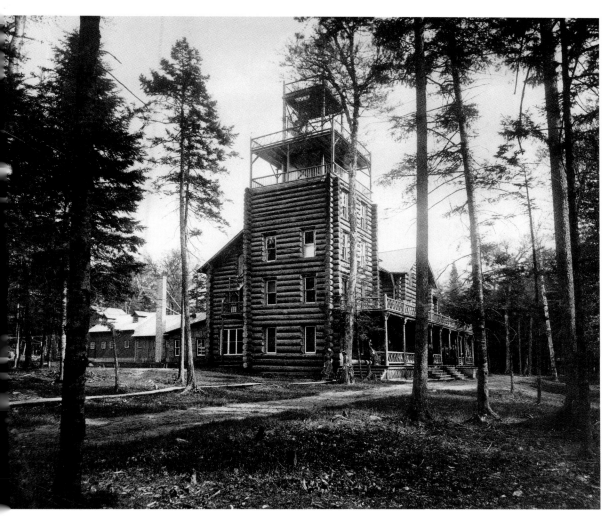

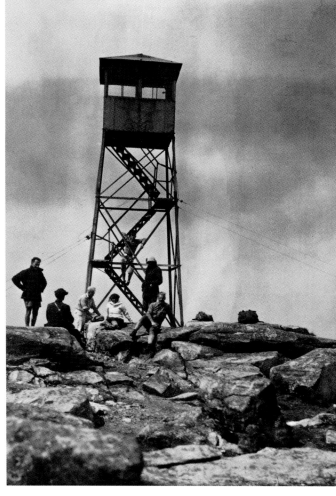

Once near their destinations, it was necessary for these components to be transported to the tops of their assigned mountains—no easy task since helicopters had not yet been invented; horses and mules figured prominently—and then assembled, like gargantuan Erector sets. It was also necessary for the men who sat in them all day long, all summer long, to be able to get to work. (Most of them lived, in season, in rudimentary cabins at the foot of their mountain.) Both of these enterprises required a path, and so it was that the dozens of mountains in the Adirondacks that suddenly sprouted fire towers in the 1910s and 1920s also just as suddenly sprouted trails to those towers.

The towers were connected to the outside world by copper phone lines, often a flimsy single strand of wire affixed to a succession of trees, with which an observer could call in the location of a suspicious plume of smoke. He didn't have to run down the mountain waving his arms and yelling "Fire!"—which would not have been especially effective because the fire could have been 40 miles away. At any rate, these

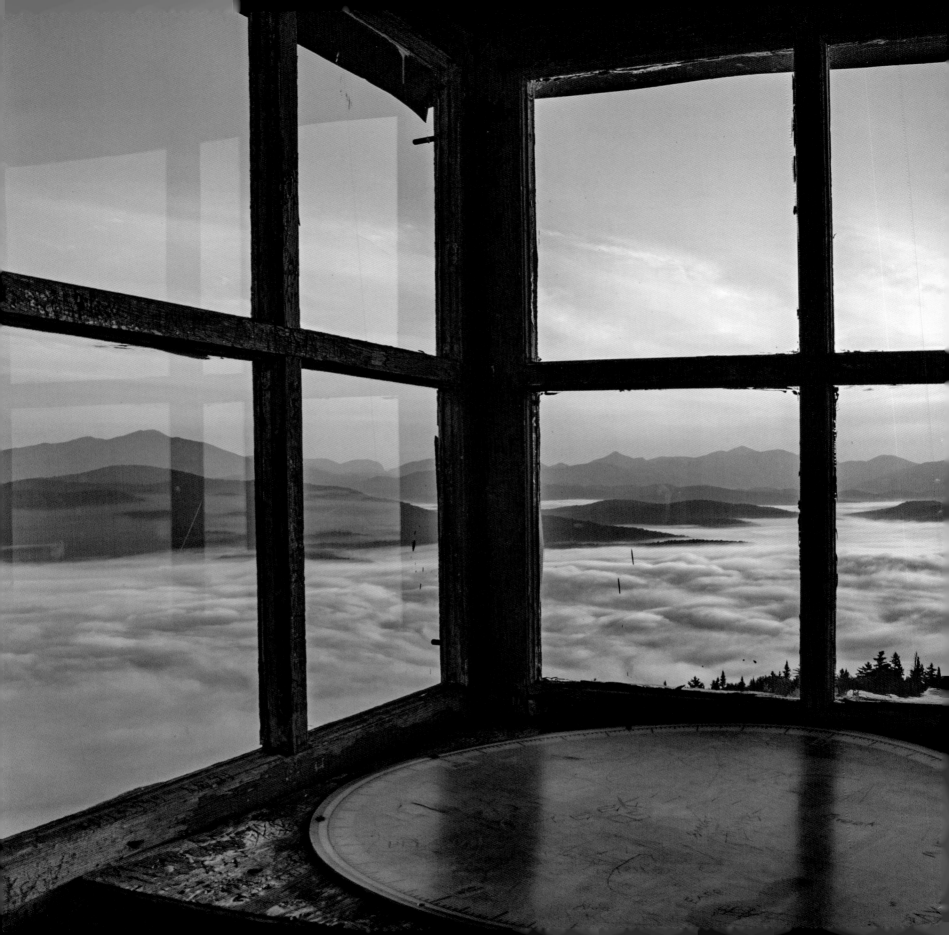

phone lines went straight down the mountain, and so the initial so-called trails went straight up. In rainy spells they turned into cascades, and most of their soil ended up at the bottom of the mountain.

Simultaneously, more and more people discovered that if a mountain had a fire tower, it had a view, and they decided to go up and see for themselves. As the 20th century progressed, fire towers became more and more popular hiking destinations, and the observers in them took on a secondary and unexpected role, that of host/docent/teacher. (The popular image of a fire-tower observer is of a gruff, taciturn, antisocial loner, but many of them enjoyed this new aspect of their job and welcomed visitors to their often lonely crow's nest workplaces.) But as much as they enjoyed the views and all, most hikers found scrambling up and down a waterfall less than desirable, and they let anyone in a position of authority know it. This became one of the first reasons for the burgeoning enterprise of trail design and remediation as the 20th century slid into its second half. Water bars, stepping stones, and switchbacks all came along in large part because the thousands of hikers who clambered up to the dozens of fire towers throughout the Adirondacks—from their inception in the World War I period to their abandonment in favor of aerial surveillance in the 1970s—clamored for something better.

POPULARIZING THE ADIRONDACKS

The word "hiking" is a British telescoping of "hill" and "walking," and in the years leading up to World War I, two brothers and their guide took this activity to new heights—literally. George and Bob Marshall (the latter became the primary founder of the Wilderness Society two decades later) and their guide Herb Clark set out to climb all 46 Adirondack summits that were understood at that time to reach 4,000 feet or more above sea level. Energetic to a fault, the three accomplished this feat in a time when few of the mountains had reputable trails and gear was primitive by modern standards. They sometimes walked from the Marshalls' summer place on Lower Saranac Lake to the destination of the day, climbed it, came down, and then walked home. (Sometimes they walked into Saranac Lake, then took the train to Lake Placid to lop a few tedious miles off their treks.) In completing their quest, they helped popularize climbing and perhaps unwittingly gave birth to an organization. Today, the Adirondack 46ers claim more than 10,000 members who have duplicated the trio's feat, even though subsequent surveys demonstrated that four of the summits the "Original Three" checked off did not in fact achieve the requisite altitude and one that they thought didn't actually did. The 46ers stick with the original list in the name of a level playing field, and also give back in the form of volunteer trail work, outdoor leadership workshops, and more.

As noted earlier, hiking has traditionally been one of society's more coeducational activities. One of the first 46ers was a woman, Grace Hudowalski of Troy, New York. She became a stalwart leader of the organization, corresponding with and encouraging thousands of hikers over several decades, and in so doing singlehandedly boosted the number of climbers heading for the trails. Grace Peak, one of the 46 summits, memorializes her name in perpetuity.

Another individual who helped popularize hiking in the Adirondacks, by sheer force of personality, also happened to become president of the United States while doing exactly that. Theodore Roosevelt, frail and sickly as a child, early on devoted himself to the active life. As his career trajectory rocketed him to

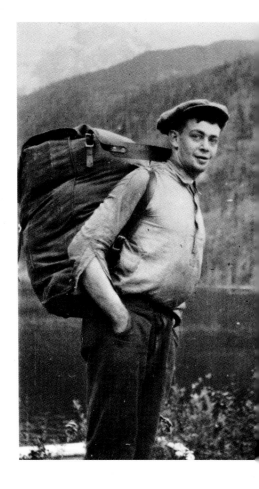

OPPOSITE: Santanoni Peak, Mount Colden, and Mount Marcy stand tall above the fog in the upper Hudson River Valley in this view from the Goodnow Mountain fire tower.

ABOVE: Bob Marshall, one of the first three people to climb all 46 Adirondack High Peaks, later became one of the founders of the Wilderness Society, the groundwork for which was laid at a series of meetings in the Adirondacks.

ABOVE, LEFT: As is evident in this photo taken on the front lawn of Adirondak Loj, packing gear in the mid-20th century was not designed to be gentle on one's back.

ABOVE, RIGHT: Adirondak Loj sits on the shore of the tranquil Heart Lake.

OPPOSITE: Rock climbing gained popularity in the early 20th century, but these climbers' gear and clothing would not be recommended today. Heart Lake's eponymous shape is evident.

the governorship of New York State and then to the White House, he continued to hike and camp in the Adirondacks, spreading their fame by nothing more than simple name association. He loved the outdoor life so much that when he was vice president he went on a camping expedition up Mount Marcy in September 1901, even though his boss, President William McKinley, had been shot a few days before (the notion persists that Roosevelt was on this outing when McKinley was plugged, but that is not the case). In Roosevelt's defense, the president was supposed to be getting better, but he up and died one night while Roosevelt and his party were "way back in." What followed was an epic tale of retrieving the vice president, careening him out of the mountains in a wagon in the dark, and briskly loading him aboard a fired-up special train in the wee hours of the morning to whisk him to Buffalo, where he was administered the oath of office. The driver of that buckboard, guide Mike Cronin, later offered as souvenirs the horseshoes that had helped render that wild ride a success and not another fatality. Legend has it that Cronin sold several hundred pairs of those shoes, ensuring a steady income for the rest of his life.

If recreation grew as an enterprise at this time, it did so at first only in warm weather. Winters were for staying indoors. Snowshoeing, mainly done only when necessary, was for transportation, running traplines, and the like—not for fun. But the arrival of skiing early in the 1900s turned trail use into a year-round activity. Winter sports had been introduced to the Lake Placid area before World War I, but they really took off after the third Winter Olympics were held there in 1932. Among the competitions that

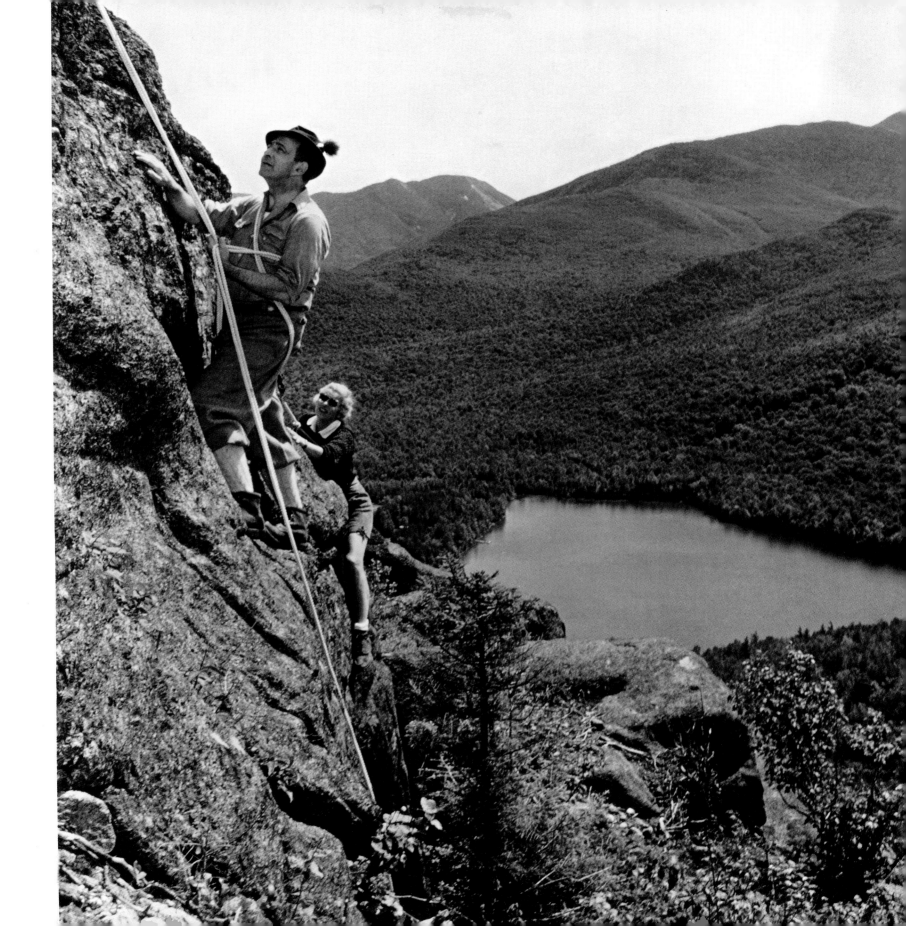

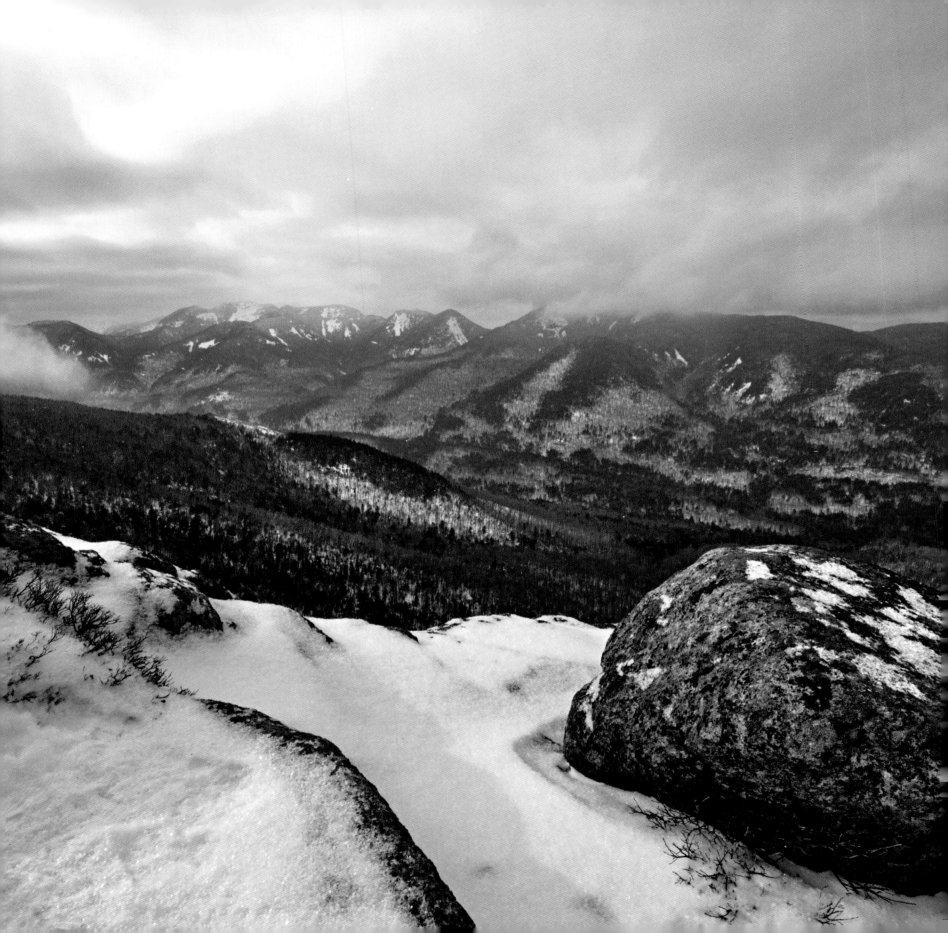

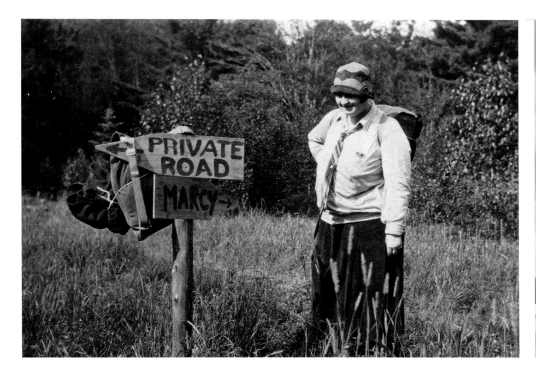

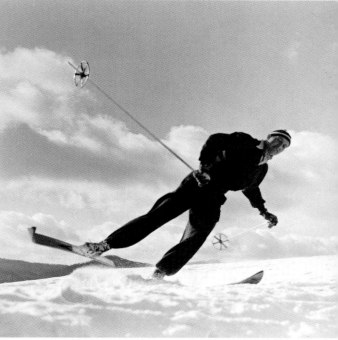

required any kind of trail at all, as opposed to a rink, the marquee activity of downhill skiing demanded its own kind of venue. But cross-country skiing, as well as snowshoeing, could be done on existing hiking trails. As the popularity of Nordic skiing grew in the latter years of the century, many trails began to see four-season use. A few—such as the Jackrabbit Trail between Keene and Paul Smiths and the Peavine Swamp Trail near Wanakena—were constructed expressly for the purpose of skiing. Gone were the days when a trail could see no one for several months.

THE FUTURE OF ADIRONDACK TRAILS

The great era of trail building in the Adirondacks occurred from roughly the Civil War through the Cold War. After that, there wasn't much left to build a trail to that hadn't already been reached. Some work did go on, of course. Jim Goodwin—famous for his trail-building, rock-climbing, and hiking exploits—laid out and cut an alternate, scenic but steep route to Gothics in 1966. Creation in the early 2000s of the "Cranberry 50," a 50-mile loop around Cranberry Lake, involved the packaging of several existing trails with construction of only a couple of miles of new connectors. Most trail work in the 2010s involves rerouting for various reasons (to dodge private land, skirt dangerous terrain, get hikers off roadways, or draw patrons away from overcrowded trailhead parking lots) and encompasses cooperative work among state agencies and organizations such as ADK, Adirondack 46ers, Adirondack Trail Improvement Society, and others. Several High Peaks that were once considered trailless developed such obvious herd paths that the state

OPPOSITE: A view of the Great Range is visible from Noonmark Mountain just before the clouds obscure it.

ABOVE, LEFT: Like the trails themselves, trail signs and markers were primitive in the early days of hiking. Women's hiking fashions have also come a long way.

ABOVE, RIGHT: Downhill skiing was introduced to the Adirondacks in the early 20th century and took off after the 1932 Winter Olympics were held in Lake Placid. Nordic skiing grew in popularity beginning in the 1970s, giving hiking trails a more year-round appeal.

 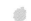

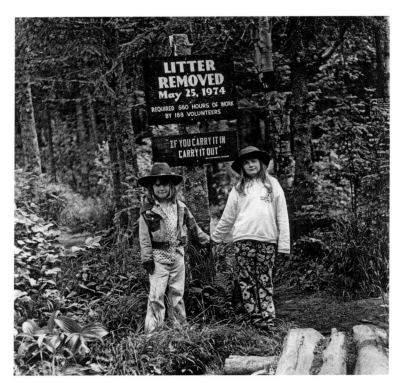

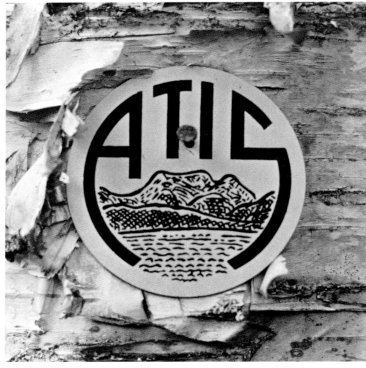

went ahead and marked them, reducing the chances that climbers would a) damage the wider terrain by thrashing around in it, and b) get lost, requiring dangerous and expensive searches and evacuations. The great era of trail building is probably over. The focus now is on maintaining and improving what's there.

So where does one go from here? What does the future hold for Adirondack trails?

Like so much else in life, trail use is cyclical. There was a burst of demand in the 1960s and 1970s, particularly in the High Peaks, when backpacking, the "back-to-nature" movement, and environmental consciousness in general took off. Suddenly, it was cool to load up with a bunch of high-tech gear and head off into the backcountry for some low-tech communing with authenticity. Concern was expressed in many quarters about damage to the trails, streams, fragile alpine vegetation, and so on. A few regulations were implemented or strengthened, and public relations campaigns were waged to alter people's behavior. Then the ardor cooled, sending things back to normal, only to be reignited in the 1990s. Same thing.

After yet another downturn in the early 2000s, trail use throughout the Adirondacks has again ratcheted up dramatically, and the same concerns have been recycled once more. A report from the Adirondack Council—an environmental advocacy organization headquartered in Elizabethtown, Essex County's seat—noted that in 2017 some trailhead parking lots in the High Peaks, near Old Forge, and in the Lake George vicinity were stuffed with more than 200 percent of the cars they were designed for. (One of the state DEC's tactics for reducing trail use the previous time around had been to reduce the size of many of these lots on the theory that hikers would realize what was up, say "Oh, well," and go away.

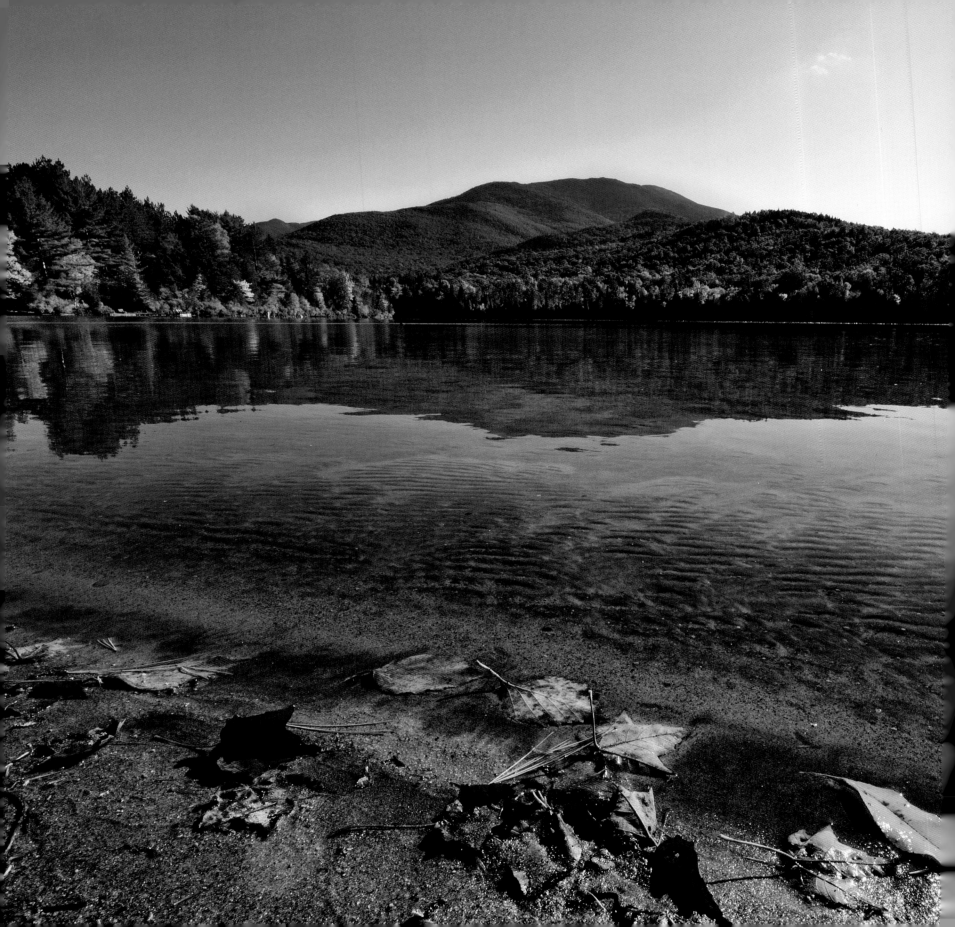

The move backfired spectacularly. Hikers, some of whom had driven for hours and were not about to be deterred that easily, simply parked wherever they could squeeze in—in ditches, on the shoulders, jammed between trees, wherever.) "With large crowds come unsafe conditions, eroded trails, packed campsites, crowded mountain peaks, an accumulation of human waste, and a degradation of wilderness," the report stated frankly and succinctly. A photograph made the rounds that showed a veritable mob of people on the summit of Cascade Mountain, one of the easiest High Peaks to attain, too many of them staring at their smartphones, tablets, and similar mobile devices rather than looking at the view, their fellow hikers, or where they were walking. On popular weekends in the fall of 2017, some 240 cars were crammed into the Cascade trailhead parking lot, which is built to handle no more than 73, according to the report.

The response has been a work in progress. History has proven that restrictive measures like making parking lots smaller fail miserably. Proposed steps like hiking permits, controlled access, and "start time" reservations have not been well received by the hiking public, many of whom go to the woods to get away from the rules and regulations of society and seek the freedom of the forests. ADK, which operates one of the most popular trailheads and parking facilities at Adirondak Loj on Heart Lake in the lap of the highest High Peaks, has instituted educational campaigns that aim to direct hikers to other, less heavily used parts of the park. This is a challenge, though. Everybody wants to climb the big ones, especially the biggest, Mount Marcy, and its shortest trail begins at the Loj's doorstep. (That spelling, in case you're curious, is a holdover from the days of a previous owner, Melvil Dewey, who was born and raised just west of the Adirondacks. In 1927, Dewey built himself a retreat on the site of the burned-down Adirondack Lodge mentioned earlier. He brought us many good things, such as the now-deposed Dewey Decimal System for library book classification, but also some horrid ones, among them Simplified Spelling—or Simplifyd Speling, as he would have had it—which thankfully did not catch on except in a few aggravating instances such as "Adirondak Loj.") ADK also conducts a summit steward program in conjunction with the state DEC, under which enthusiastic and tireless young people park themselves on the most sensitive summits for the summer and talk to climbers about the fragile high-altitude vegetation, the need to stay on the trail and not heave empty plastic water bottles into the Lapland diapensia, and so on. The 46ers conduct a similar program at high-use trailheads. Both groups, and others, sponsor Leave No Trace workshops, classes, and broad-based promotion of mountain-minded behavior.

It remains to be seen how all this will play out. There's no small irony in the realization that while there are many who lament the loss of interest in outdoor activities as social media and electronic entertainment grow in popularity, pressure on hiking trails, at least in the Adirondacks and especially the High Peaks, has once more reached worrisome proportions. It's a fine line that outing organizations must navigate when they exist in part to encourage people to get outdoors, recreate in nature, enjoy the wilderness, and do all that goes with that. Yet simultaneously they feel the need to turn around and say, "Oh, but not all of you at once," or "Over there, please, not right here," or "Not just now, though—wait a few years so the trails can recover." Time will tell. The cycles will continue. Hikers will forever seek to stand on the tops of the highest mountains and sit by placid ponds and gaze at roaring waterfalls, regardless of what anybody says or does. The best that can be hoped for is that we all do so wisely and with respect for what a special privilege that is.

George Washington SEARS

CHRISTINE JEROME

The woodsman George Washington Sears stood five foot three and weighed 112 pounds, with a high forehead, a full white beard, and penetrating brown eyes. He was self-educated and fond of quoting Shakespeare, Virgil, and contemporary poets. A cobbler by trade, he was afflicted by wanderlust and traveled extensively: to Ontario, to Michigan while it was still a frontier, to the Amazon basin twice, and to Florida's east and west coasts. Yet aside from the wild country near his Pennsylvania home, he was fondest of the Adirondacks, where three paddling trips between 1880 and 1883 made him a nationally known figure, thanks to articles he posted along his route to *Forest and Stream* magazine under the pen name Nessmuk (a Nipmuck word for "wood drake").

A pioneer in solo touring (he was too poor to pay a guide to row him and carry his duffle), the diminutive Sears needed a lightweight

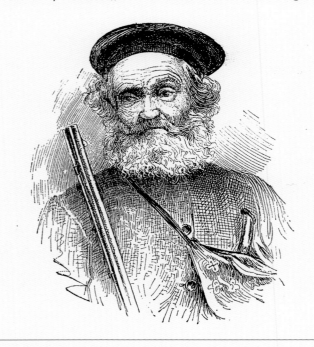

Opposite: A paddler explores the northern flow in Amy's Park.

boat he could handle himself. Luckily, he found a boatbuilder named J. Henry Rushton in Canton, New York, who fabricated small but strong white cedar canoes. The boats Sears commissioned for his first two expeditions were shorter than 11 feet and easy to heft, but the model that made Sears famous was the one he used on his third trip, the radically lightweight *Sairy Gamp*, 10.5 pounds and only nine feet long. From mid-July to late August 1883, Sears covered 260-plus miles, from Old Forge in the southern Adirondacks to Paul Smiths in the north, and then back again. In the years that followed her acclaimed voyage, the *Sairy Gamp* was displayed in New York City, New Orleans, and at the Chicago World's Fair. Today, she resides at the Adirondack Experience in Blue Mountain Lake, New York.

In 1884, Sears wrote *Woodcraft*, the first how-to guide to camping that quickly became a classic. In it, he told neophyte "outers" how to make a fireplace, how to cook a porcupine, and how to equip themselves. "The temptation to buy this or that bit of indispensable camp-kit has been too strong, and we have gone to the blessed woods handicapped with a load fit for a pack-mule," he observed. "Go light; the lighter the better."

A protoenvironmentalist, he used his pulpit in *Forest and Stream* to decry the ecological damage caused by logging, tanning, and dam building. Moreover, having spent much of his life outdoors, he had seen firsthand the decimation of wildlife caused by overhunting and overfishing. He became an eloquent advocate for regulation of industry and enforcement of fish and game laws.

That iconic 1883 Adirondack trip marked his final ambitious cruise; he died in 1890 of tuberculosis at age 68. And although he left behind little of monetary value, his was a legacy of wisdom. "There is but one Adirondack Wilderness on the face of the earth," he warned. "And, if the great State of New York fails to see and preserve its glorious gifts, future generations will have cause to curse and despise the petty, narrow greed that converts into saw-logs and mill-dams the best gifts of wood and water, forest and stream, mountains and crystal springs in deep wooded valleys that the sun shines on at this day."

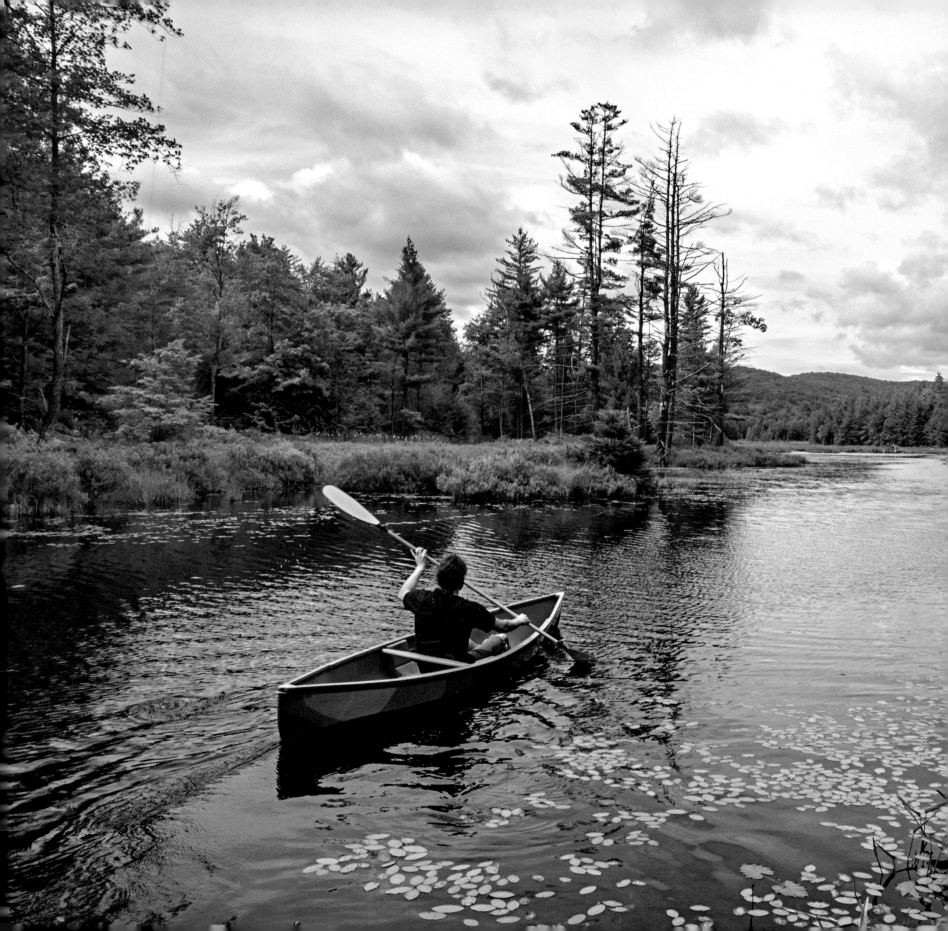

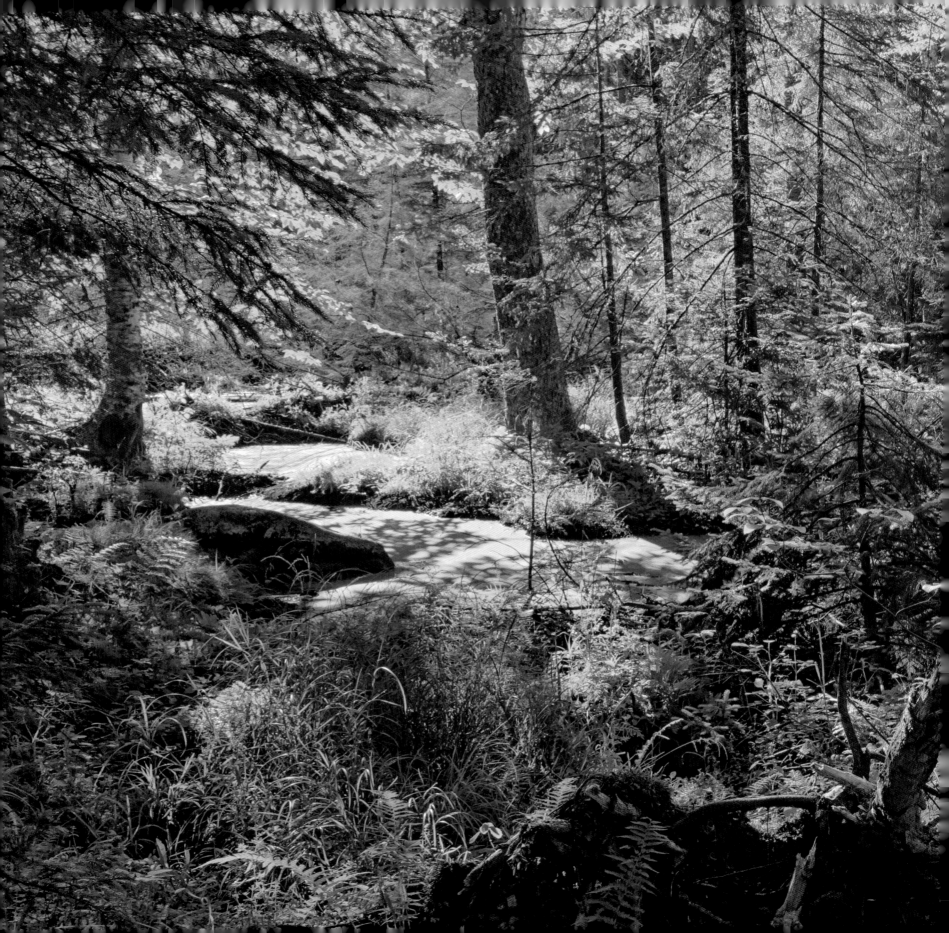

The ADIRONDACK TRAIL EXPERIENCE

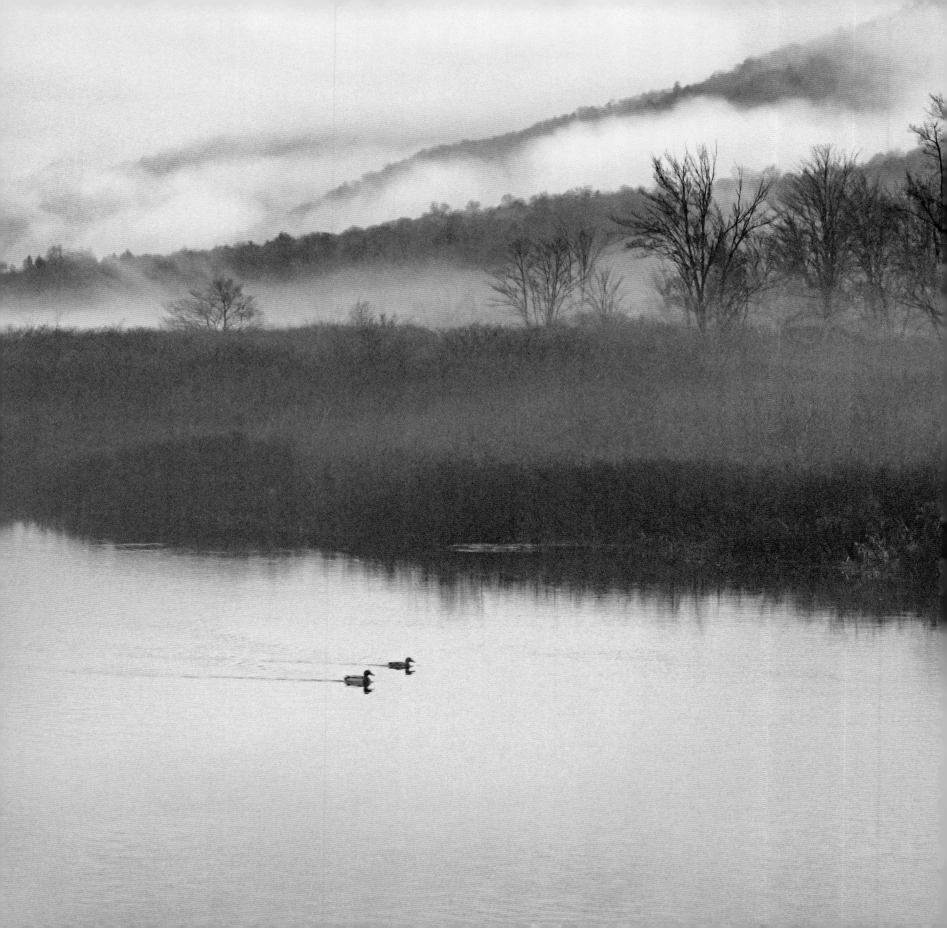

A dirondack trails are long and short, flat and steep, easy and hard, muddy and dry, inspiring and boring. They switchback up rocky faces and follow the level, arrow-straight beds of former logging railroads. They can trip you with roots, propel you with pine duff. They can transport you into a palette of different environments: deep woods, craggy summits, buggy marshes, silent silken ponds. They can exhilarate you, exhaust you, frustrate you, soothe you. They can heal your heart and wreck your knees. They can take you to the homes of deer and deerflies, bear and moose, trout, loons, eagles, alpine azalea, and purple trillium. They can take you home.

It's no exaggeration to say there are hundreds of trails in the Adirondacks. The Adirondack Mountain Club (ADK)'s series of five guidebooks (plus another dedicated to the Catskills) contains detailed descriptions of more than five hundred. And that's not counting all the herd paths, bushwhacks, informal hunters' treads, fishermens' and -womens' trails, and other unmarked byways in every recess and corner of the park.

One of ADK's books is devoted to a single long route: the Northville-Placid Trail. That's an anomaly in the park; most trails are short enough to be executed in a day. But it's an iconic one, and a deserving part of the short sampler that follows, demonstrating the variety of trails, trail destinations, and trail experiences in the Adirondacks.

NORTHVILLE-PLACID TRAIL

The 138.6-mile Northville-Placid Trail (henceforth NPT) was the second long trail in the Northeast, but the first project for the nascent ADK. Neighboring Vermont's Long Trail, the oldest long-distance trail in America, preceded it, with construction beginning in 1910 under the auspices of the Green Mountain Club, which was organized primarily for the purpose of constructing the trail. That 273-mile corridor runs north and south over the backbone of the Green Mountain State, between the Massachusetts line near Williamstown and the Canadian border. Both of these footpaths preceded the better-known Appalachian Trail by several years.

The NPT's origin bears some similarities to the Long Trail's. But in the NPT's case, the club came first and then conjured up the trail, not the other way around. ADK sprang into being in 1922, and its founders immediately identified the need for a significant and highly visible project in order to gain name recognition. In the fifth edition of the club's guidebook to the trail, authors Jeff and Donna Case explain that George Pratt—a visionary who was a wealthy top executive in the Rockefeller family's Standard Oil Company, as well as ADK's first president—came up with the idea (and the money) for the trail. In a level of integration that would raise eyebrows in the modern era, he was also commissioner of the state's Conservation Commission, which eventually morphed into the modern Department of Environmental Conservation (DEC). Literally looking at the forest and not just the trees, he understood the public relations value of giving an increasingly mobile public access to the woods in the form of a major trunk trail. As a state official, he gave himself, the nonprofit's president, the government's blessing to proceed with a public relations move that he'd kicked in the money for.

PREVIOUS SPREAD: The Northville-Placid Trail, just south of Piseco Lake, crosses the outlet of a primeval wetland.

OPPOSITE: A pair of mallards enjoys a misty evening on the outlet flow of Lewey Lake.

ABOVE: Businessman and bureaucrat George Pratt was a founder of the Adirondack Mountain Club and a prime mover behind its Northville-Placid Trail.

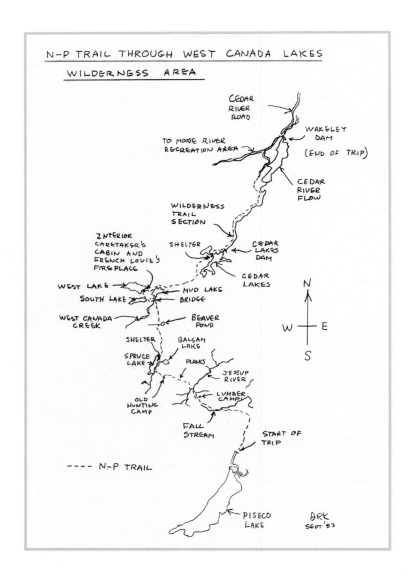

N–P TRAIL THROUGH WEST CANADA LAKES

WILDERNESS AREA

CEDAR RIVER ROAD

TO MOOSE RIVER RECREATION AREA

WAKELEY DAM (END OF TRIP)

CEDAR RIVER FLOW

WILDERNESS TRAIL SECTION

SHELTER

INTERIOR CARETAKER'S CABIN AND FRENCH LOUIE'S FIREPLACE

CEDAR LAKES DAM

CEDAR LAKES

WEST LAKE

SOUTH LAKE

MUD LAKE BRIDGE

WEST CANADA CREEK

BEAVER POND

N

W —+— E

S

SHELTER

BALSAM LAKE

SPRUCE LAKE

PLANKS

JESSUP RIVER

LUMBER CAMP

OLD HUNTING CAMP

FALL STREAM

START OF TRIP

- - - - N–P TRAIL

PISECO LAKE

ARK SCOT '03

ABOVE: An early map of a portion of the Northville-Placid Trail illustrates how it pond-hopped and followed river and stream routes rather than climbing up and down summits.

OPPOSITE: Buckhorn Lake is a short sidetrack from the Northville-Placid Trail just south of Piseco Lake.

The impression persists that the NPT traverses the entire Adirondacks, the way the Long Trail ties together every inch of Vermont, but such is not the case. It does start roughly 10 miles inside the southern border of the park, at the village of Northville, but it penetrates only about three-quarters of the way through, to Lake Placid, or almost. There it stops, at a parking lot at the end of a road.

Why those two termini? Trains. When the trail was conceived, that was how most people got around, although the automobile era, with its huge impacts-to-be on outdoor recreation styles as well as everything else, was just beginning. Both Northville and Lake Placid were served by trains at the time (neither has been for decades now), so one could ride the rails to one end, walk to the other, and hop a train back to his or her starting point. Furthermore, lands north of Lake Placid were almost all privately owned and, truth be told, not very interesting. Proposals have surfaced from time to time to extend the trail northward to the Blue Line, but they have not taken off.

In the terrain where the trail was to go, extensive logging had been undertaken not many years before, and, as the Cases put it, "A convenient network of woods roads stretched through the wilderness." In other words, the trail practically presented itself; all that was left for long portions was to mark it. The forests would eventually restore themselves, the second growth disguising the fact that they had been decimated at one time. On top of that, substantial river valleys provided gentle thoroughfares for foot travel where construction did have to be done. Neither of these conditions existed north of Lake Placid, further discouraging continuation past that central hub.

The NPT provided the incentive for two of the Adirondacks' three greatest contributions to wilderness travel (the first being the guideboat, mentioned in the previous chapter): the lean-to and the trail marker. The route's planners and builders realized that if hiking neophytes were going to use a 130-something-mile trail, reliable places to shelter for the night would have to be made available and some sort of signage would have to be installed so they would know where to go.

Regarding the first goal, they borrowed a simple idea that hunters and guides had been employing for years: the "open camp," usually a temporary, more or less three-sided structure cobbled together with spruce boughs, sheets of waterproof birch bark, and whatever else was handy on-site. The new "lean-tos"—the name derives from the wing of an existing building that "leaned to" a standing wall, thereby offering protection from the elements—were meant to be permanent. Retaining the "open concept" long

THE TRAILS OF THE ADIRONDACKS

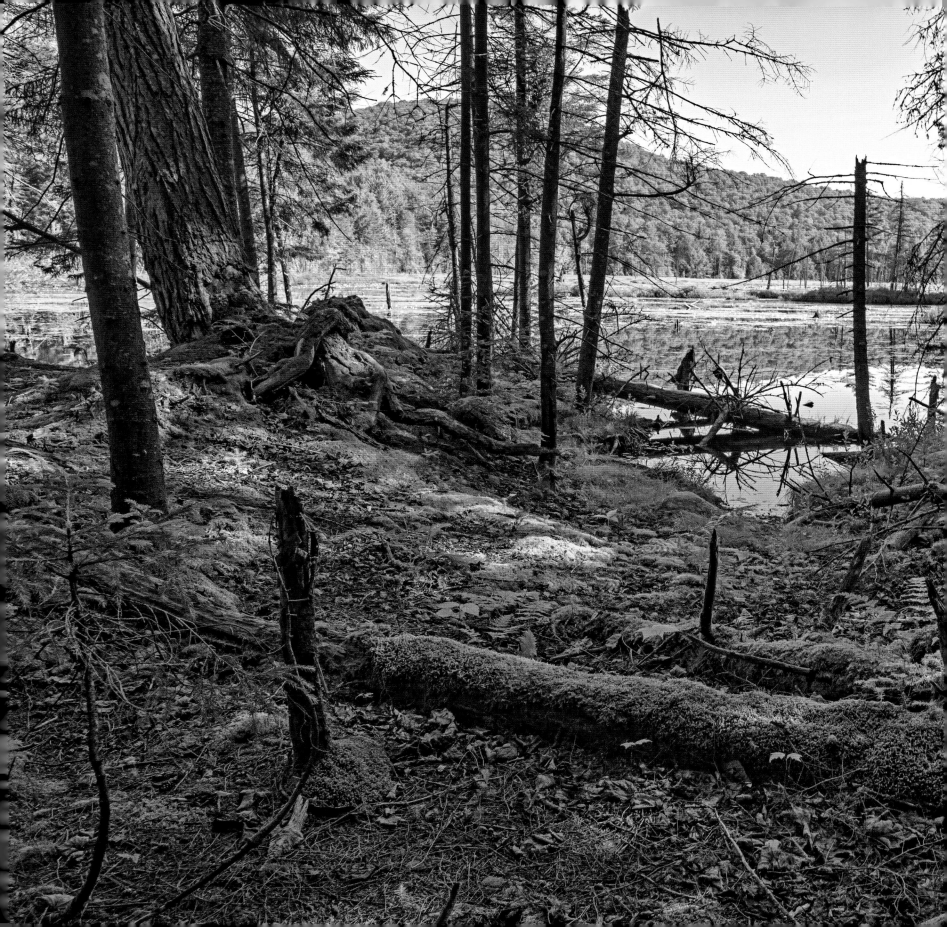

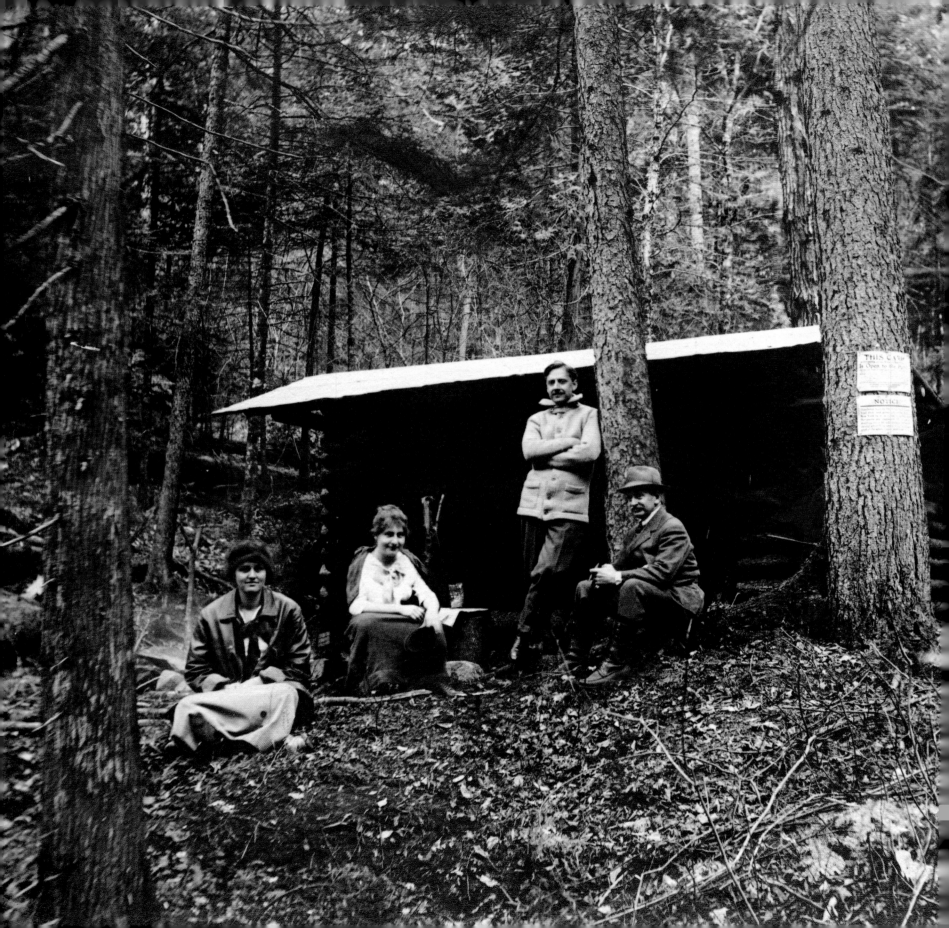

Shelter for the Night Paul Jamieson

It is nearly inadmissible to go to the woods without camping. Camping is the essence of life in the woods. So there has been pressure on the word "camp" to encompass the needs and whims of ninety thousand summer residents and of several million annual visitors who come for overnight or longer stays. Some of them like nature but not wilderness. They expect a million-dollar beach, an eighteen-hole golf course, and hot and cold running water. Others go in for varying degrees of roughing it. The Adirondack Park is large enough and hospitable enough to cater to all these folk. When they go home they can say, in perfect conformity with established usage, "We have been camping in the Adirondacks."

"Camp" had proved its versatility by the early 1880s, but the real breakthrough came shortly after. "'Camp' has come to mean," wrote Fred Mather in 1882, "a commodious log house used either as an occasional resort by a private person or a backwoods hotel." Structures of either purpose, he adds, cost from $500 to $1,500 to build. But even as he wrote, William West Durant was evolving on Raquette Lake a luxurious summer residence called Camp Pine Knot, which combined the styles of the native log house and the Swiss chalet. An exterior facade of rusticity disguised city amenities such as efficient plumbing (and later wiring), powder room, and banquet hall. A family camp of this kind soon became a small village to accommodate staff and guests. When sold to Collis Huntington in 1895, Camp Pine Knot consisted of ten cottages and a dozen or so other buildings. It was the first of many show places in the woods. And these, too, whether of logs or not, whether of native or foreign style, were "camps."

Less subject to the whims of the wealthy and of time is the three-sided open camp or lean-to. . . . The Adirondack lean-to is aesthetically pleasing. Favorably located, it seems almost an emanation of the forest floor. As a shelter, its marginal protection against wind, rain, and cold enables you to revel in all the minor inconveniences and discomforts of camp life. . . . The open front invites big thoughts. Out there, unscreened after the fire dies down, is the untamed wilderness of our ancestors on the continent.

before HGTV turned that term into a cliché, they conformed to the extent feasible to a standard design that approximately replicated that of a saltbox house minus the front wall. They were made of logs, with a shingled roof and flat boards for the floor, and were accompanied by a stone fireplace that cynics say was placed to ensure that smoke would fill the structure no matter which way the wind was trending. They also included, at a discreet distance away, a privy. Five of these structures, spaced at roughly equal intervals along the trail, graced the NPT upon its unveiling; although others have since been added, a couple of these patriarchs still welcome the weary nearly a century later.

In the years following, lean-tos cropped up all over the Adirondacks—along trails, on ponds, and wherever officials thought hikers would need a place to pass the night in relative comfort and safety. Although in more enlightened times some of these have been removed for various offenses (e.g., too close to water, no potable water, fires not recommended, or so high as to violate fragile alpine environments), the lean-to remains one of those symbols of the outdoor life in the Adirondacks that hikers recall with fond, perhaps just a tad embellished, stories.

OPPOSITE: The lean-to was one of the Adirondacks' contributions to outdoor recreation as it grew in popularity in the early 20th century. Also known as the "open camp," the three-sided log structures provided shelter for the night, encouraging longer trips into the backcountry.

The Lean-to Register Stuart Mesinger

If you go hiking in the Adirondacks, it won't be long before you come across a lean-to placed in some scenic spot to provide shelter for the passing hiker. If you take a look inside, you're likely to find a journal—known locally as a "register"—stored in a plastic baggie. If you take it out and start to read, you probably won't be going anywhere for a while.

The official purpose of the registers is public safety. A hiker who has recorded his or her presence has left a clue if a search ever becomes necessary. On the most basic level, the registers are diaries of use and conditions: who was there, what they saw, and what they thought about it.

The entries are by turns inspirational, hilarious, pathetic, and downright crazy, to name just a few moods. They provide insight into the minds and motives of people who, for diverse reasons, have chosen through physical hardship to reach places of solitude, beauty, and sometimes misery and danger.

What follows is a sampling of wit, woes, weather—and tall tales, the latter a recurrent feature. Nearly every register contains a few whoppers.

> *What a great place! Killed my companion yesterday; he ate the last twinkie. He's buried 500 steps to the left, so don't dig for worms there. Please leave the place as nice as you found it.*
> —OXSHOE POND LEAN-TO

The weather is the one thing that can make or break a camping trip. Although there are a lot of entries commenting on "what a beautiful day it is," the interesting weather-related entries are about bad weather and the misery it brings.

> *Arrived here soaking wet and tired from boots being full of water . . . Rained most of the way in Friday . . . still raining now 9 a.m. Tues. Why did the weatherman have to be right?*
> *Rained so hard last night it was impossible to sleep. Left my metal frame tent with the foil insulating blanket underneath for the safety of the lean-to twice when thunderstorms rolled thru. When I got up at 6 a.m. I almost expected to see animals lined up in pairs waiting to board my inflatable raft.*
> —COWHORN FOND LEAN-TO

Some of the most amusing lean-to register entries cover bad trips in a group context. Maybe the reason misery loves company is because there are more people to whom you can complain.

> *On the second day on our way to Long Pond J. A. & his son flipped their canoes. They were ok, just wet. S. G.. at the end of the carry to Floodwood Pond . . . was attacked by a wasp nest and stung. So WATCH OUT.*

Above: A hiker signs in at the Cascade Mountain trail register.

And then it rained and it seemed like it could get no worse but it did. We couldn't find a camp. We ended up camping off the side of the canoe carry to Long Pond. When we went to bed our utensils and pots were licked clean by raccoons and chipmunks. Earlier in the day our guide sent us the wrong way twice.

Today it was raining still but we continued our 1½-mile carry to be attacked by wasps again. We finally made it to this lean-to. Went for a swim out to the rocks and back and J. G. and S. had leaches on them. So WATCH OUT again!! This lean-to is like a high-priced hotel compared to what we've been through. Boy Scout Troop 354.

—FISH PONDS 1 LEAN-TO

For many, the fire symbolizes the camping experience. At one time, all lean-tos were equipped with fireplaces of some sort (and most still are). They are usually built of local fieldstone and generally have convenient metal grates. Just because it's protected from the elements on three sides doesn't mean fire starting is easy.

Tried to light a fire last night with rain-soaked wood and damp tinder. After 30 min. of dizzying head rushes, trying to blow life into wet wood, we left it for dead, and sat to eat our grilled bear for dinner. (Pete caught and killed it with his "bear" hands—hee hee—on the way up Yard yesterday.) Actually it was Lipton's Stroganoff—a tasty treat. . . . Much to our surprise, after 5 bites of goo, and with us no closer than 10 feet to the failed fire, flames danced to life on the logs! Whooowhee!! Pete dried his crusty Bucknell hat, and we sat in silence for an hour, entranced by the fire. Nothing could touch or hurt us. . . . All there was was the fire, the brook, the fading light, and then the night; it was still, and quiet, and we slept. Amen.

—KLONDIKE LEAN-TO

The greatest number of entries in the registers is devoted to critters, and bears are by far the most popular topic.

Friday evening I came face to face with a bear on the Calkins Creek Road at dusk. He and I came to an agreement as to who had the right of way. I breathlessly waited in silence as he ambled by, then catching my scent at last, he took off up the hillside. Honestly, 300+ lbs. A bear on the run always seems to me to defy all of the laws of physics—there is nothing faster. Astonished that I met the bear less than ¼ mile from where I had a similar encounter 2 years ago.

—COLD RIVER 4 LEAN-TO

Bugs get their fair share of entries too.

The bugs are closing in. I don't have much time . . .

—BIG SHALLOW LEAN-TO

Of all the entries, some of the most compelling say, in so many words, "There's no place I'd rather be."

Today I hike along the trail—contemplating the silent competition of the trees. Buggy walk in wet woods. Short paddle in leaky boat. Bold chipmunk in the lean-to. Warm fire in my mind.

—STEPHENS POND LEAN-TO

I enjoy bathing naked in the morning and fly fishing in the painted evening dusk. I enjoy watching a man building a fire as he would build his life—one log at a time. I enjoy the chill of the night air bringing a rosy hue to my cheeks and the warmth of a touch of another hand. I enjoy a stiff heel and a dirty earth. I enjoy the birds, and the echo of a child's laugh across the lake. But most of all I enjoy the company of myself, mother earth, and the man I love, and tomorrow I will enjoy the walk home.

—STONY POND LEAN-TO

As mentioned, the NPT was also the impetus for another innovation in the Adirondacks: trail markers. In earlier times, people knew where they were going and how to get there, or they lined up a guide to take care of those details for them. But if novices were going to be invited to go wandering in the woods without professional assistance, it might be a good idea to show them the way. And so it was that colored metal disks, about three inches in diameter and affixed to trees every so many yards, came into being. They now appear on all official Adirondack trails—mounted by the state or by private entities such as ADK—in red, blue, and yellow (green being too hard to discern in the woods).

The trail was completed in 1924, just two years after it was begun. In 1927, it was ceremoniously turned over to the Conservation Department (the Conservation Commission having undergone one of its periodic name changes a year earlier). That agency would from then on be responsible for the trail's condition. But ADK has remained heavily engaged with its first child. Its staff and volunteers contribute hours of labor to trail work, as well as to the care of its bridges, lean-tos, and other infrastructure, directed and supervised by DEC personnel. ADKers adopt sections of the trail, or its lean-tos, and look in on them regularly, not unlike general practitioners giving their patients regular wellness checks. Work parties on National Trails Day, annually in early June, further benefit the trail. And in recent times, ADK crews have rebuilt sections of the trail, particularly at its southern extremity, to relocate it off of active roadways. The NPT is a living example of successful cooperation between public and private entities.

As for the trail itself, it is a wilderness walk par excellence. In its entire distance, it crosses only two major—which is to say paved and numbered—highways, along with a dirt back road every now and then. Paradoxically, and characteristic of the Adirondacks, it also passes close to several communities, and in three of them obliging postmasters will accept resupply packages hikers mail to themselves before they start out and will kindly send dirty laundry home. In between, the trail traverses some of the most wild and remote parts of the park and stretches where civilization seems light-years away. More akin to the earlier trails of Native Americans, hunters, and sportsmen than to the later trails to mountaintops, it lingers at lower altitudes, only occasionally experiencing noticeable elevation changes. Unlike its cousin the Long Trail, it goes over no summits. Its highest point, just more than 3,000 feet above sea level, is hundreds of feet lower than some of the mountains it bypasses.

Side trails to "the outside," along with a few road crossings, provide on- and off-ramps for those who want to do only a section of the trail. But as with any such magnet, the lure of the whole thing is there. The trail can be completed in segments, over a period of years, or in one fell swoop, those strategically placed lean-tos and newer primitive campsites providing overnight harbors. Many who thru-hike take 10 days to two weeks or more to fulfill their end-to-end mission. South to north seems to have emerged within the hiking community as the preferred route, because the terrain is a tad easier in that direction and the sun is not in one's face. One individual, the noted mid-20th-century naturalist Orra Phelps, took 51 years to finish, while a Vermont photographer did the same in 31 hours, 37 minutes (whether he stopped to take pictures is not recorded). Those who complete the trail receive a patch denoting the achievement; those who do so in winter, no easy feat given the Adirondacks' rugged climate, earn an additional rocker.

And what will you see on the NPT? Trees, trees, and more trees. Mile after mile of them, with occasional intermissions courtesy of streams, ponds, wetlands, and so on. This is a trip one takes not for

OPPOSITE: The Northville-Placid Trail nears its northern terminus at Lake Placid.

ABOVE: Women have played a prominent role in Adirondack hiking history. Orra Phelps was an accomplished naturalist, teacher, and author of the Adirondack Mountain Club's first trail guide in the 1930s.

scenic panoramas, but for seclusion, for immersion in the forest, for the rewards that come with being profoundly inside nature and getting reacquainted with its mysteries and its lessons. At some times of the year, it's possible to go for days, for miles, without seeing another hiker. Loons will call, dive, surface, and call again across mirrored ponds. A deer will look up from drinking at a stream. Campfire smoke will antagonize and mesmerize. Clocks and calendars will become meaningless. You will go back to your roots and find out who you really are and where you really came from.

AZURE MOUNTAIN

The trail up Azure Mountain, an isolated monadnock in the northwest Adirondacks, is emblematic of a substantial list of trails all over the park that climb to fire-tower summits—from the curiously named Poke-O-Moonshine in the northeast to Goodnow Mountain and Bald Mountain in the center to Kane Mountain in the south. (A good source for more on this topic is *Views from on High: Fire Tower Trails in the Adirondacks and Catskills* by John Freeman and Jim Schneider, second edition, published by ADK in 2017.) They provide relatively easy or moderate hikes that are secure in the sense that they are hardly ever encumbered with intersections, so you won't get lost. Just keep going up until you can't anymore, and you're there. And they promise great views. After all, why would anyone park a fire observer where he couldn't see anything? What's more, many of the towers have been restored and are open to the public, often with "Friends of . . ." organizations not only helping maintain the towers and trails, but also placing knowledgeable hosts on the summits on summer and fall weekends and holidays. So not only will you have a super view; if you go on the right day, you'll also have someone to tell you what you're looking at, discuss the history of the tower, identify trees and wildfowers, give the kids a souvenir card so they can prove to their pals that they hiked all the way up there, and so on. Or leave you alone, if that's your preference.

Perhaps the biggest challenge in climbing Azure Mountain is finding the trailhead. "Off the beaten path" comes close to describing it. You have to look for Blue Mountain Road, along State Route 458 between St. Regis Falls and Santa Clara, on the distant north slope of the park, then take it a few miles until you come to a bathtub (that's right, a bathtub, the old rusty clawfoot kind; it marks a spring, but do not trust the water). Less than half a mile on, you will see a sign on your right for the parking area. A privy is located here, but resident wildlife usually demolish the toilet tissue as soon as it's stocked, so be forewarned.

The name Blue Mountain Road, incidentally, tells the story of one of those quirks of local history that help make any place distinctive. It's named for the mountain, which is Azure, but it was once Blue. During the fire-tower placement frenzy of the 1910s, the state put a unit on Blue, but it already had one on another, bigger Blue Mountain—the well-known summit some 50 miles away near Blue Mountain Lake. So some bureaucrat in Albany, the state capital, arbitrarily changed the name of the one up north to Azure, probably without any notion of where it was, in hopes that firefighters wouldn't go dashing off in the wrong direction when one of the observers reported a blaze "near Blue Mountain." But the independent-minded folks of the St. Regis River country didn't care to have Big Government change the name of their mountain, and so there are those who still call it Blue, bootheels dug into the duff. As a further mark of

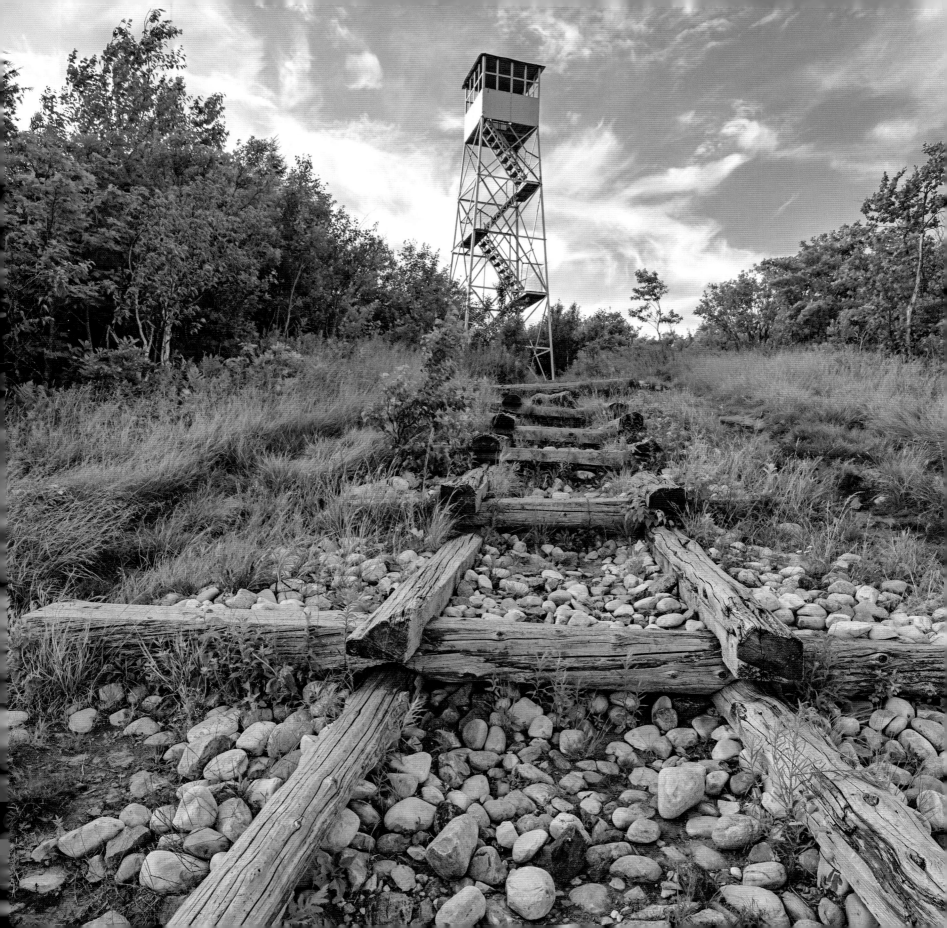

their resistance to this intrusion into their affairs, they flat-out refused to flip the name of the road. So to this day Blue Mountain Road leads to Azure Mountain, among other backwoods destinations.

Once you locate the trail, it's an ascent of almost a thousand feet through mixed hardwood forest in almost a mile to the summit. That's a steep grade by any standard, but you won't be sorry. It's gentle at first, becoming steeper at an intermittent stream that marks the site of the cabin where observers lived when the tower was in operation. It was here in 1915, during the wooden-platform period (the current steel tower came along in 1918), that the first observer, Fred Smith, was struck in the thigh by lightning. He hobbled down the trail to the Blue Mountain House, a hotel that once stood near today's parking lot, where he was treated by a guest who happened to be a doctor. Not one to be deterred from his obligations by a mere piercing of his leg by a bolt of lightning, he went back to work.

As was the case with most fire-tower mountains, the trail was originally the observer's commuter route, and it followed the phone line straight up. Recent work by state and ADK crews has remediated some of the resultant erosion, but, with heavy use, it can still be a mudslide at certain times. Proposals have been formulated to reroute the trail completely, essentially spiraling it around the mountain, which would add length but also soften the grade and reduce the likelihood of hikers slogging up and down cascades in rainy spells. When this will be accomplished is known only to fortune-tellers, but it symbolizes the status of many trails throughout the Adirondacks in the 2010s as the era of trail building morphs into the era of "let's fix this so both the public and the resource have better experiences."

BELOW, LEFT: Fractured rocks make small "caves" along a section of the Azure Mountain Trail.

BELOW, RIGHT: Water bars help protect sections of the well-used Azure Mountain Trail from erosion.

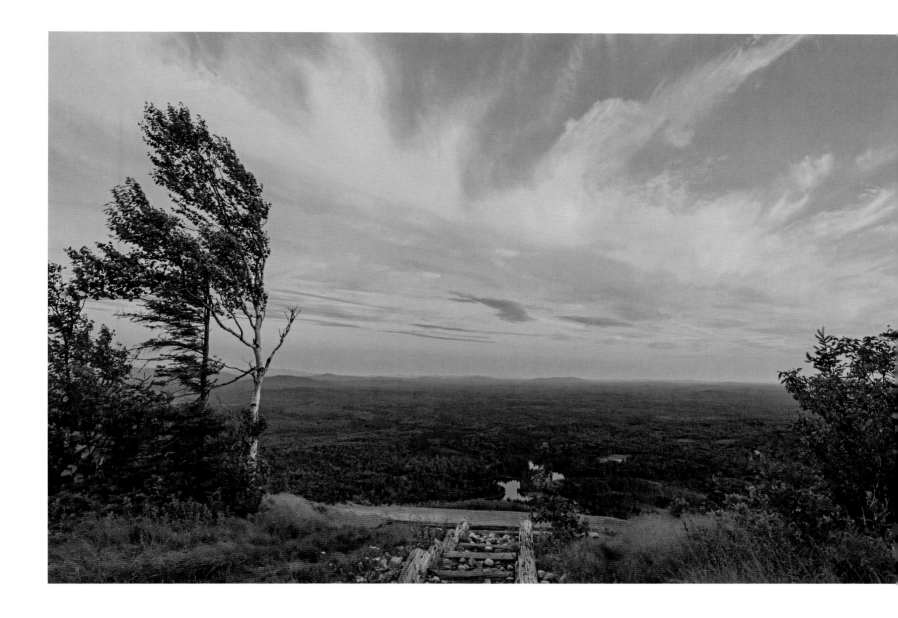

Partway up, you will notice a distinct change in the thickness of the vegetation, the height of the trees, and the dominant tree types. Juries are still out on why this is the case; either it marks the altitude at which 19th-century logging ceased—for above this elevation the terrain was too steep to render the removal of timber profitable—or it marks the limit of a long-ago fire. Or both. Either way, this is an example of the Adirondack history observant hikers can absorb from their surroundings while exploring the region's trails.

A little past the midway point, "caves" on the right are fun to explore. These are not true caves, but the result of the jumbling of immense glacial erratics transported here from several hundred miles

ABOVE: Sunset light colors the clouds above windswept birch and pine at the Azure Mountain summit.

 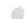

north during the last Ice Age. And so another bit of history, this one geologic, can be acquired as the trail becomes a textbook.

But the best scenery awaits on top—of the tower, that is—although the views from cliffs a few yards from the mountaintop on which the tower has stood for more than 100 years are nothing to sneeze at either. And a massive balancing rock perched on the brink of the precipice, another one of those souvenirs from the departing glaciers, is a popular attraction. (Do not try to push it off, please.) If you are not acrophobic, climb the exposed but wire-fenced zigzag stairs up the 35-foot tower (its height is measured from its base to the floor of the cab) for what many contend is the best view in the Adirondacks.

The astonishing 360-degree panorama, especially spectacular during fall foliage season, takes in a wide variety of Adirondack scenery: the famed pyramid of Whiteface to the east; the forested ridges on the brink of the distant Champlain Valley; the High Peaks beyond (invisible) Lake Placid; the faraway Blue Mountain that generated all that naming trouble; the edge of the distant Tug Hill Plateau to the southwest; the sprawling watersheds of the northern Adirondacks; the flat St. Lawrence Valley farmland, sunlight reflecting off metal silos and barn roofs in northern New York, Ontario, and Quebec; and, with binoculars and under what pilots call "severe clear" conditions, even the skyline of Montreal. Indeed, you can take in a huge chunk of the Adirondack Park and its surroundings from this little mountain just a one-mile walk from your car. And with a bit of imagination you can see how the land slopes up from the low agricultural valleys that frame the Adirondacks, through more and more uneven and wooded terrain, finally to proper mountains. Azure Mountain proves the assertion that whereas views from the High Peaks can be limited by neighboring tall summits, those from the scattered low peaks that pop up across the rest of the park can go on forever because nothing gets in the way.

But do not ignore the views nearer at hand. Look down on a peregrine falcon diving for its dinner like a fighter jet, or a bald eagle cruising on thermal columns. The forest far below demonstrates the mix of public and private lands that characterizes the Adirondacks and renders the region so different from anywhere else. At your feet is a quilt of hunting grounds, camps, managed forest, and preserved wilderness, the latter the public part of the amalgam. From up high, save for a handful of buildings nearly engulfed by the vastness of the woods, it's impossible to tell the difference. And that's what gives the Adirondacks their unmatched personality.

LAMPSON FALLS

What is it that attracts hikers to waterfalls? Perhaps we are drawn to them because they are so much like us: short and tall, boisterous and reserved, rough and smooth, reclusive in winter, leaping for joy in spring. They are destructive and creative—shaping pebbles, shaping mountains, shaping earth. There is much more to them beneath the surface. But beware: like the Sirens of mythology, they beguile, and if we are not strong willed they do not let us go. Be wary of their slippery brinks, the invisible traps in their plunge pools, before you get too intimate.

Or perhaps we are so captivated by waterfalls because they are so mysterious. Mountains we can see; most waterfalls, unless they are behemoths like Niagara or Yellowstone, lie in wait in the deep dense

OPPOSITE: The waters of the Grasse River spread out to more than 100 feet wide as they cascade down a 40-foot-high ledge at Lampson Falls.

THE TRAILS OF THE ADIRONDACKS

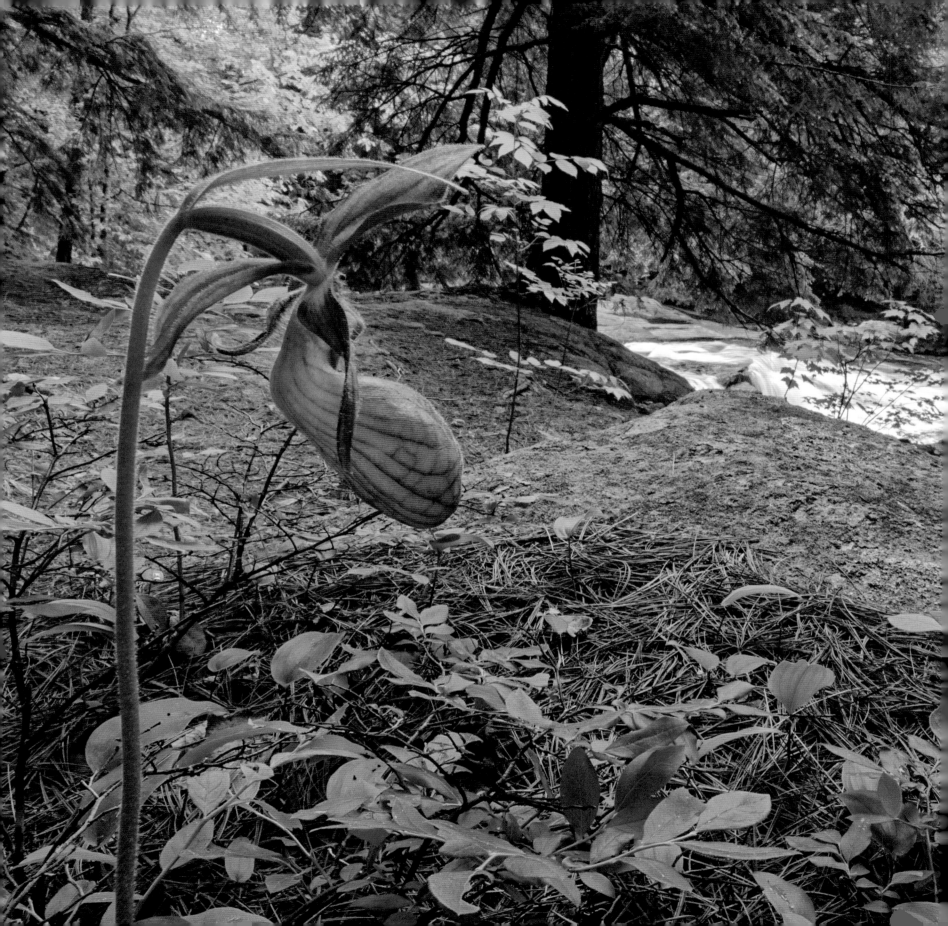

forest, in a gorge, or around a bend. Frequently we hear them first; where are they, and what do they look like? And why do we so often speak of them in the plural—water*falls*—when we normally encounter just one at a time?

So it is that from the earliest days when it became socially permissible to go and view scenery without being dismissed as addled, trails in the Adirondacks have gone to waterfalls. There's Wanika Falls, a short side trip off the Northville-Placid Trail. And OK Slip Falls, the name borrowed from old-time logging lexicon, where some have died. And towering Roaring Brook Falls, on the precipitous side of Giant Mountain at Chapel Pond Pass, where others have died. Along those lines, there's also the worrisome Death Falls, the evocatively named Hanging Spear Falls and Fairy Ladder Falls, and more than one Rocky Falls. There's Shelving Rock Falls, and Square Falls, and . . . well, entire books have been written directing people to the dozens of waterfalls all over the Adirondacks.

Lampson Falls sits almost on the Blue Line, on a river whose name is spelled Grass if you believe it was named for the sawgrass that Mohawks at its mouth on the St. Lawrence still use to make baskets and other wares, or Grasse if you believe it was named for, or by, a French explorer named DeGrasse. Like so many falls along the periphery of the Adirondacks, it marks one of the points where water, flowing down off the central dome, tumbles into a surrounding valley. As so often happens in these situations, upstream is a long stretch of flat water, excellent for paddling and viewing great blue herons, beavers' artistry, turtles sunning themselves on driftwood logs, and the flaming cardinal flowers that herald the beginning of the end of summer.

The flat, wide, half-mile, handicapped-accessible trail to Lampson Falls, off a rural road in central St. Lawrence County, is a former logging lane. The history of its transformation into a hiking trail is like that of many such trails in the Adirondacks. In a nutshell, concerned citizens arranged an easement through private lands so hikers, campers, and students from four nearby colleges could get to the falls, which are state owned. At the falls, a scramble down the marked trail along the edge leads one to a natural sandy beach decorated with driftwood, flotsam, and the occasional carcass of a drowned animal. A rocky promontory provides a front-row seat toward the cascade, and there is a safe swimming hole on the downstream side, the current slowly eddying in such a way that it's impossible not to float right back to shore.

The trail continues, now as a footpath, downstream along the riverbank for about half a mile, above rocky channels, and along open stretches of the once heavily logged woods that are almost savannah-like. It ends at the site of a bridge that was taken out by a major-league ice jam a few years ago. Hikers, snowshoers, or skiers can return via the trail or by the unmarked woods road, which goes up and over a shoulder through forest that is so typical of the lower Adirondacks that you could be anywhere from the Yukon to the Piedmont.

But it is the falls themselves that are most hikers' preferred destination. They change with each month of the year: encased in ice in January, when temperatures in this northwest extremity of the Adirondacks can plunge to under 40 degrees below zero; rip-roaring in hollering, uninhibited exuberance as they carry five months of snow out of the high country in April; mellow, restrained, and inviting on a hot July afternoon; framed in screaming oranges and reds and yellows in October. They are never the same two visits in a row, and that is why people keep going back.

OPPOSITE: A pink lady's slipper blooms along the Grasse River in June.

THE GREAT RANGE

Keene Valley and its sister hamlet, Keene, are quintessential mountain towns and hikers' oases. Squeezed into the deep upper valley of the East Branch of the Ausable River, they offer stores that can outfit you with provisions and gear for everything from a stroll to a pond a few minutes off the main road to an epic ice climb. There's even a diner named for one of the nearby mountains (Noonmark, so called because in summer, the sun, when directly over its sharp peak as seen from the center of town, "marks noon"). Best of all, they feature popular trailheads to surrounding peaks that are 4,000 feet or more farther above sea level than they are.

The Great Range contains half a dozen of the 10 highest peaks in the Adirondacks. As in most of the other high ranges in the East, it tops out in a rounded alpine summit named for a dead white guy: Mount Marcy. As New York's highest point, it was named in honor of the governor of the state when the peak was first surveyed and officially measured in 1837. (A rumor has persisted for a century and a half that it previously bore a Native American name, Tahawus—supposedly meaning "cloud-splitter"—but there is ample evidence that that name and its myth were invented by an overly imaginative New York City newspaper reporter in the days when the mountains were first being discovered by people who didn't already live there.) But, unlike those other ranges, particularly New Hampshire's Presidential Range, most of the rest of the Great Range roster is named for physical features, aesthetic suggestions, or animals. From Marcy approximately northeastward, and generally getting lower, there is Skylight, Haystack, Basin, Saddleback, Gothics, Armstrong (an exception to the "no people" rule, named for a lumber baron who owned the mountain for 21 years following the Civil War), Upper Wolfjaw, Lower Wolfjaw, Hedgehog, and, finally, down toward Keene Valley, Rooster Comb.

The Great Range Trail over these summits is actually two separately managed but conjoined trails, the lower or northeastern segment maintained by ADK and the upper or southwestern portion (the Mount Marcy end) by New York State. This trek is not for the faint of heart. The 14th edition of ADK's *High Peaks Trails* guidebook indicates that a traverse from lowly Rooster Comb's trailhead to imposing Mount Marcy racks up 14.5 miles of clambering and some 9,000 feet of total elevation gain as a hiker attains one peak after another, with knee-torturing descents between. Imagine walking along the business edge of a giant's crosscut saw (indeed, an ancillary summit alongside Gothics bears the name Sawteeth, for good reason). And that's just to get to the top of Mount Marcy; one still has to come down. Nor is a multiday attempt desirable; camping is prohibited above 4,000 feet, and once you get up there, there aren't many places that are lower than that. Undertake this expedition only with exceptional levels of mental and physical preparation, as well as the proper gear for any condition at any time of year and knowledge of how to use it.

That said, the journey is nothing short of spectacular. Here can be found most of the 175 acres in New York State that are truly alpine, with exceptionally rare, simultaneously tough and fragile vegetation that lives nowhere else in the state—and is not seen elsewhere unless one travels several hundred miles toward the Arctic. Here can be found snowfields that linger into July. Here can be found lethal weather that can, and does, take fingers, toes, and lives. Here can be found bare rockslides, ladders and cables,

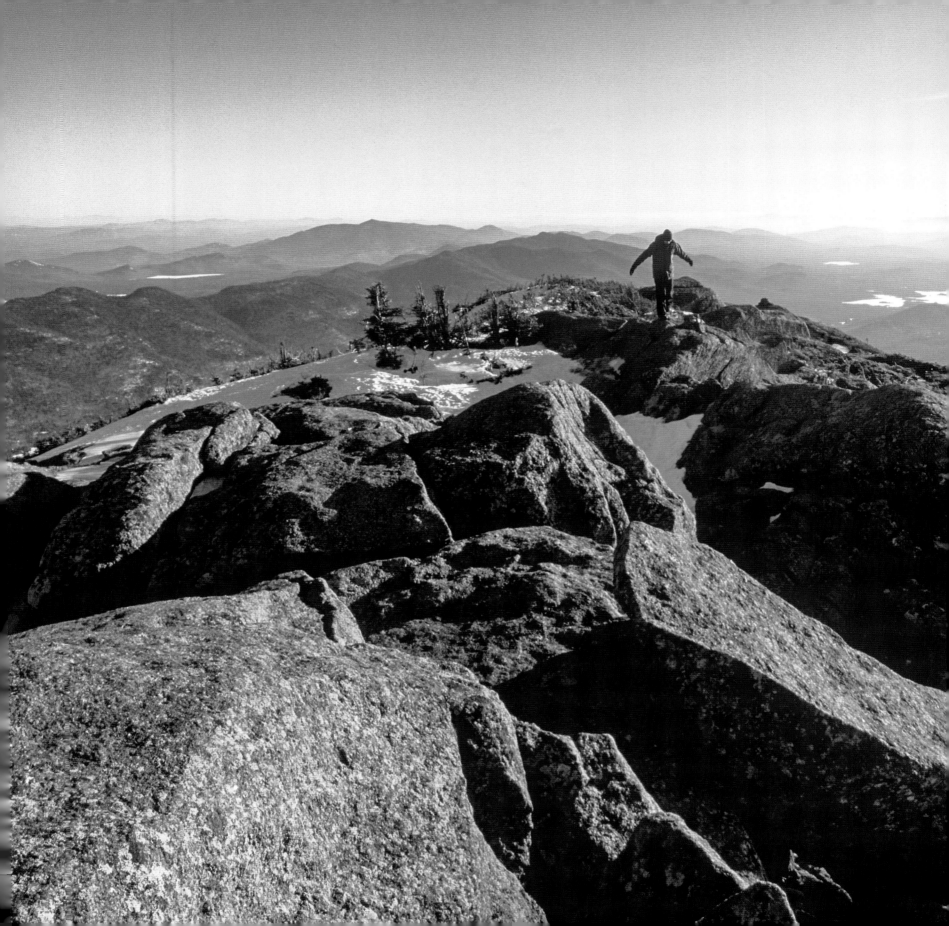

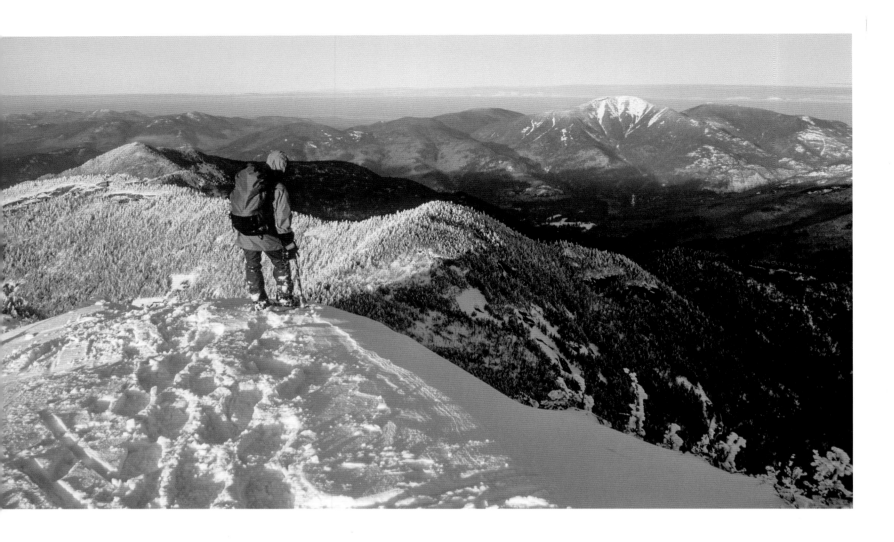

ABOVE: This late winter view from the summit of Gothics looks east along the Great Range toward Armstrong Mountain and the Wolfjaws, with Giant Mountain in the distance on the far-right horizon.

saber-like winds that turn stubby trees into one-sided phenomena. Here can be found timberlines. And here can be found tiny puddles of clear, cold rainwater in depressions on granite summits that if drunk from, it is said, bind one forever to the mountains.

With height comes views. From the Great Range one can see ocean swells of peaks rolling on to peter out on the horizon, glacial lakes far down, the white-roofed arena in downtown Lake Placid where the "Miracle on Ice" confounded the Russian hockey team in the 1980 Winter Olympics, the Champlain Valley as much as a mile below, the Green Mountains marching up and down Vermont, and, on an exceptionally clear winter day, distant Mount Washington, three states away.

THAT'S JUST A QUICK LOOK AT A TINY FRACTION of all the trails that exist in the Adirondacks, of all the thousands of miles of footpaths that permeate this massive park. Find them for yourself. Go up Sleeping Beauty Mountain, with its breathtaking views of the Lake George area, or easy Castle Rock, smack in the

THE TRAILS OF THE ADIRONDACKS

middle of the park—the kids will love it. Explore the banks of Calamity Brook, the flowered channels of Wickham Marsh, and the renowned hermit Noah Rondeau's stomping grounds, still discernible far in on the Northville-Placid Trail. Discover Belfry Mountain in the east, Mount Arab in the middle, and Stillwater Mountain to the west, all with fire towers. Climb Goodman Mountain, named for Andrew Goodman—the young civil rights activist infamously martyred in an earthen dam in the "Mississippi Burning" summer of 1964—whose family summered on nearby Big Tupper Lake. Seek out Beaver Meadow Falls, Whiskey Brook Falls, Cowhorn Pond, and Grizzle Ocean. Visit Billy's Bald Spot, Drunkard Creek, and Halfmoon Lake. There is enough here to keep one occupied for a lifetime. The Adirondacks await.

The Hermit of Cold River Paul Jamieson

Noah John Rondeau chose one of the wildest and most remote parts of the Adirondacks for his hermitage, the Cold River. For several years he lived in the woods only during winter months when he could not do guiding, but in 1929 he began living there year round. His longest continuous stay was 381 days. He called himself the Mayor of Cold River City, population 1. (The tiny log hut he lived in is now on display at the Adirondack Experience [formerly the Adirondack Museum].) He was forced to leave after the Big Blow of 1950 (he was then sixty-seven years old), when the Cold River was closed because of the danger of fire.

A colorful personality, Noah, who died in 1967, is by far the most celebrated of Adirondack hermits. Most of the others have been rather dour, but Noah was friendly and outgoing . . . A visitor to his hermitage described him thus: "A pippin of a man with a face as smiley as the full moon . . . When he was speaking it seemed as if he was vocalizing the mystic spirit of the woods. . . . I could plainly see that beneath his frolicking humor there lurked a soul of rare sincerity and worth. I once heard that nature is our oldest and best teacher, and after spending those few hours with Rondeau I believe it is true. . . . Noah John had graduated from this unique school with a *magna cum laude* degree."

Right: Noah John Rondeau was known as the hermit of Cold River.

Adirondack WATERWAY TRAILS

CHRISTINE JEROME

From the summits, they resemble jewels scattered across the landscape, lakes strung like beads along rivers that form restless pathways among the immutable mountains. These trails invite us to explore the watery world in all its configurations, from backwoods ponds to meandering rivers to lakes dotted with islands.

In this liquid world, each season brings waves of change. In spring, the melting snow creates runoff that quickens streams and pushes you downriver so urgently you need only steer with your paddle. As floodwaters drown landings and spill over riverbanks, they create new corridors that delight bushwhackers. It's a vibrant green world. You can pull your boat over beaver dams on your way upstream and gleefully slide over them coming back, all the while serenaded by white-throated sparrows and wood thrushes. Wetlands ring with the calls of red-winged blackbirds.

In high summer, paddling competitions and regattas offer waterborne entertainment, while people seeking quieter experiences may opt for motor-free lakes. Here is travel at its most serene, a sensory meditation on forest, rock, water, and sky. Yet even on the busier lakes, particularly as quiet descends at dawn and dusk, you can watch wildlife going about the business of raising their families. You may see mink, otters, beavers, loons, dabbling and diving ducks, ospreys, great blue herons, kingfishers—and, if you're lucky, a soaring bald eagle. Along riversides and in marshes you'll find plants that don't mind getting their feet wet: cardinal flowers, Labrador tea, closed gentians, pitcher plants, white and yellow water lilies, and the pickerelweed so delicately rendered in Winslow Homer's Adirondack painting *The Blue Boat*.

Amid blazing fall foliage the winding inlet streams you paddled in April are unrecognizable as dropping water levels raise the marsh grasses head high. In September, the mountain ashes along lakeshores offer orange-red berries; on riversides, sandpipers patrol the now-exposed mudflats. Migrating monarch butterflies may keep up with your canoe for a time as honking Canada geese pass overhead. By November, the riot of color on mountainsides has yielded to somber tones, but yellow tamaracks still brighten the marshes.

Winter's grip tightens too soon, but even as the waters still and then congeal, there are pleasures to be had in this chiaroscuro world. After docks have been hauled ashore and boats stored, lakes come alive with skiers and snowshoers and snowmobilers and ice fishers, all of them making the most of frozen Adirondack waterways.

Wherever and whenever you venture out, you'll find images that linger in memory. You'll remember how light works on water—winking, shimmering, and painting a golden pathway across a lake at sundown. How a blustery wind stacks waves and raises spumy whitecaps. How raindrops create Escher patterns on the surface, tiny rings during showers and hobnails in downpours. You'll remember the sound of water tinkling through a beaver dam, the pulse-quickening roar of a waterfall, the gentle slapping as boat wake meets rocky shore, the way far-off voices carrying across a darkening lake. At dusk comes the wail of a loon, as your campfire throws shadows on the trees.

Beyond the beauty that Adirondack waterways bring, there's another gift, that of perspective. Immersed in nature, freed from workaday cares, we're able to assess what's really important in our lives. And that may be the greatest gift of all.

Opposite: A common loon keeps some canoeists company on the Boreas Ponds.

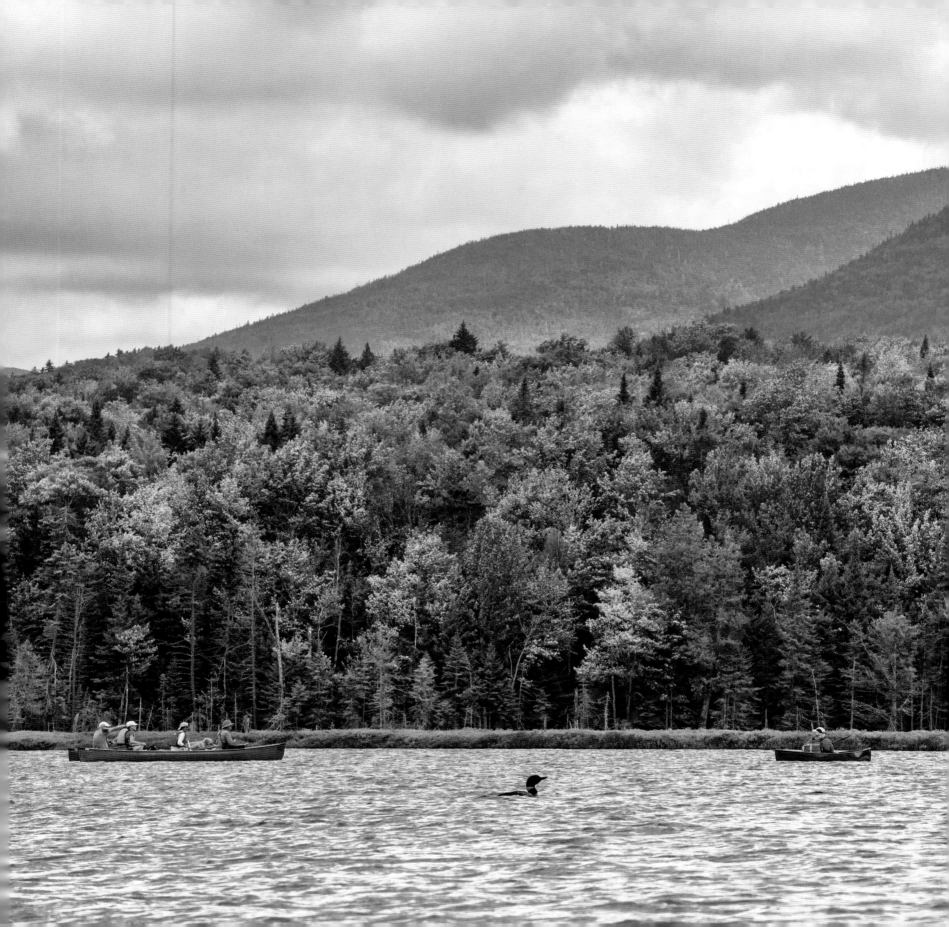

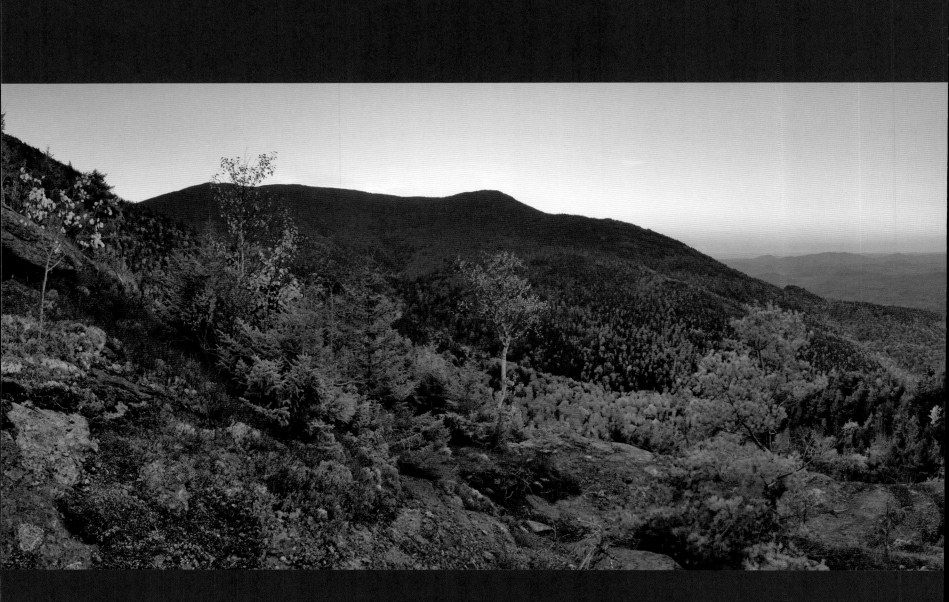

ADIRONDACK TRAILS

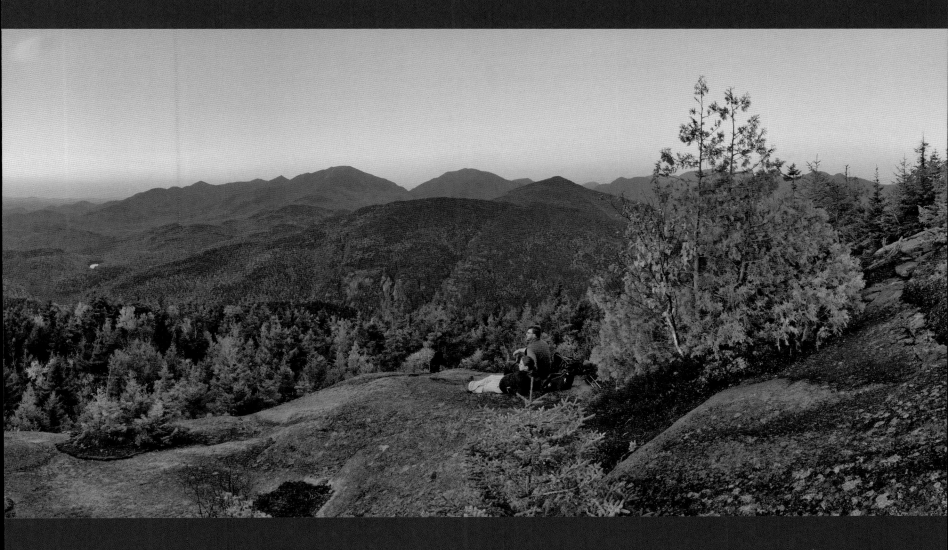

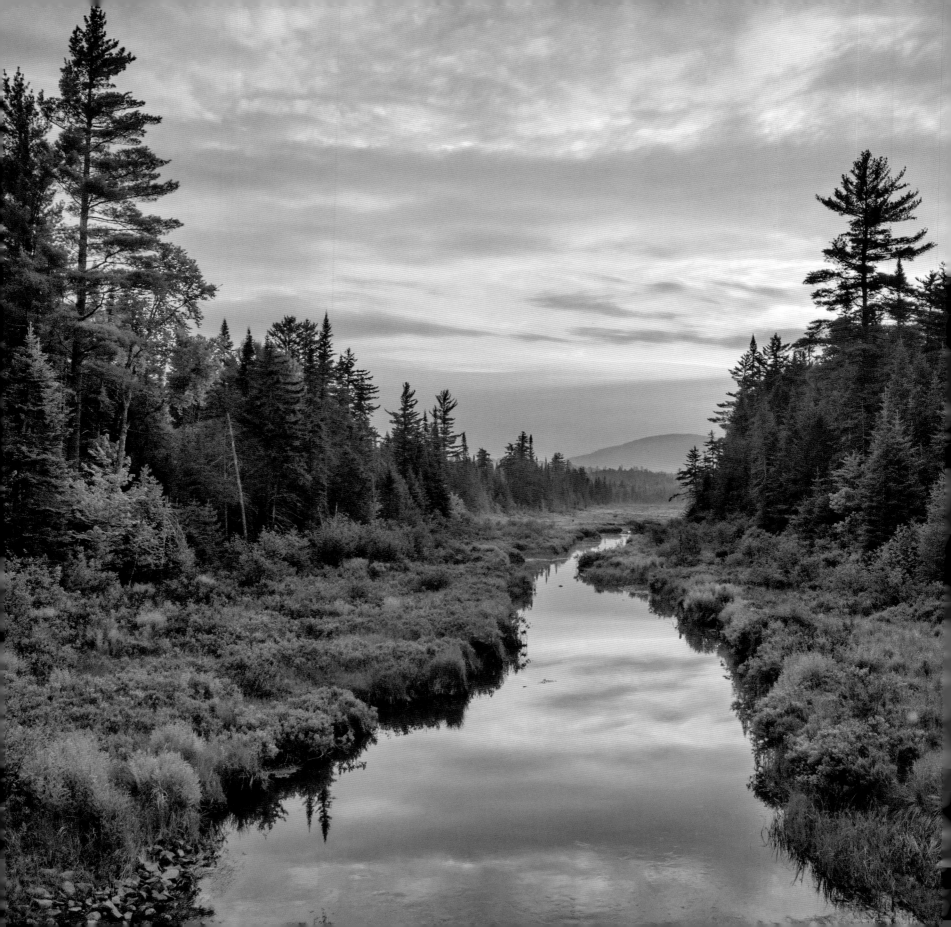

HIGH PEAKS, CHAMPLAIN VALLEY, *and* NORTHERN ADIRONDACKS

In this portion of the Adirondacks can be found the greatest variety of trail types and conditions, since it presents the greatest variation in altitude. From the rocky banks of Lake Champlain, at an average of 95 feet above mean sea level, to Mount Marcy's summit, New York State's high point at 5,344 feet, is a stone's toss short of a vertical mile. The hiking opportunities are as varied as that interval suggests. You can find rare alpine ecosystems at the highest elevations, such as the MacIntyre Range, culminating in 5,114-foot Algonquin Mountain, second highest in the Adirondacks. You can hike up conical Whiteface, the Adirondacks' most-famous landmark, and wave triumphantly to the tourists driving up the Whiteface Veterans Memorial Highway. At 4,867 feet, it is the only mountain in the Western Hemisphere to host two Winter Olympics alpine skiing events (1932 and 1980). You can head in to glacial Avalanche Lake, jammed between precipices so tightly that the trail skirts the cliffs on bridges known as "Hitch-Up Matildas" in honor of the experience of guide Bill Nye. In the days before the bridges, he was obliged to carry a portly client through the water on his shoulders, their companions urging the relentlessly sinking Matilda to "hitch up!" (The gallant Nye, not to be slighted, has a nearby mountain named for him.) Or you can stick to the lowlands, with their gentler and more sedate trails, exploring the rugged shores of Lake Champlain at Split Rock. Cliché though it may be, there's something for everyone in this part of the Adirondack Park.

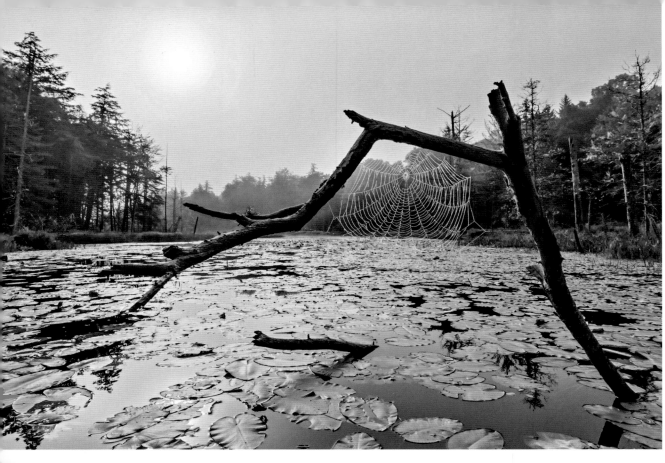

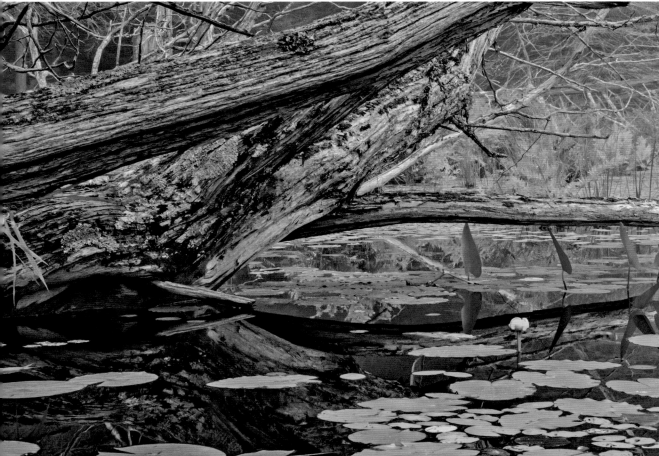

PAGES 74–75: Rocky Peak Ridge, the Boquet River valley, Round Mountain, the Dix Range, Nippletop, Noonmark Mountain, and the Great Range are all visible from open ledges along the Giant Ridge Trail.

PREVIOUS SPREAD: The Grampus Lake outlet flows along the handicapped-accessible John Dillon Park near Long Lake and Tupper Lake.

LEFT, TOP: The Essex Chain of Lakes is a series of lakes and ponds that are connected by trails and waterways. The sun highlights a spider web on this flow between Fifth and Sixth Lakes.

LEFT, BOTTOM: Mist covers the inlet flow of Third Lake.

OPPOSITE: A lightweight Hornbeck canoe, pictured at the canoe access site on Deer Pond, is easy to portage from one pond to another.

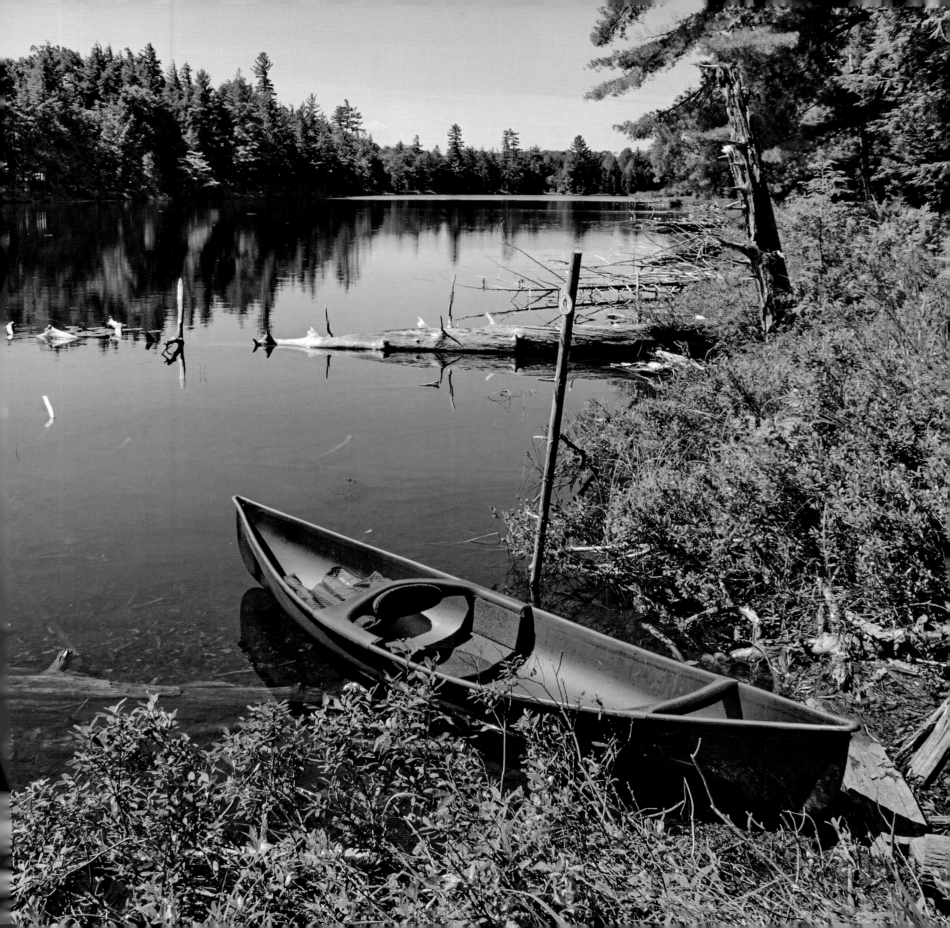

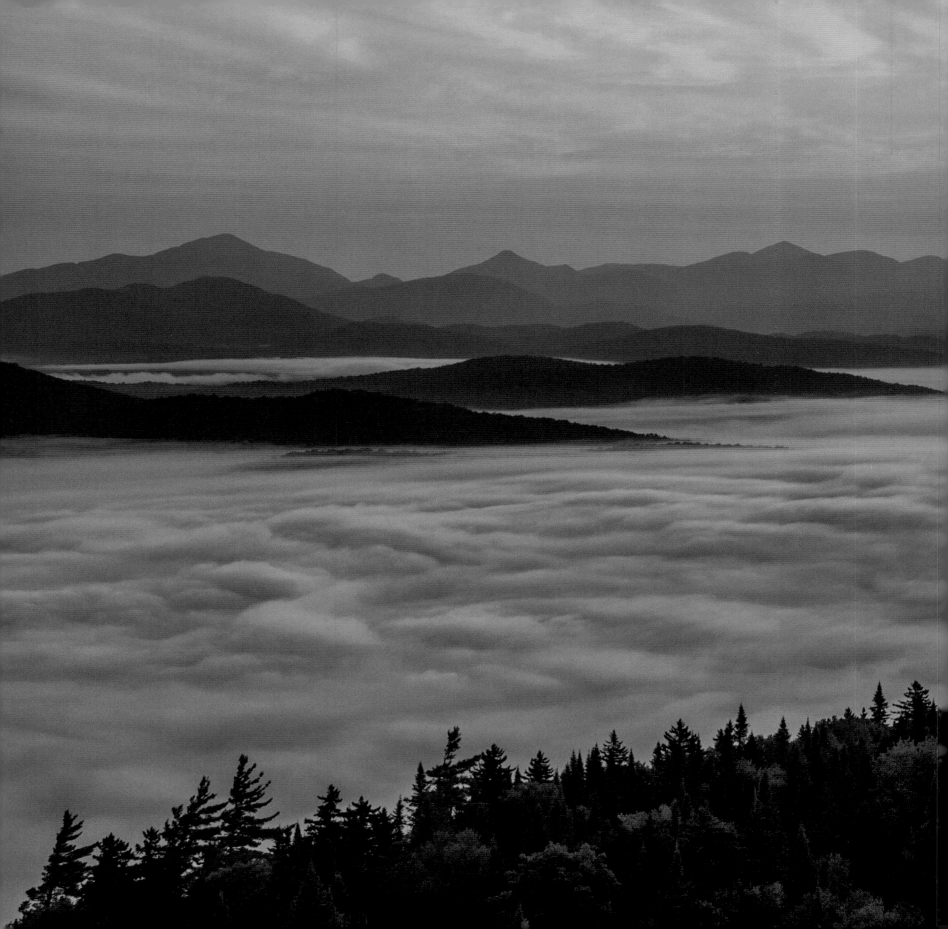

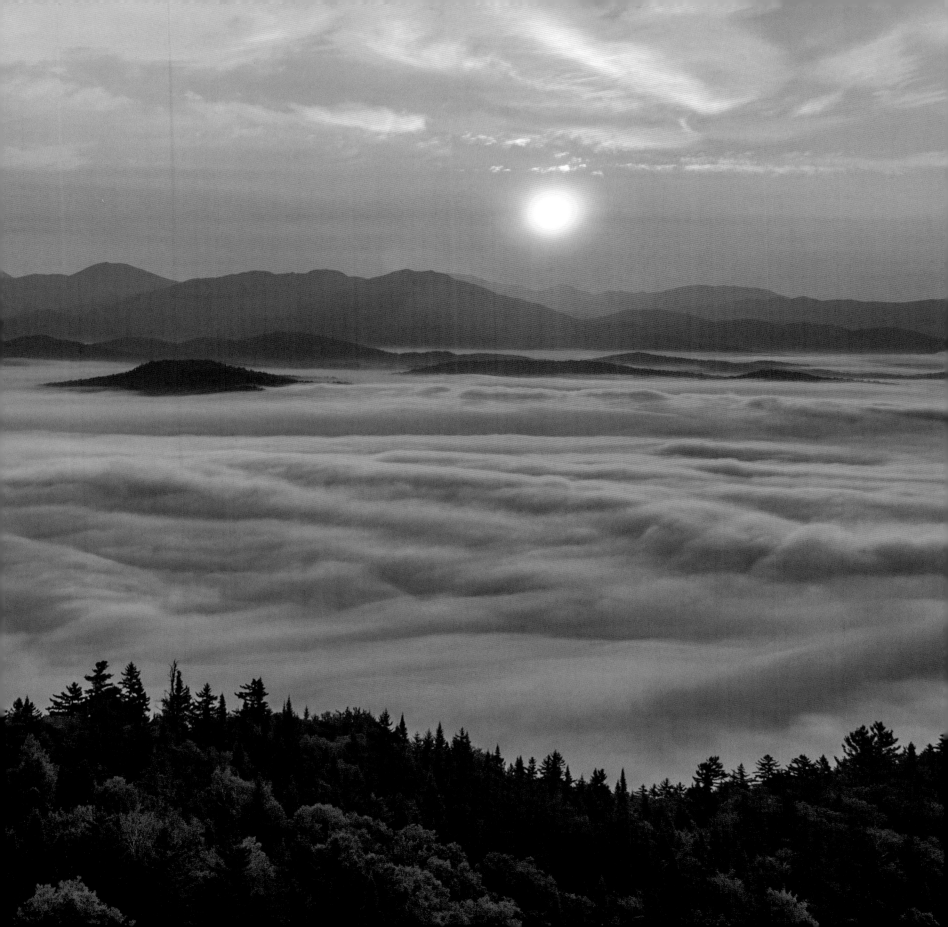

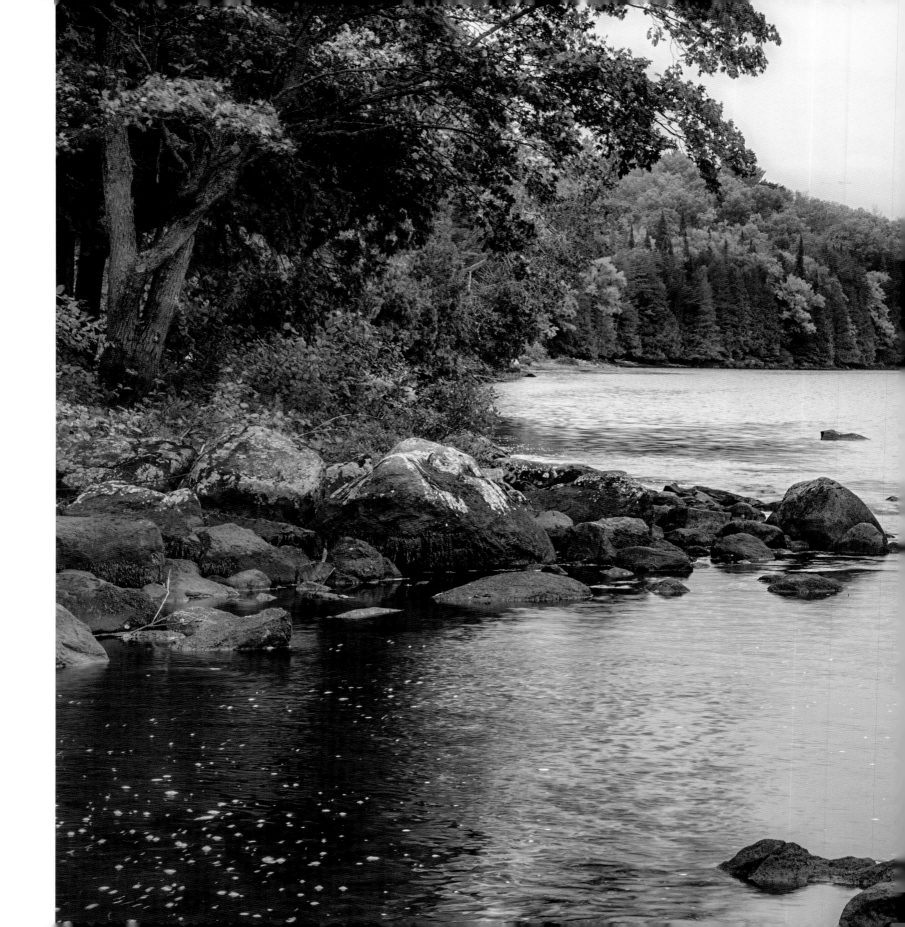

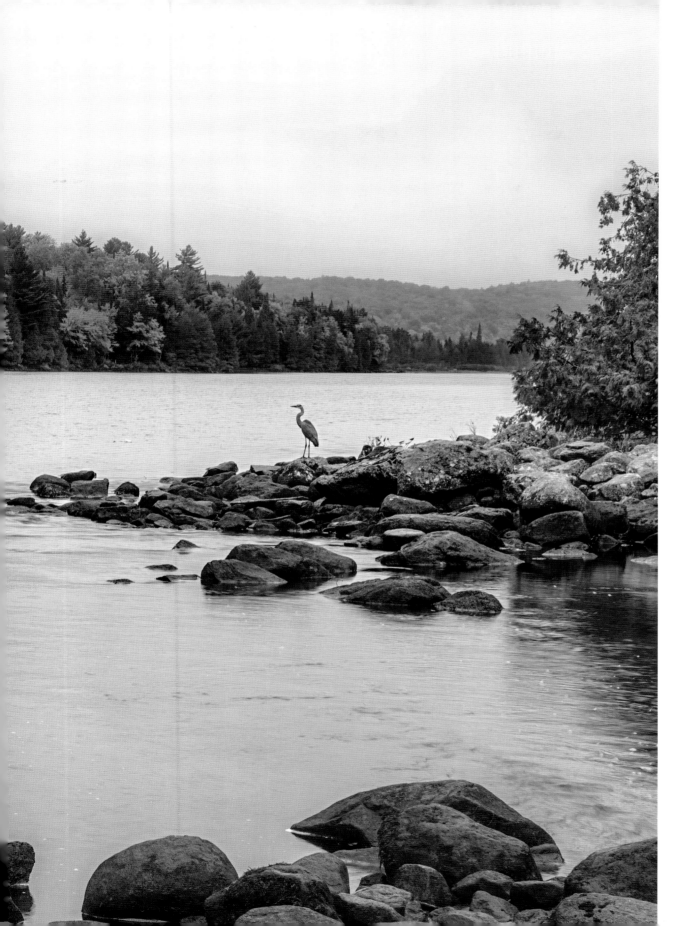

PREVIOUS SPREAD: A tranquil view from the Goodnow Mountain fire tower shows Algonquin Peak, Mount Colden, Mount Marcy, and several other High Peaks at sunrise.

OPPOSITE: A blue heron fishes along the shore by the entrance to the Camp Santanoni Historic Area.

FOLLOWING SPREAD: The old road to Great Camp Santanoni in Newcomb is a popular cross-country skiing destination (left, top). Cross-country skiers along the Northville-Placid Trail head downhill onto the snow-covered flow at Duck Hole (left, bottom). A full moon rises over Moose Pond and Whiteface and Moose Mountains (right).

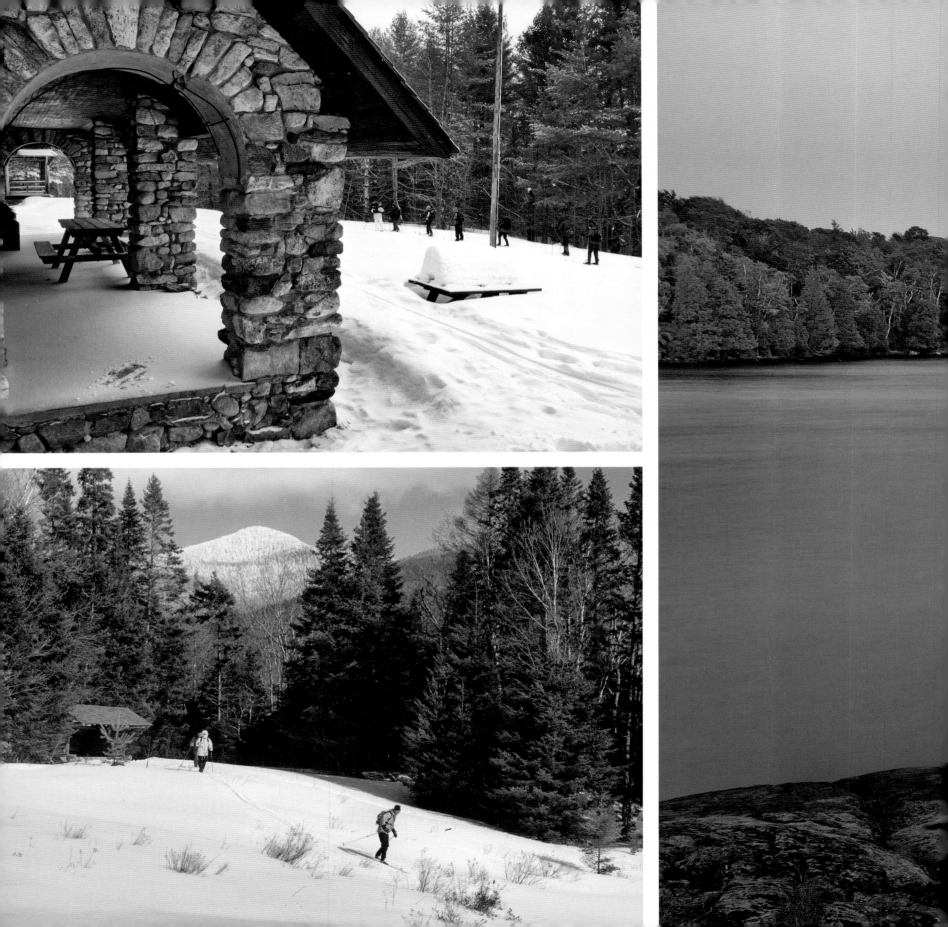

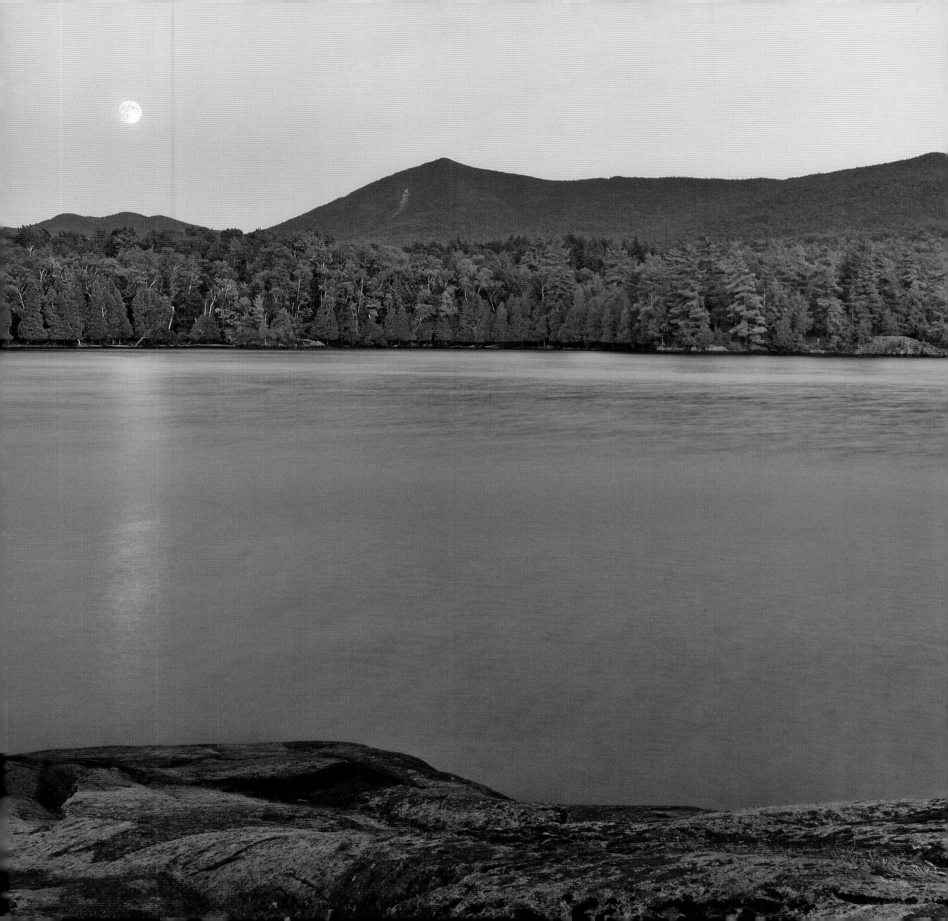

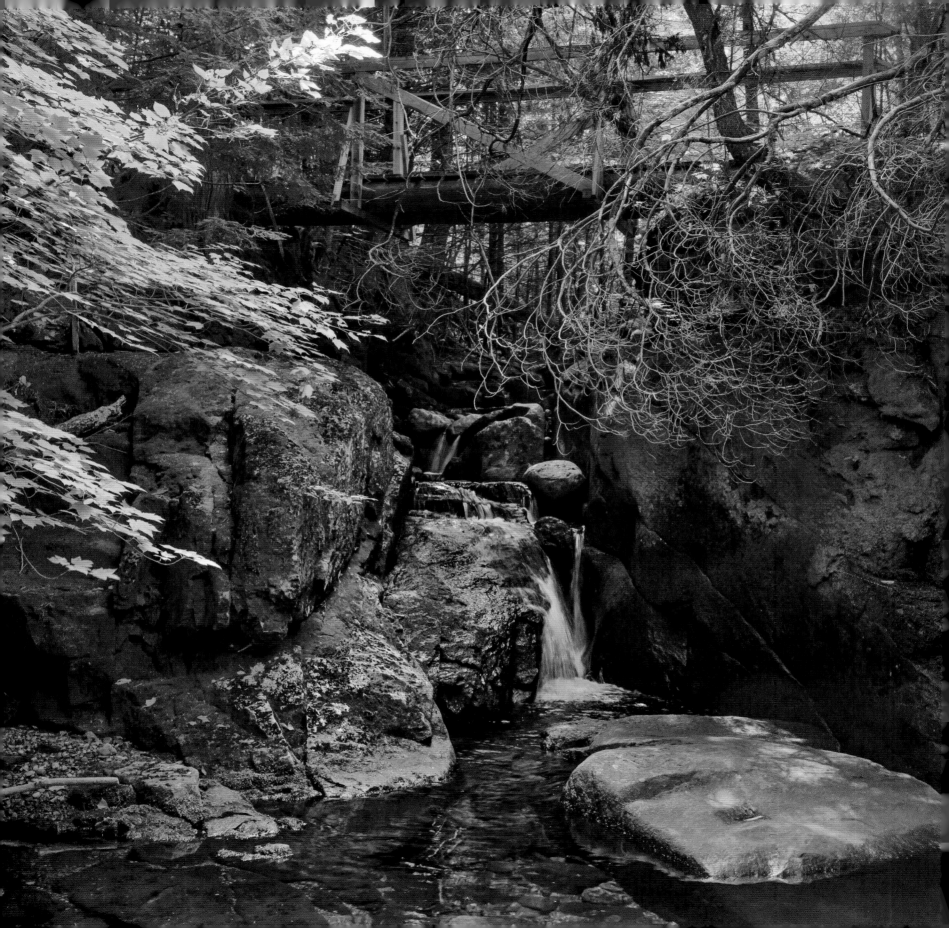

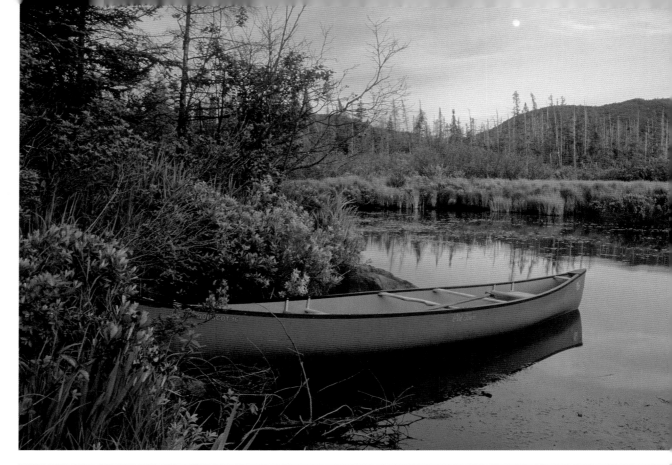

OPPOSITE: A sturdy bridge on the Northville-Placid Trail crosses a small cascade and gorge on the Chubb River.

RIGHT, TOP: A full moon rises over the Chubb River near the northern end of the Northville-Placid Trail.

RIGHT, BOTTOM: The Northville-Placid Trail traverses a wetland of jewelweed in the Wanika Falls area on a series of moss-edged hewn logs.

OPPOSITE: An American toad scouts for lunch along the shore of the plunge pool at the base of Wanika Falls, which is a short hike off the Northville-Placid Trail.

FOLLOWING SPREAD: Henderson Lake, a nice paddling destination, is a short portage from the Tahawus trailhead (left). Hikers cross a log bridge over the southern Indian Pass Brook just north of Henderson Lake (right, top). A hiker camps at the Wallface lean-to along Indian Pass Brook, a quiet, wild place to spend the night (right, bottom).

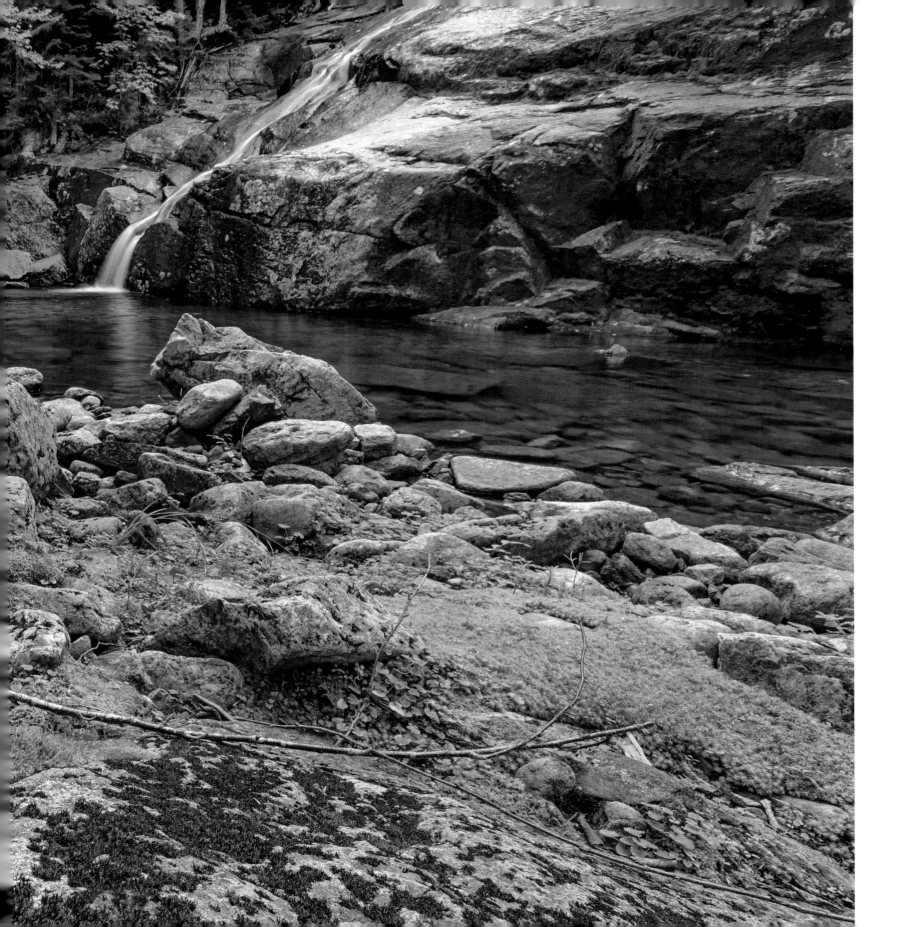

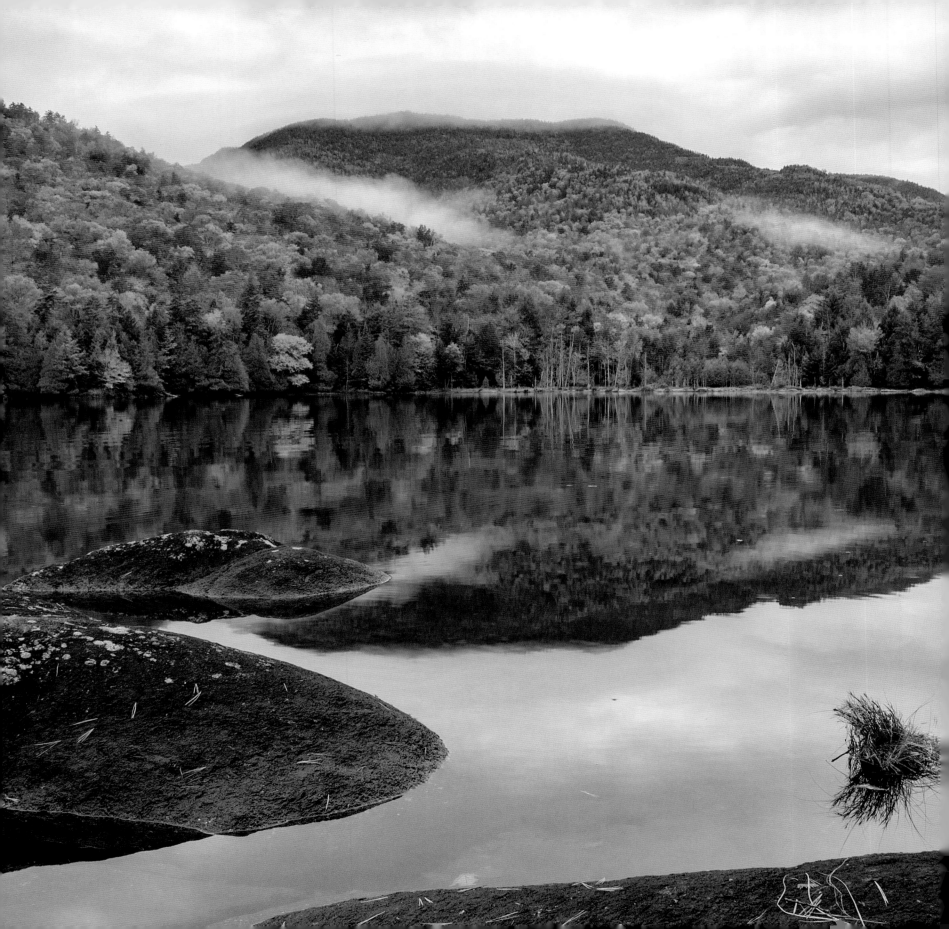

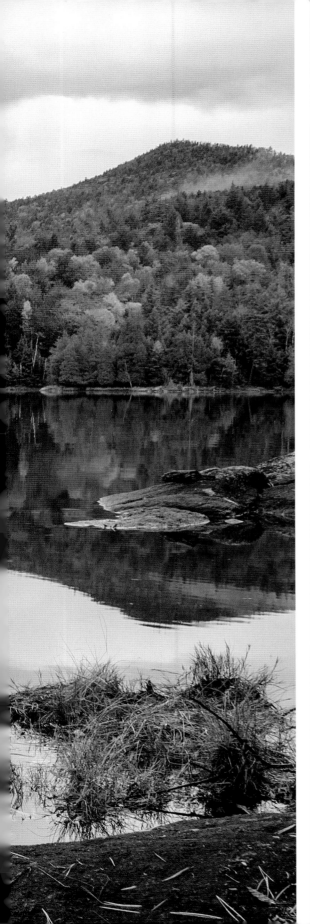

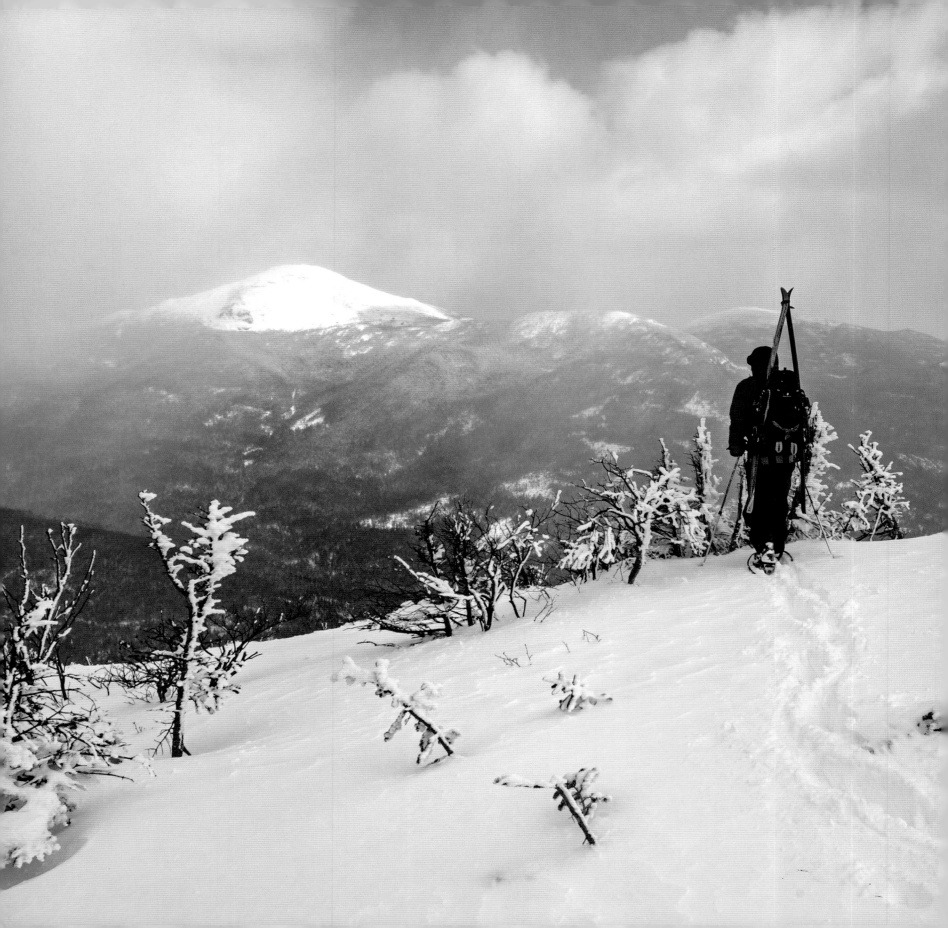

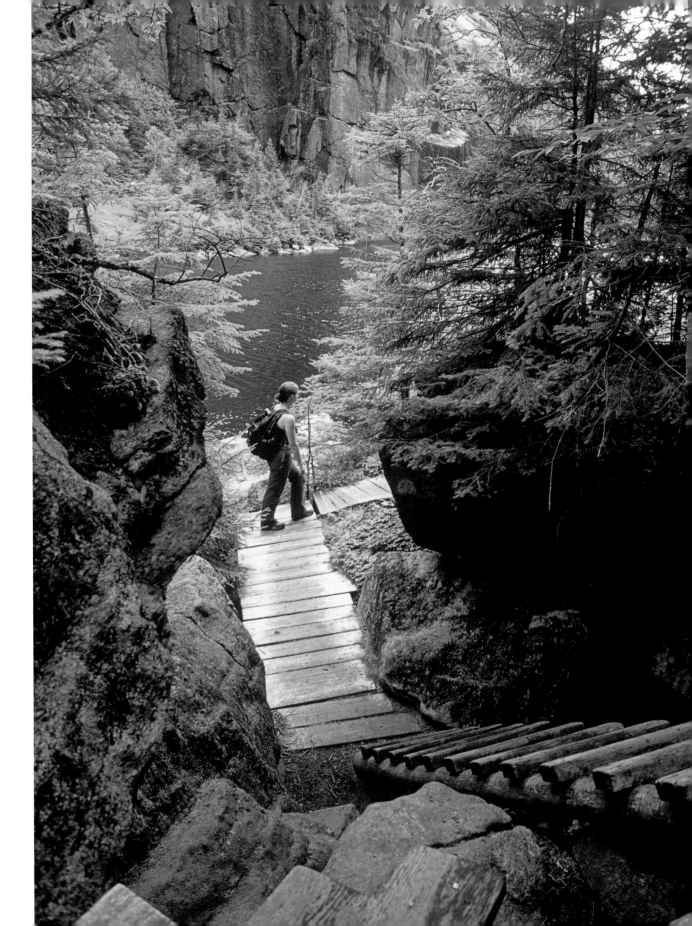

OPPOSITE: This snowy view from Mount Colden shows Mount Marcy and Gray Peak.

RIGHT: There are many ladders and boardwalks along the trail through Avalanche Pass.

FOLLOWING SPREAD: This well-worn section of corduroy trail appears near the 4,000-foot level on Mount Marcy (left). This view from the 5,344-foot summit of Mount Marcy, the highest point in New York State, looks east toward the Great Range and shows Giant Mountain, Haystack Mountain, Mount Colvin, Nippletop, and the Dix Range (right).

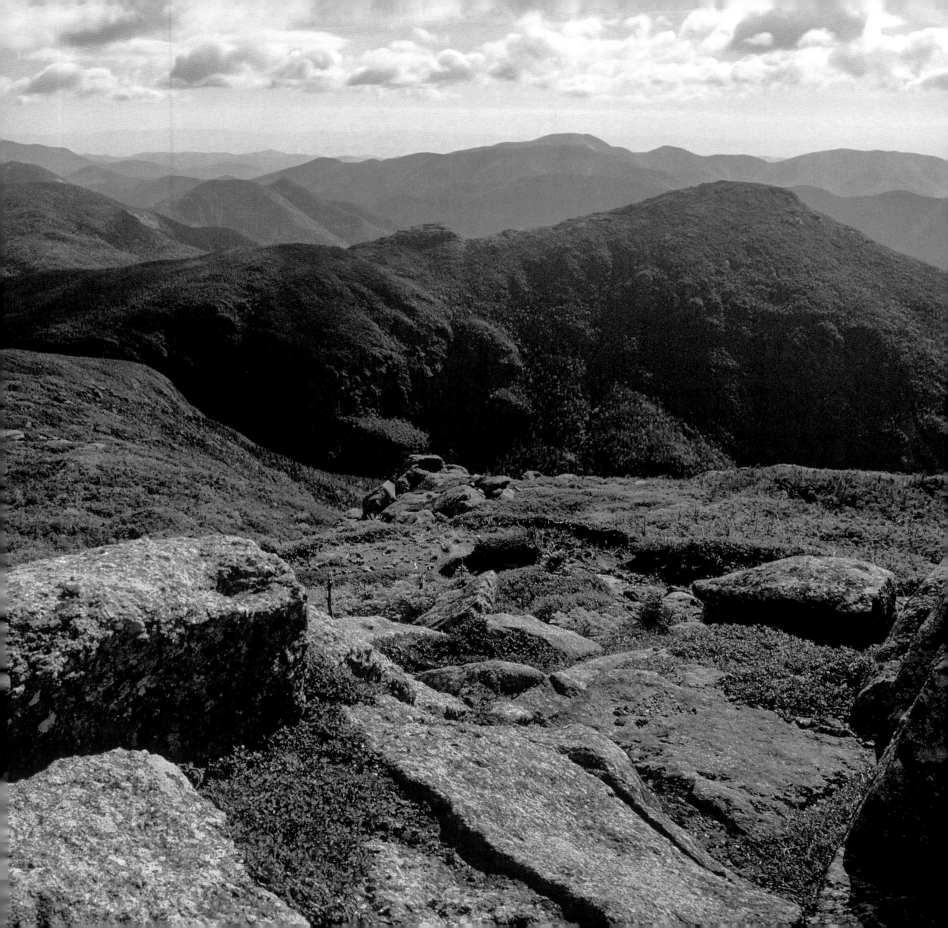

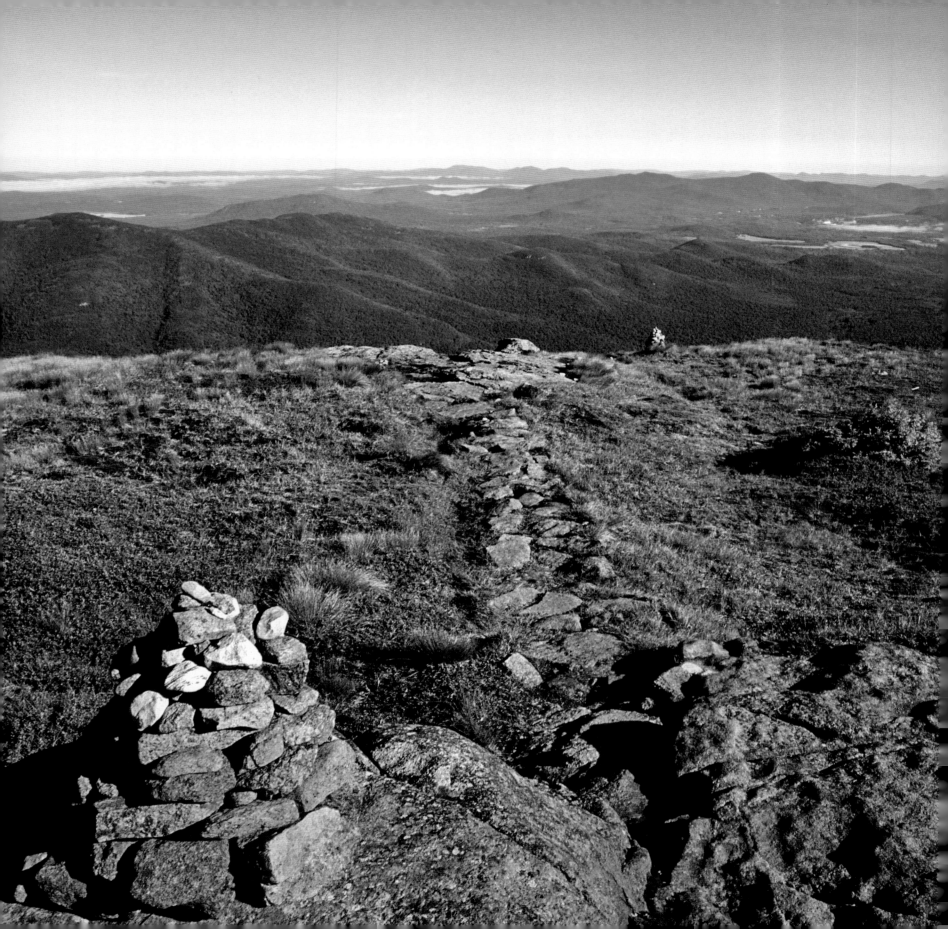

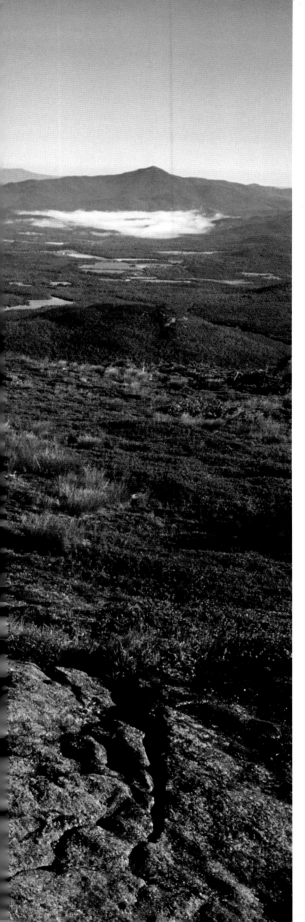
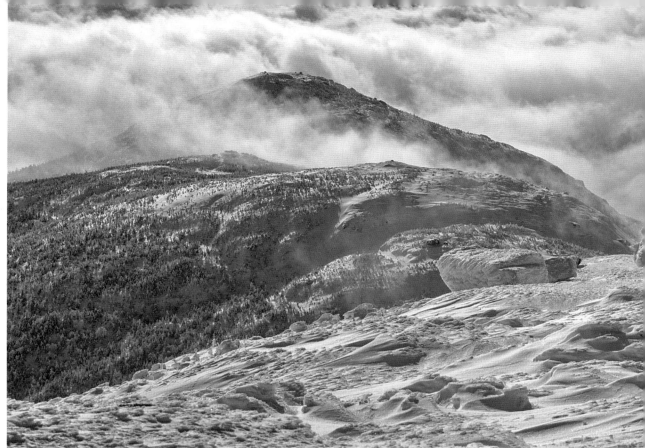
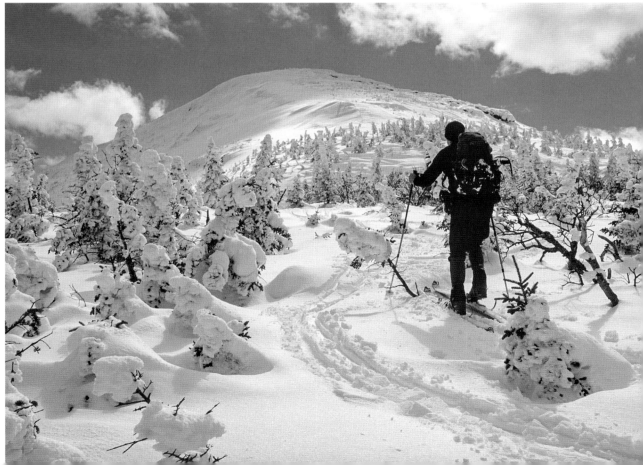

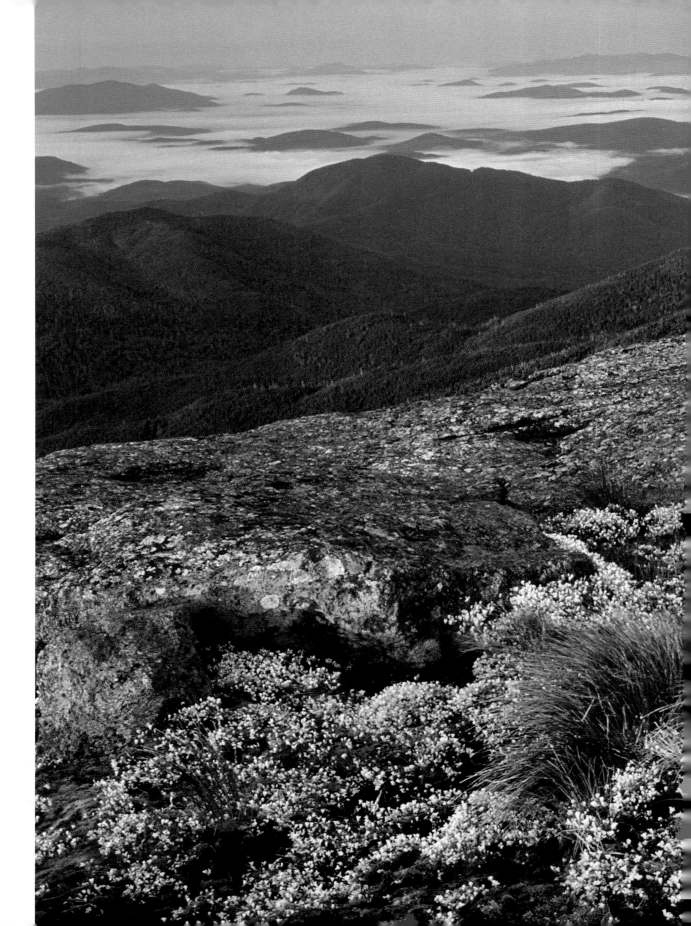

PREVIOUS SPREAD: At 5,114 feet
above sea level, Algonquin
Peak is the second-highest
mountain in the Adirondacks
and the state. Hand-laid
rock trails keep hikers off the
fragile alpine terrain (left).
This view from the summit
of Algonquin looks south
toward Boundary and
Iroquois Peaks (right, top).
A snowshoer approaches the
summit of Algonquin through
the stunted timberline
spruce on the trail from the
Adirondack Mountain Club's
High Peaks Information
Center (right, bottom).

OPPOSITE: Mountain sandwort
is an alpine flower that
blooms through the summer
on the summit of Algonquin
and other alpine regions
on the highest summits of
the High Peaks.

FOLLOWING SPREAD: A large
rock cairn marks the trail to
the summit of Wright Peak.

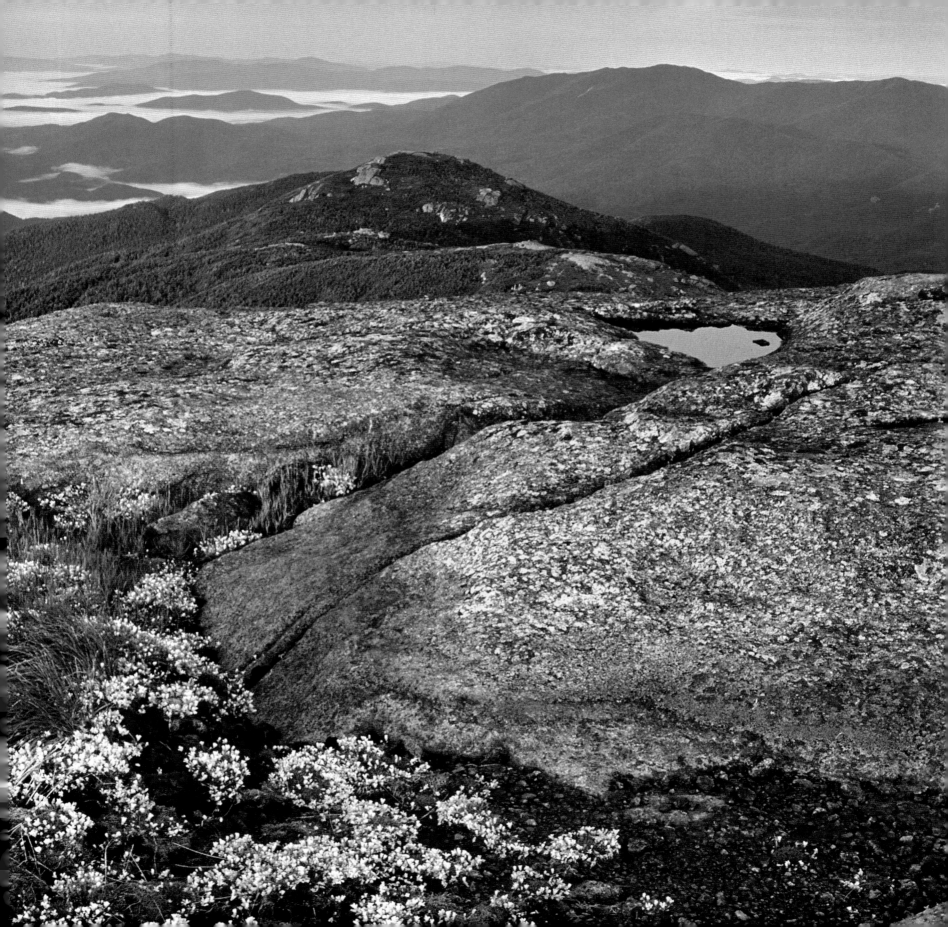

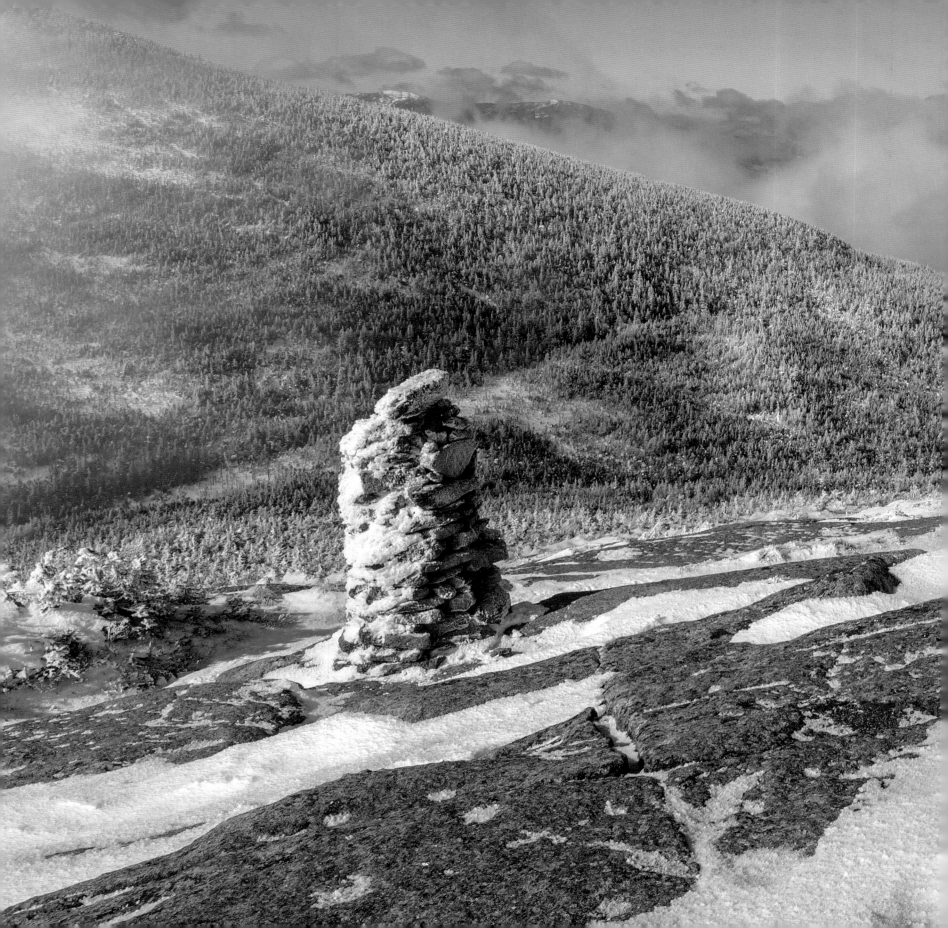

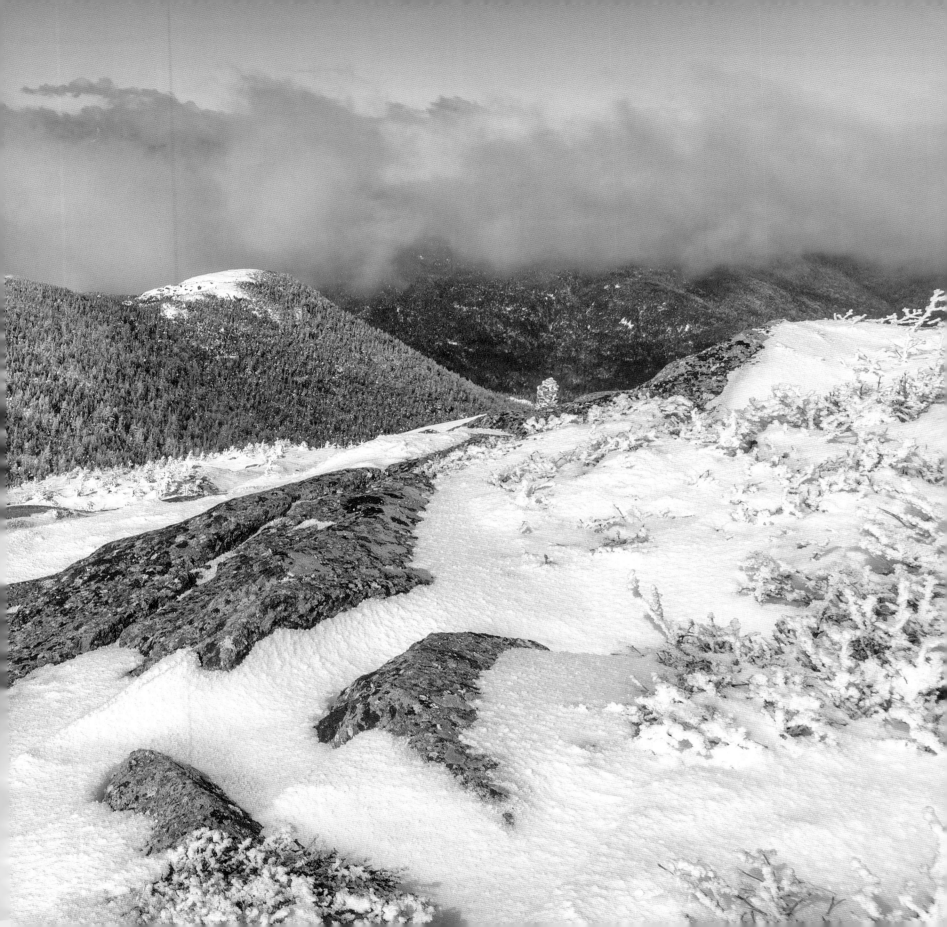

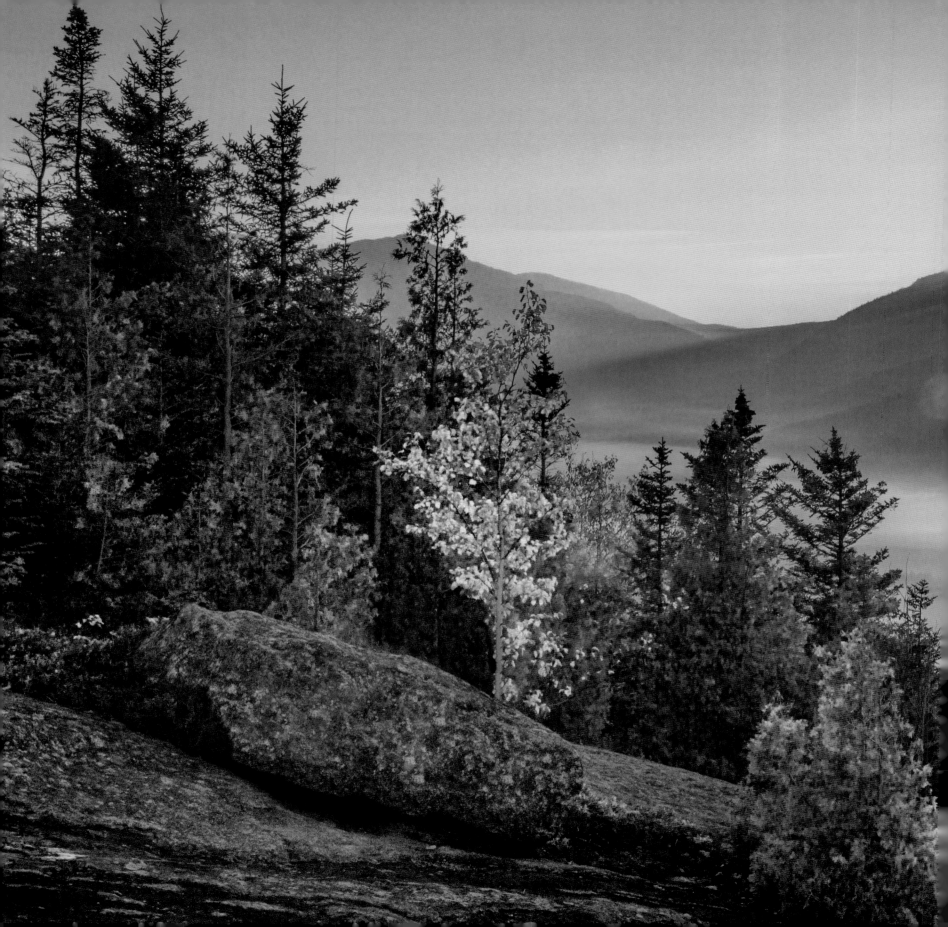

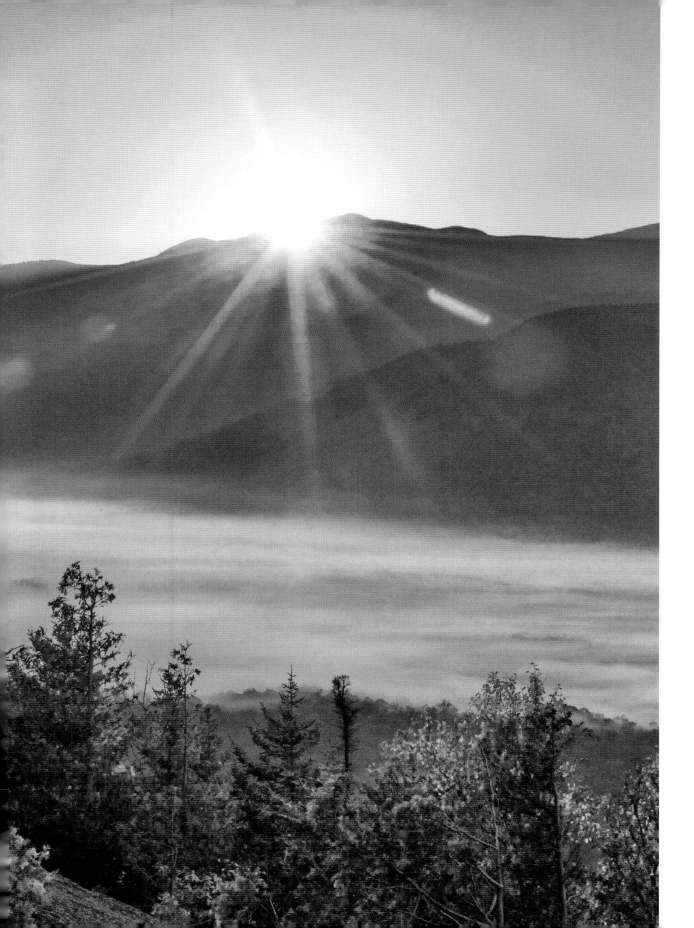

OPPOSITE: A view from Mount Jo to Cascade Mountain and the mist-filled South Meadow valley below shows the sun peeking over the summit of Big Slide.

FOLLOWING SPREAD: Weathered floating trees along the Boreas Ponds shoreline are home to sundews and other bog-loving plants (left). Paddlers enjoy the Boreas Ponds, with Gothics as a backdrop (right, top). The Boreas Ponds canoe access site is near an earthen and concrete dam (right, bottom).

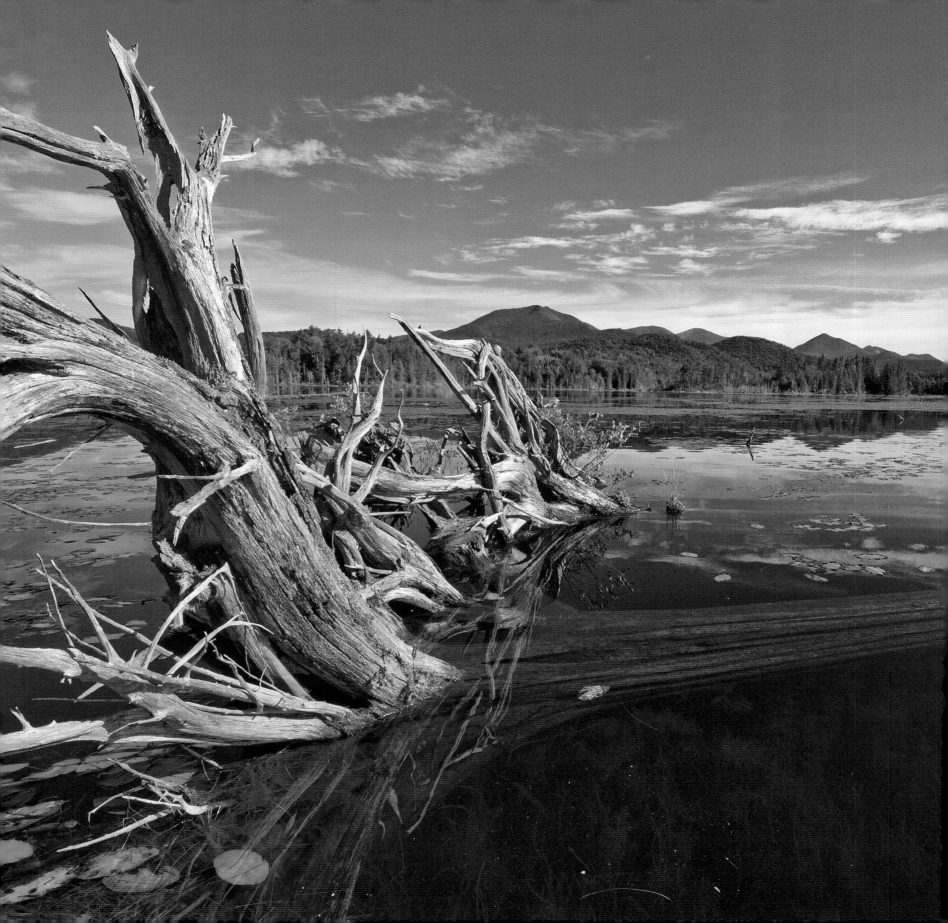

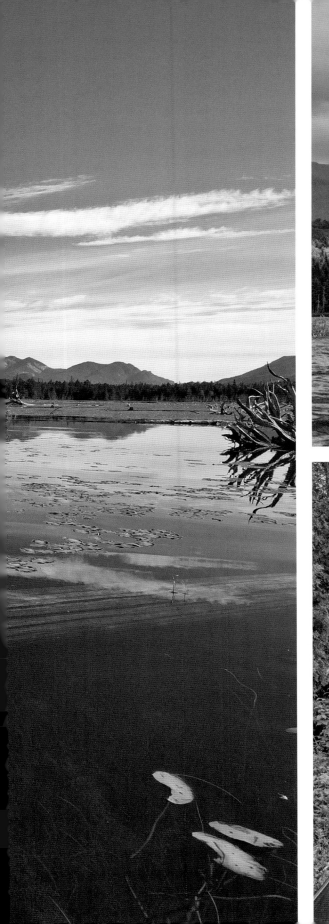
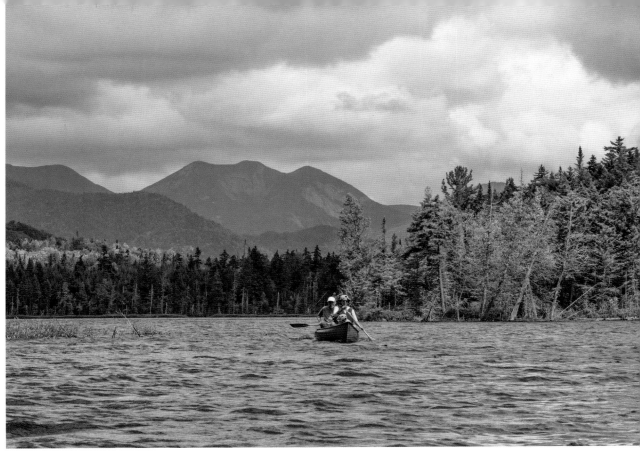
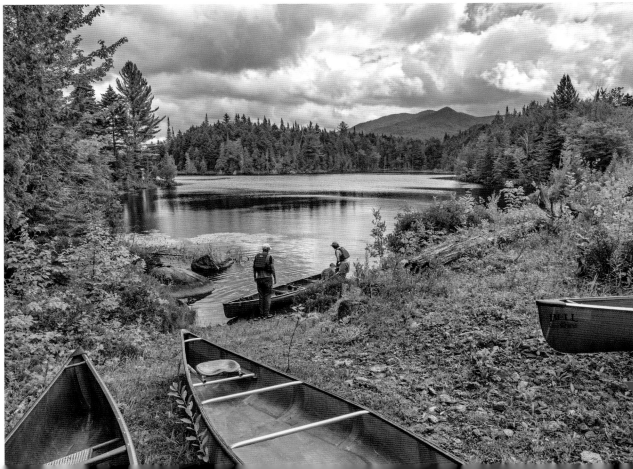

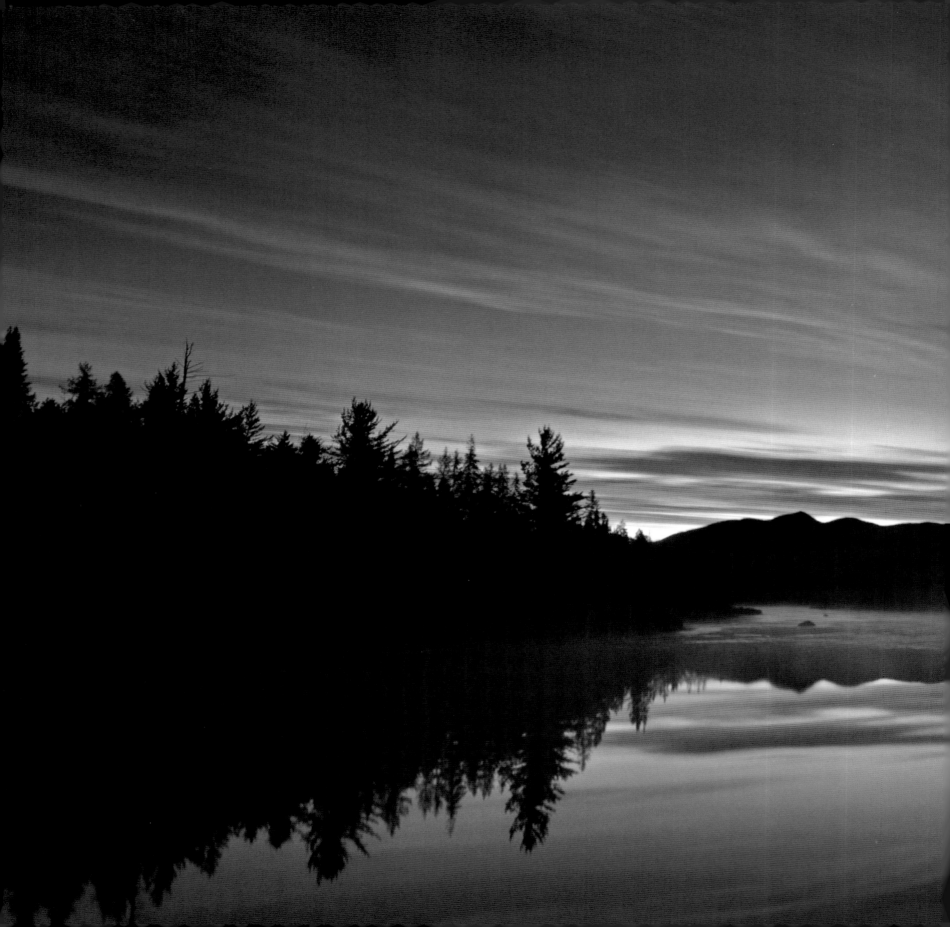

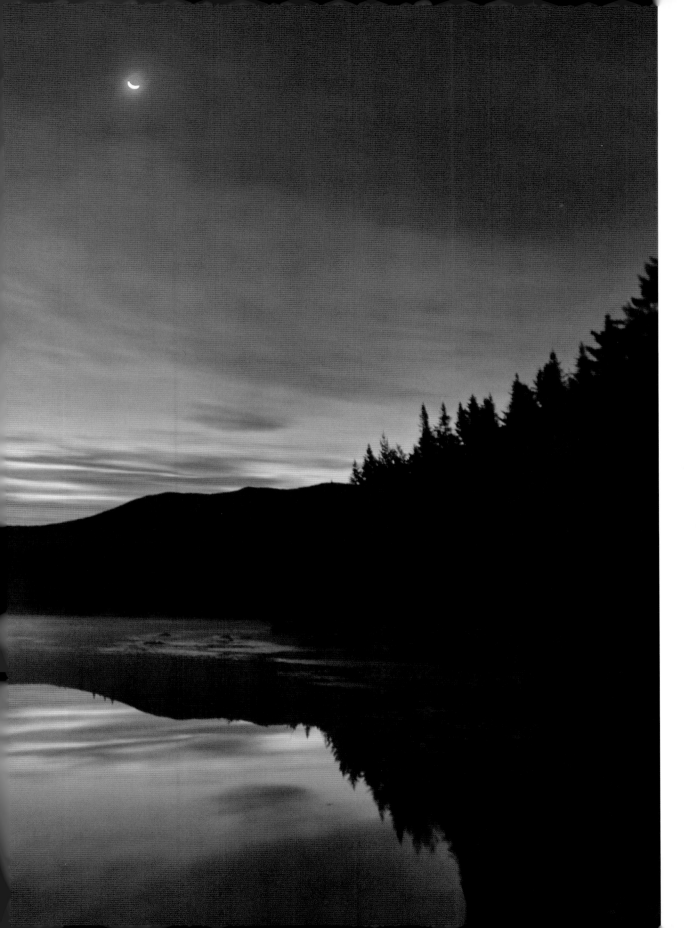

OPPOSITE: Dawn light filters over the Boreas River's LaBier Flow, just south of the Boreas Ponds.

FOLLOWING SPREAD: This sunset view from Armstrong Mountain looks toward Gothics, Saddleback Mountain, Basin Mountain, Haystack Mountain, Mount Marcy, and Mount Colden, with Algonquin Peak on the far right in clouds (left). This humpback-whale-sized erratic perched on the shoulder of Gothics is a glacial masterpiece (right, top). A skier heads toward the Wolfjaws via the Bennies Brook Slide for some backcountry skiing (right, bottom).

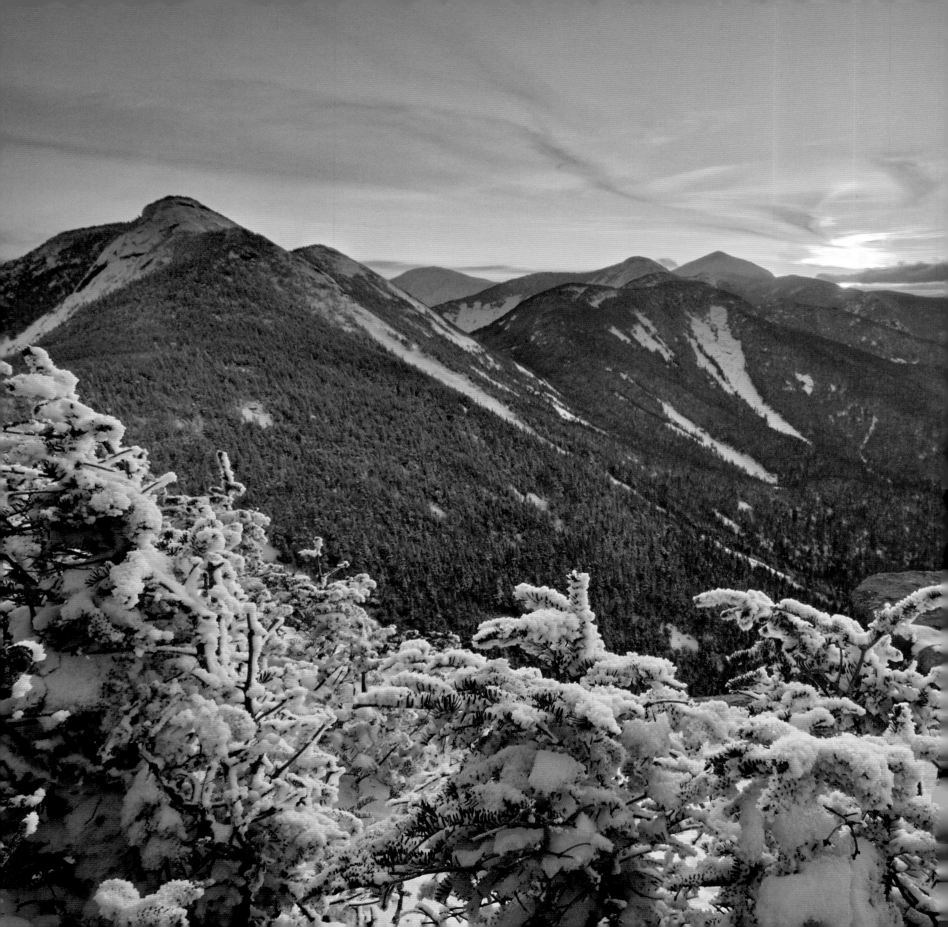

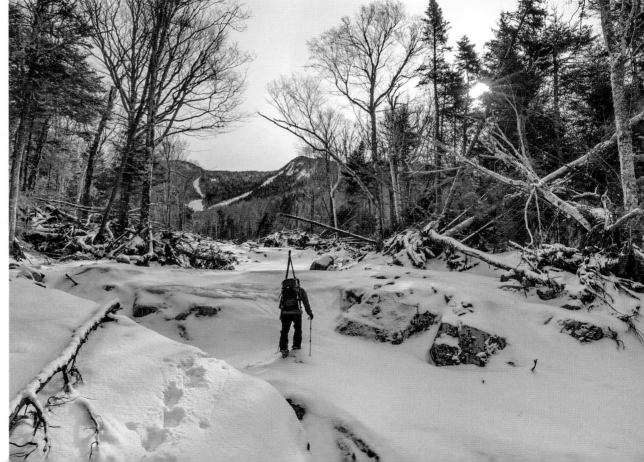

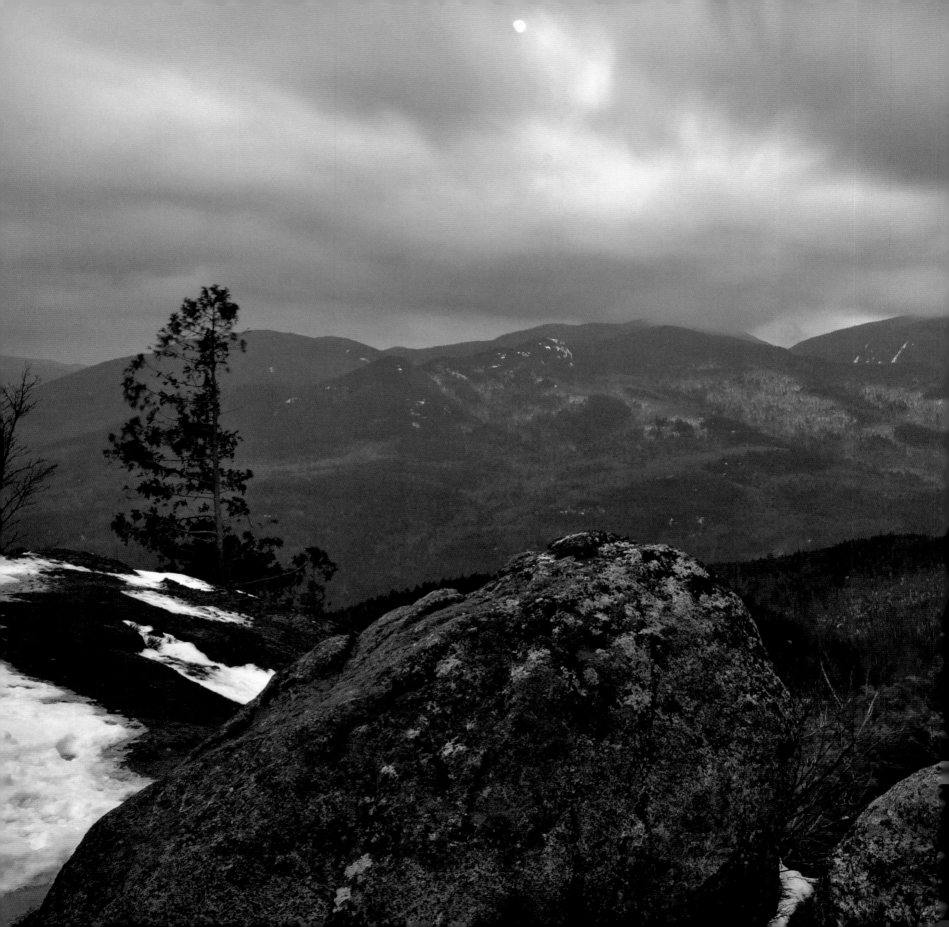

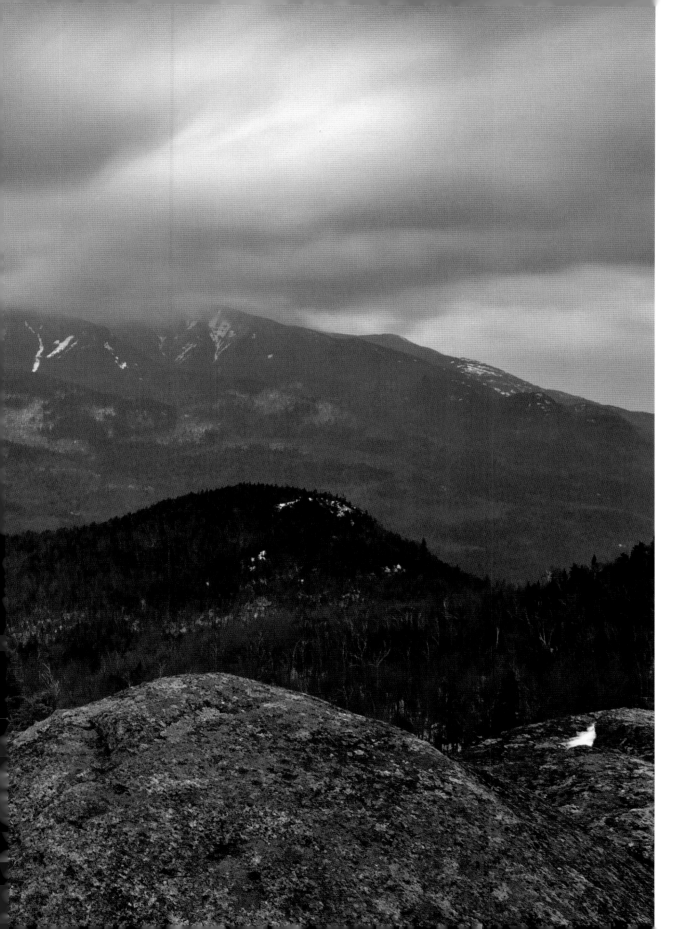

OPPOSITE: Giant Mountain and a full moon are visible from Rooster Comb, the first summit climbed when traversing the Great Range from Keene Valley.

FOLLOWING SPREAD: This view from the ridgeline of the Brothers shows the Great Range (left). St. John's wort grows along the trail to First Brother, with a backdrop of Johns Brook Valley and the Great Range (right).

111

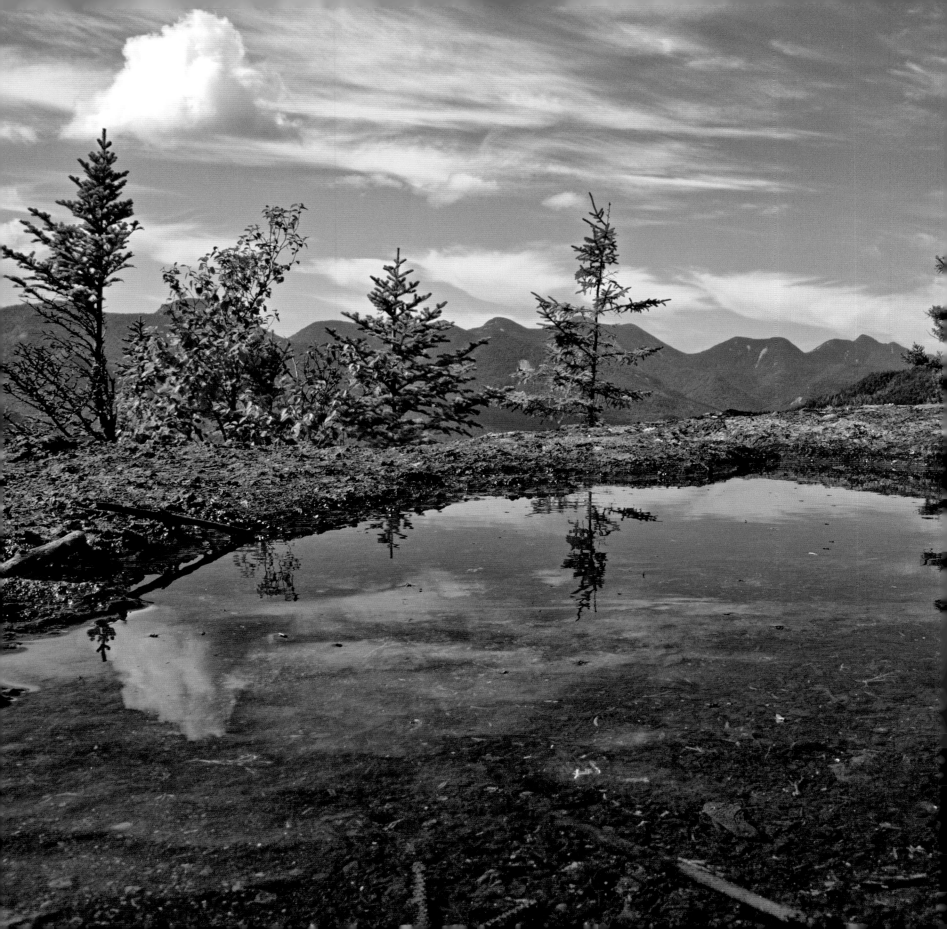

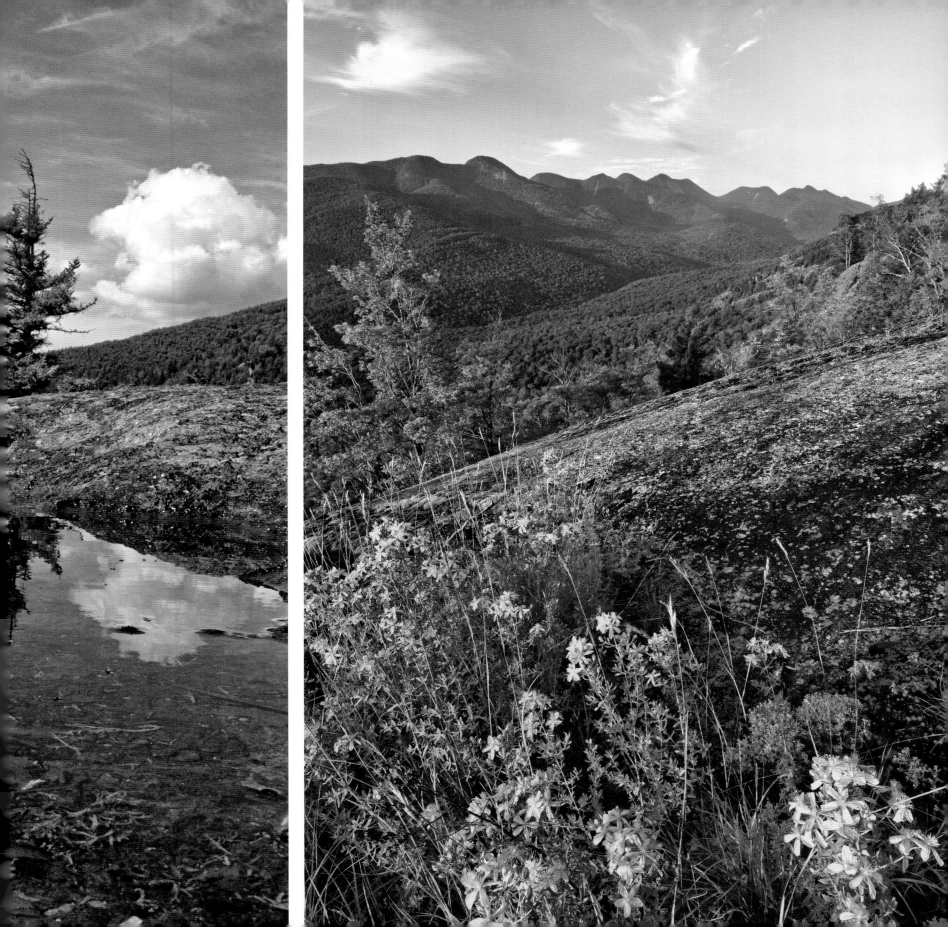

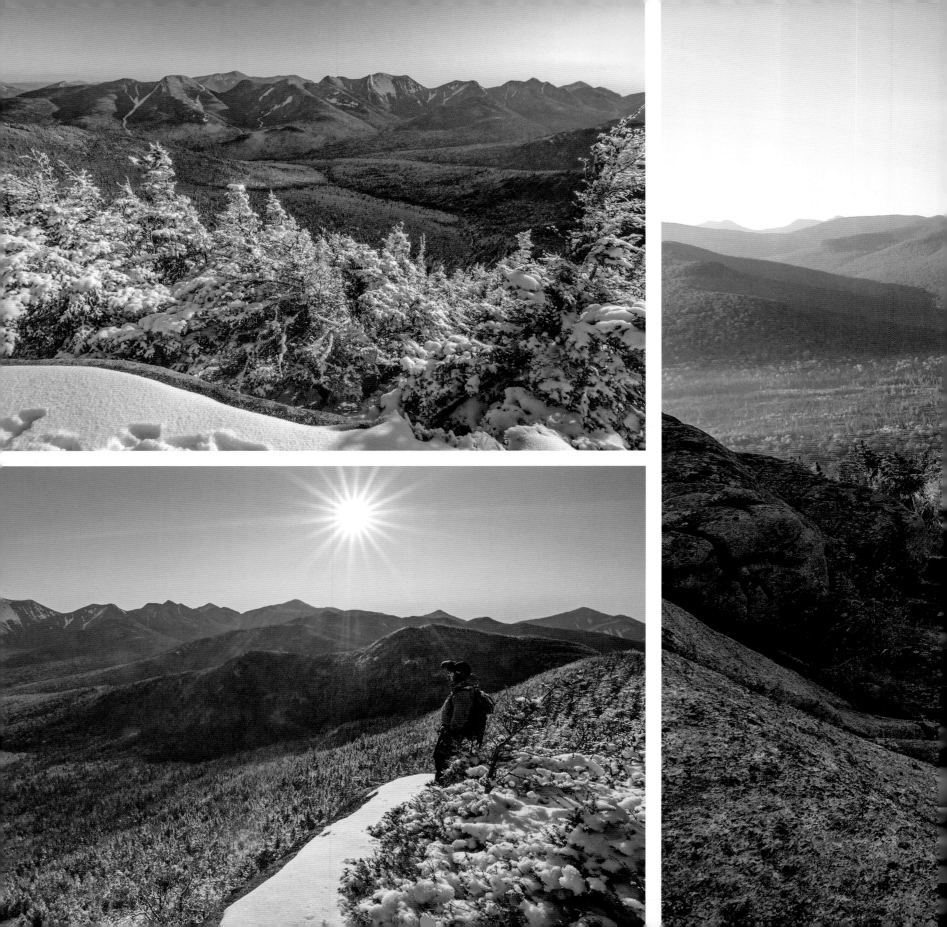

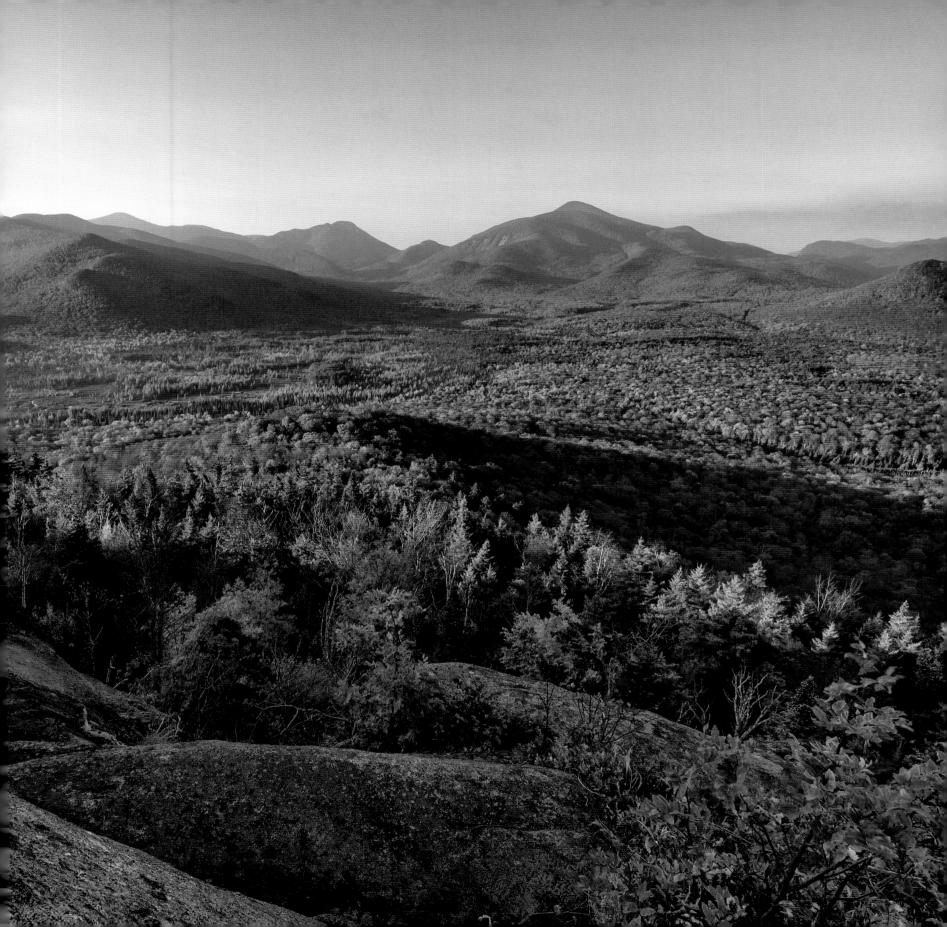

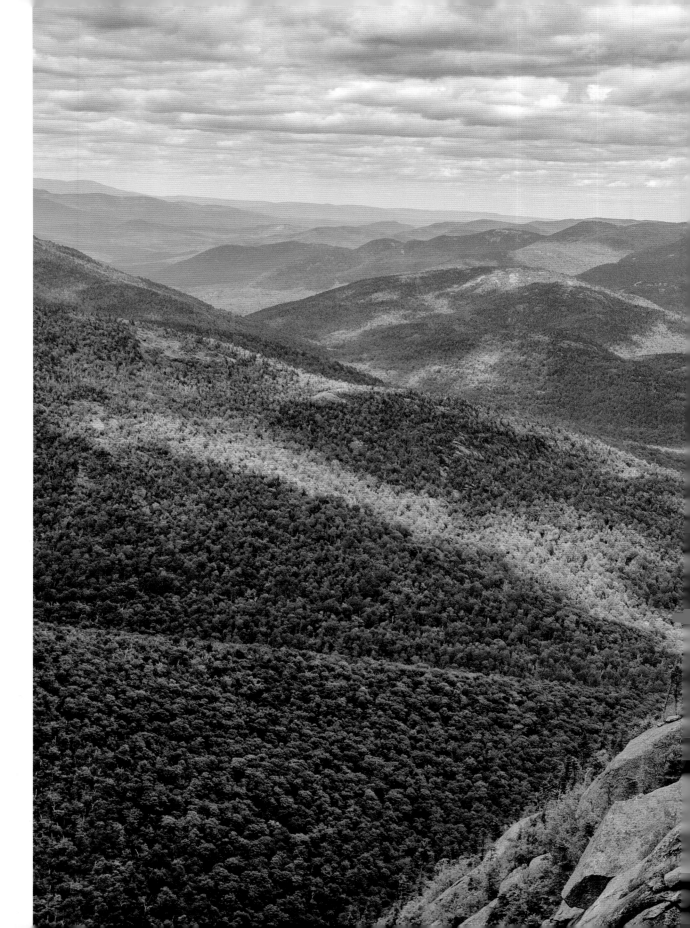

PREVIOUS SPREAD: Two winter views from the summit of Big Slide Mountain look out over the Great Range (left, top and bottom). The view from Mount Van Hoevenberg over South Meadow shows Mount Marcy, Mount Colden, Wright Peak, Algonquin Peak, Indian Pass, and Mount Jo (right).

OPPOSITE: A group of 46ers celebrates the first official ascent of Grace Peak on June 21, 2014, just after East Dix was renamed for Grace Hudowalski, the first female 46er and a historian who corresponded with and kept track of all those climbing the 46 peaks for close to 50 years.

FOLLOWING SPREAD: An aerial view shows the Beckhorn and summit of Dix Mountain with a backdrop of the eastern High Peaks (left). A snowshoer travels along the summit ridge of Dix Mountain (right).

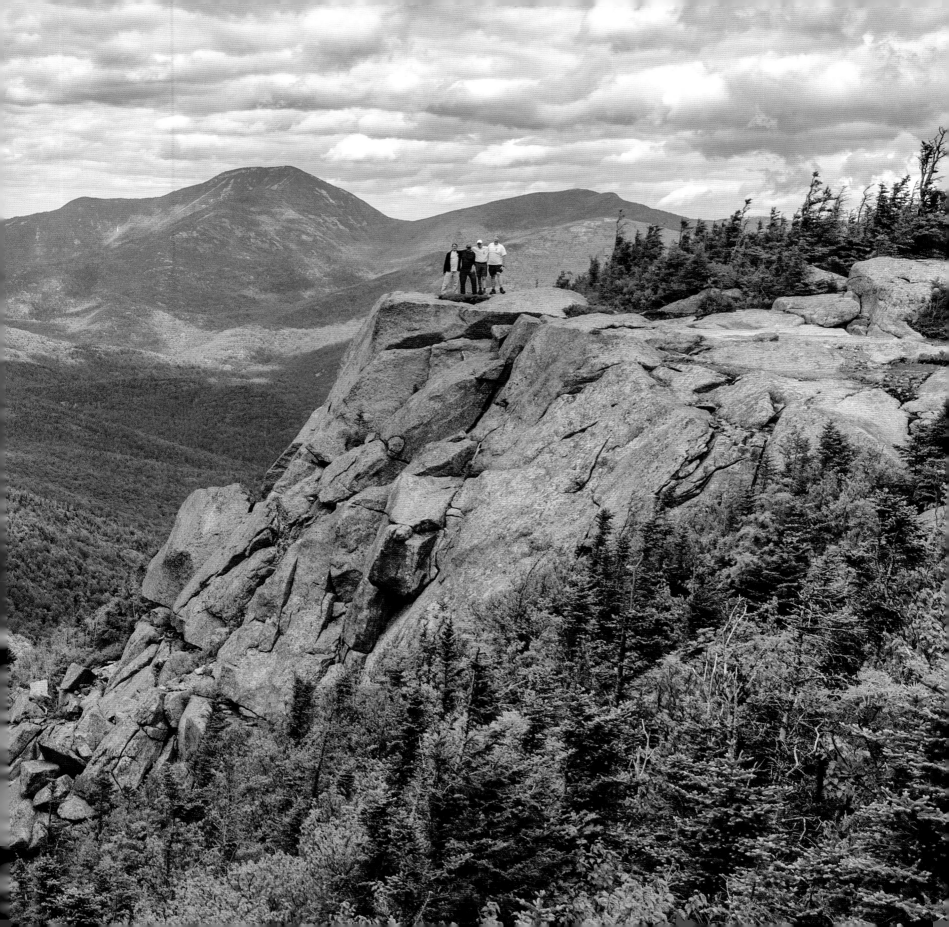

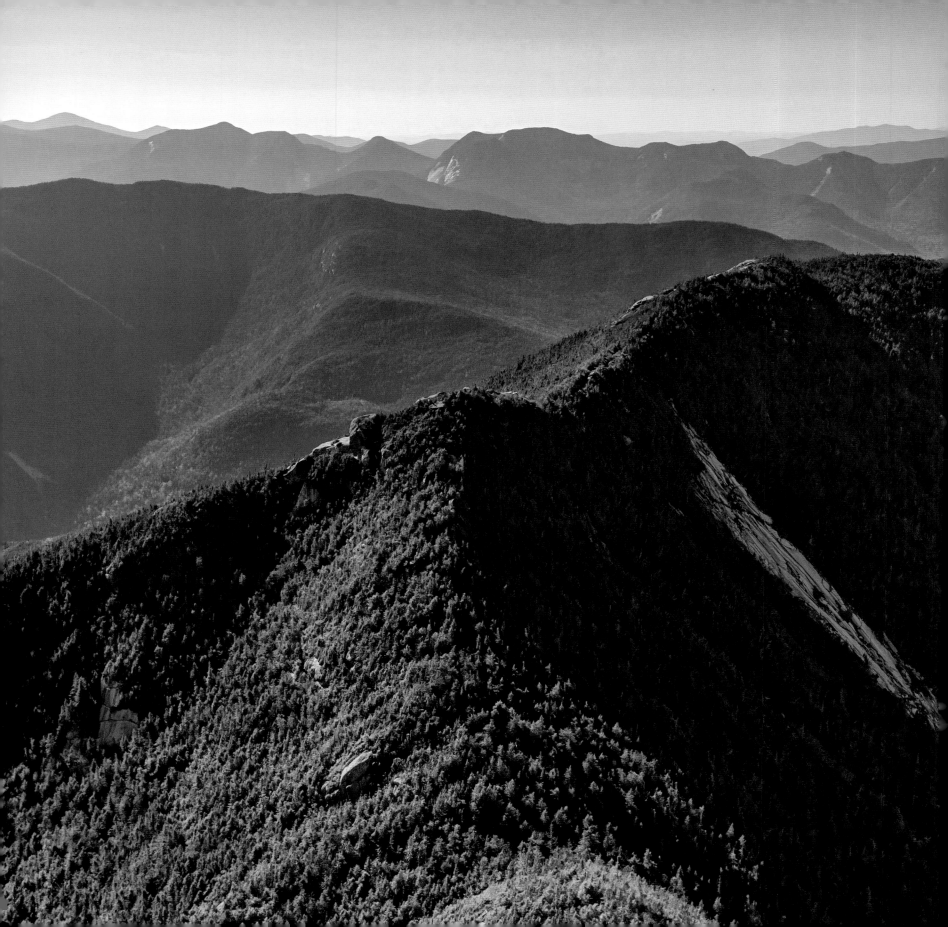

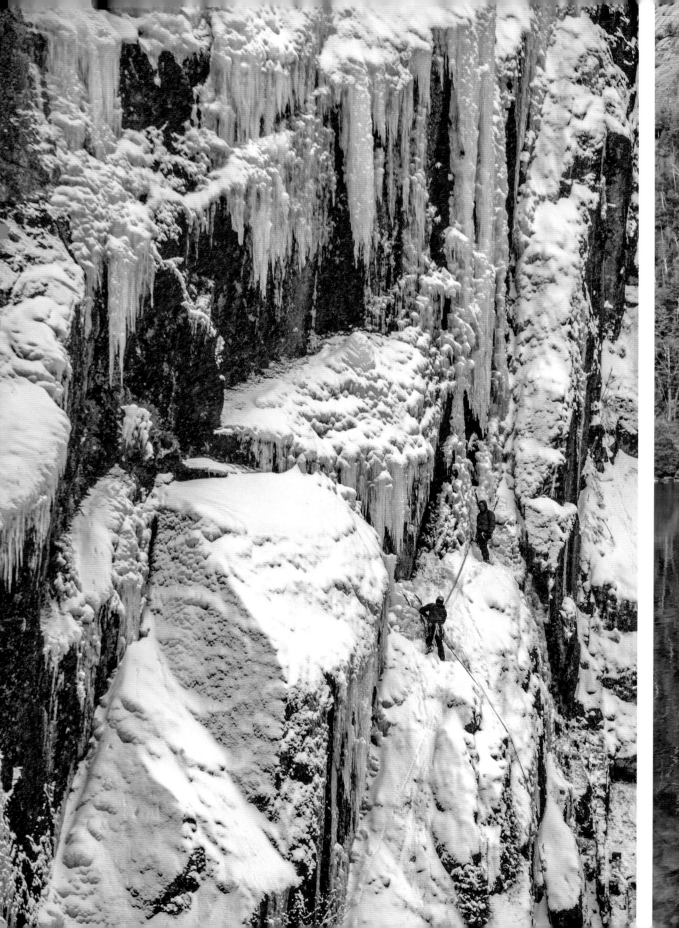
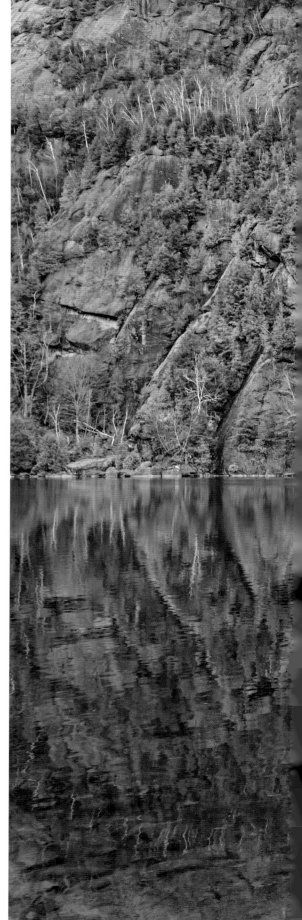

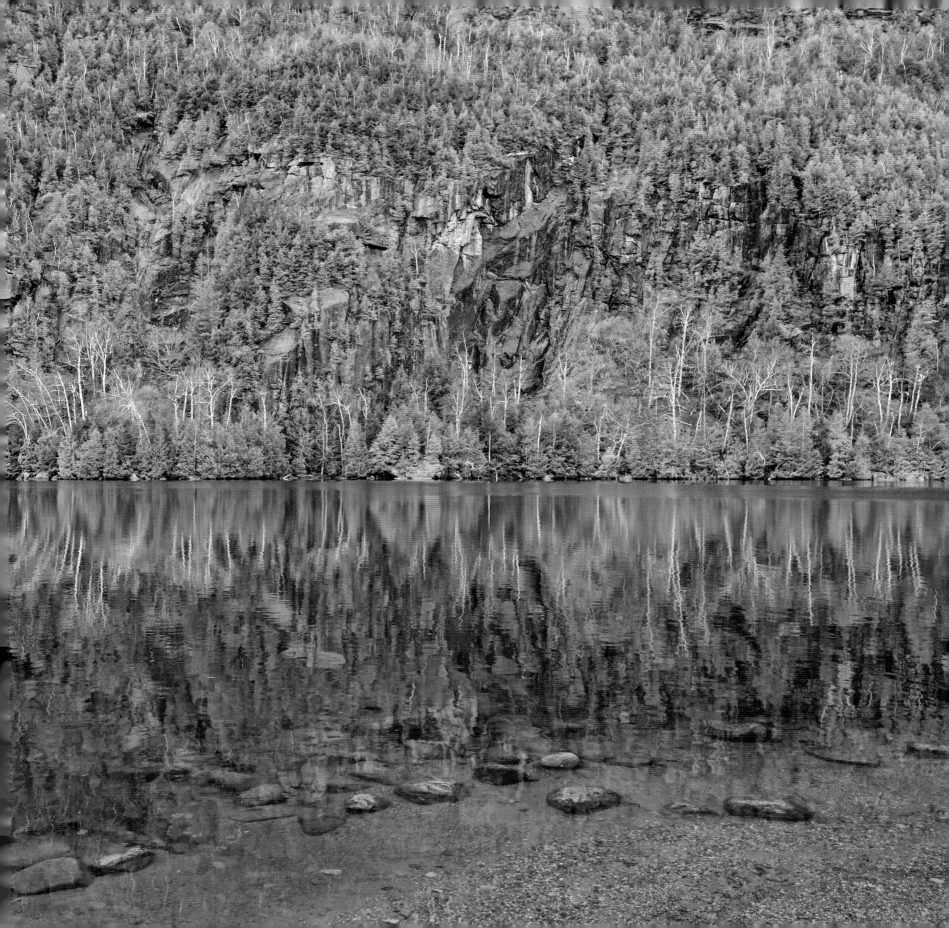

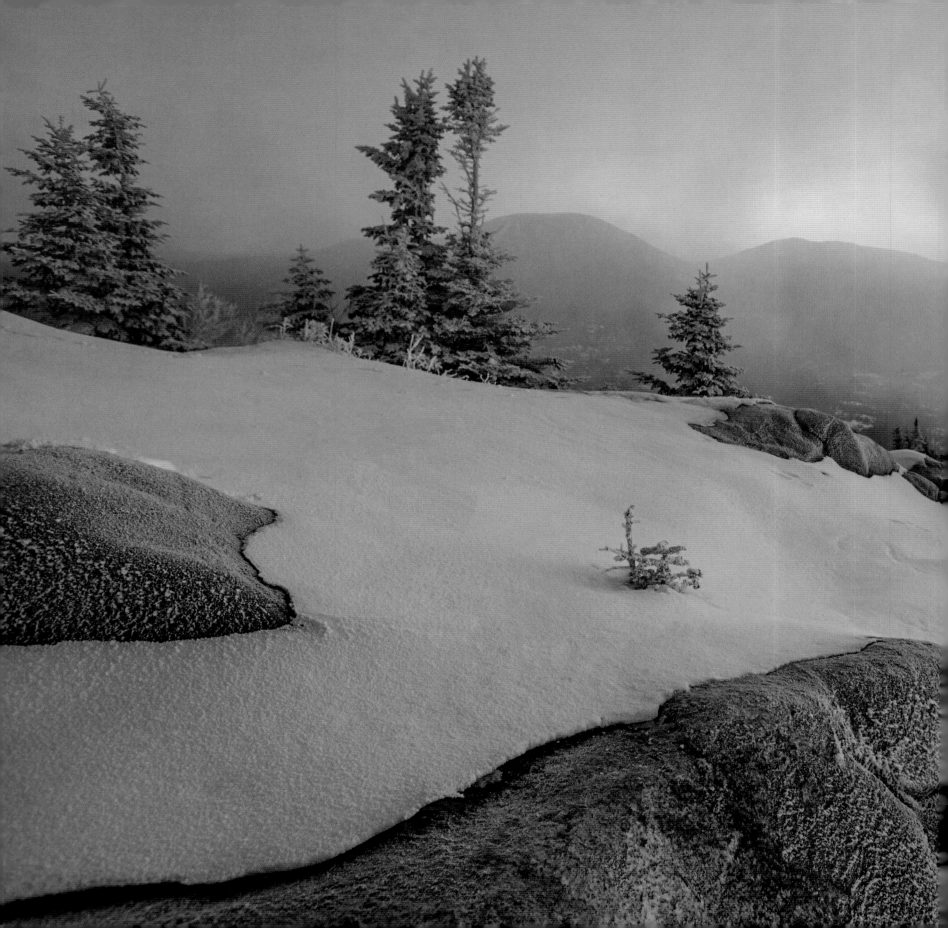

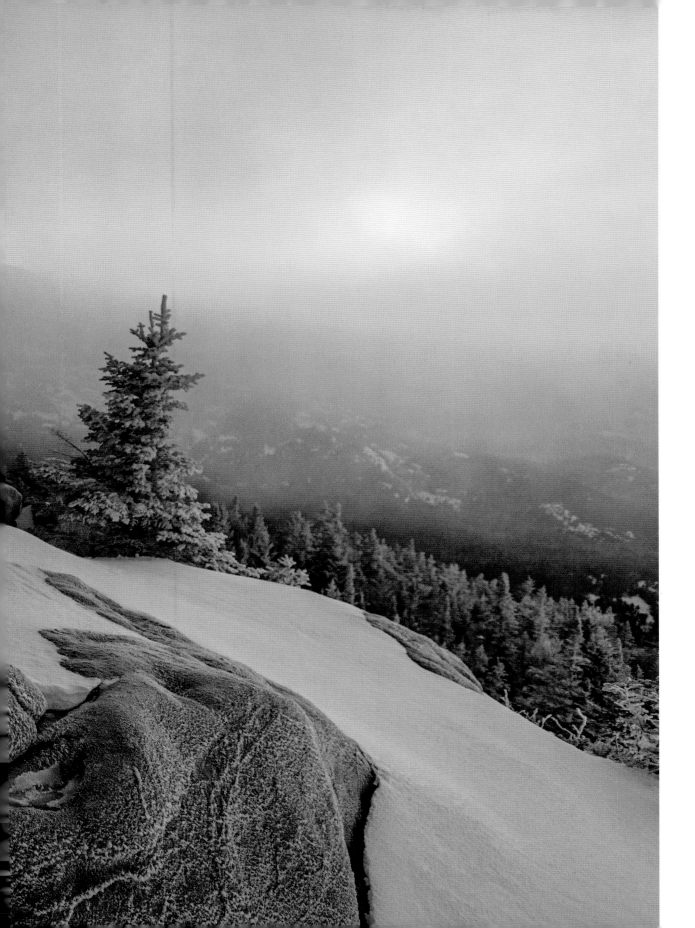

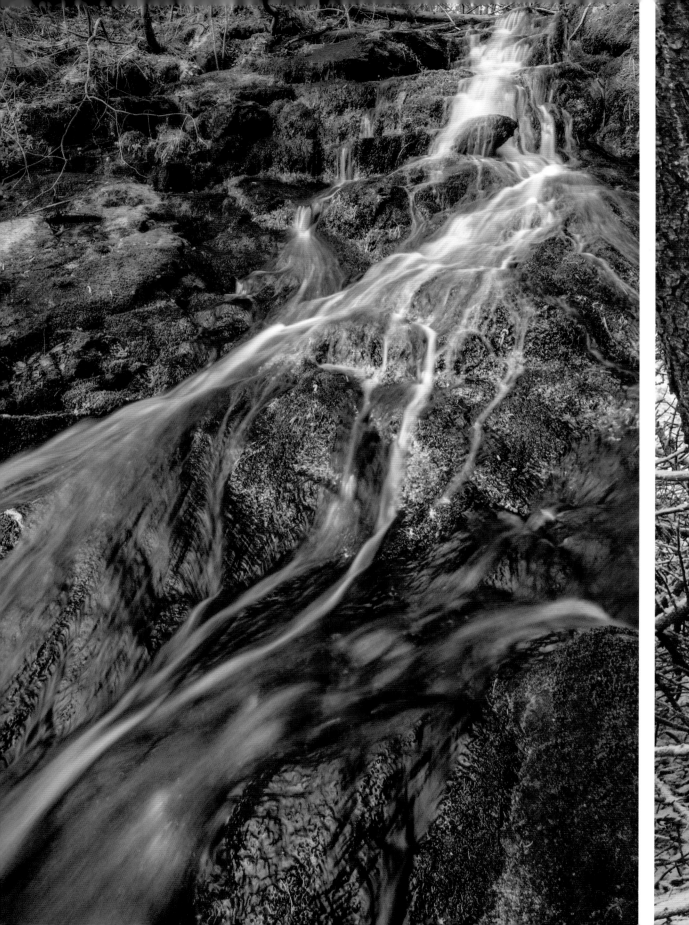

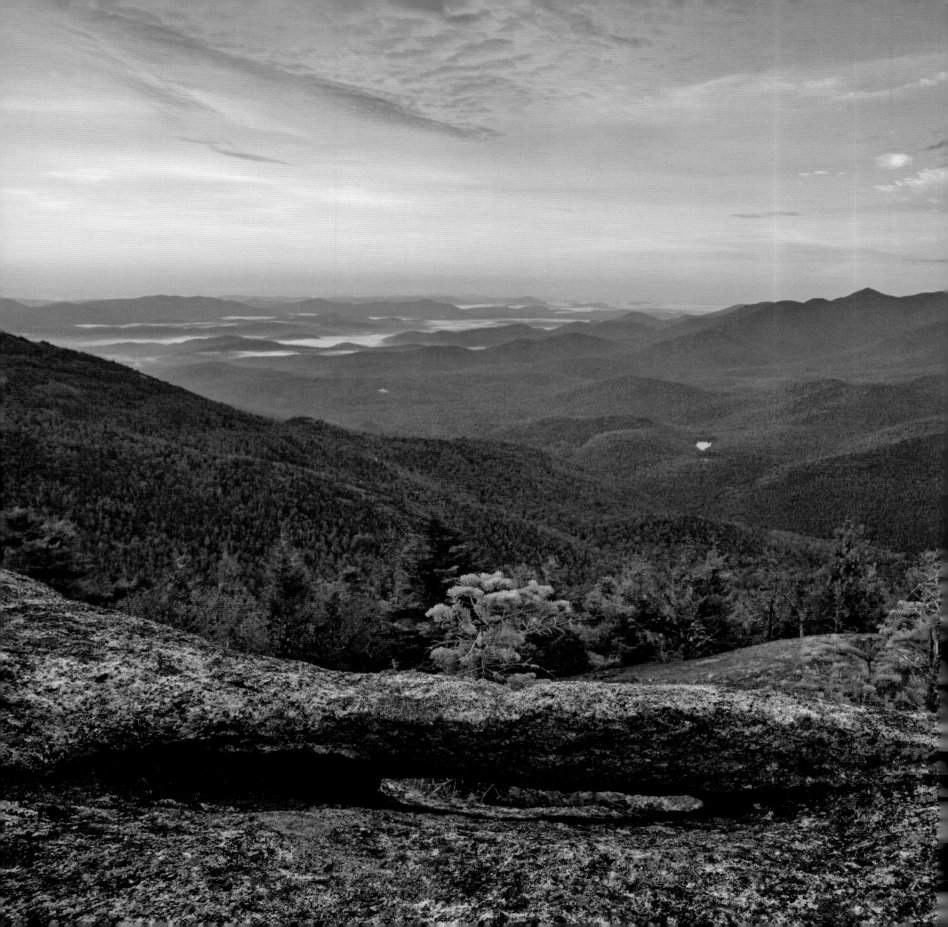

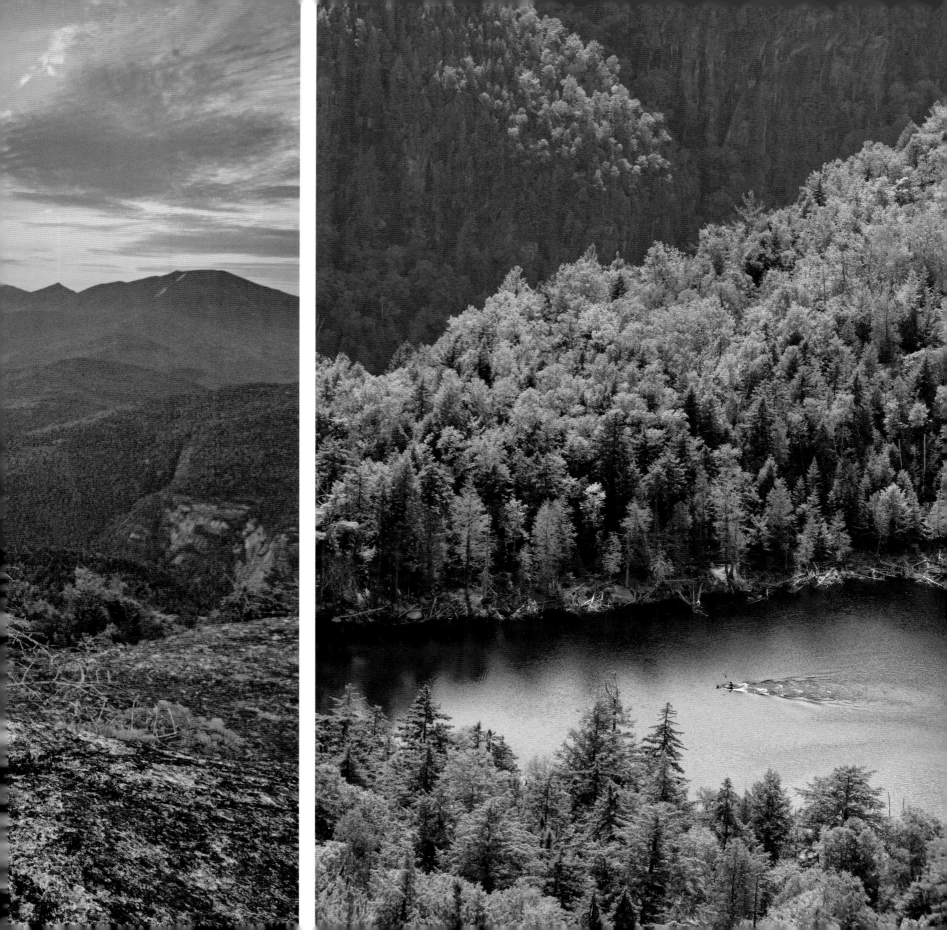

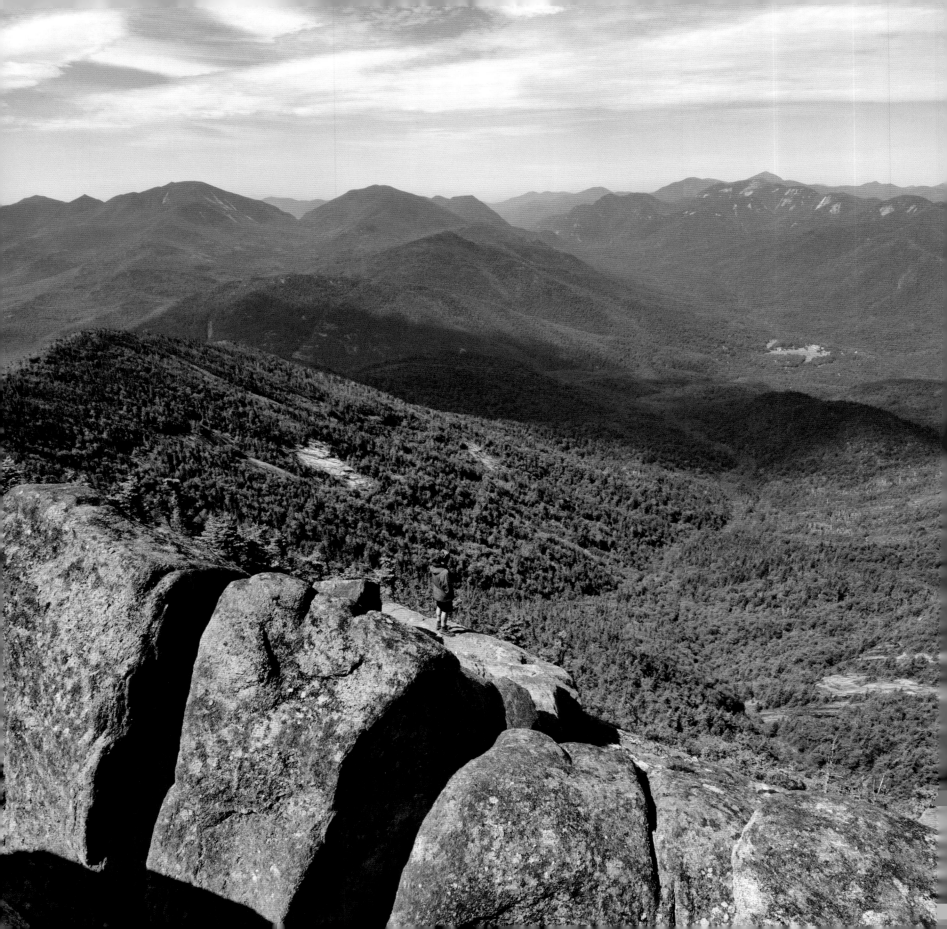

PREVIOUS SPREAD: The view from this unique rock feature on Giant Mountain looks toward the eastern Adirondacks, Schroon River valley, and Dix Range (left). A paddler canoes on Giant Washbowl, with a backdrop of the Round Mountain cliffs that drop down to Chapel Pond (right).

OPPOSITE: A hiker surveys the Dix Range, Nippletop, Mount Colvin, Sawteeth Mountain, the Great Range, and the East Branch Ausable River valley from the summit of Giant Mountain.

RIGHT, TOP: A paddler portages a lightweight Hornbeck canoe over a bridge above the outlet of Giant Washbowl.

RIGHT, BOTTOM: Fall color reflects in Giant Washbowl on a beautiful calm morning.

FOLLOWING SPREAD: Three views look toward Gothics and the Great Range from the summit of Cascade Mountain: in winter (left, top), under the light of a full moon (left, bottom), and in the last light of a summer afternoon (right).

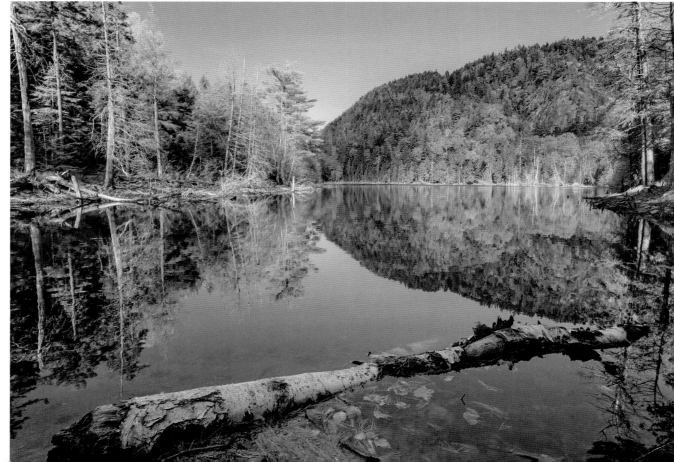

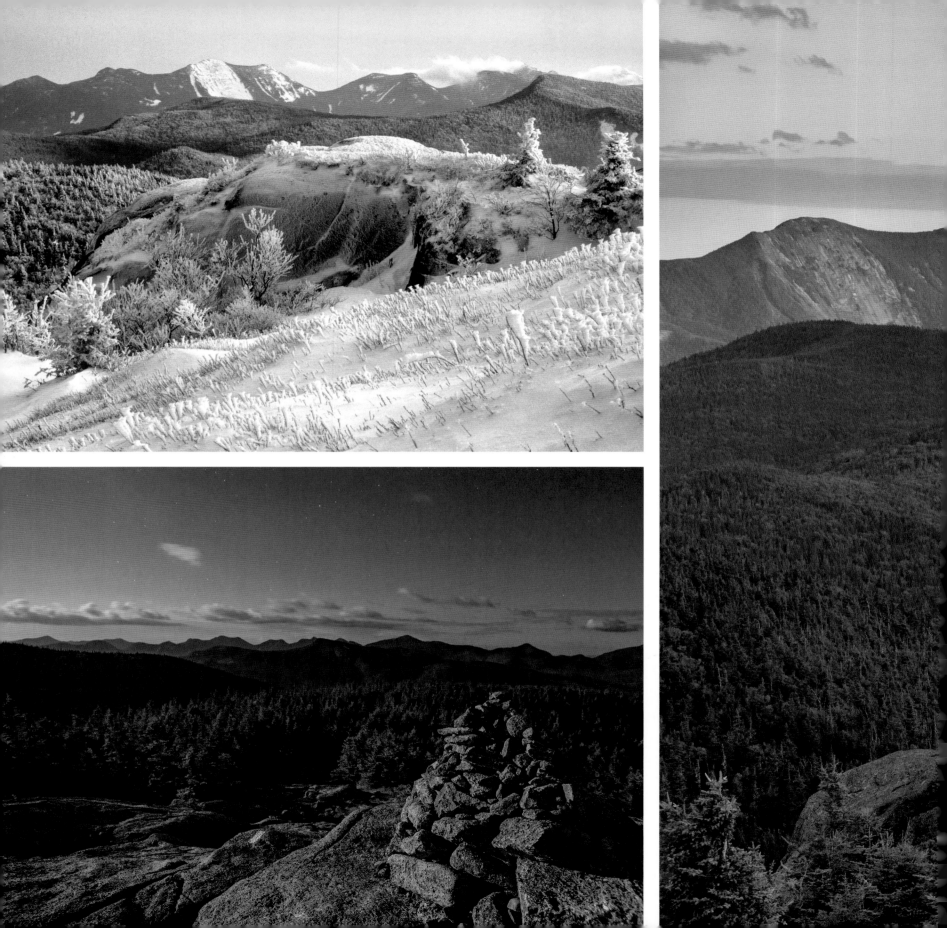

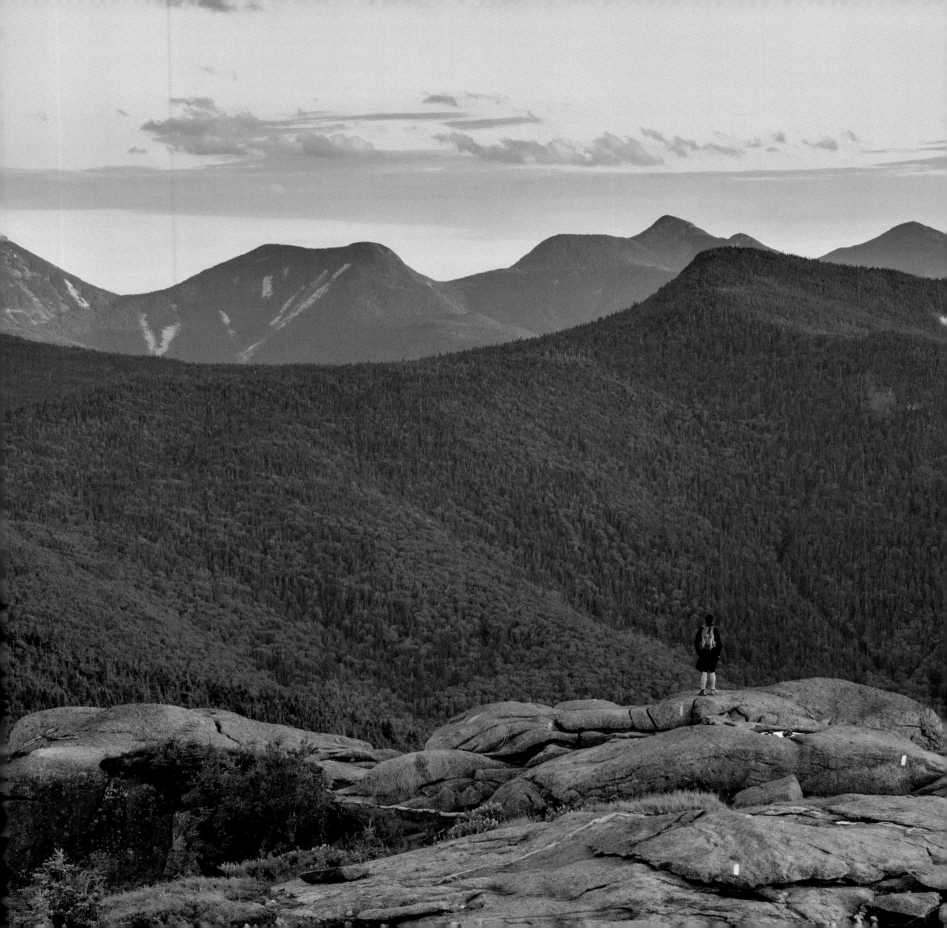

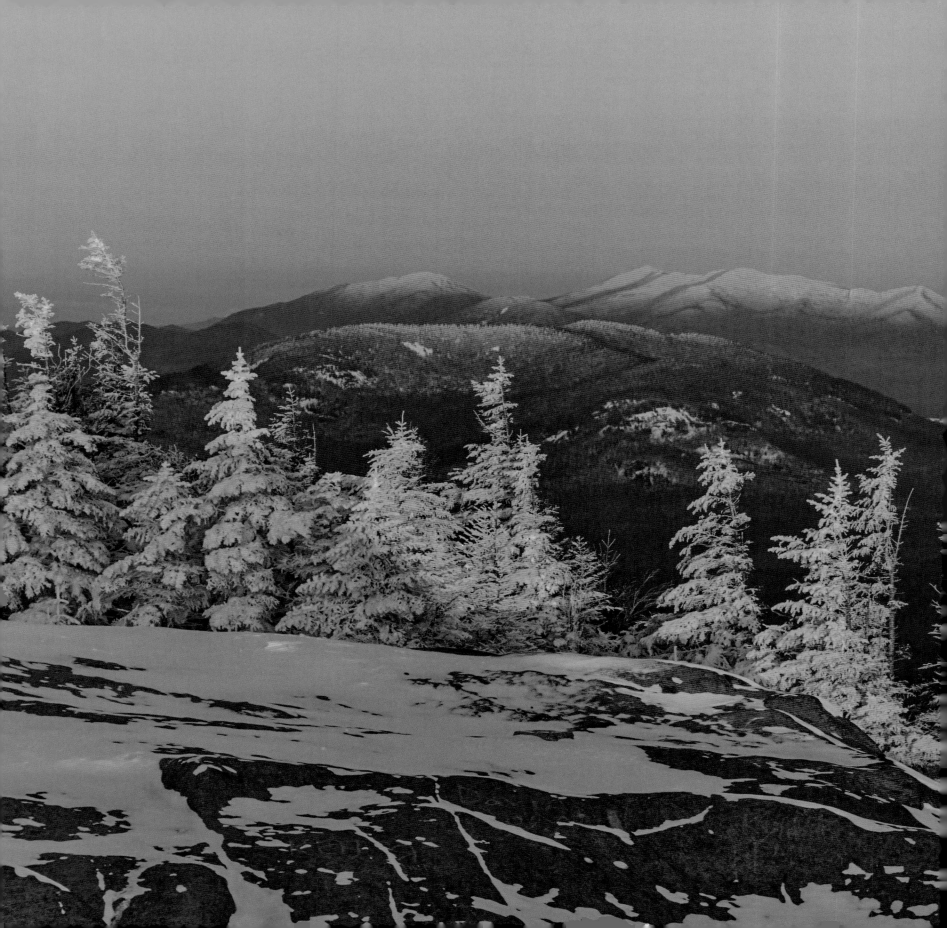

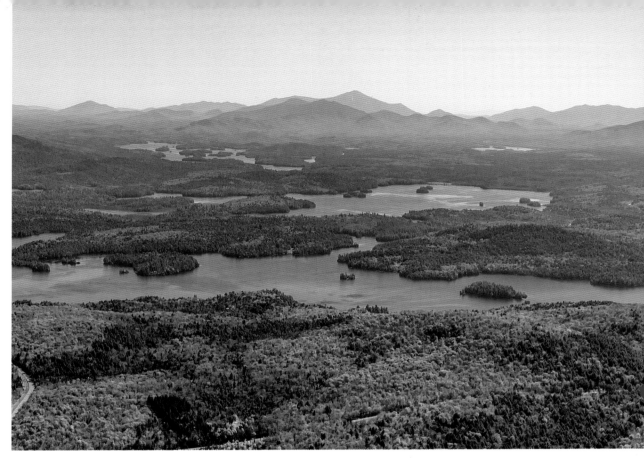
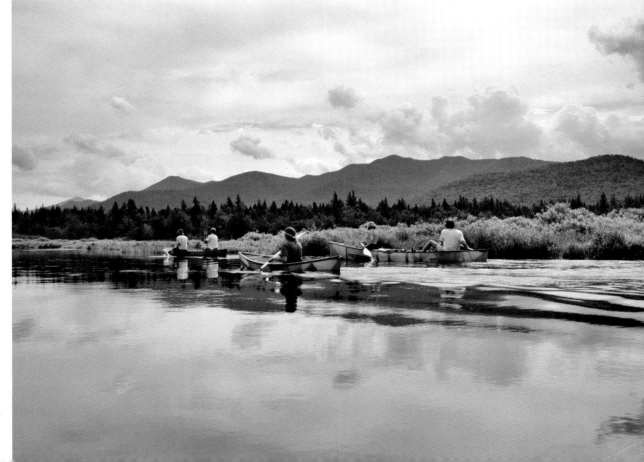

PREVIOUS SPREAD: The last
rays of the setting sun
glow over the summits of
Scarface Mountain and the
Sentinel Range (left). An
aerial view shows Upper,
Middle, and Lower Saranac
Lakes, a historic canoe
route through the central
Adirondacks and part of
the 700-mile Northern
Forest Canoe Trail, which
extends from Old Forge in
the western Adirondacks
to eastern Maine (right,
top). Paddlers explore the
Saranac River, a few miles
north of Saranac Lake
village (right, bottom).

OPPOSITE: Fog rises from
the Keene Valley area,
with Noonmark Mountain,
the Dix Range, Nippletop,
and Mount Colvin in
the distance.

FOLLOWING SPREAD: These two
sections of the popular trail
on Baker Mountain, at the
edge of Saranac Lake village,
are well worn (left, top and
bottom). Sunlight filters
over Whiteface Mountain
and the grass-lined shore of
Connery Pond on a frosty
November morning (right).

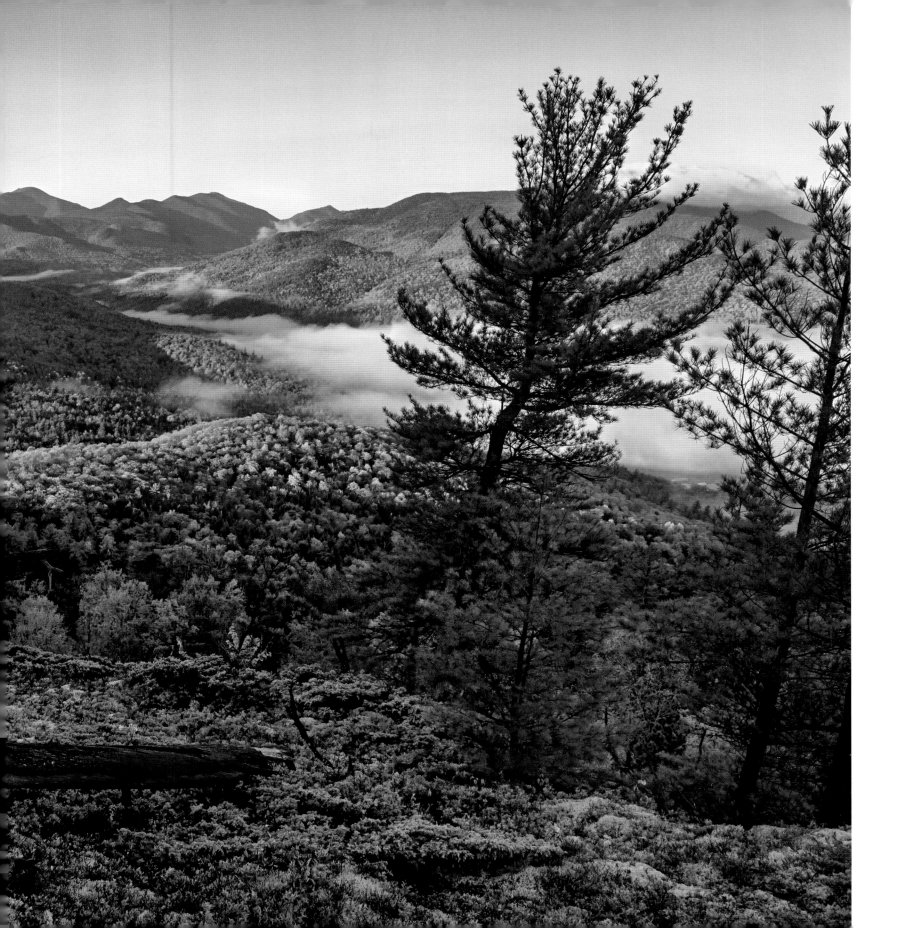

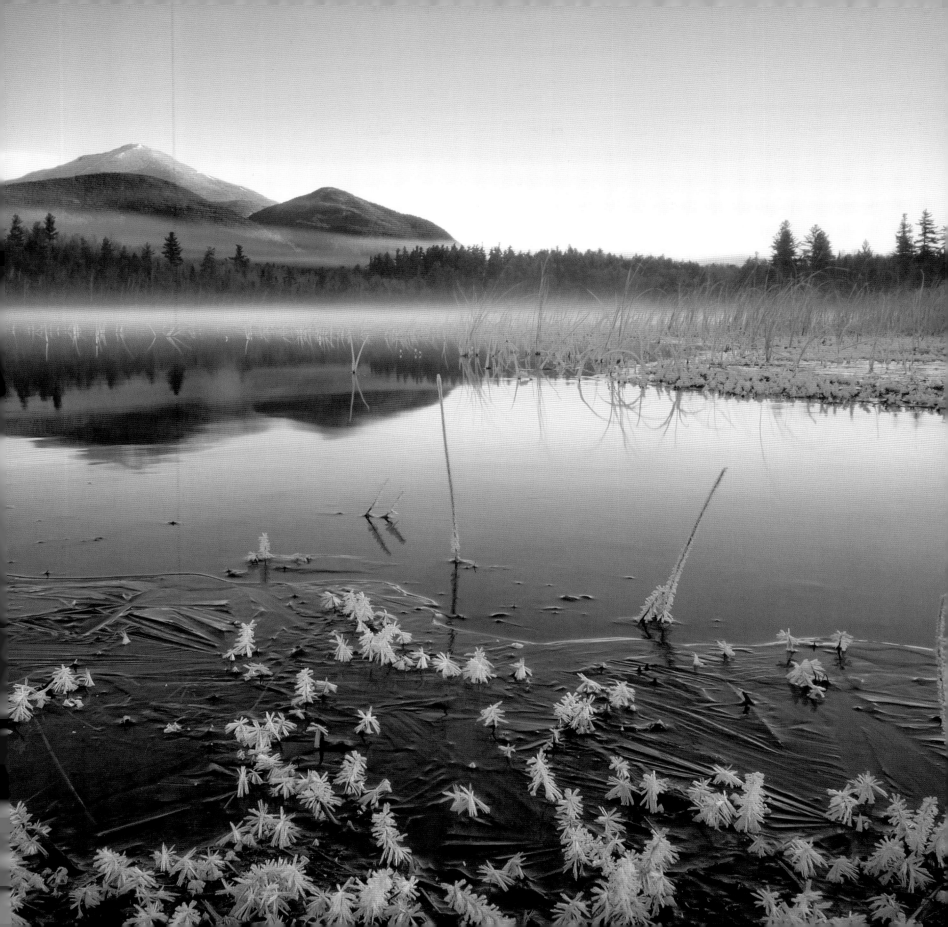

OPPOSITE: Sunrise color fills the sky over Copperas Pond and Whiteface Mountain.

FOLLOWING SPREAD: Moonlight sparkles over the handrail-lined trail along the arête from the castle to the observatory on the summit of Whiteface Mountain (left). The Whiteface Veterans Memorial Highway turns into a popular cross-country ski route as soon as snow falls (right, top). A trail marker covered with rime ice on the summit of Whiteface Mountain marks the footpaths that traverse the north and south sides of the mountain (right, bottom).

139

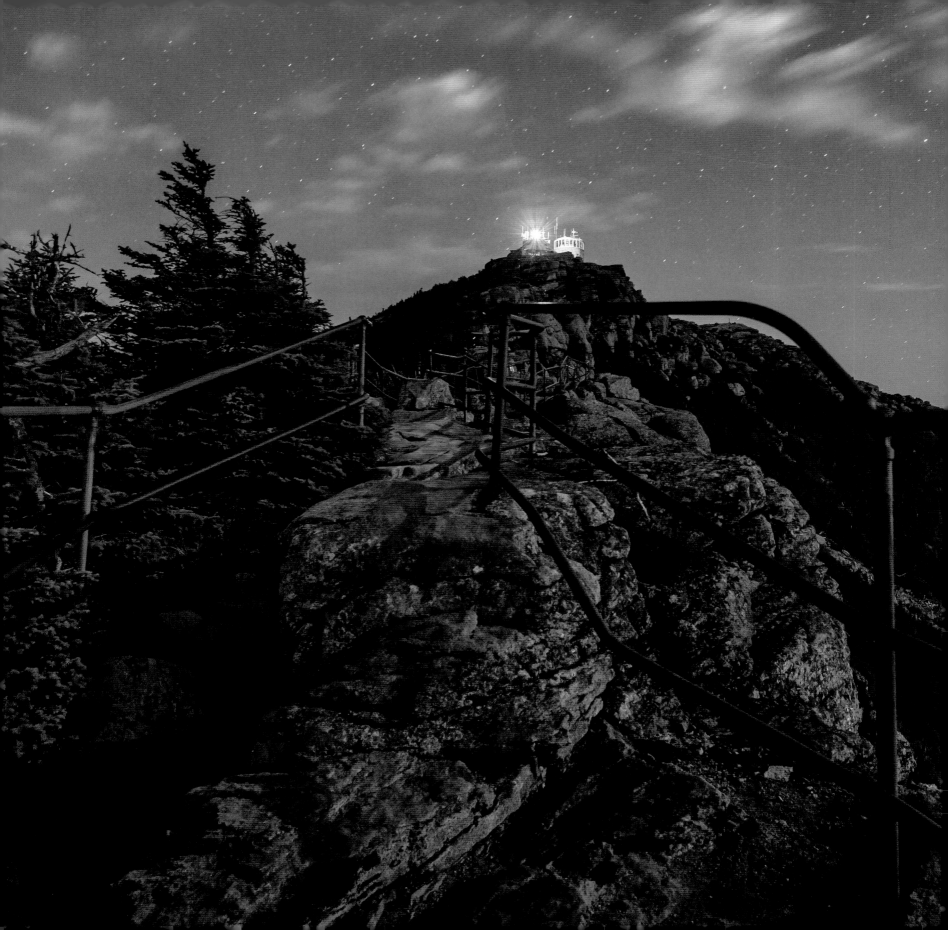

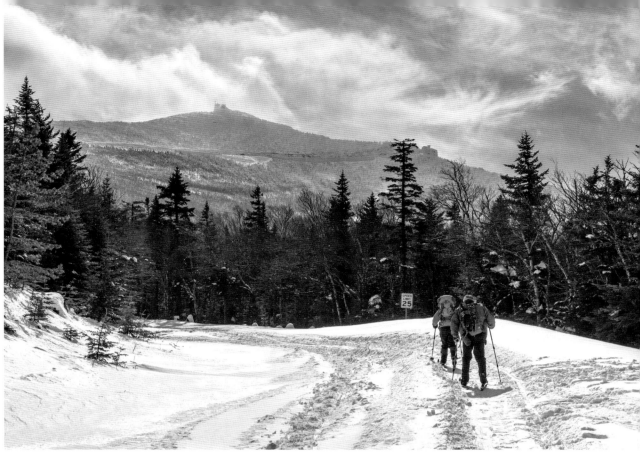
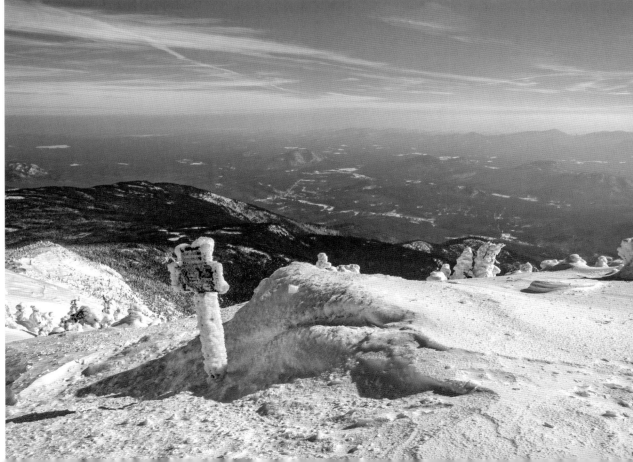

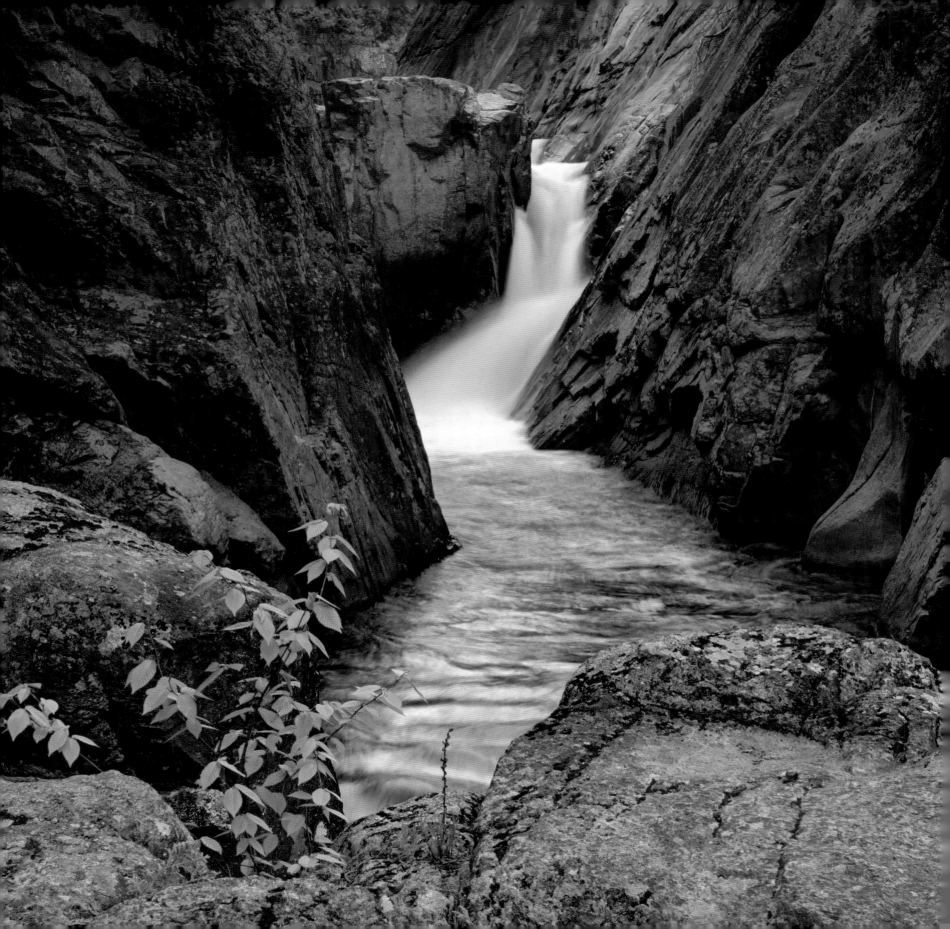

OPPOSITE: Glaciers and thousands of years of erosion shaped the contours and pothole features found in the Wilmington Flume.

RIGHT: A pair of young hikers nears the top of Big Crow Mountain in the Keene area.

FOLLOWING SPREAD: This January view shows Whiteface Mountain from the trail along the summit of Hurricane Mountain (left). The sun rises behind the fire tower on top of Hurricane Mountain, with a backdrop of Lake Champlain and the Green Mountains of Vermont (right).

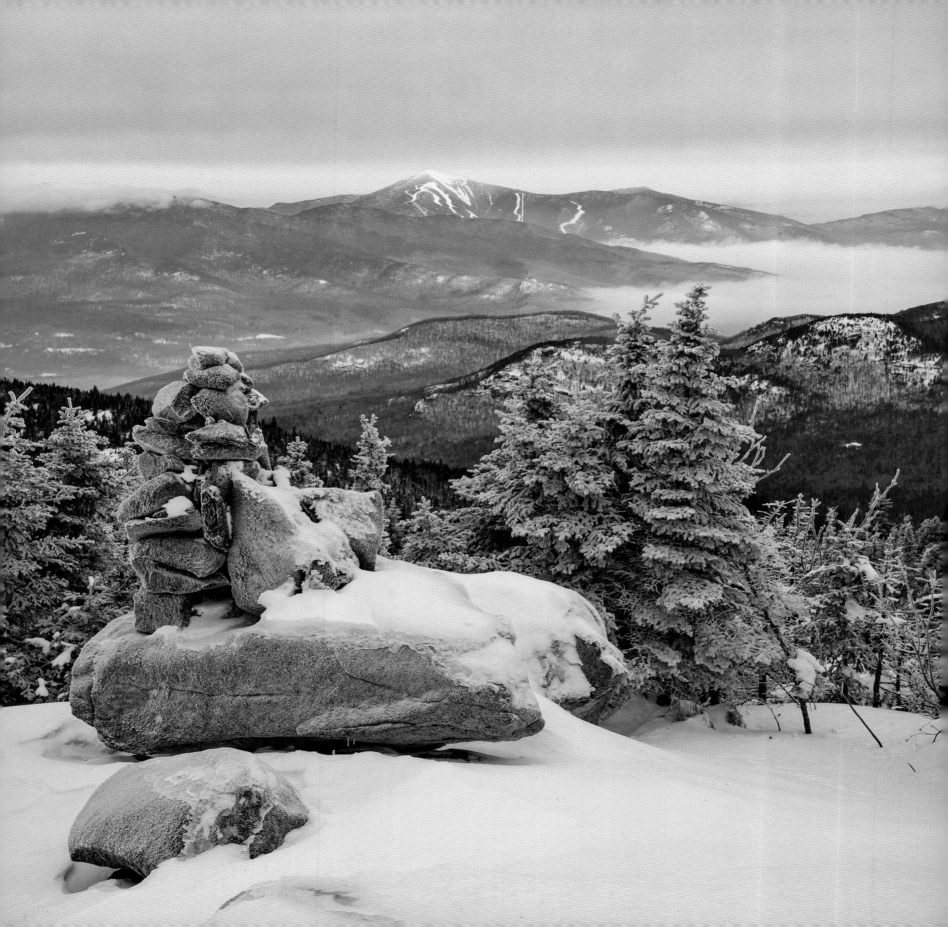

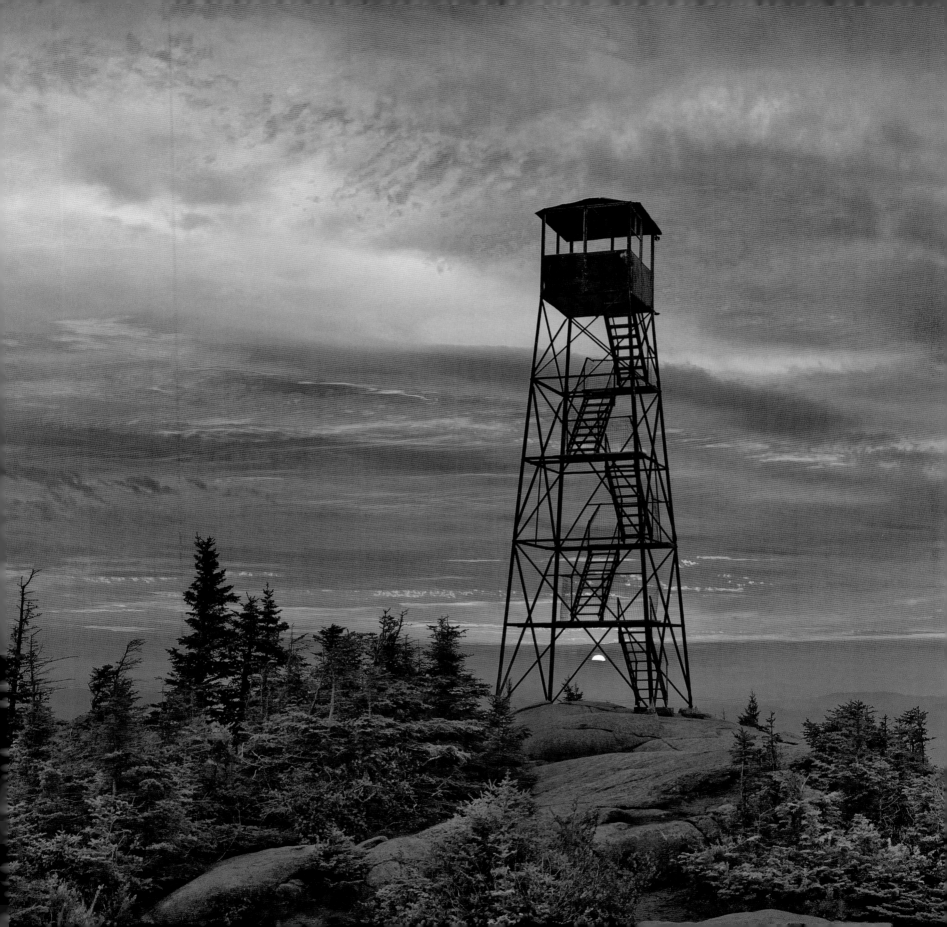

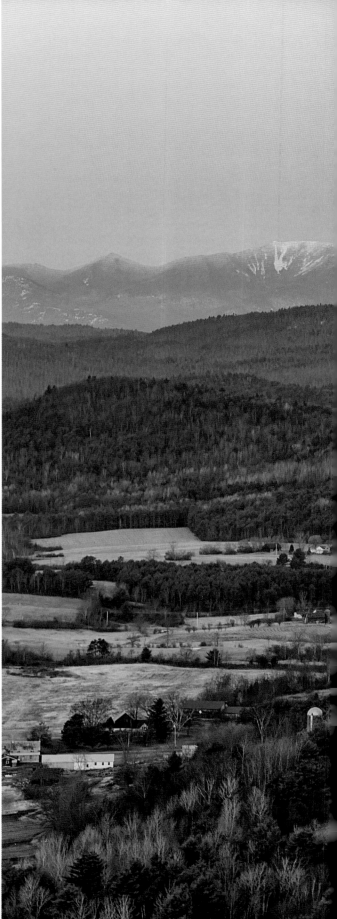

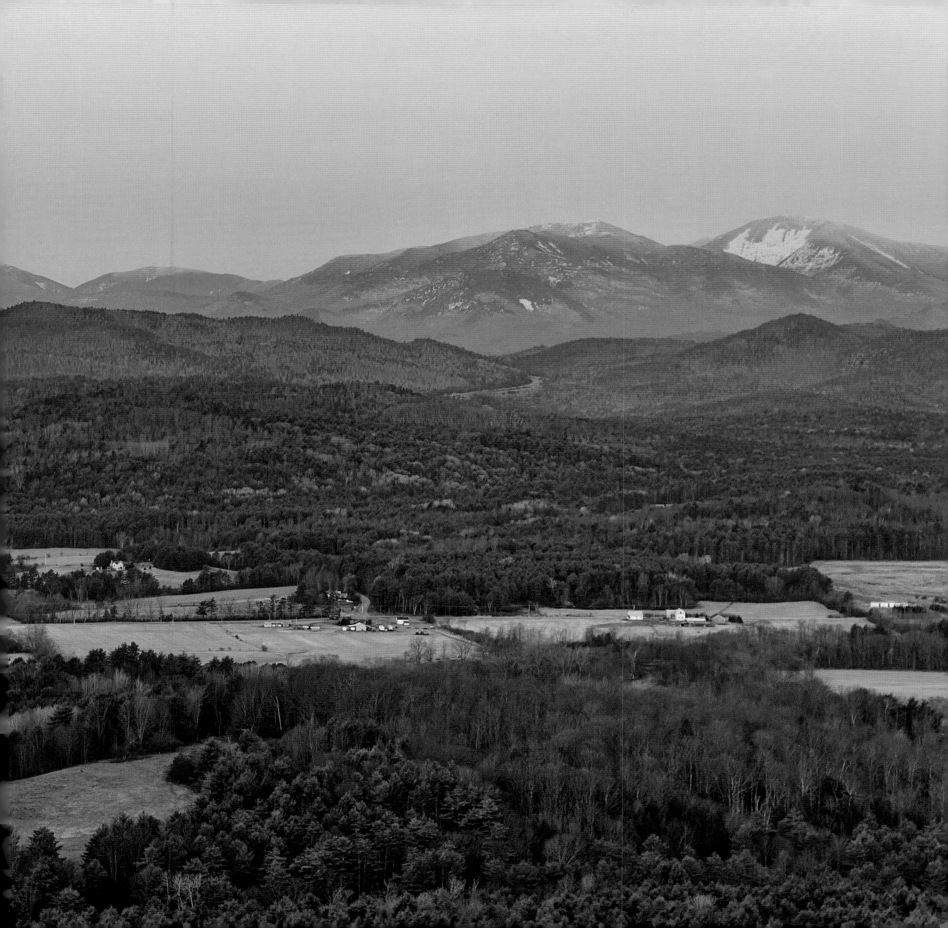

PREVIOUS SPREAD: Red trillium and Dutchman's-breeches bloom along the trail on Coon Mountain in the Champlain Valley (left). Morning light covers farms in the Westport area of the Champlain Valley, with the Dix Range, Rocky Peak Ridge, and Giant Mountain on the horizon (right).

OPPOSITE: The North Rim overlook on Split Rock Mountain provides views through the trees to farms in the Essex area and Lake Champlain.

FOLLOWING SPREAD: Extensive rockwork has been done on the trail to the fire tower at the summit of Poke-O-Moonshine Mountain (left). A careful observer may spot a wood thrush's nest, usually hidden by grass and leaves (right, top). Red efts are rather common in some areas, especially in the early morning or after a summer rainfall (right, bottom).

149

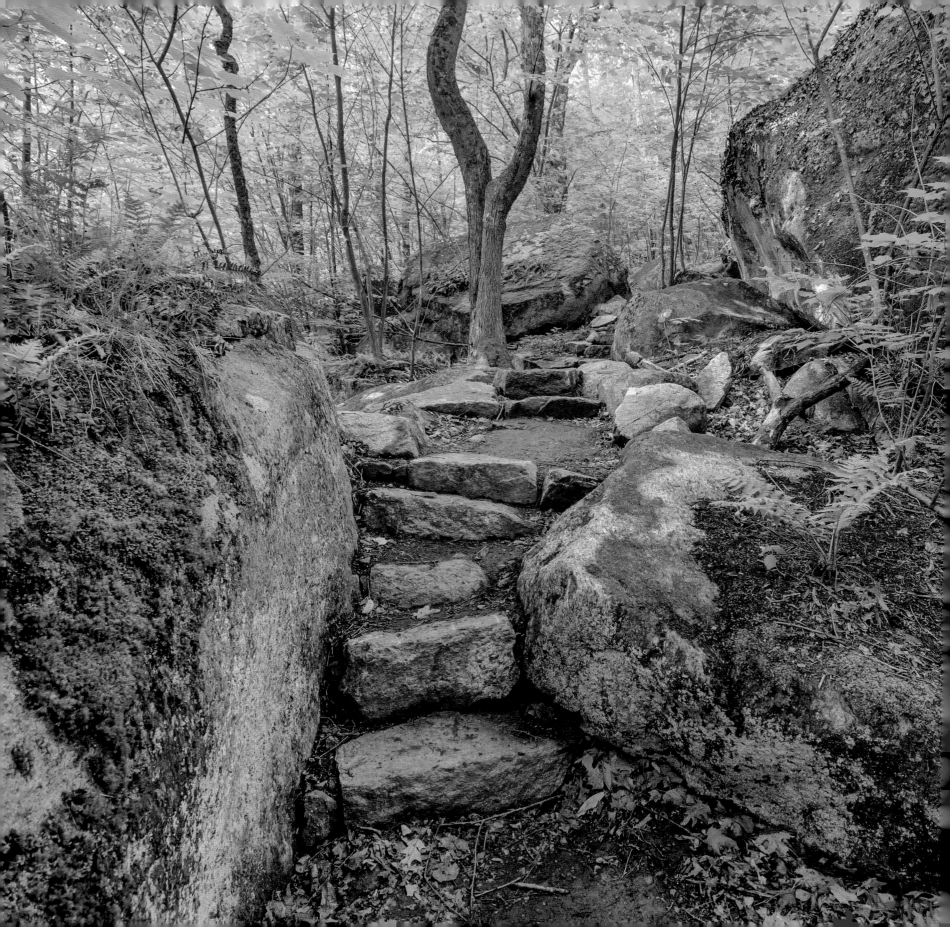

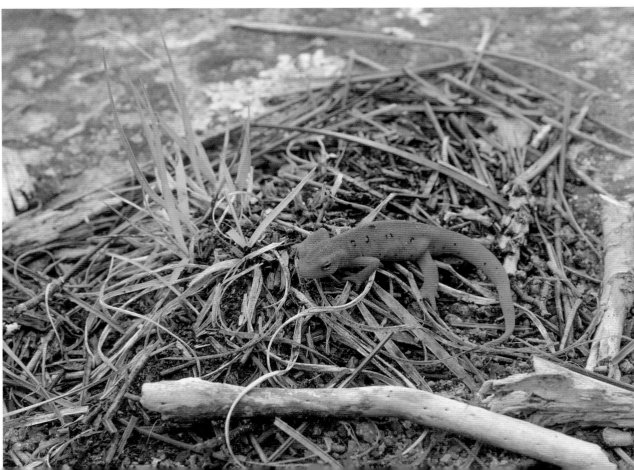

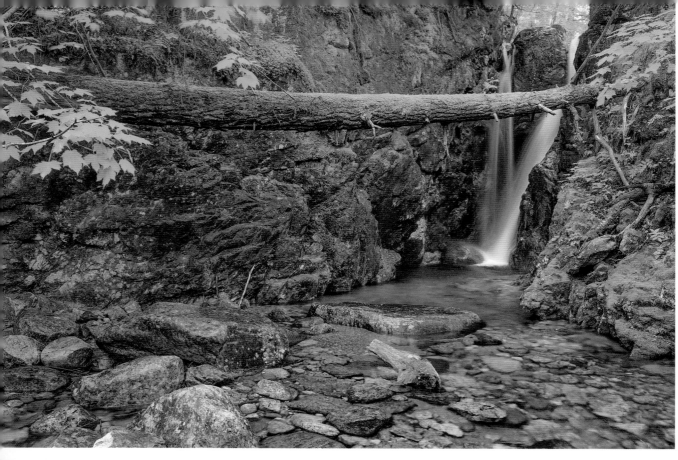

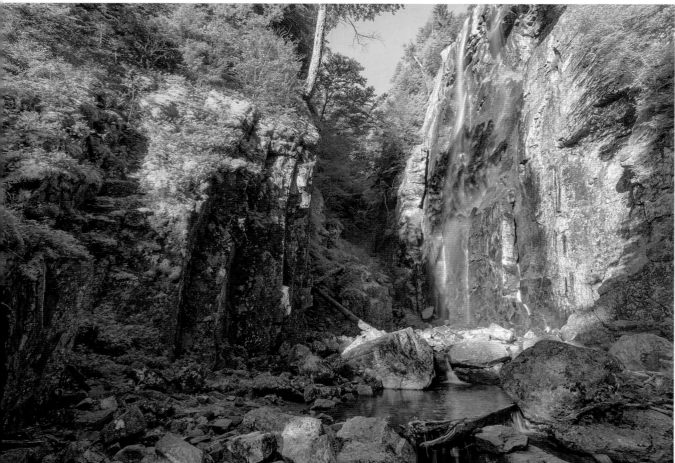

LEFT, TOP: The trails in the Adirondack Mountain Reserve lead to or pass by numerous waterfalls and cascades, including this one along one of the valley trails.

LEFT, BOTTOM: Rainbow Falls is one of the tallest waterfalls in the Adirondack Park.

OPPOSITE: Harebells bloom along the Ausable River in the Adirondack Mountain Reserve against a backdrop of Mount Colvin.

FOLLOWING SPREAD: The sun rises over Vermont's Green Mountains, Lake Champlain, and the Champlain Valley in this view from a shoulder of Catamount Mountain (left). The 3,830-foot Lyon Mountain, the highest mountain in the northern Adirondacks, overlooks Chazy Lake and the Lake Champlain area around Plattsburgh. On a clear day it may be possible to see the skyline of Montreal to the north and the High Peaks to the south from the fire tower on the summit (right, top and bottom).

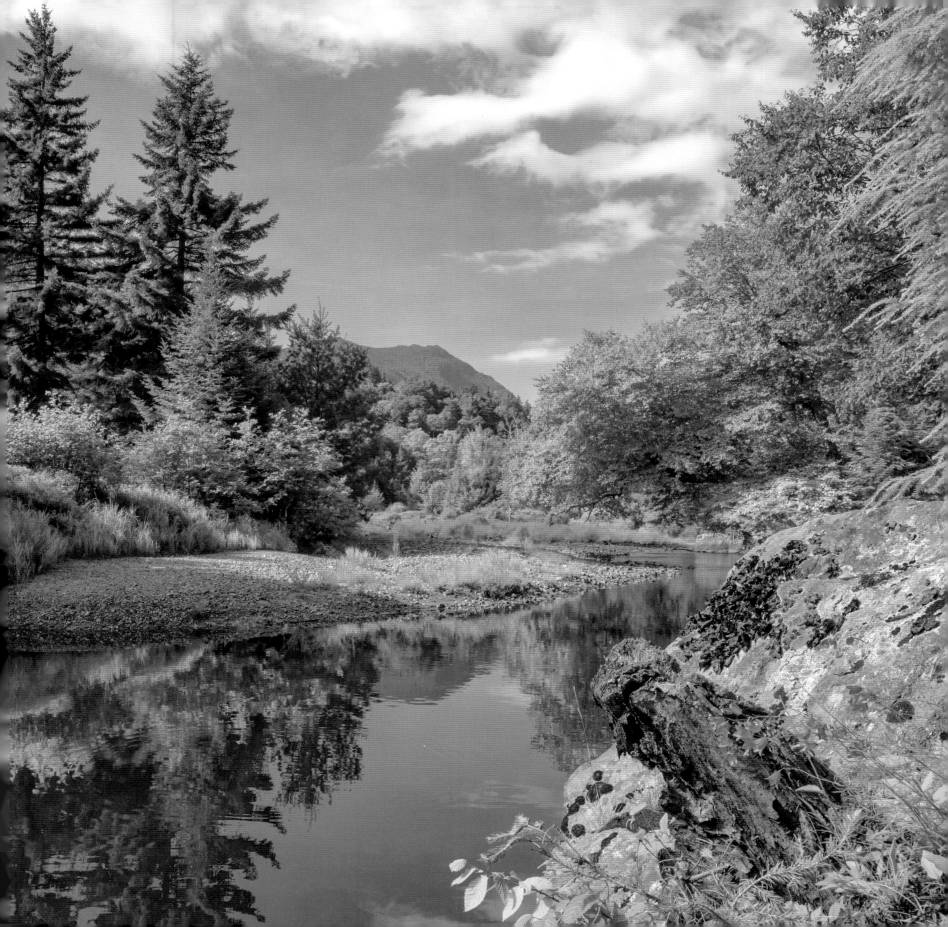

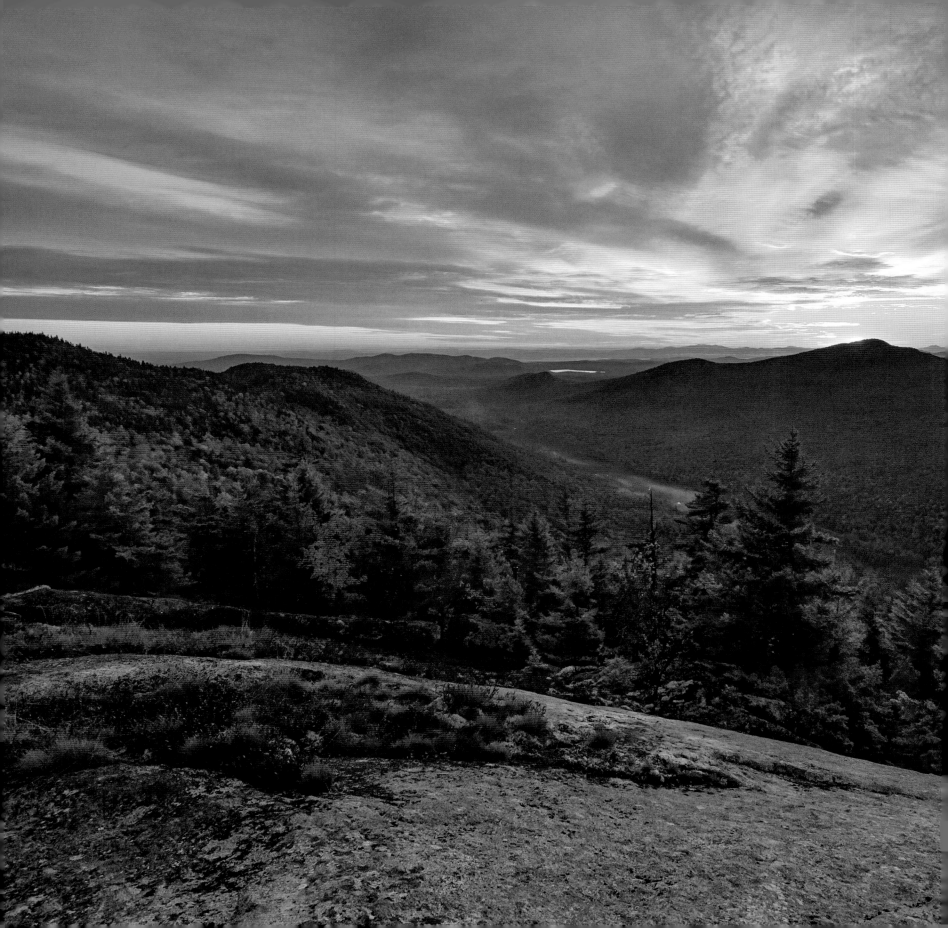

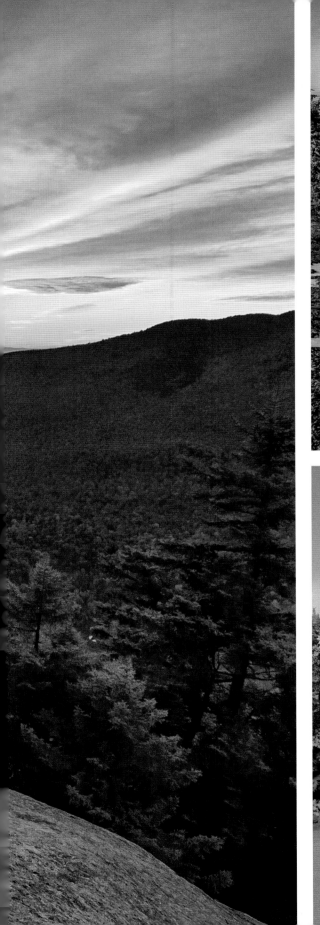
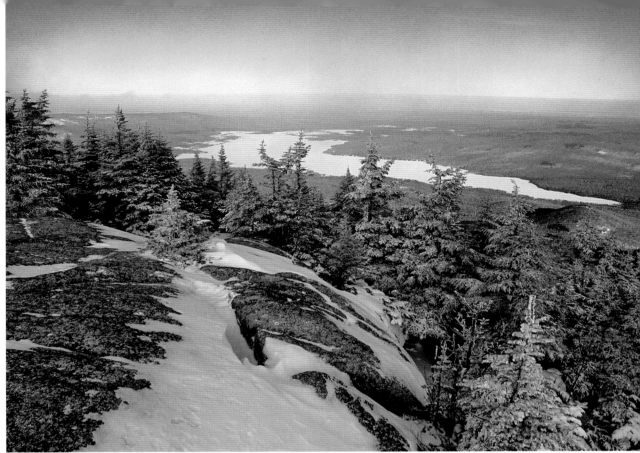
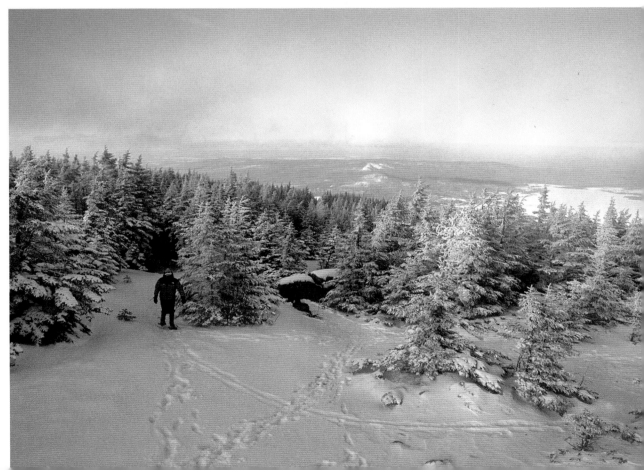

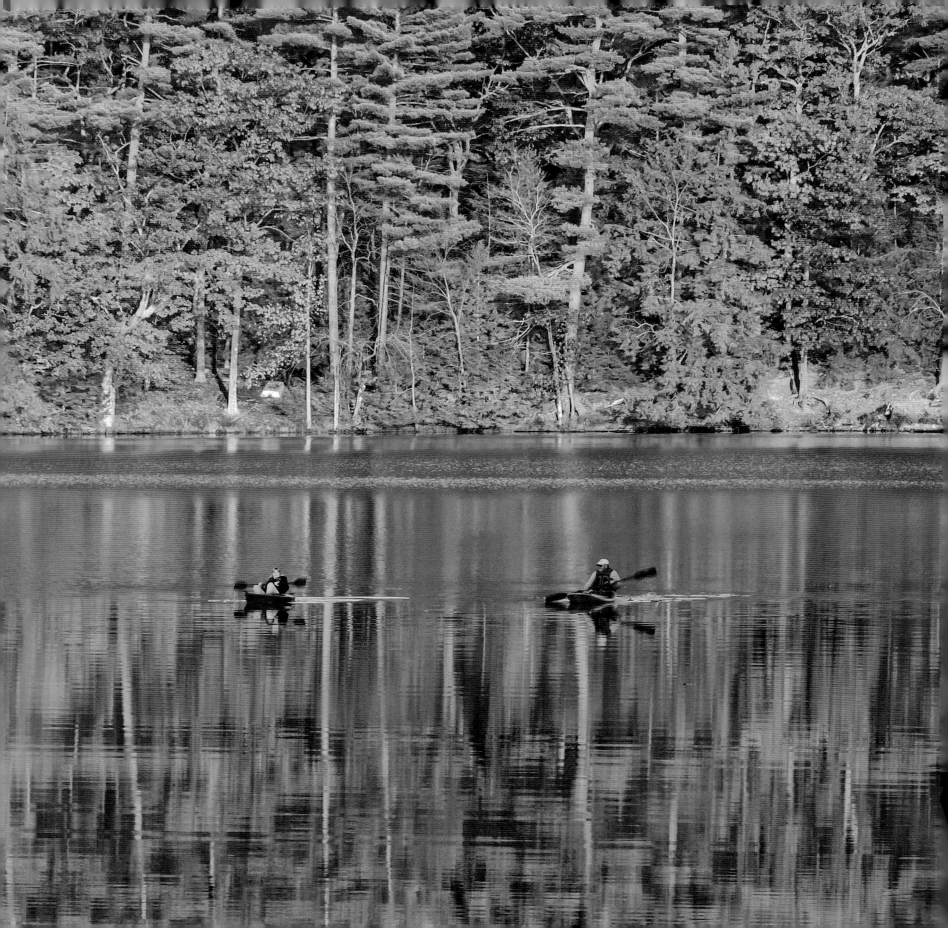

LAKE GEORGE REGION
and EASTERN ADIRONDACKS

Lake Champlain forms the eastern border of the Adirondacks for most of their length from the edge of the St. Lawrence River Valley on the north to the slope into the Mohawk-Hudson Valley on the south, but it is in the Lake George vicinity where significant trail networks are located. One favorite is Tongue Mountain, bearing a series of trails leading to spectacular views of the lake— often described in florid 19th-century prose as the most beautiful body of water in America—and its enveloping mountains. Take note that this is timber rattlesnake habitat, and you are the intruder. But they are as anxious to avoid you as you are to avoid them, so if you leave each other alone, all will end well. Away from the lake, which can get crowded during peak times, satisfying destinations range from Hadley Mountain, with its fire-tower panoramas, to the Putnam Ponds (you simply have to go there, if for no other reason than to see a tiny body of water named Grizzle Ocean by an early and anonymous local comedian), to Hoffman Notch, a longer trek that will put you in mind of real remoteness, though it is less than six miles from an interstate highway.

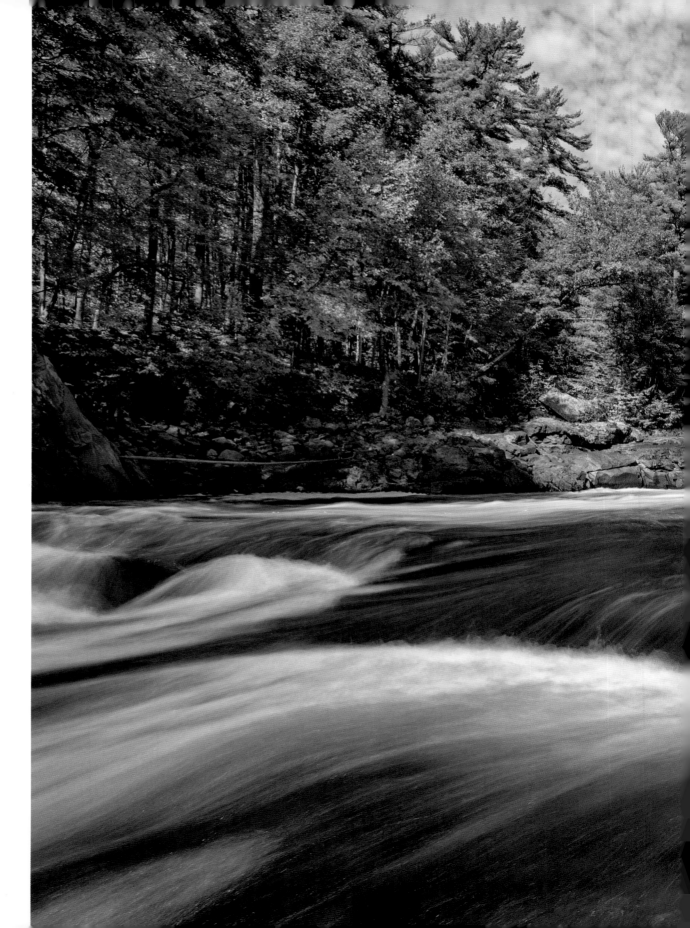

PREVIOUS SPREAD: Kayakers enjoy a beautiful fall day on Lake Luzerne.

OPPOSITE: Rockwell Falls is a portage location for anyone traveling down the Hudson River.

FOLLOWING SPREAD: Hadley Mountain is a fire-tower mountain in the southeast Adirondacks with views of the High Peaks, Great Sacandaga Lake, and surrounding mountains (left). With lots of hardwoods on the surrounding mountains, the view from Hadley Mountain can be quite spectacular during the peak of fall color (right, top). Young hikers enjoy a stream from a bridge along the trail to Pine Orchard (right, bottom).

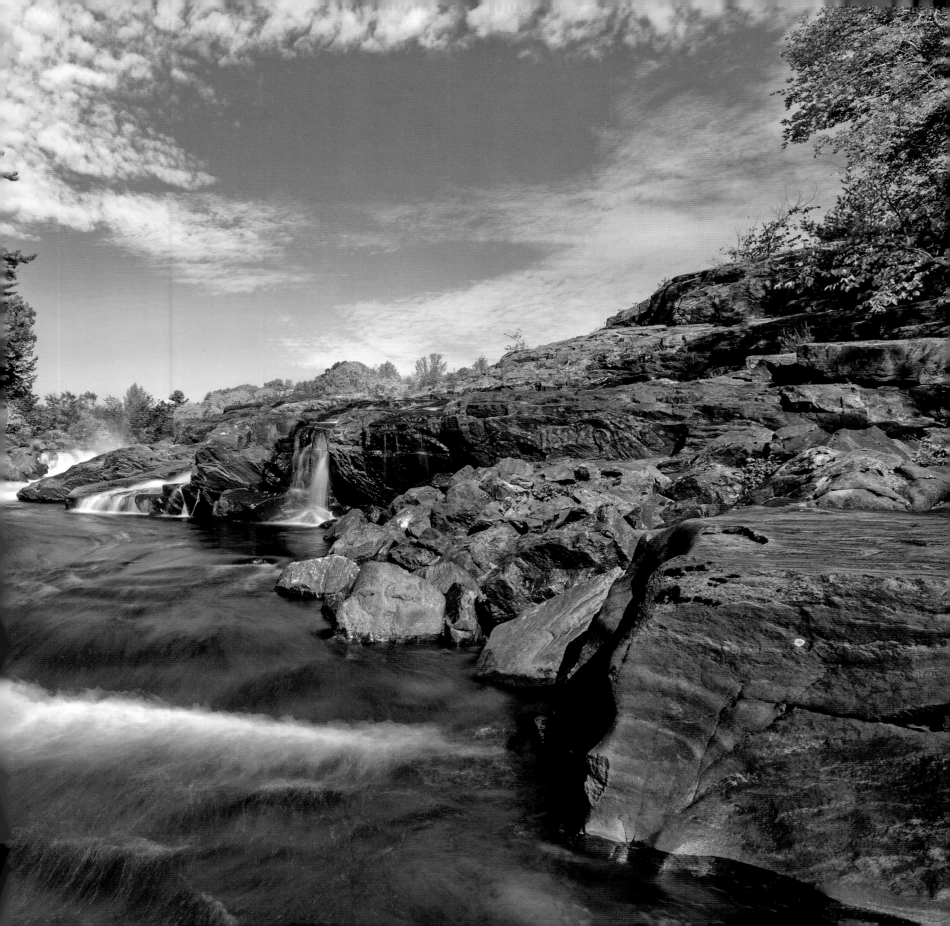

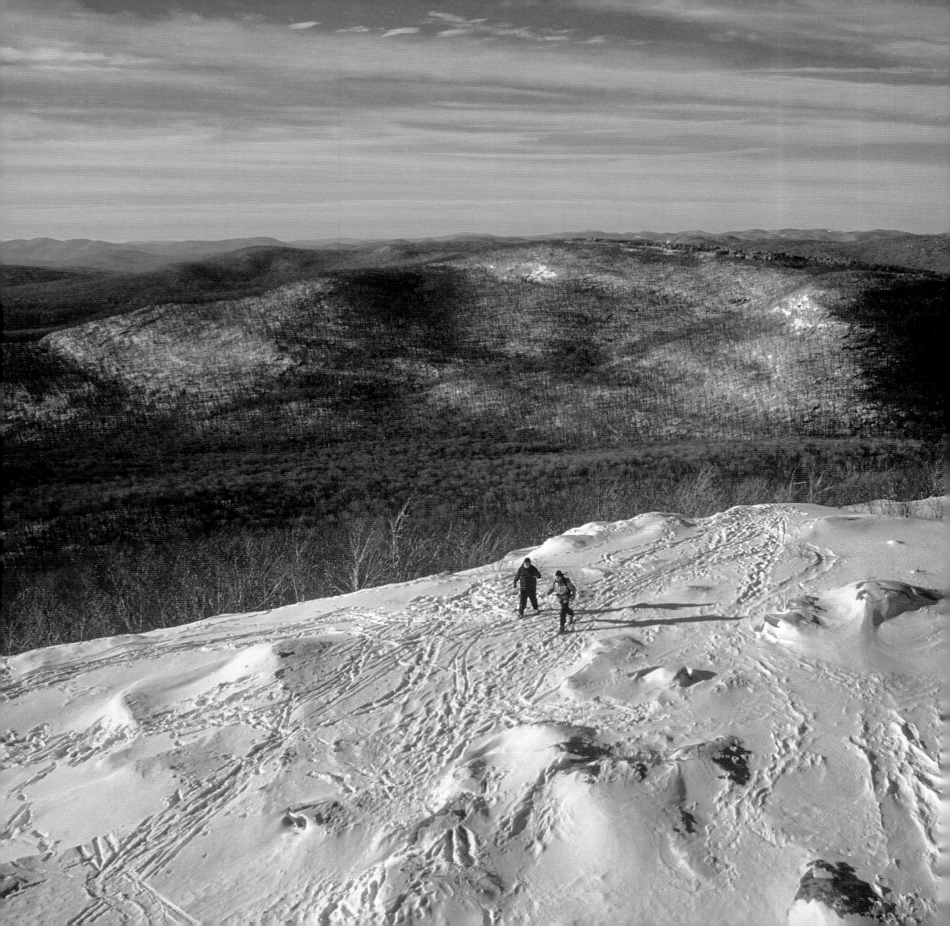

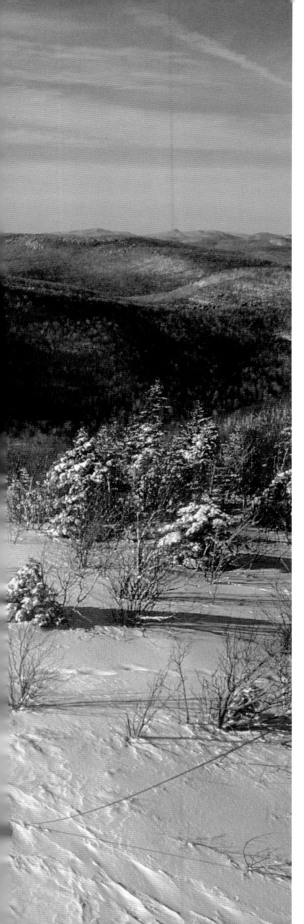
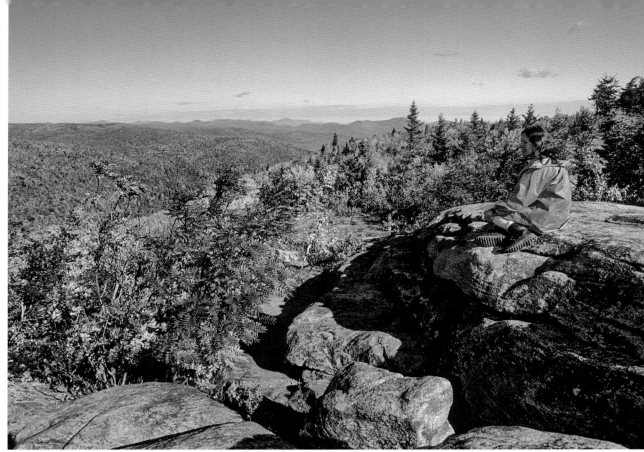
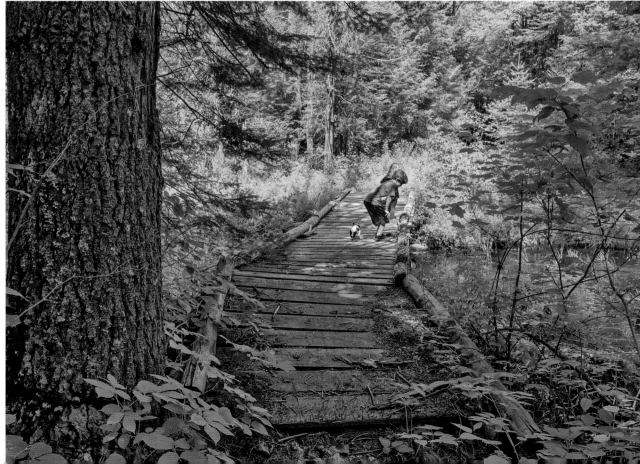

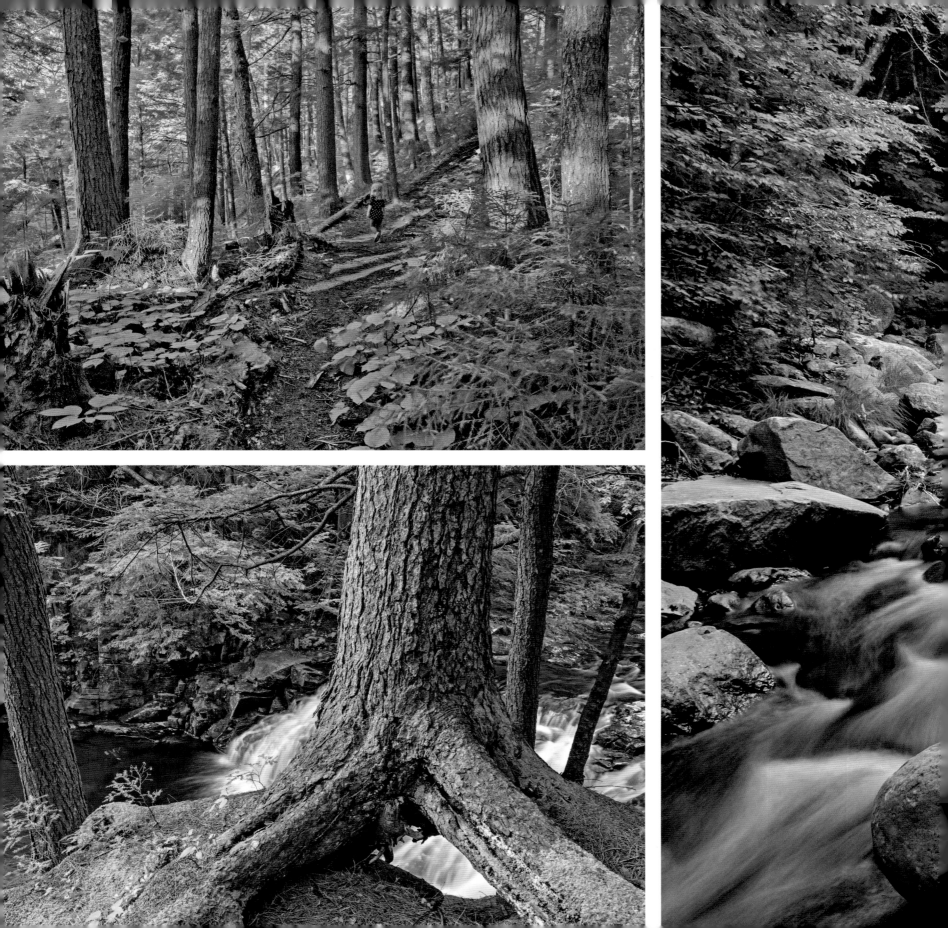

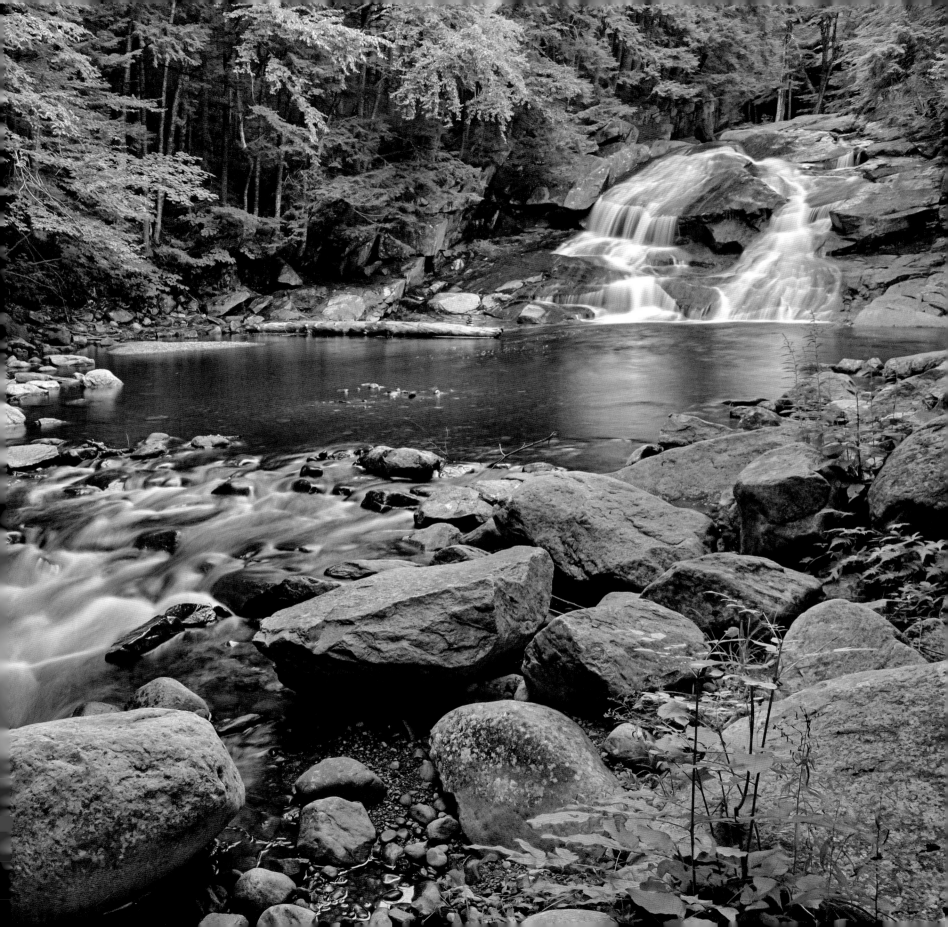

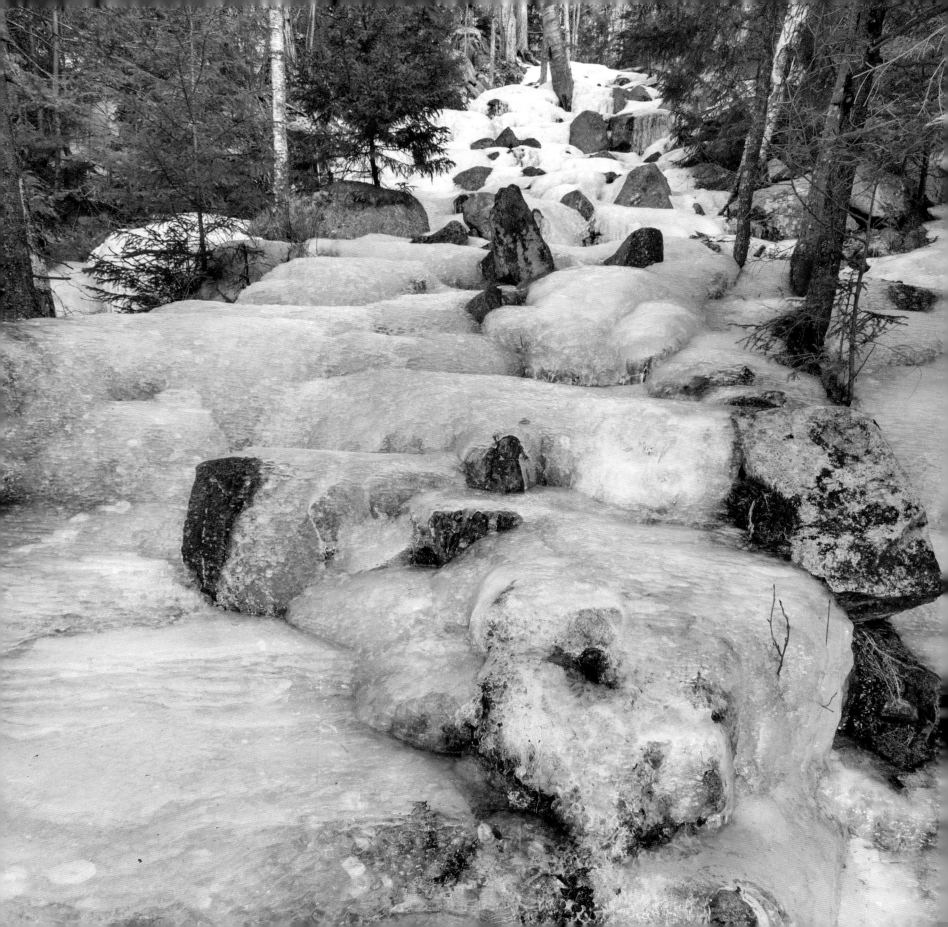

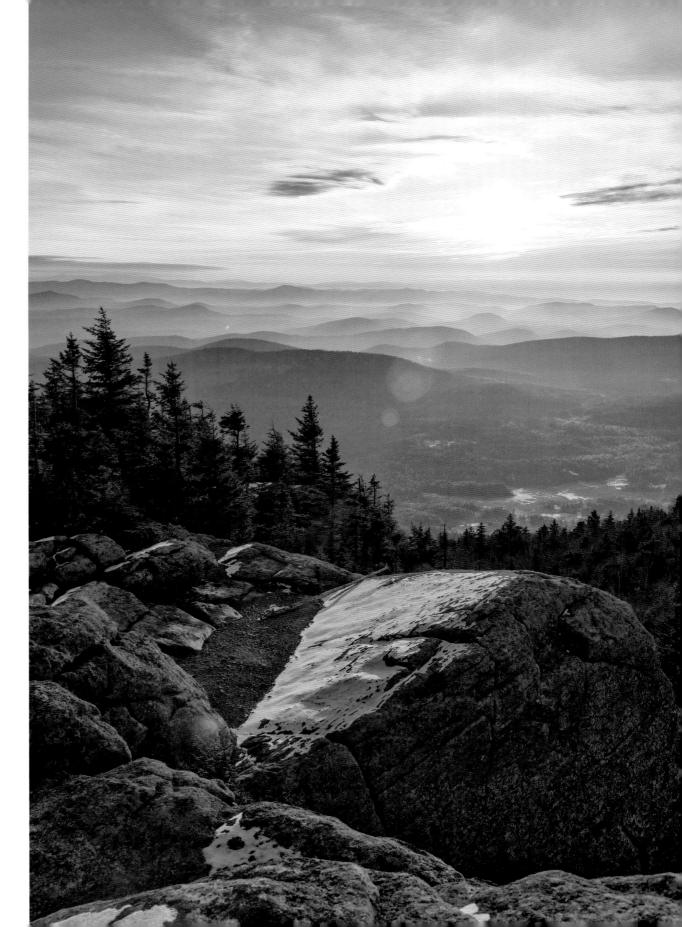

PREVIOUS SPREAD: The pleasant trail along Tenant Creek in the town of Hope leads to three sets of waterfalls and passes by some nice stands of evergreens (left, top), an overhanging hemlock by the second set of falls (left, bottom), and the lower falls, the most popular of the three, which cascades into a large pool (right).

OPPOSITE: Sections of the trail to Crane Mountain can get quite icy in winter, requiring the use of microspikes or crampons to safely hike on the trail.

RIGHT: Morning light filters over the southern Adirondack foothills in this view from Crane Mountain.

FOLLOWING SPREAD: This view from the summit ridge of Crane Mountain looks toward Crane Mountain Pond and Gore Mountain on the far right as the moon sets in the dawn sky.

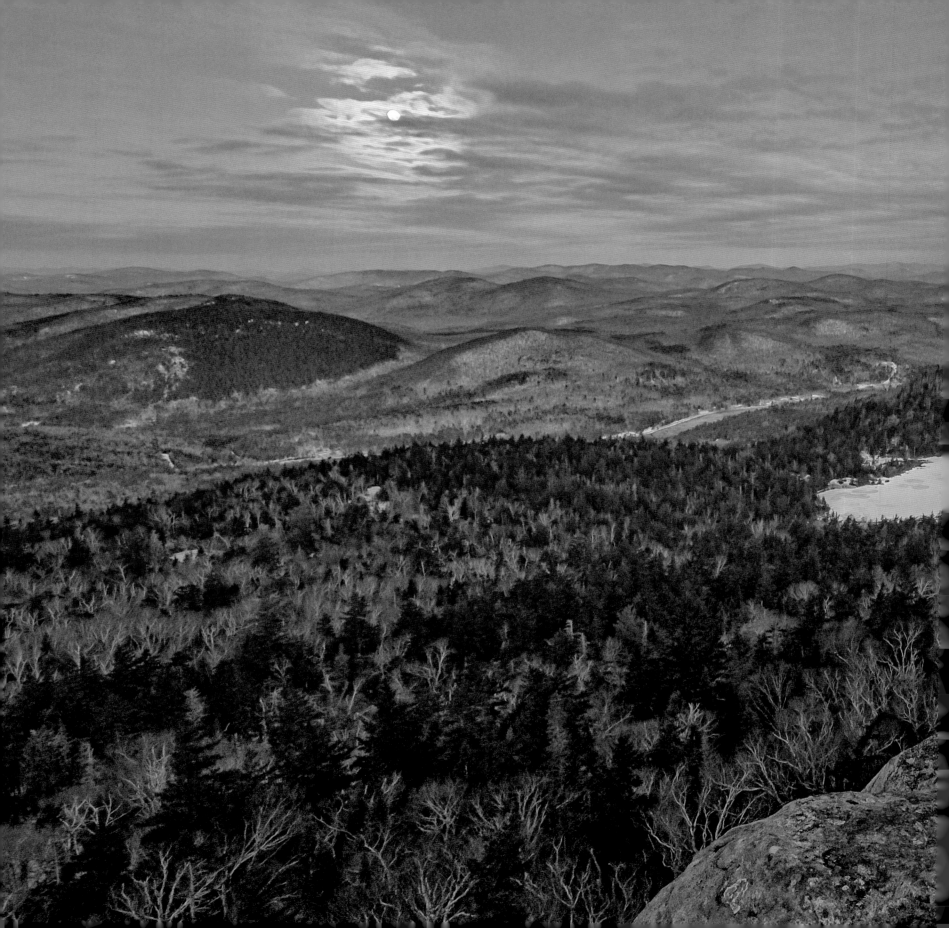

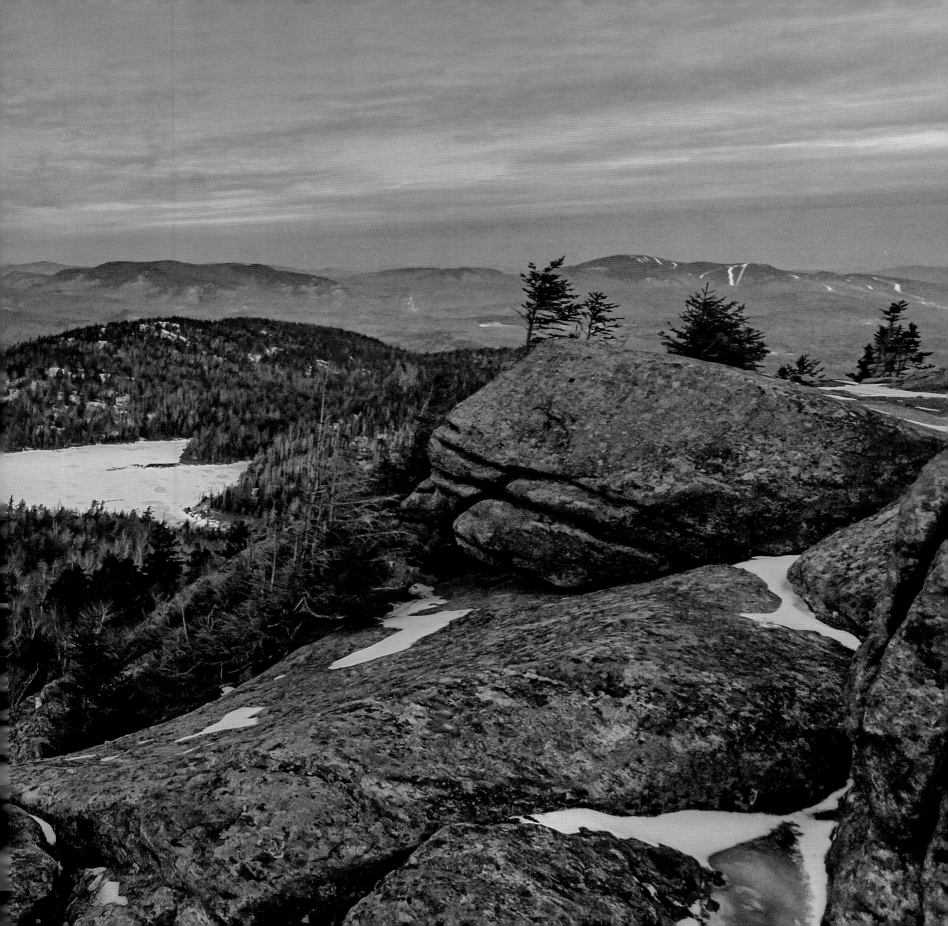

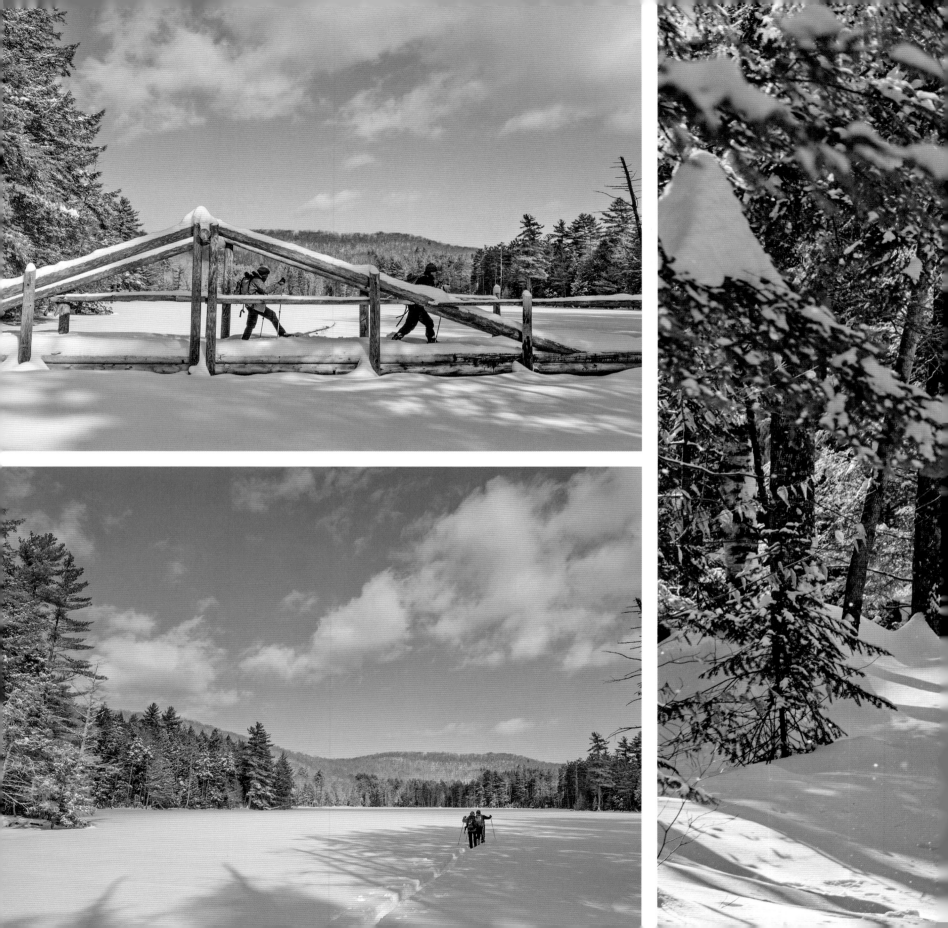

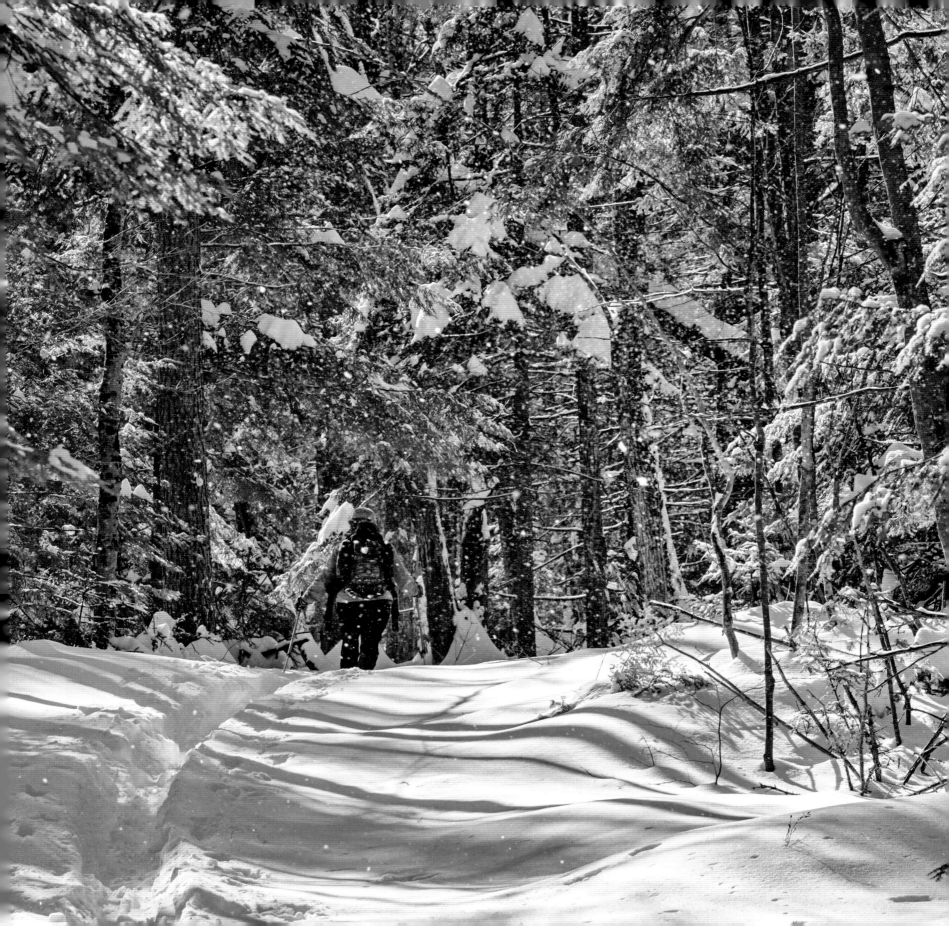

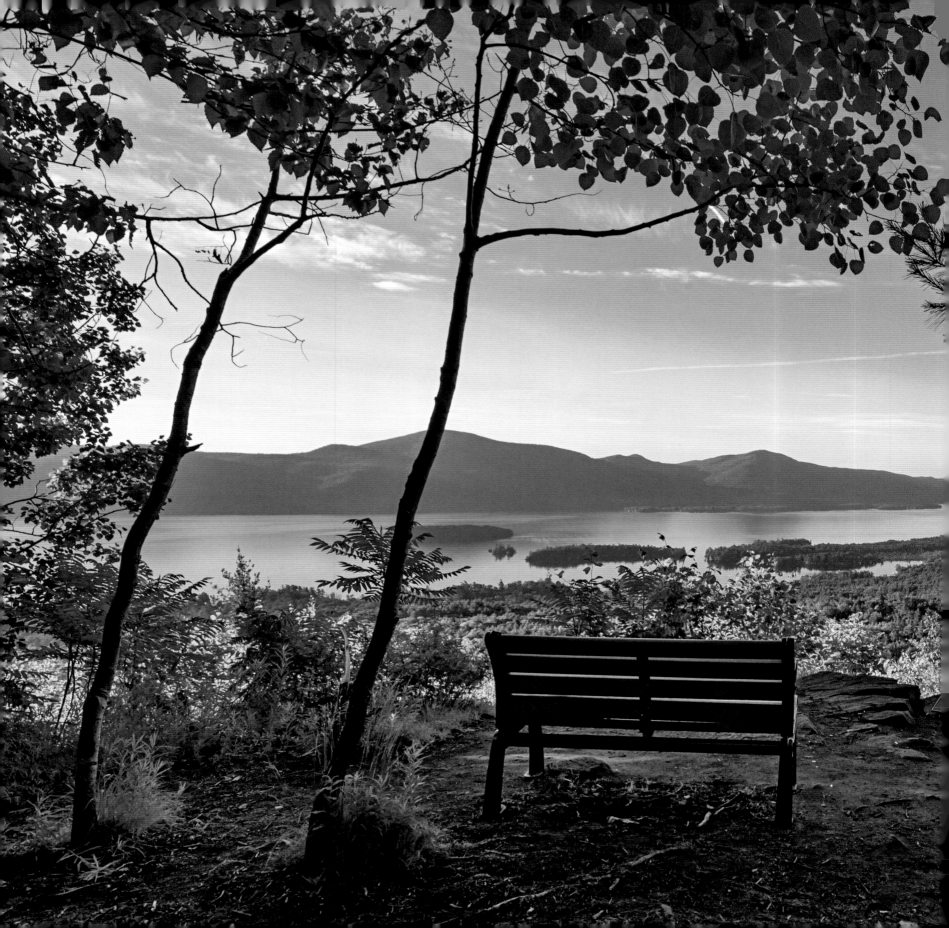

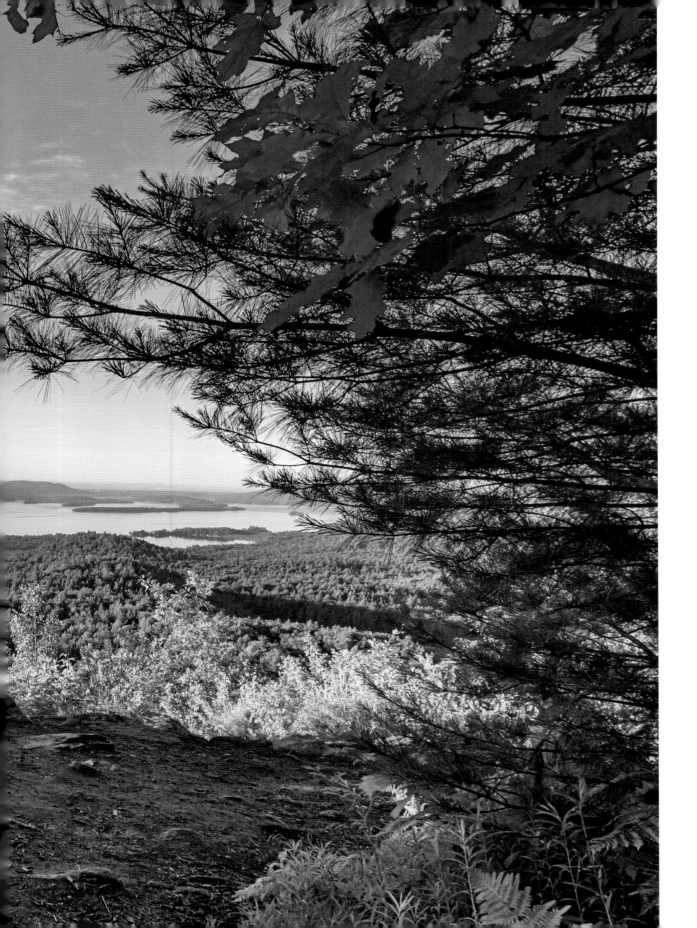

PREVIOUS SPREAD: Camp Dippikill has several public trails that are great for hiking in the summer and cross-country skiing in the winter. This ski trip included a route across the frozen, snow-covered Dippikill Pond (all).

OPPOSITE: This view from the Pinnacle overlooks the Bolton Landing and Diamond Point area of Lake George.

FOLLOWING SPREAD: Cat Mountain offers great views of Lake George and the surrounding mountains. It helps to be a good skier to get to the top in winter (left). In spring, both shadbush and wild cherry trees blossom on the summit (right).

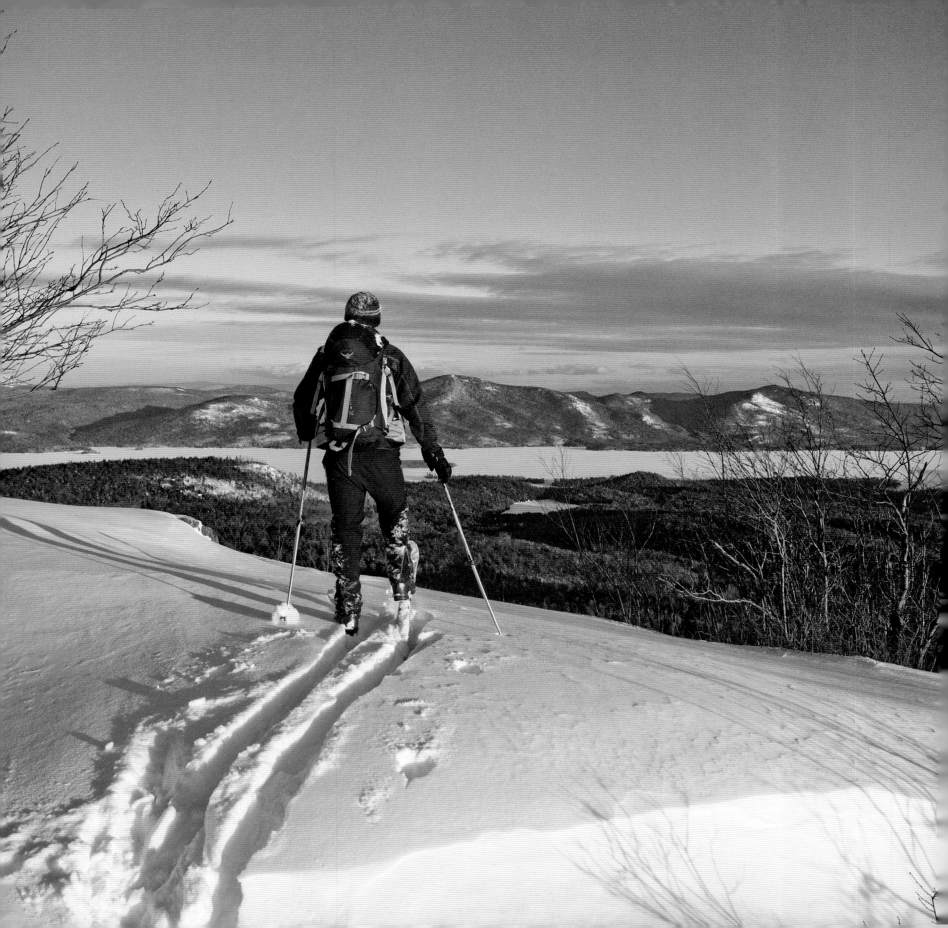

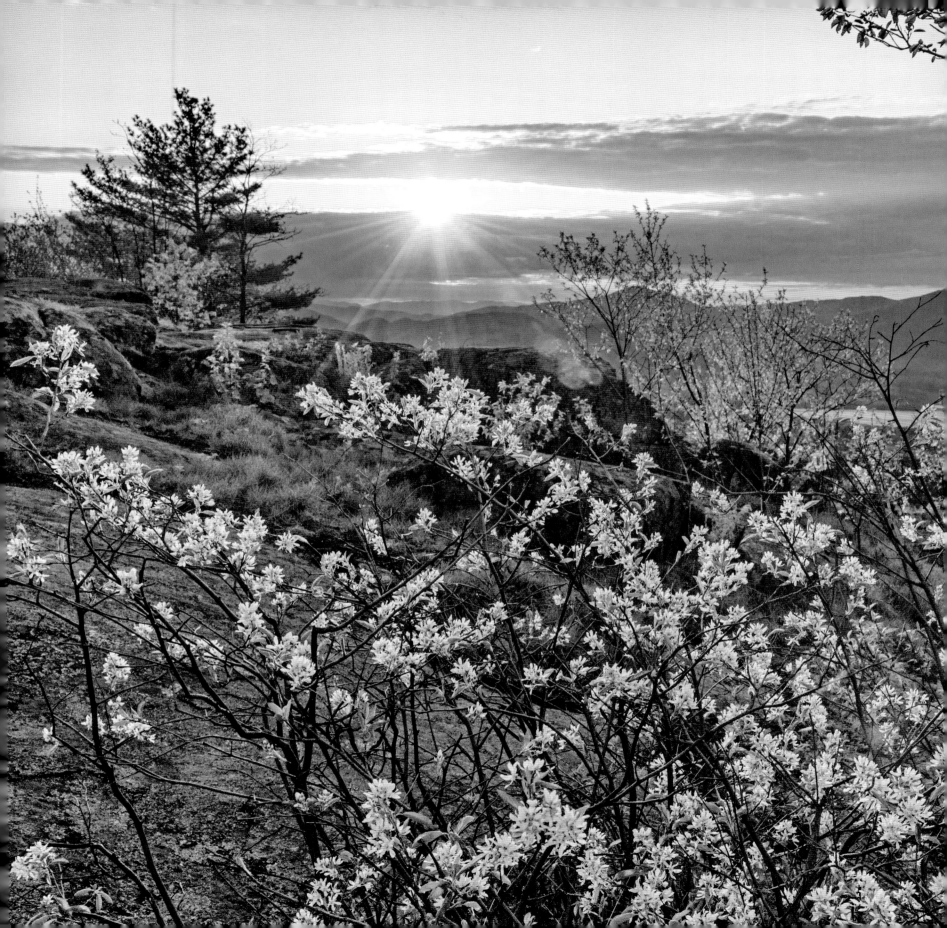

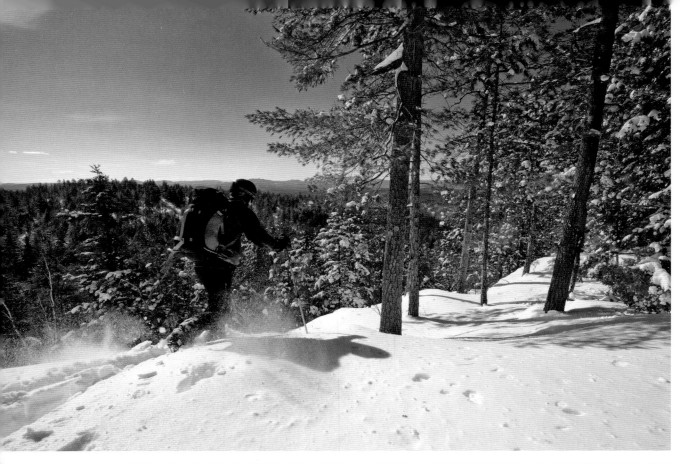

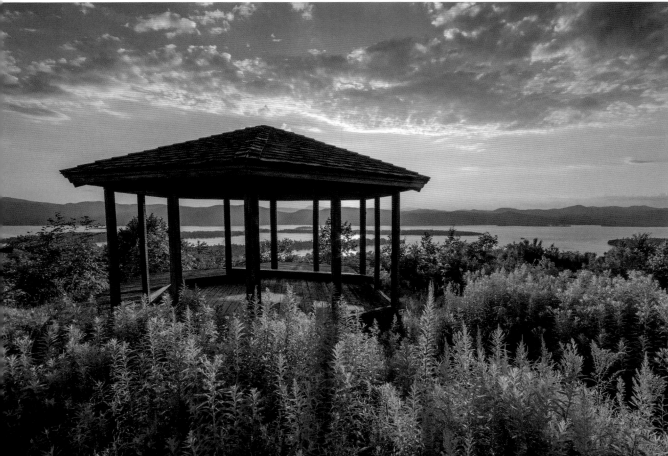

LEFT, TOP: A cross-country skier heads down the trail that traverses the ridge from this overlook on Thomas Mountain to the trail near the top of Cat Mountain.

LEFT, BOTTOM: This view from the Lake George Land Conservancy's Schumann Preserve shows late afternoon light filtering over the lake.

OPPOSITE: From Stewarts Ledge, this view looks south toward the Lake George village area.

FOLLOWING SPREAD: Buck Mountain is a popular climb on the east side of Lake George. These three views show a summit detail after a late April ice storm (left), the Tongue Mountain Range with the High Peaks on the distant horizon (right, top), and an aerial shot of the summit and the lake and mountains beyond (right, bottom).

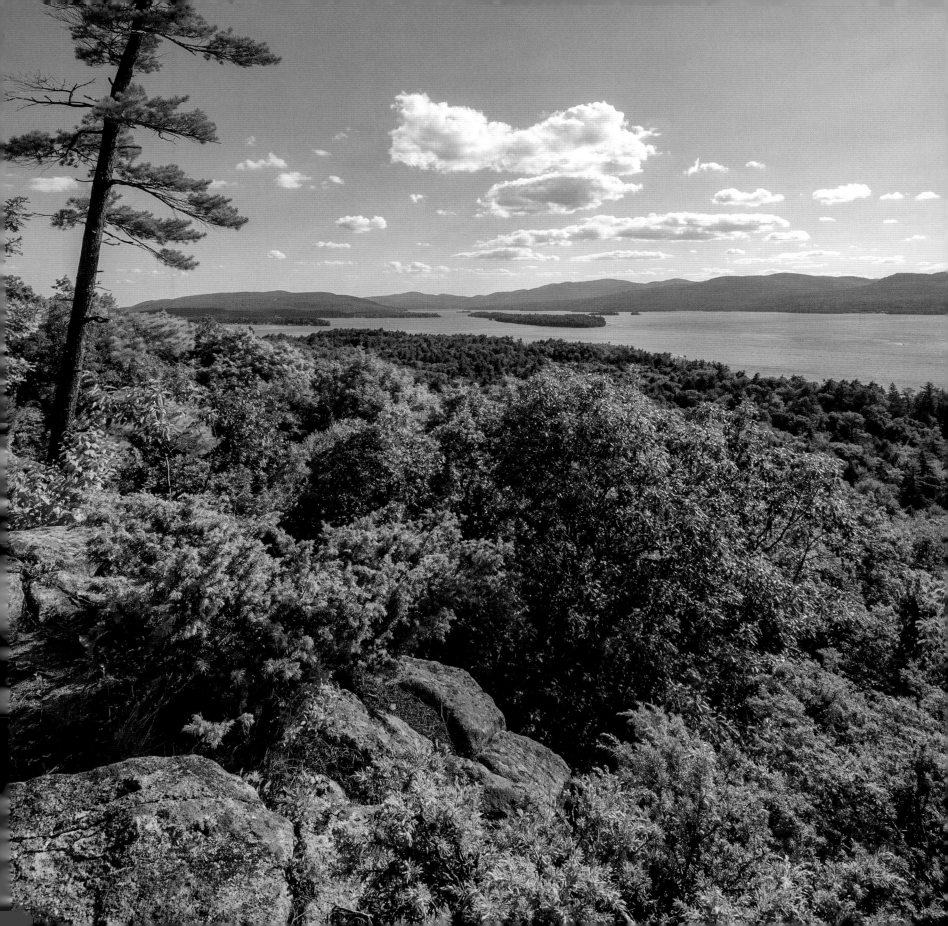

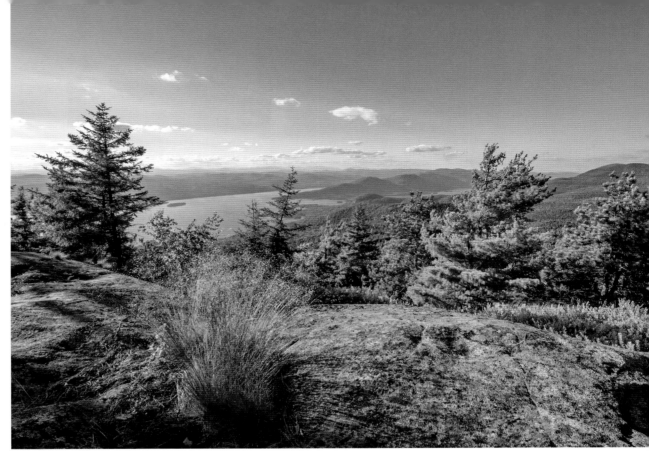
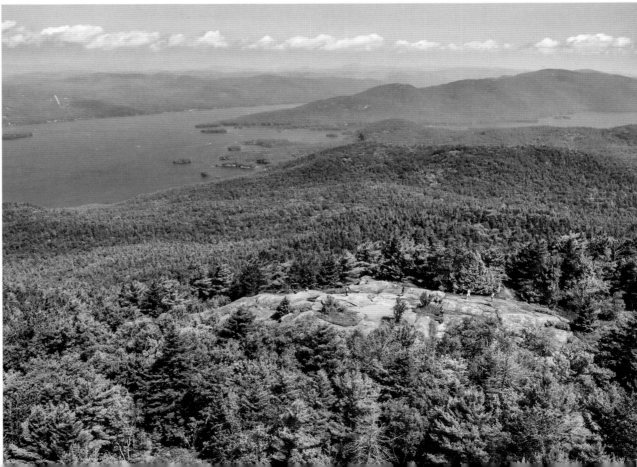

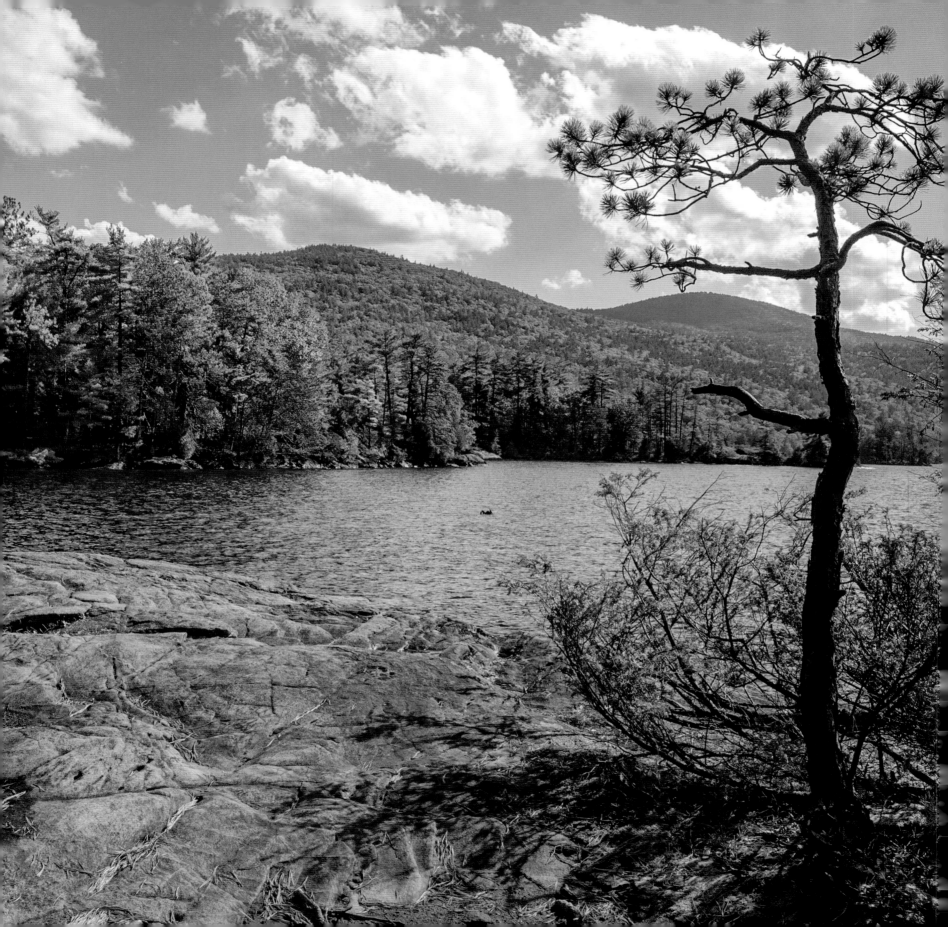

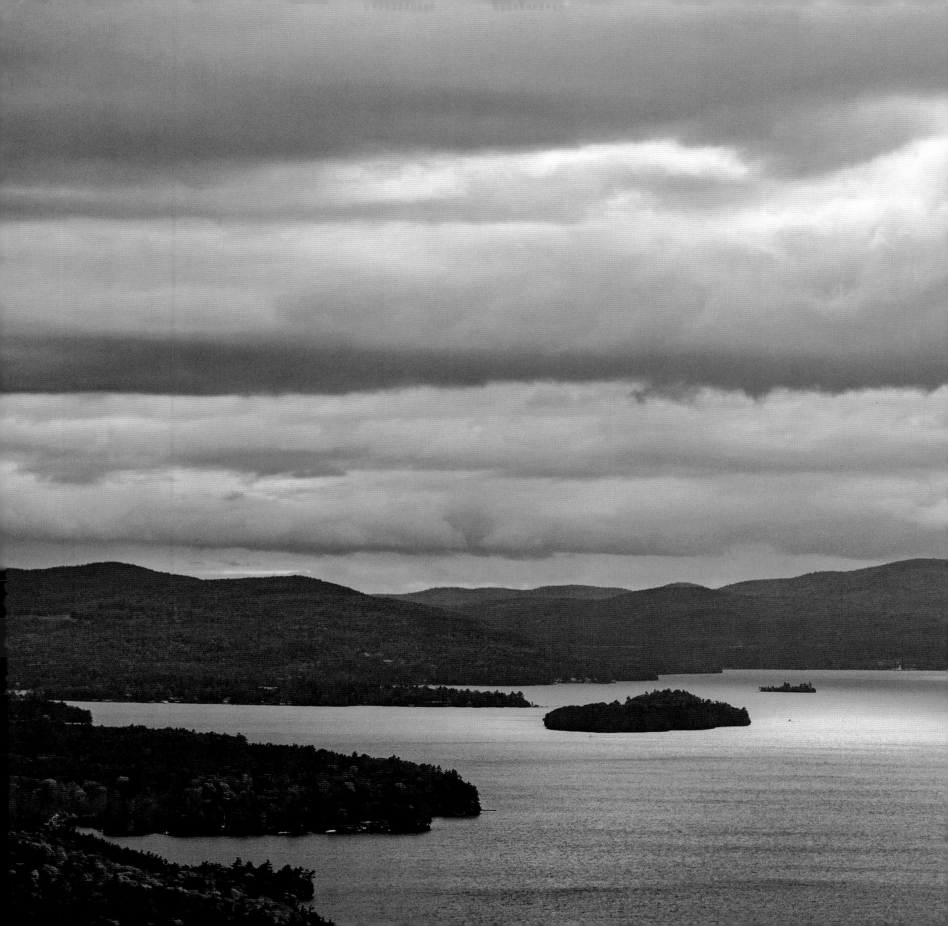

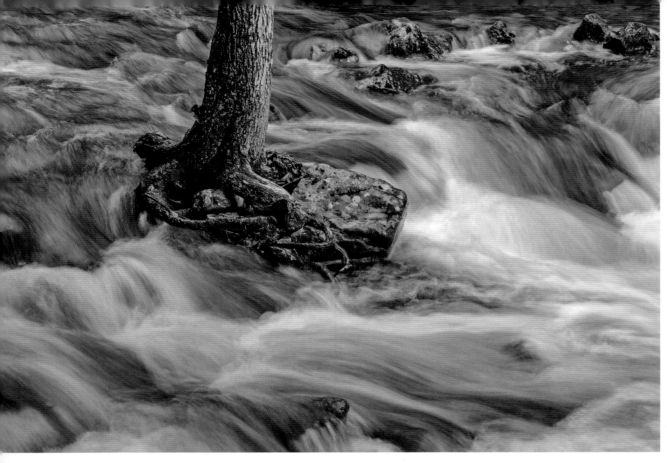

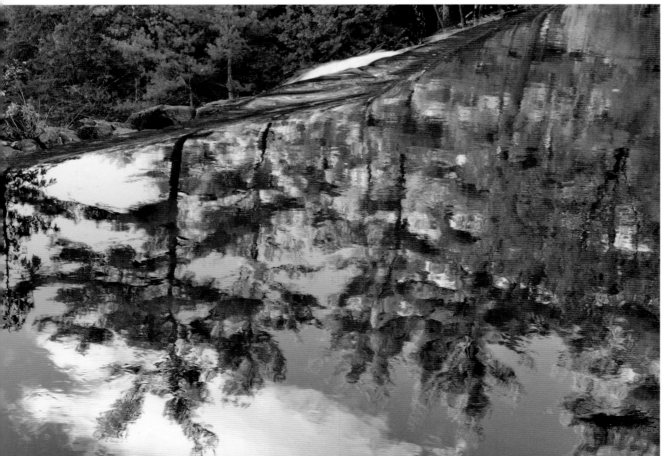

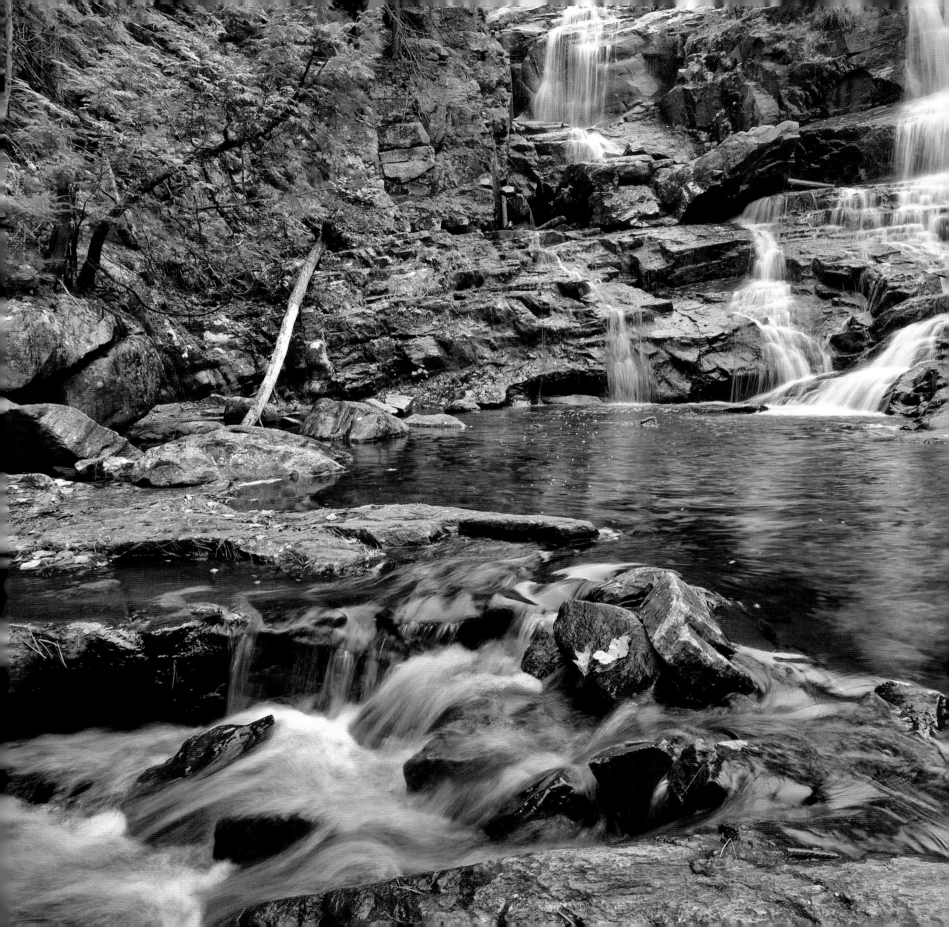

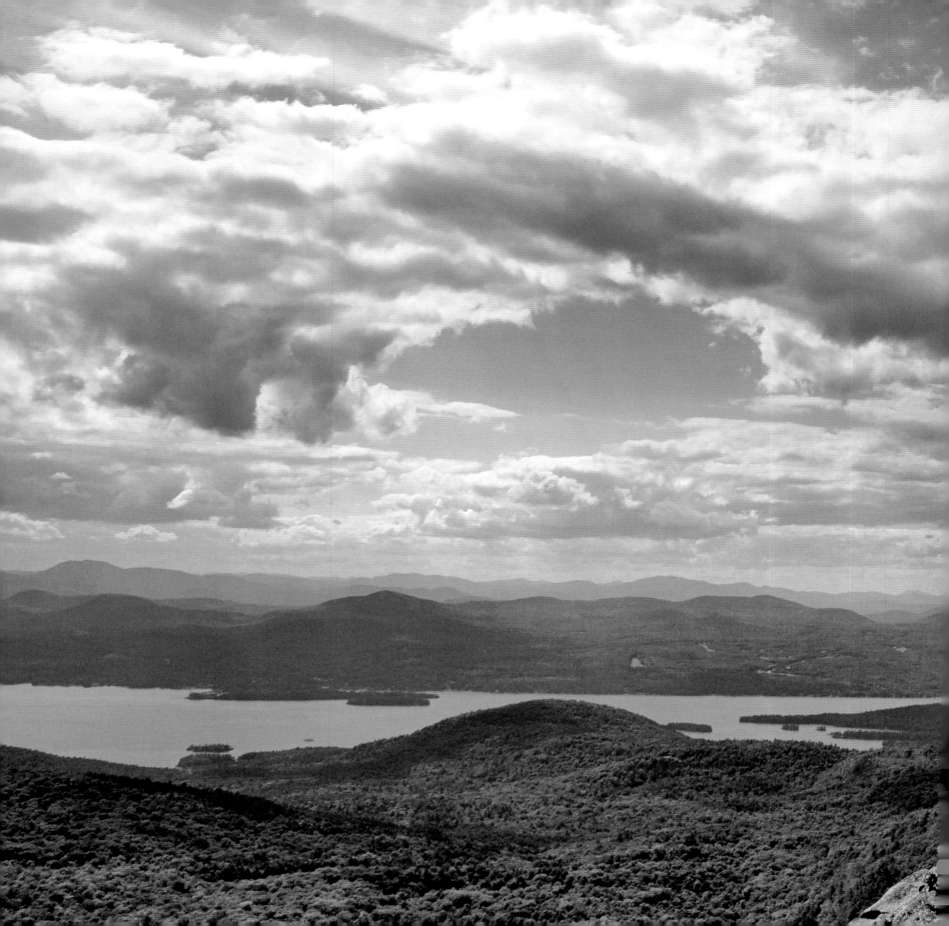

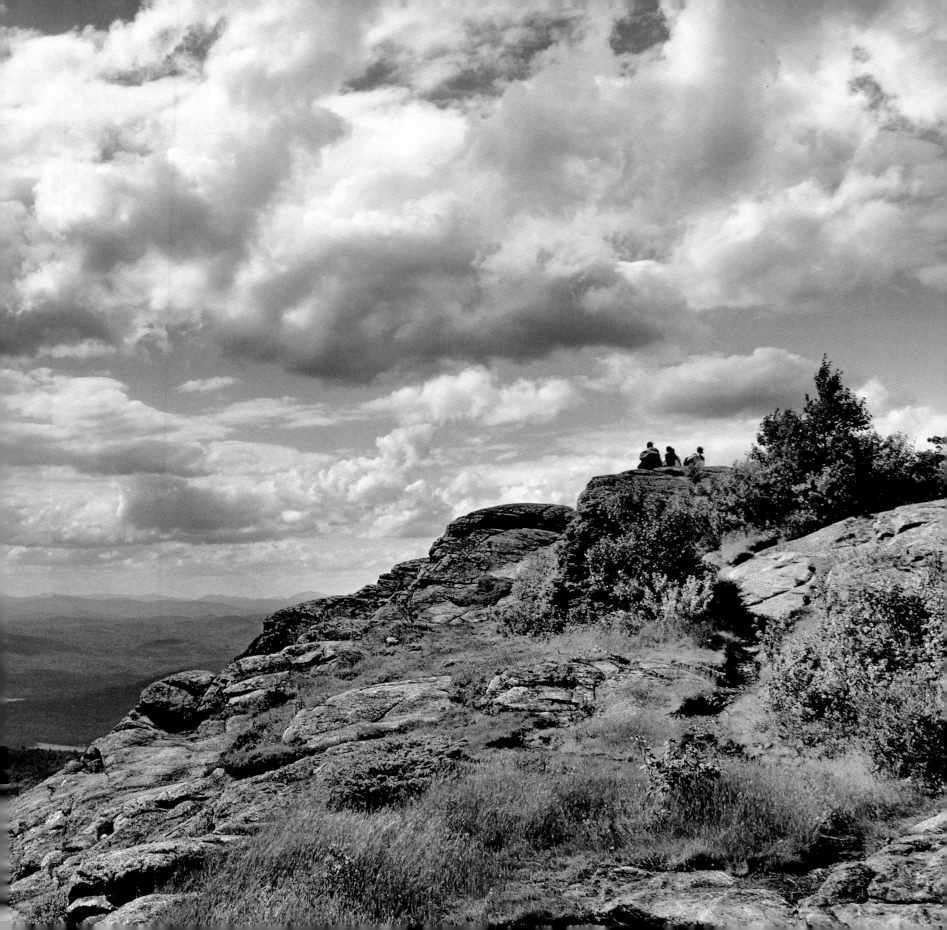

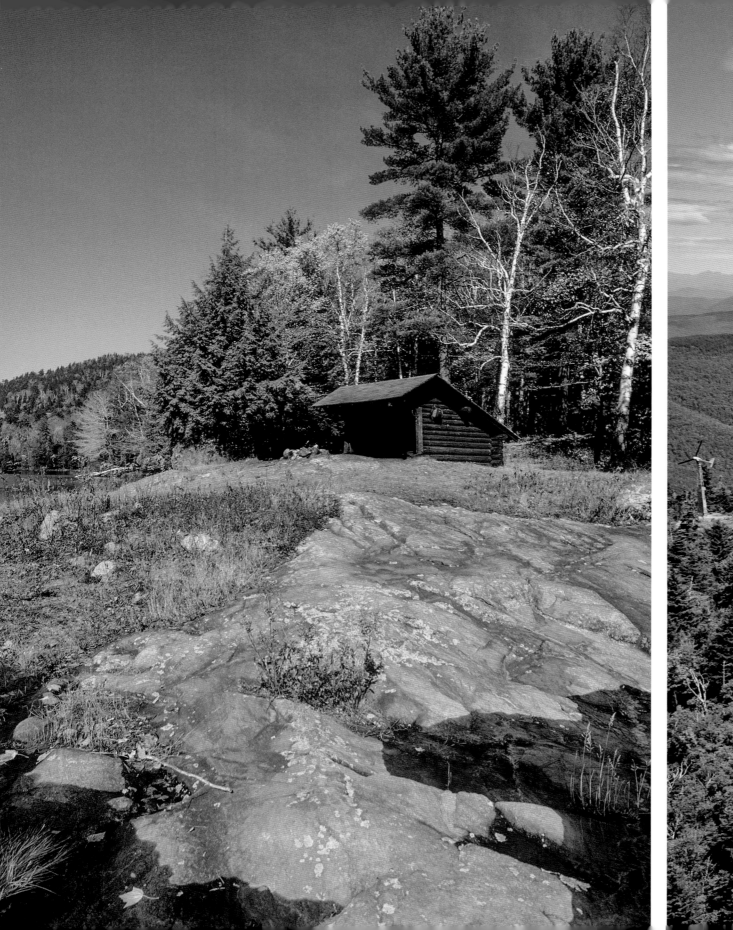
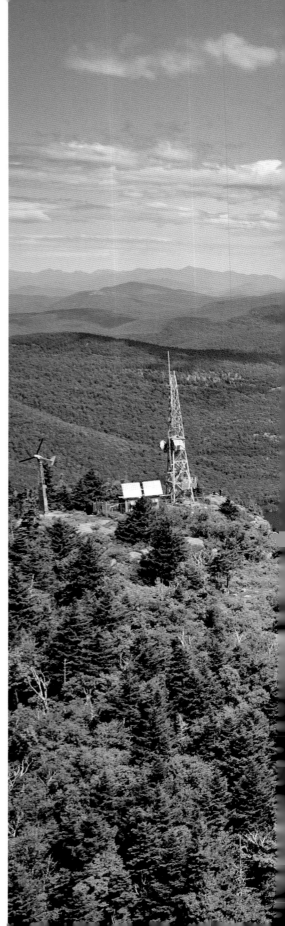

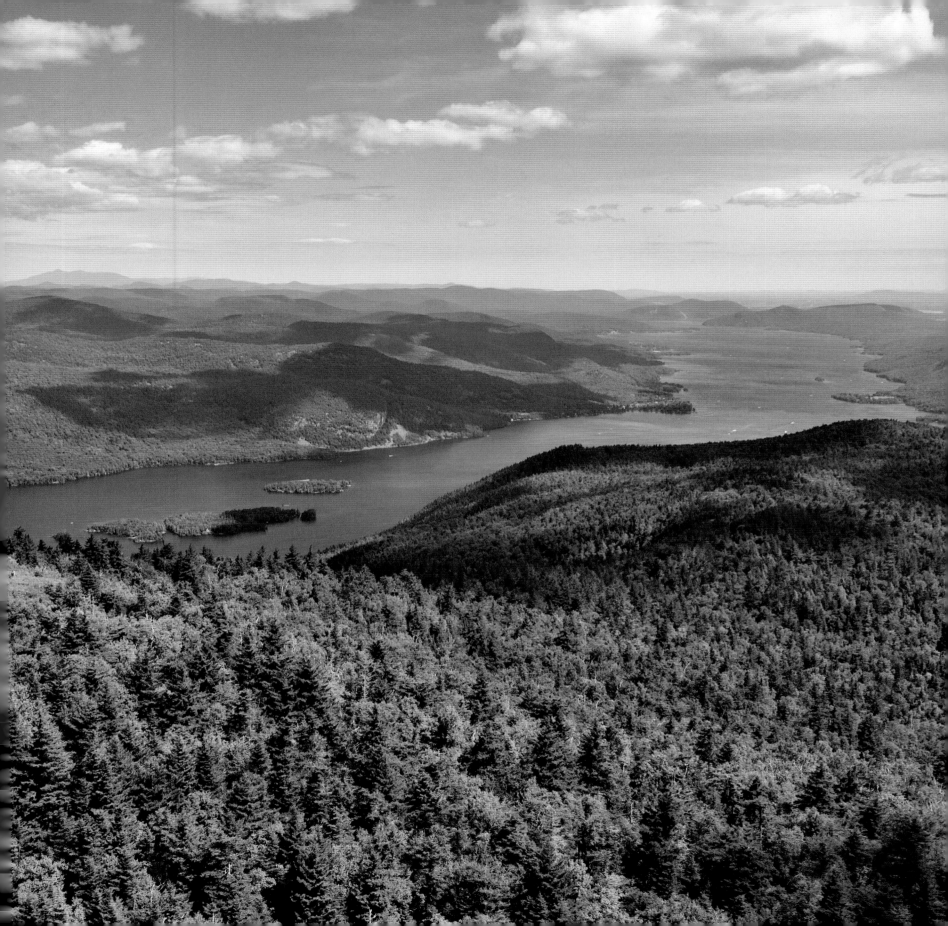

PREVIOUS SPREAD: Fishbrook Pond has two lean-tos that are about four or five miles from the Dacy Clearing trailhead (left). At 2,646 feet above sea level, Black Mountain is the highest mountain in the Lake George area, rising more than 2,200 feet above the waters of the lake (right).

OPPOSITE: A summer storm passes just to the east of the northern end of 32-mile-long Lake George.

FOLLOWING SPREAD: Fog settles over the Tongue Mountain Range in this view from the Harbor Islands (left, top). Rowers look toward Black Mountain from the Narrows (left, bottom). The Northwest Bay Brook area offers a quiet paddle among the bay's wetlands and wildlife (right).

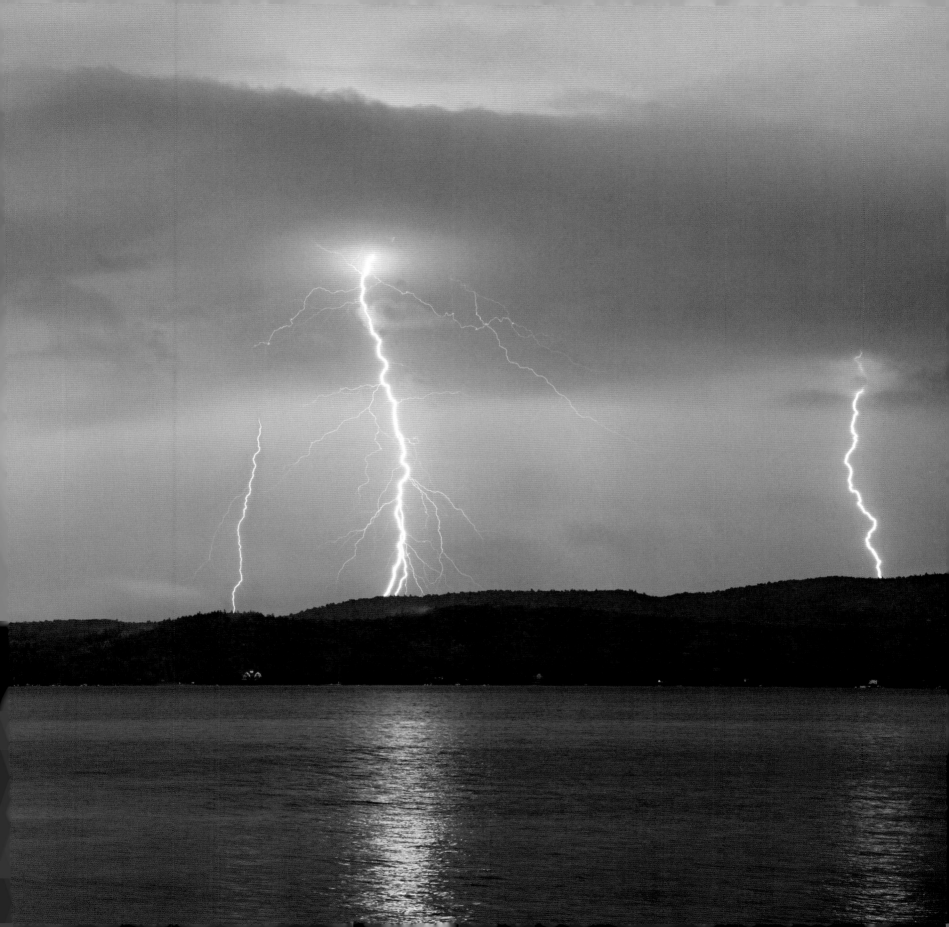

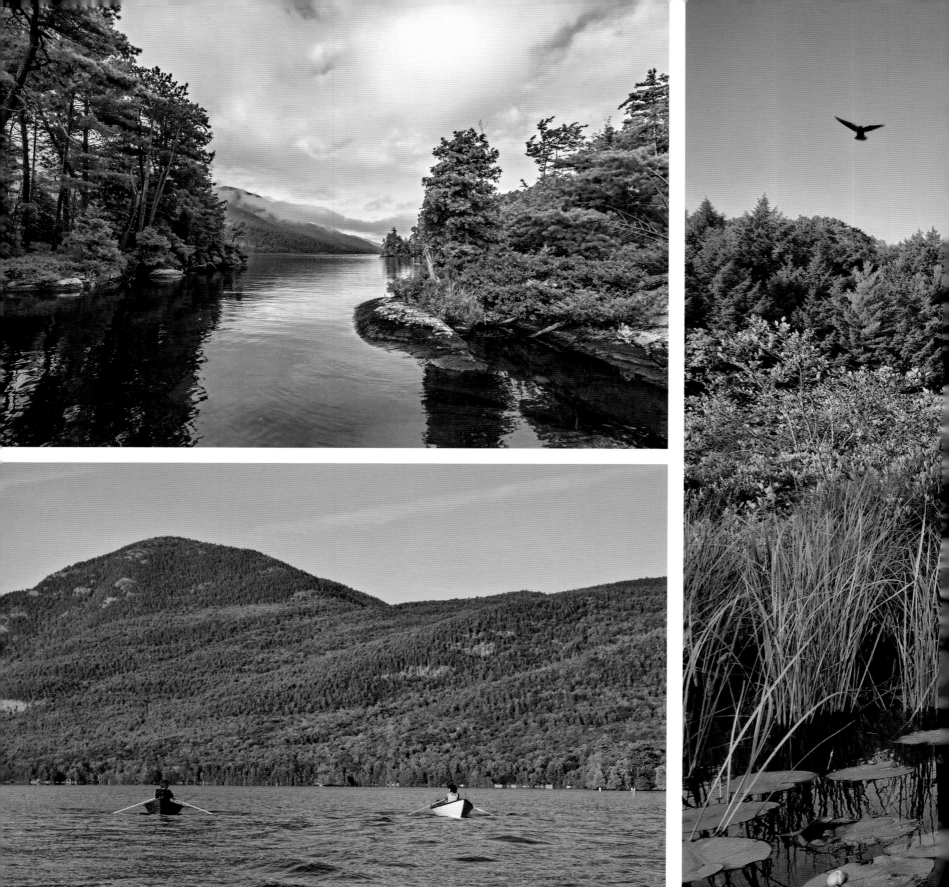

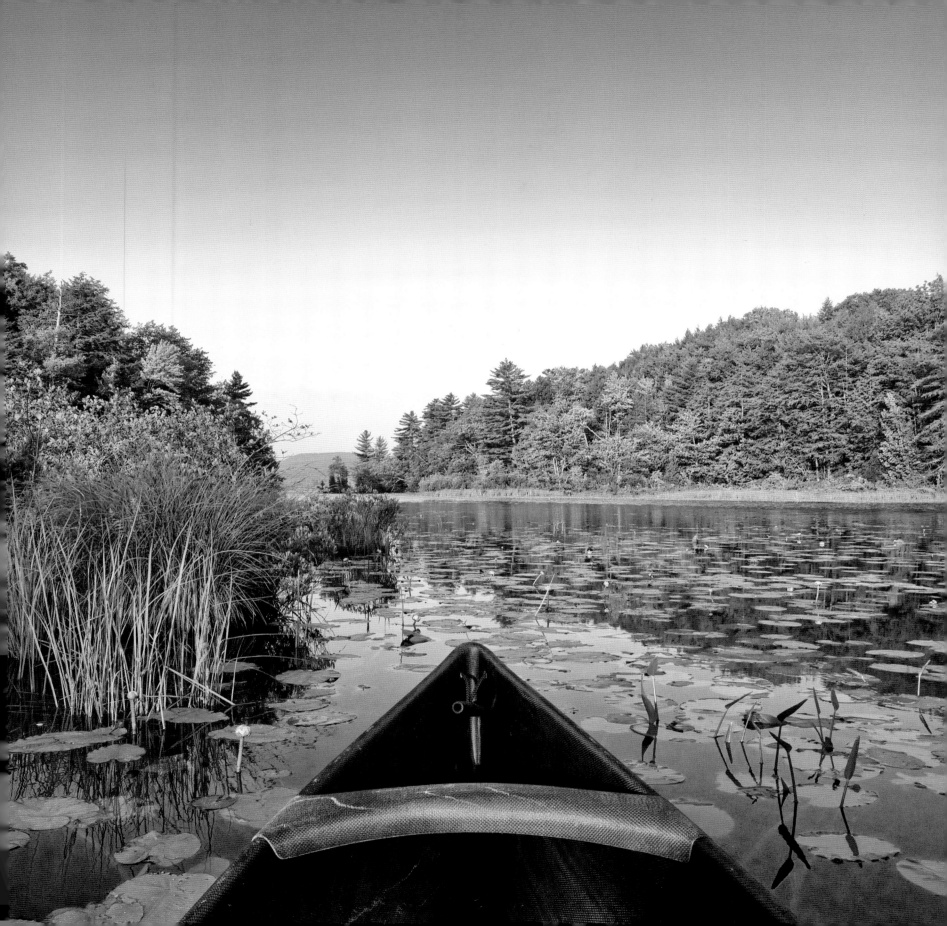

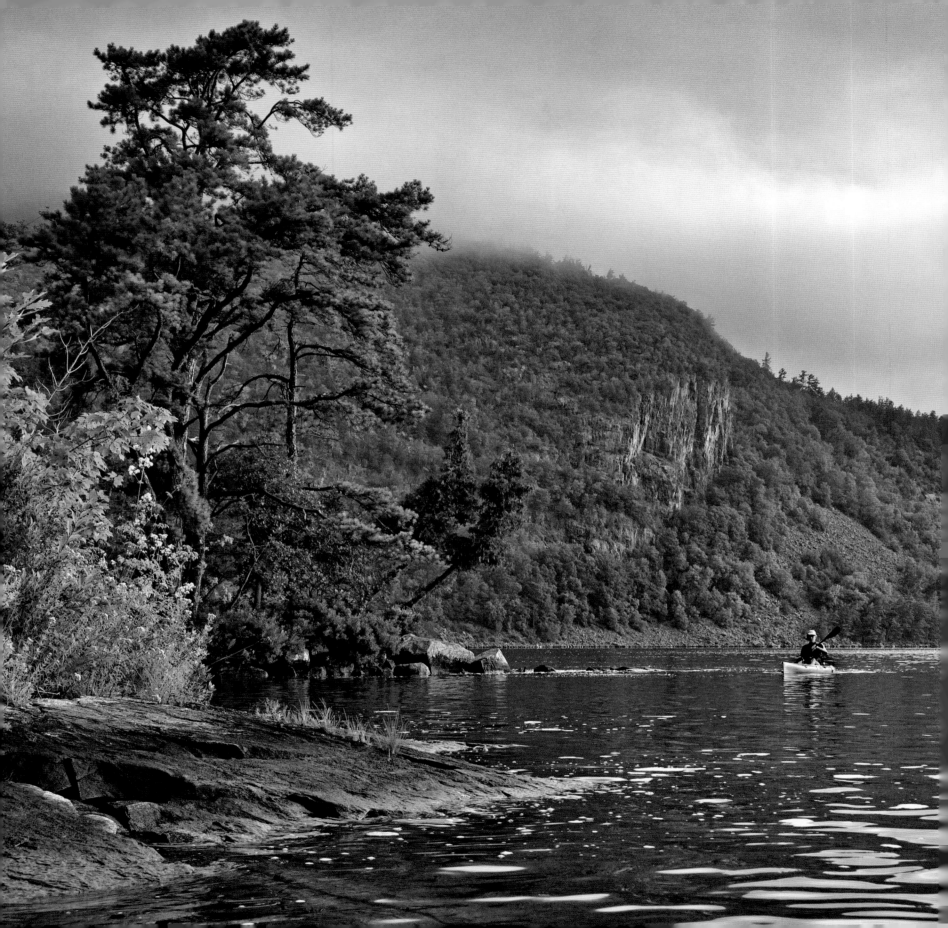

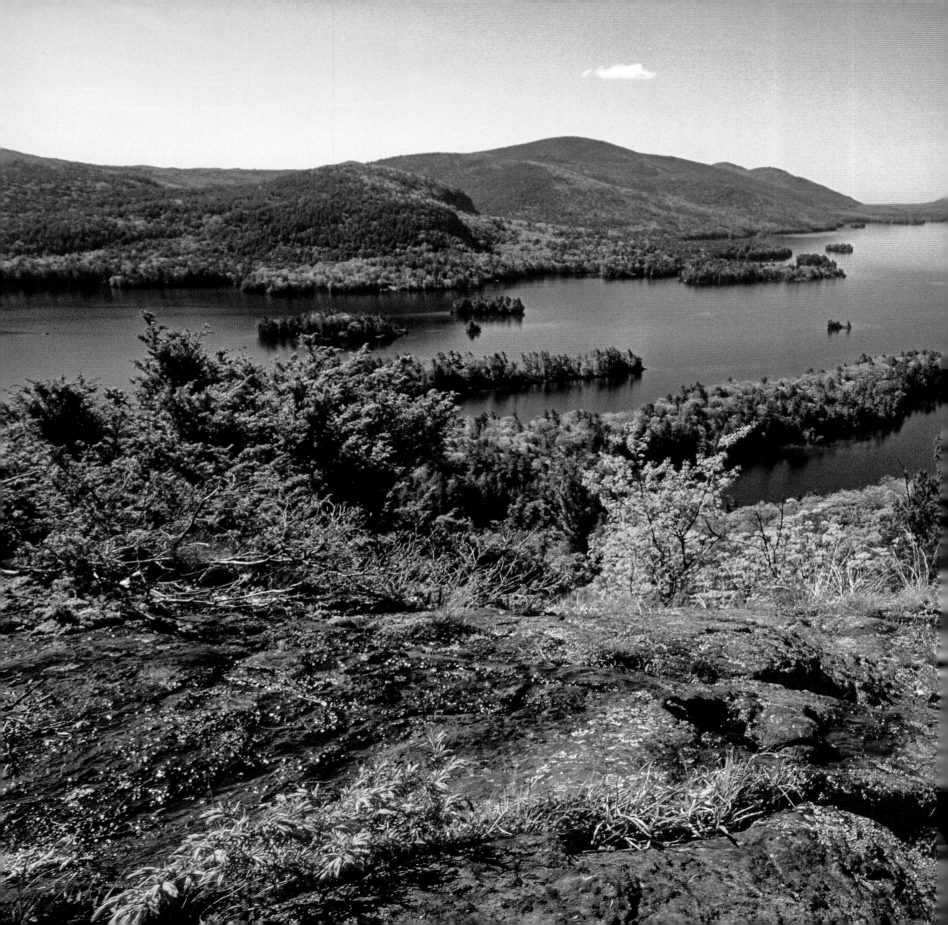

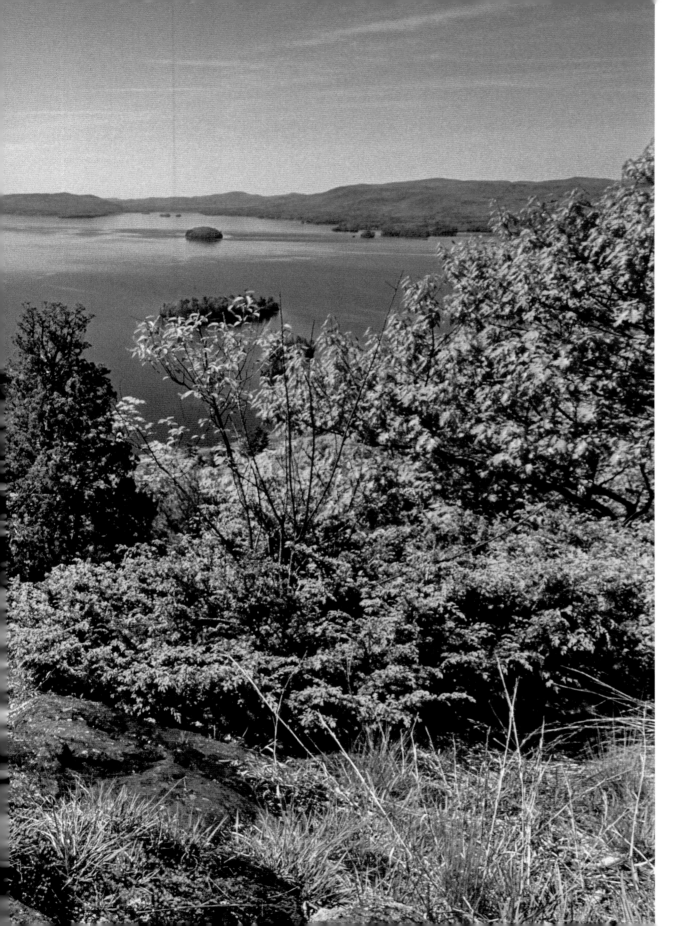

PREVIOUS SPREAD: A kayaker explores the Harbor Islands with the cliffs of Deer Leap in the background (left). Witch hopple blooms around the edge of a beaver dam along the trail to Deer Leap (right).

OPPOSITE: This view from First Peak at the southern end of the Tongue Mountain Range looks toward the Narrows and southern Lake George.

FOLLOWING SPREAD: A pair of young hikers explores this view of Lake George from Walnut Ridge (left, top), an overlook that is a short climb from Pole Hill Pond (left, bottom). In the trail system just west of Northwest Bay, Amy's Park is a Lake George Land Conservancy property with a series of trails around the pond, a hike to a lookout, and canoeing and kayaking options. This cairn is at the end of a trail where there is a rock ledge overlook in the wetland (right).

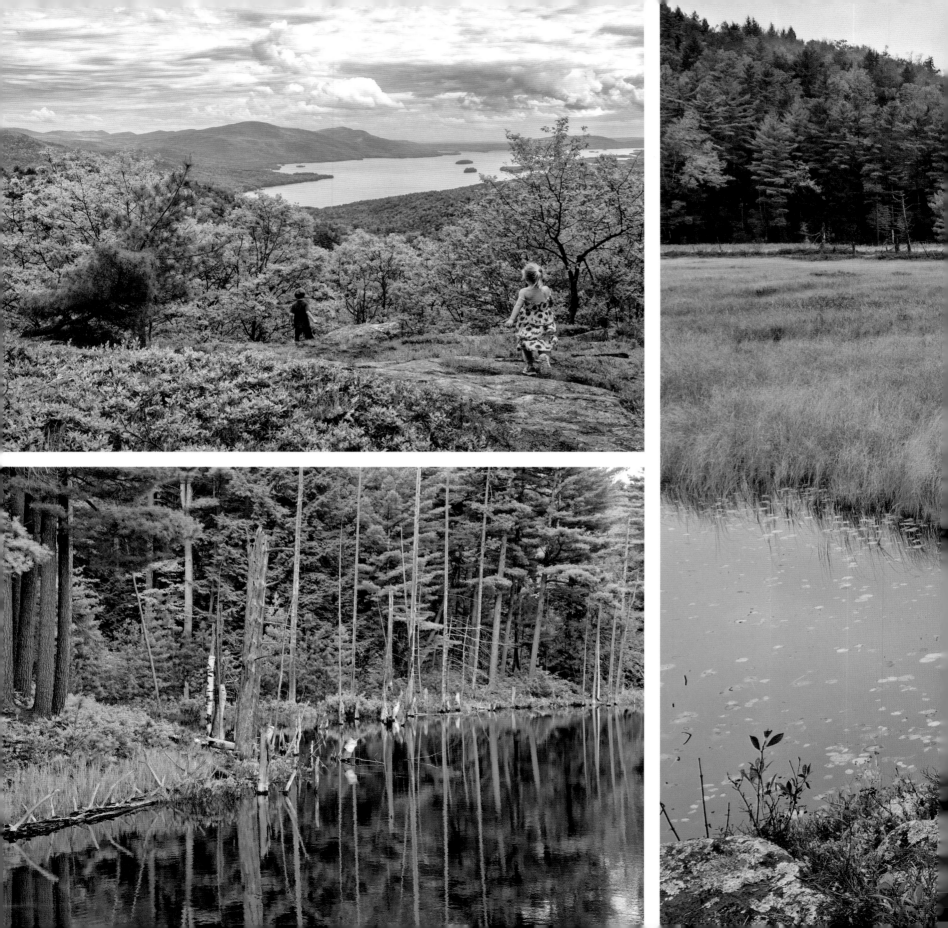

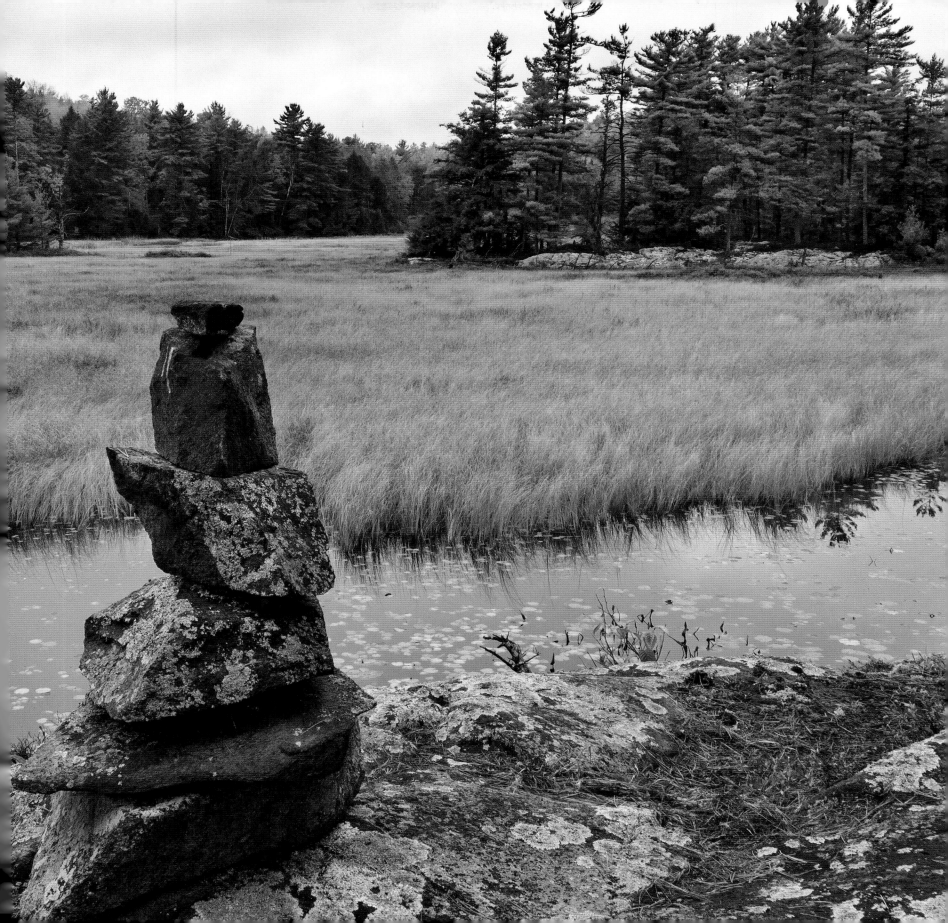

OPPOSITE: The sun sets over the wetland in Amy's Park.

FOLLOWING SPREAD: The Wardsboro Road was a main transportation route between Northwest Bay and Graphite many years ago. The southern part of the old road is still maintained, while the northern part is now a foot trail (left). Jabe Pond, just west of Hague, offers both hiking and paddling opportunities (right, top). The trails around the wetlands at the Lake George Land Conservancy's Gull Bay Preserve offer different options for viewing wildlife (right, bottom).

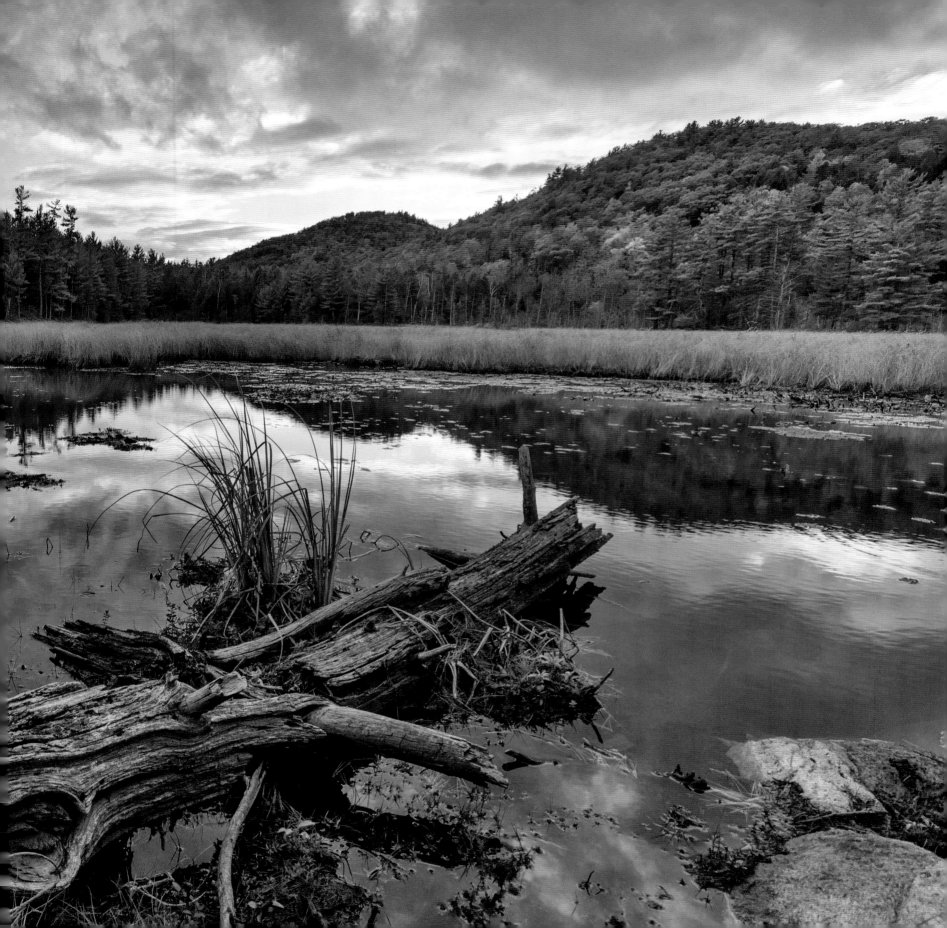

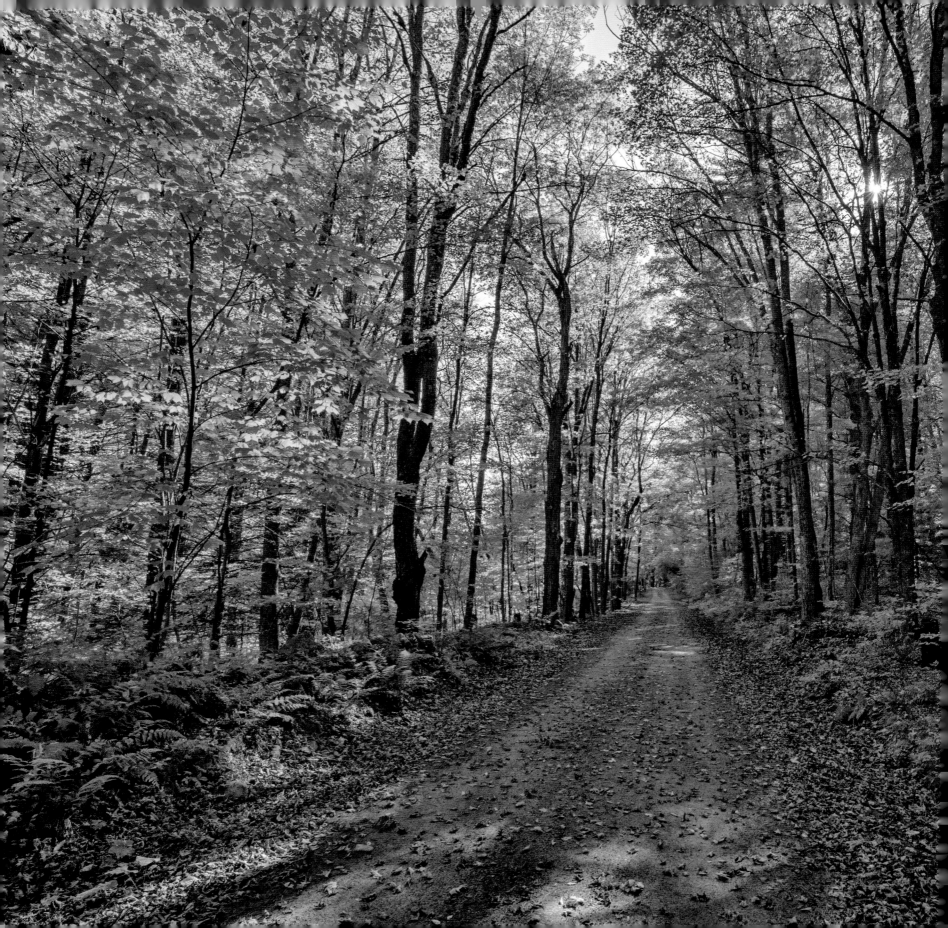

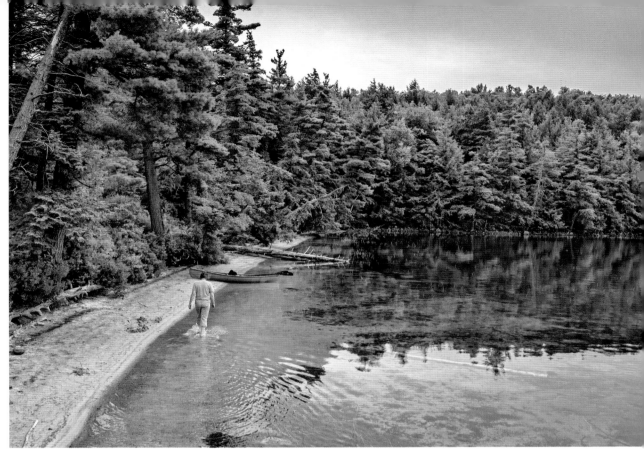
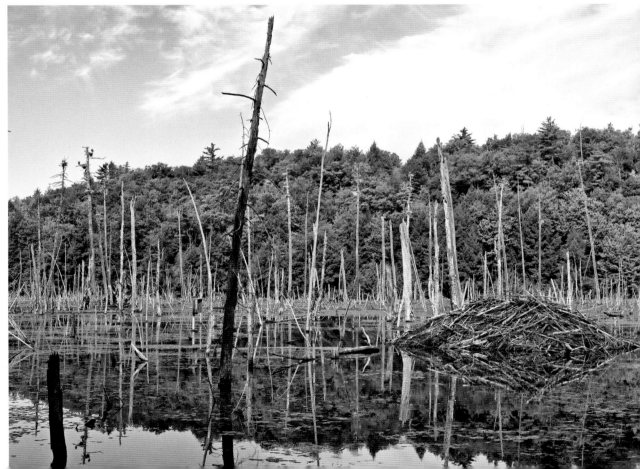

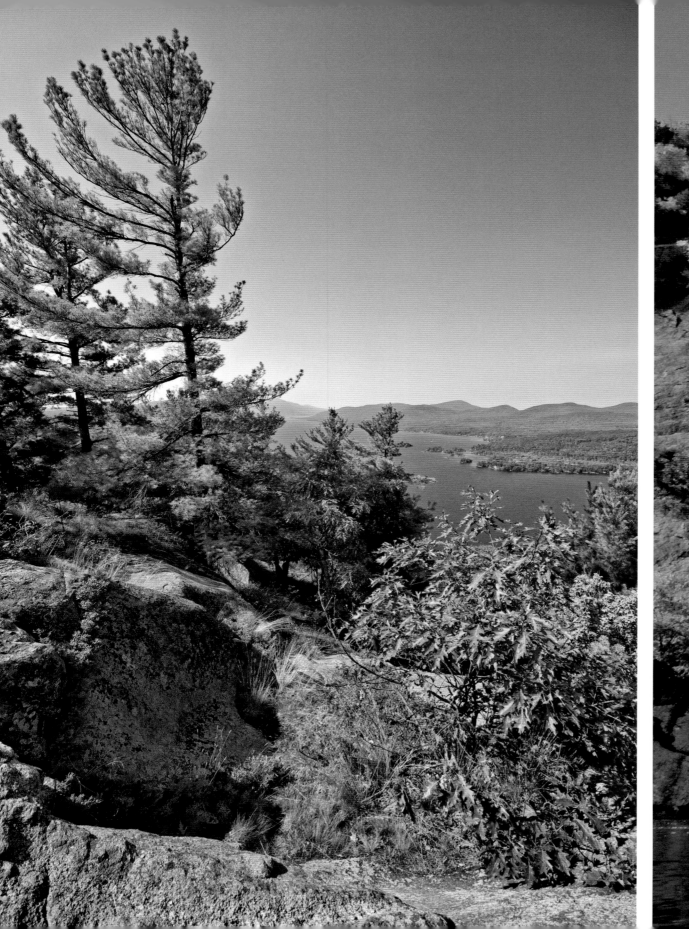
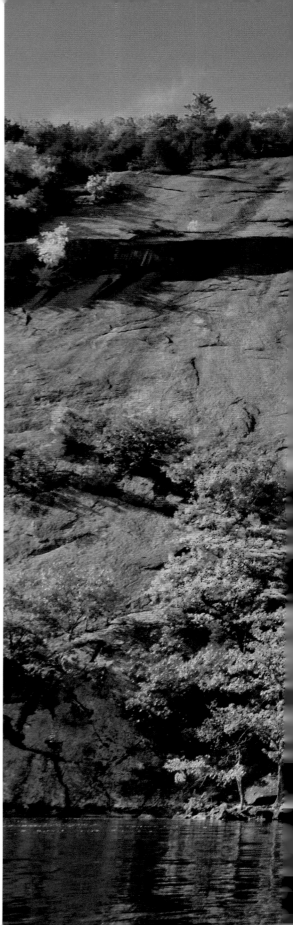

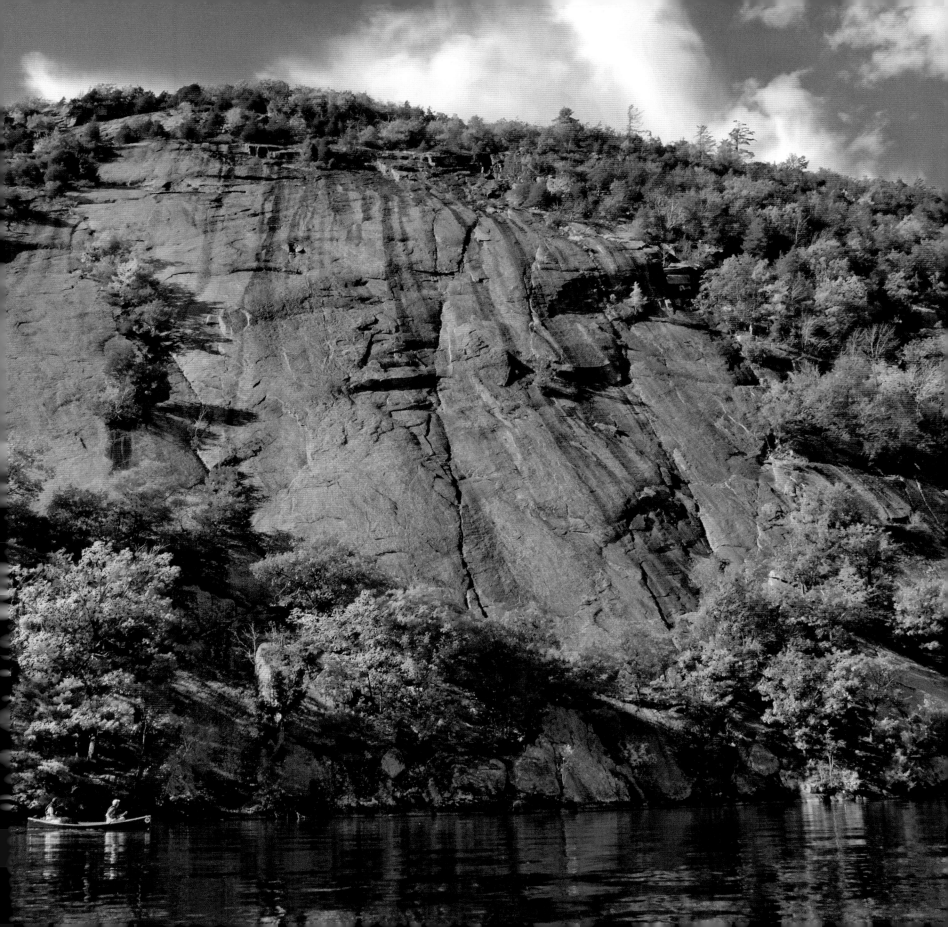

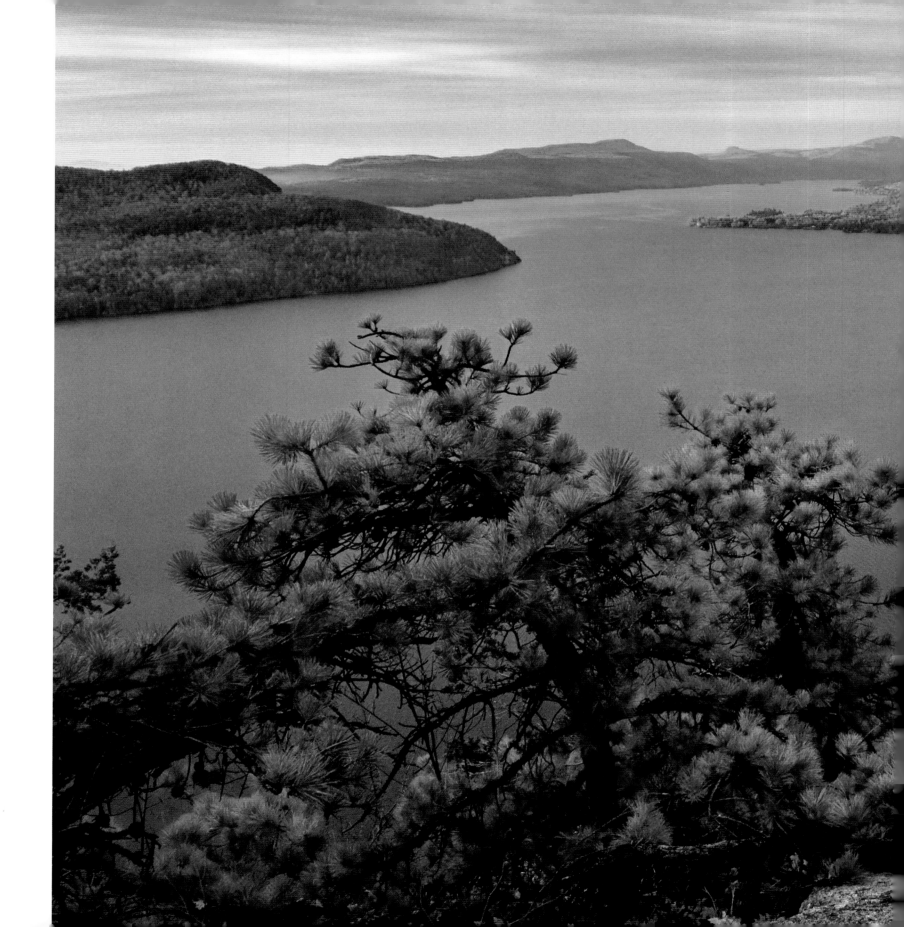

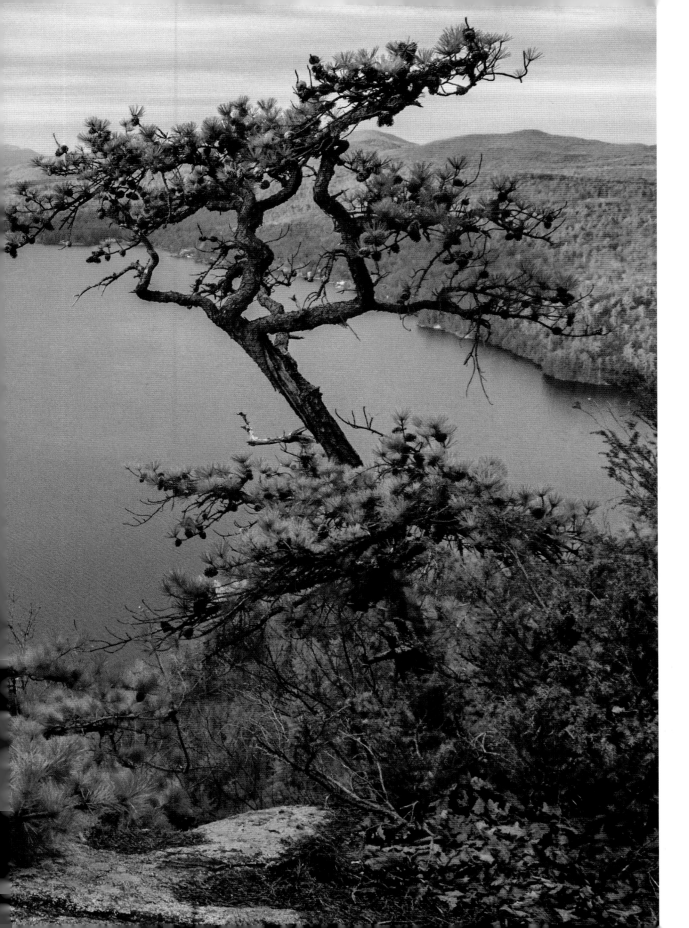

PREVIOUS SPREAD: Anthony's Nose near Glenburnie overlooks the northern Lake George region from open ledges near the summit (left). The historic Rogers Slide offers unique rock-climbing options with a 700-foot-high slab that rises from the waters of northern Lake George (right).

OPPOSITE: Trails on top of the mountain above Rogers Slide lead to a number of overlooks such as this one, which offers a view down the length of northern Lake George.

FOLLOWING SPREAD: The Cook Mountain Preserve near Ticonderoga has a series of trails leading to a beaver meadow and wetland and an overlook on top of the mountain (left). Spectacle Pond in the Pharaoh Lake Wilderness provides a great view of the rocky ledges on the south side of Pharaoh Mountain (right).

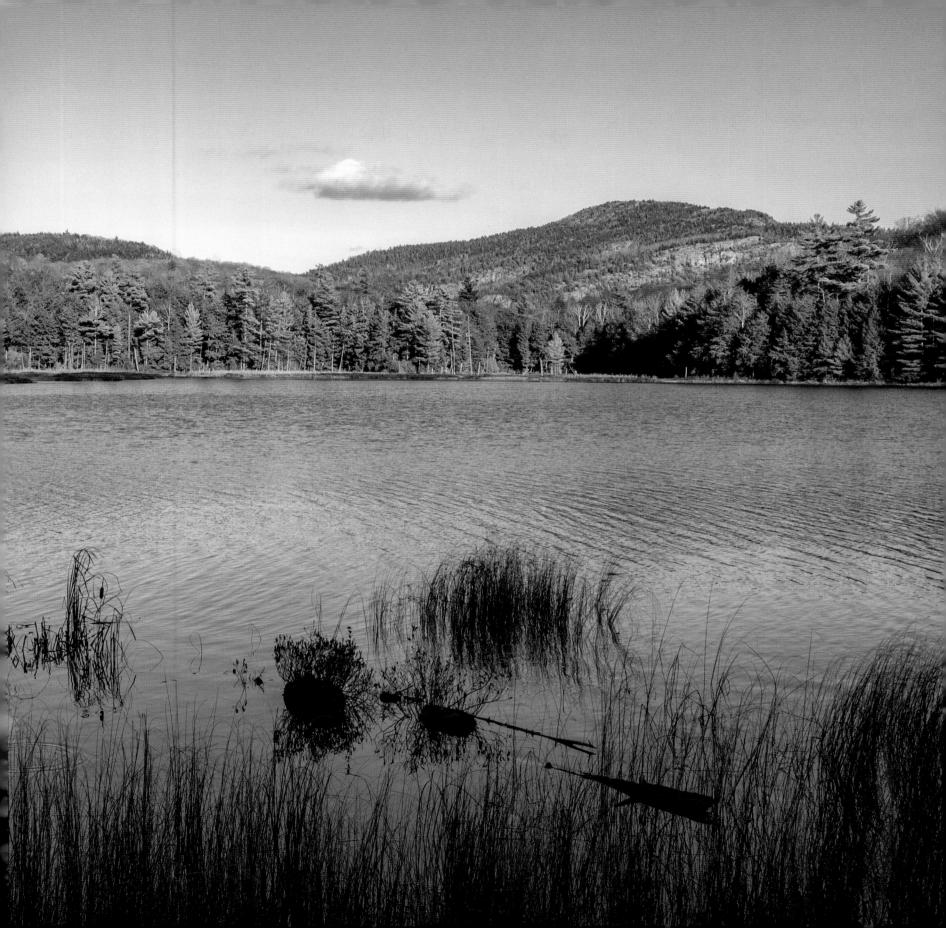

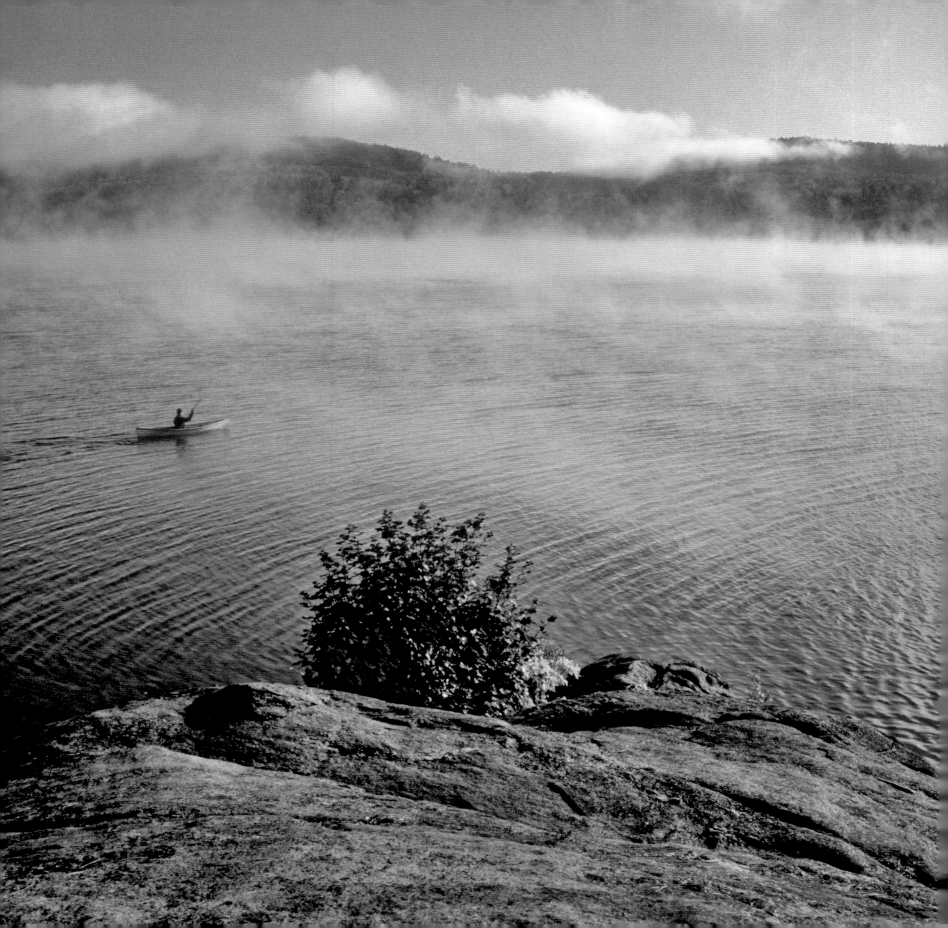

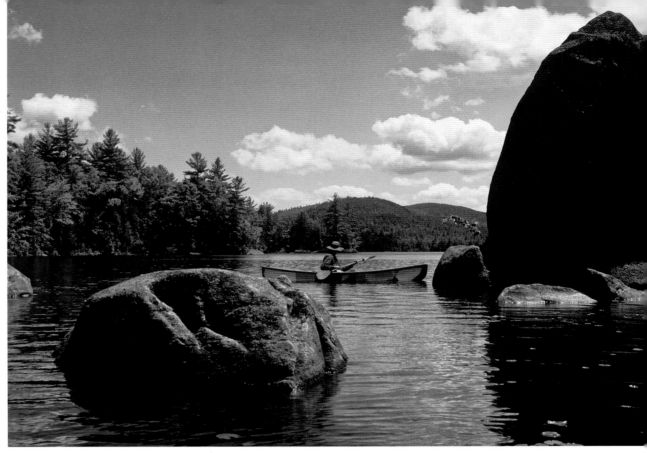
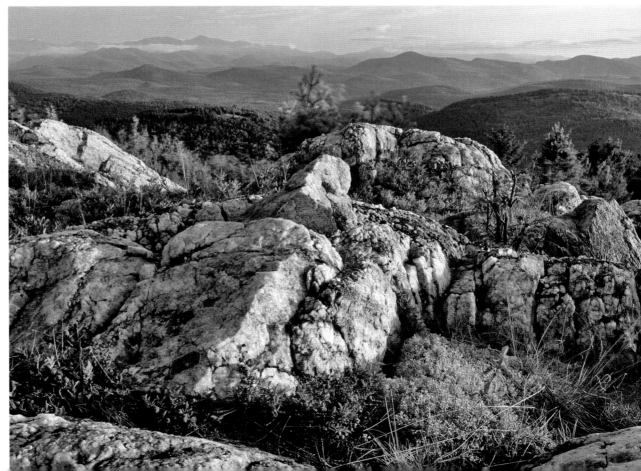

PREVIOUS SPREAD: It's easy to portage a lightweight Hornbeck canoe when planning to paddle on Pharaoh Lake (left). A paddler navigates around some huge boulders in a bay on northern Pharaoh Lake (right, top). The summit of Treadway Mountain offers great views that overlook the High Peaks to the north and west and Pharaoh Lake and the eastern Adirondacks in the opposite direction (right, bottom).

OPPOSITE: A paddler enjoys Goose Pond on a beautiful fall day, with a backdrop of Pharaoh Mountain.

FOLLOWING SPREAD: There's no turning back once you're off the ledge at this wild pond in the Pharaoh Lake Wilderness (left, top). A cross-country skier travels on the Berrymill Flow Trail in the Hammond Pond Wild Forest (left, bottom). The trail to Peaked Mountain in the eastern Siamese Ponds Wilderness follows the shore of Thirteenth Lake before turning north and then up this wild rocky mountain summit (right).

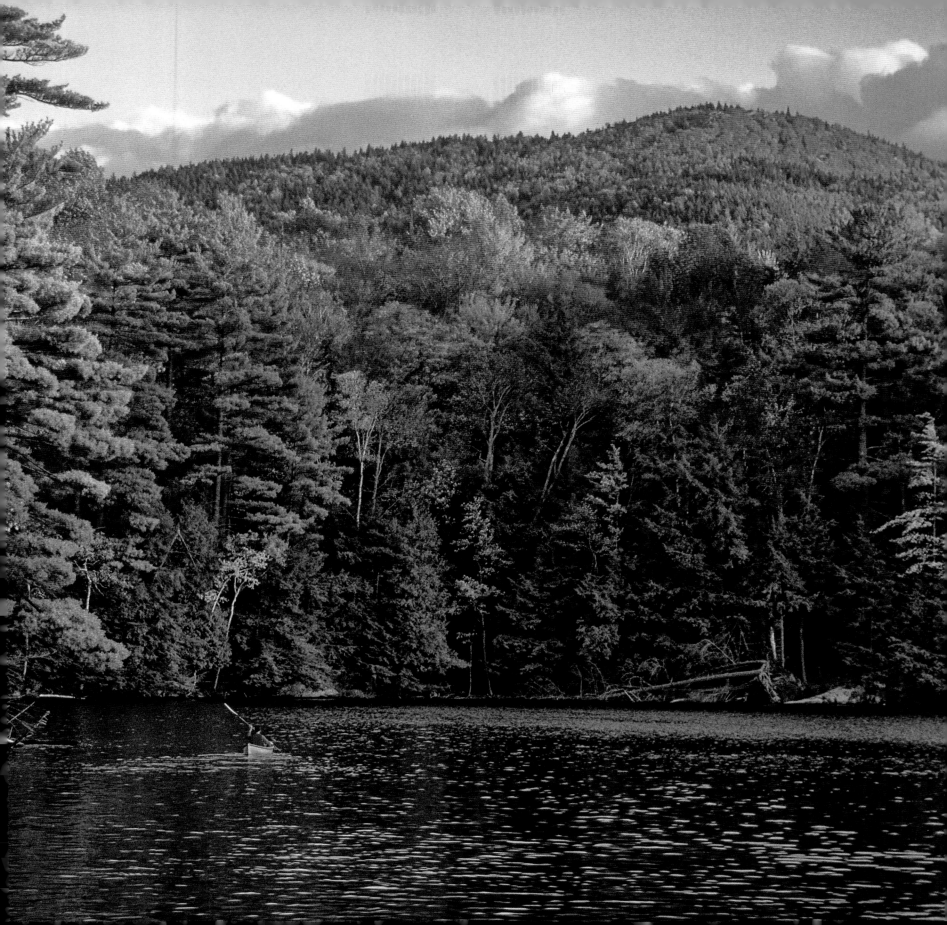

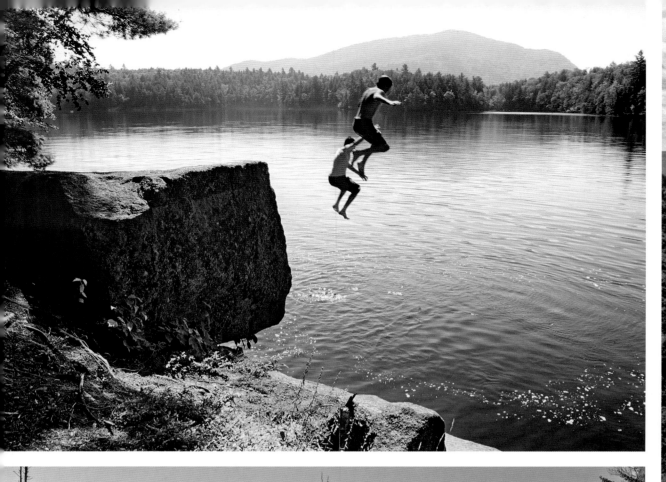

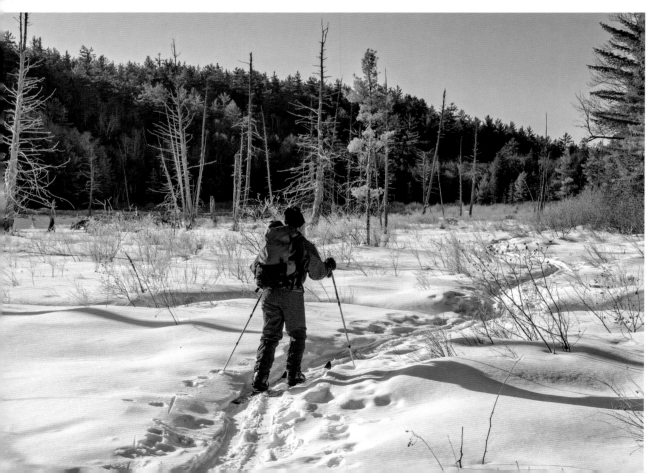

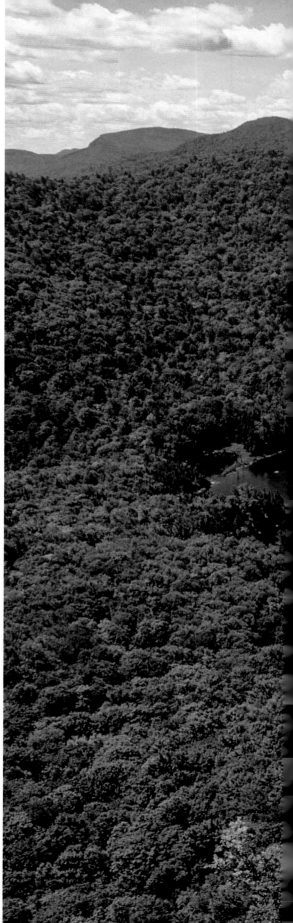

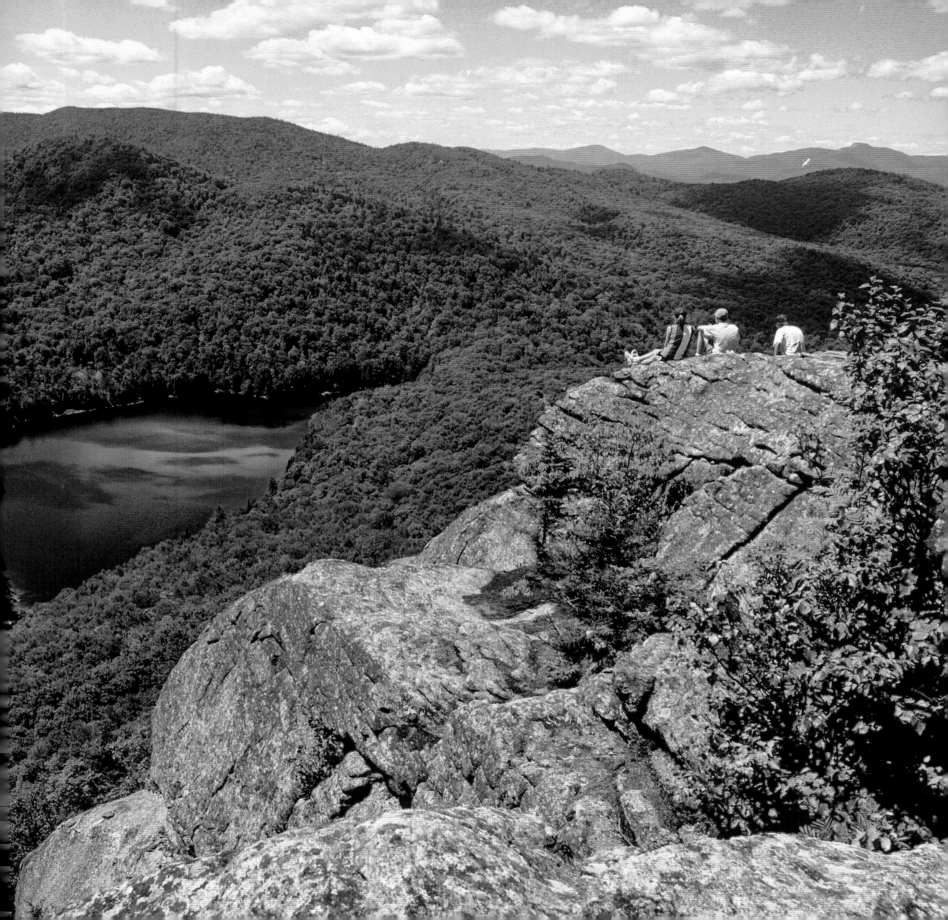

INDIAN LAKE AREA *and* CENTRAL ADIRONDACKS

It is here where it becomes obvious that the Adirondacks are not just mountains. They are also big, artful lakes and quiet, remote ponds. They are wetlands teeming with flora and fauna ranging from moose to no-see-ums, towering white pines to tiny lichens. And they are mile after mile of undulating forest. You can climb Blue Mountain or Snowy Mountain—almost 46ers—for commanding scopes of the surrounding countryside. If you want to walk for days at a time without the bother of a mountain in your way, the 138.6-mile-long Northville-Placid Trail beckons. Waterfalls are numerous and often easily reached; Auger Falls and Griffin Falls, near each other on the East Branch of the Sacandaga River, are favorites. (As at any falls, watch your footing, please.) Ponds are popular destinations as well; they are usually easy to reach and entertaining to visit, what with loons calling, trout jumping, and water darters, well, darting across the surface. The Adirondack Mountain Club's *Central Trails* guidebook describes hikes to eight ponds with enticing names such as Helldiver, Icehouse, and Sly—all but one of the treks less than three miles long—in a span of just five pages.

PREVIOUS SPREAD: Witch hopple closes in on the Northville-Placid Trail just south of Piseco Lake.

LEFT: The steep trail to Good Luck Mountain Cliffs passes by some huge boulders and other unique rock and cliff features.

OPPOSITE: Access to the cliff can be by trail or by water to this landing on the west shore of Good Luck Lake.

FOLLOWING SPREAD: The Northville-Placid Trail crosses the outlet of Buckhorn Lake.

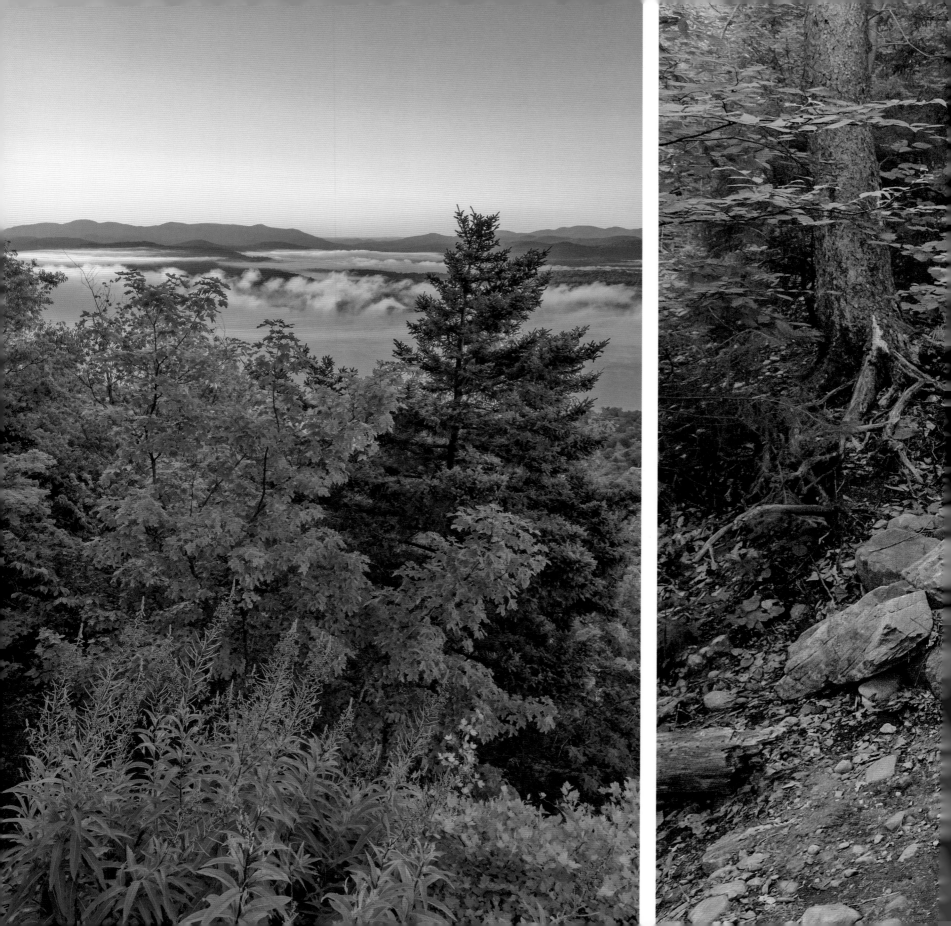

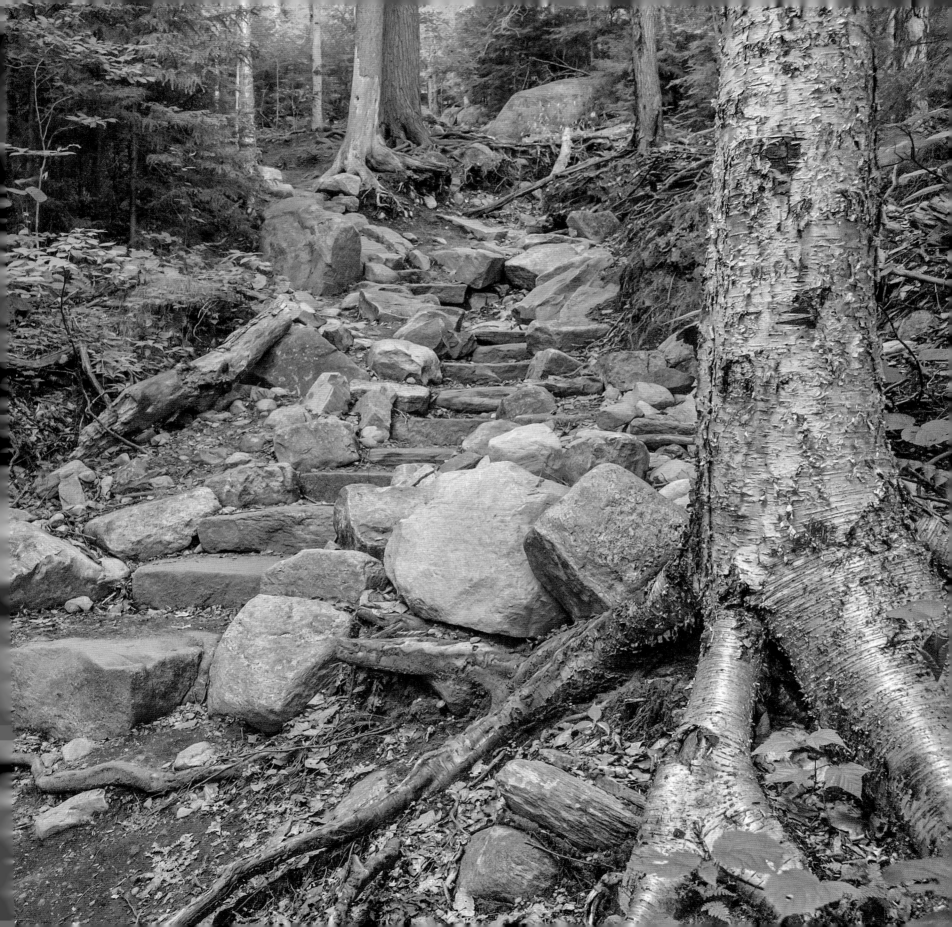

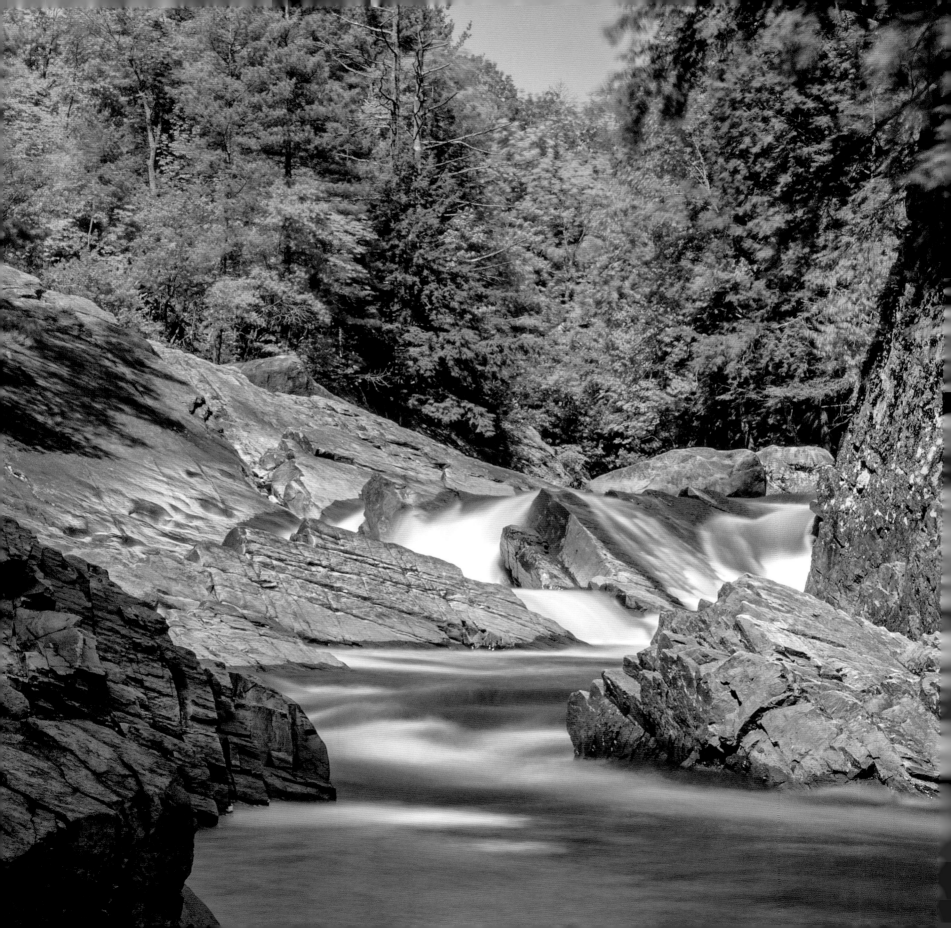

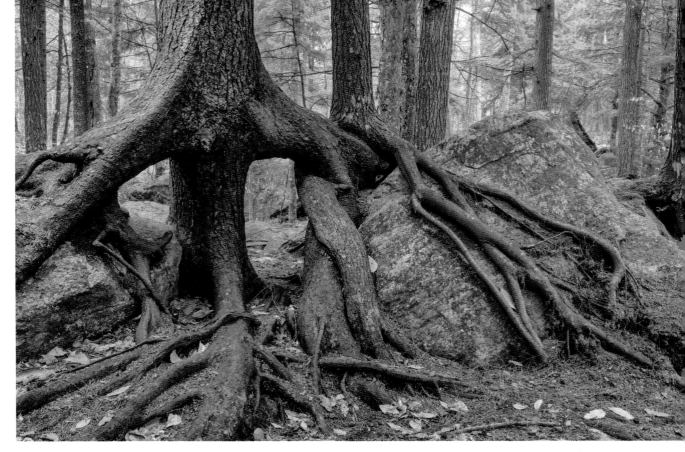

PREVIOUS SPREAD: Fireweed blooms along the edge of Echo Cliff, with morning mist over Piseco Lake in the background (left). This is one of several recently built sets of stone stairs that help stabilize the popular trail to Echo Cliff (right).

OPPOSITE: Griffin Gorge, on the East Branch Sacandaga River, is near the beginning of the trail to the east side of Auger Falls.

RIGHT: A unique woods sculpture of trees and roots (top) sits along the trail to the gorge below Auger Falls on the Sacandaga River (bottom).

FOLLOWING SPREAD: Bluets and violets bloom along the Sacandaga River upstream from Auger Falls (left, top). A small waterfall cascades along the shore of the Jessup River at the beginning of the trail to Dug Mountain Brook Falls (left, bottom). Mist rises from Buck Bay, where the Kunjamuk River joins the Sacandaga River (right).

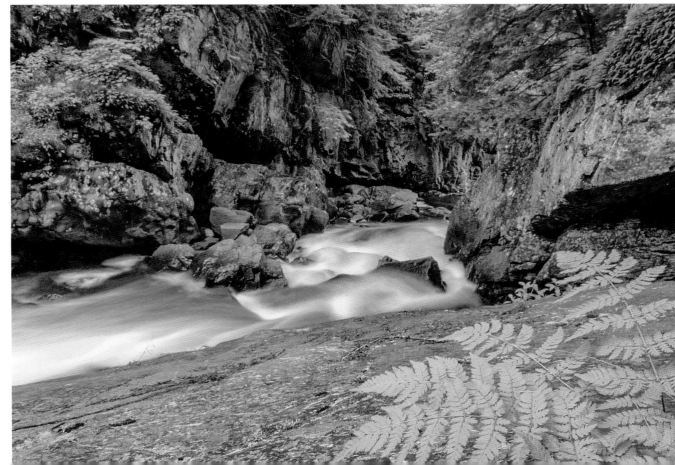

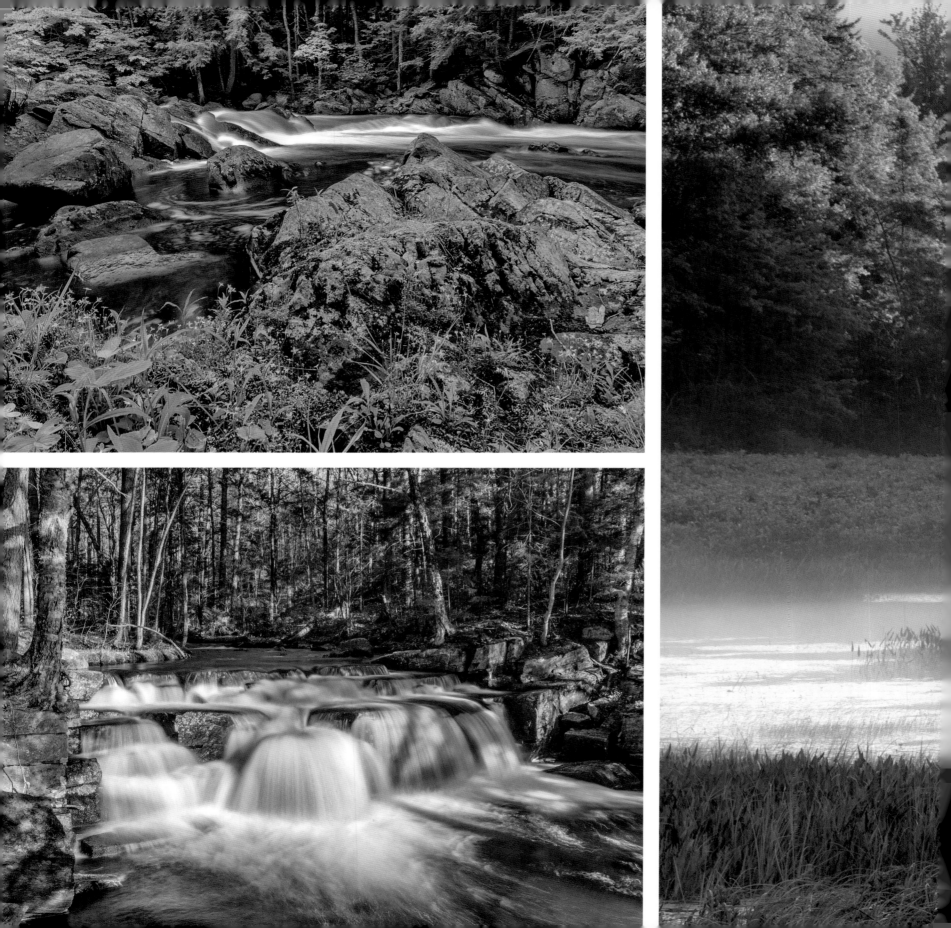

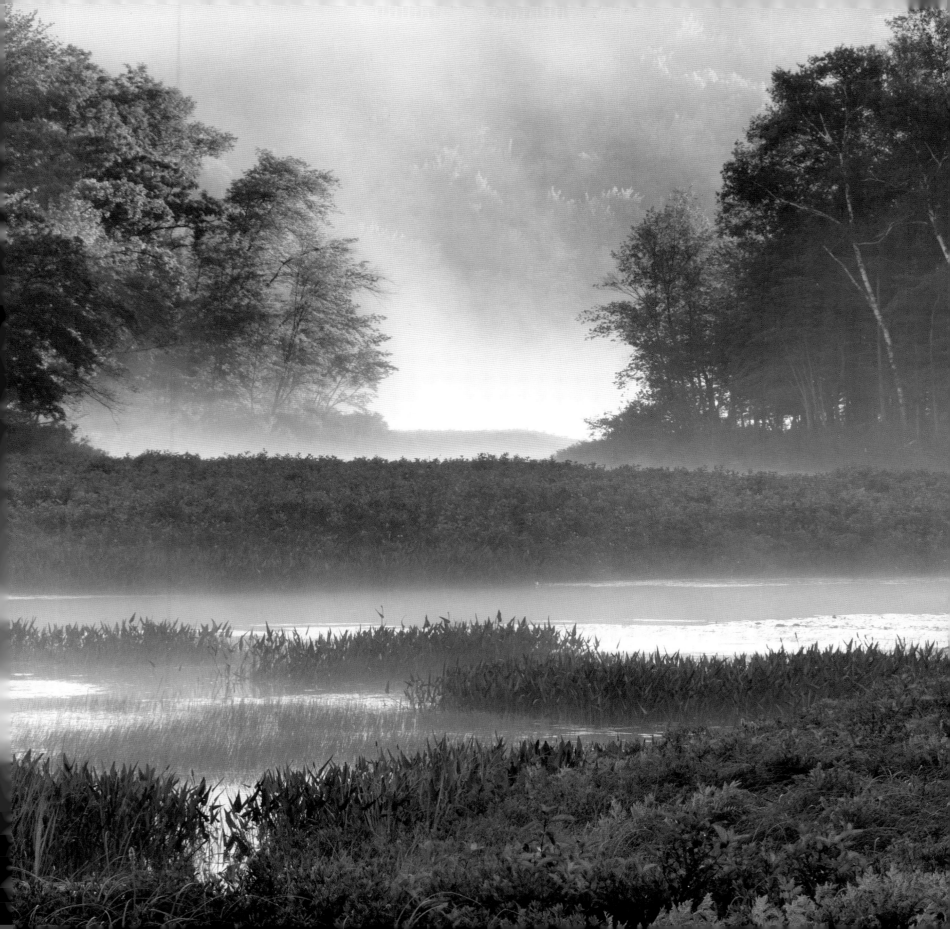

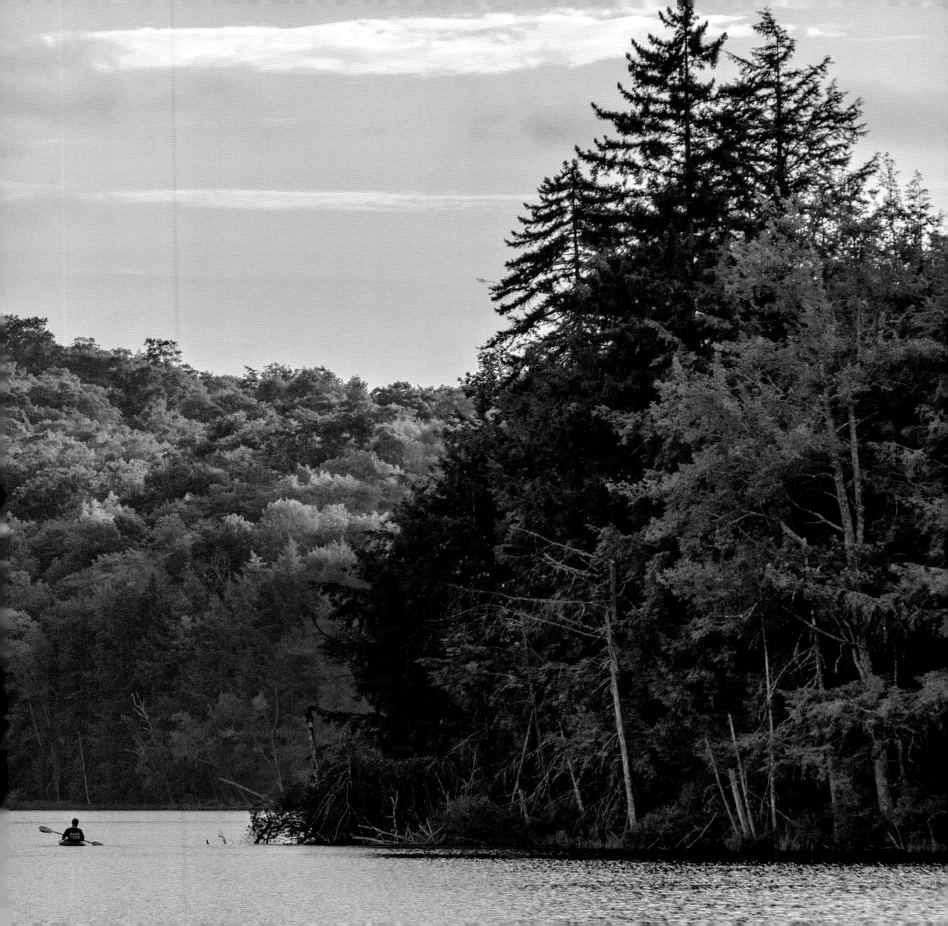

PREVIOUS SPREAD: A pair of kayakers enjoys a late afternoon paddle on Mason Lake.

OPPOSITE: A recently built beaver dam barricades the paddling route on the Miami River.

FOLLOWING SPREAD: At 3,899 feet, Snowy Mountain is the highest mountain in the park outside of the High Peaks region. While the fire tower provides a 360-degree view, this opening on the summit ridge offers a great view of Indian Lake and mountains to the east (left). Exposed roots and stone stairs are a common sight along the trail (right, top). The trail passes by a huge burl at the base of a yellow birch on a more level section (right, bottom).

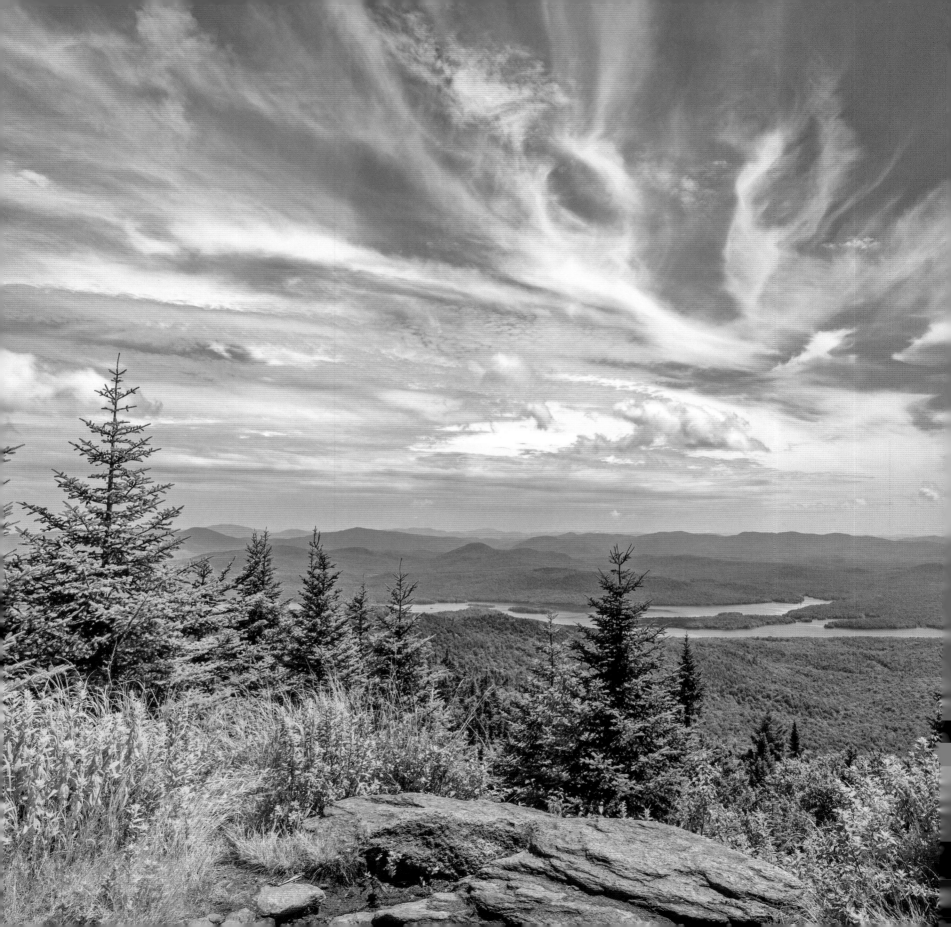

PREVIOUS SPREAD: Ice-encased branches glitter in the sunlight along the trail to Sawyer Mountain (left). The beautiful Cedar River is near the Essex Chain of Lakes (right).

OPPOSITE: Blueberries bloom on a spring morning near the summit of Moxham Mountain.

FOLLOWING SPREAD: Fall color surrounds the trail along the summit ridge of Moxham Mountain, while sunrise color highlights the clouds (left, top). Shadbush blooms on the summit in mid-May (left, bottom). This rather unique cairn was once along the Moxham Mountain Trail (right).

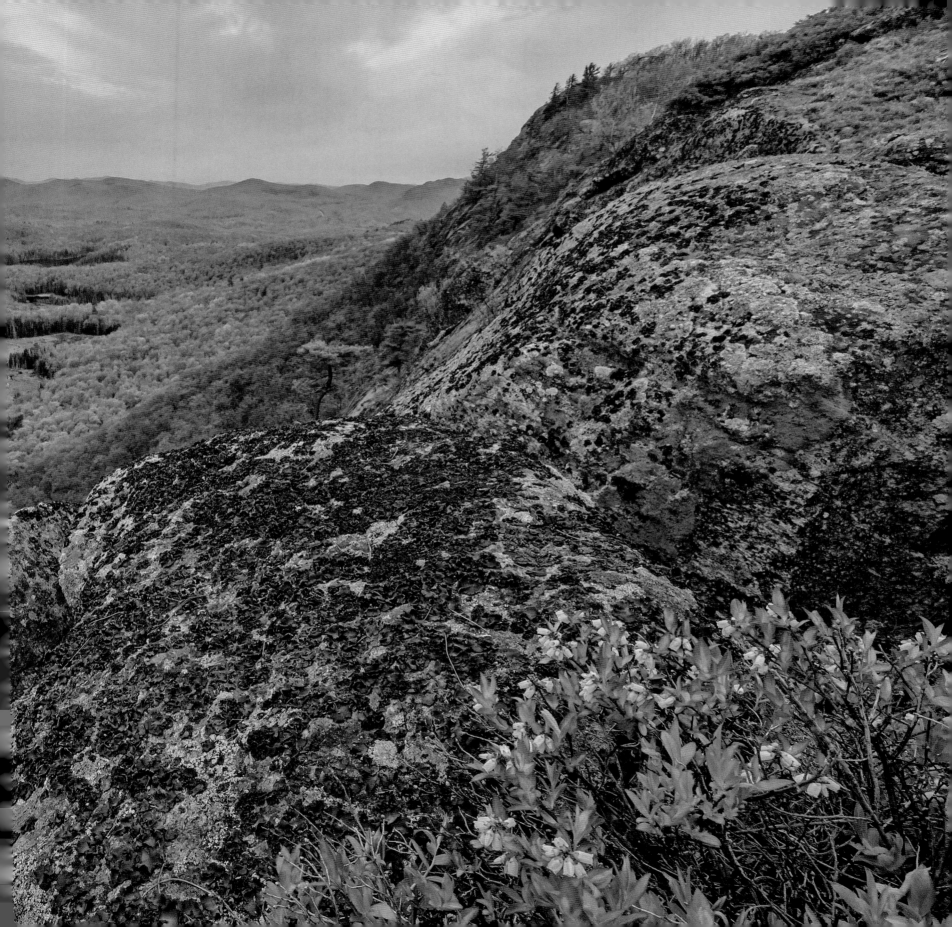

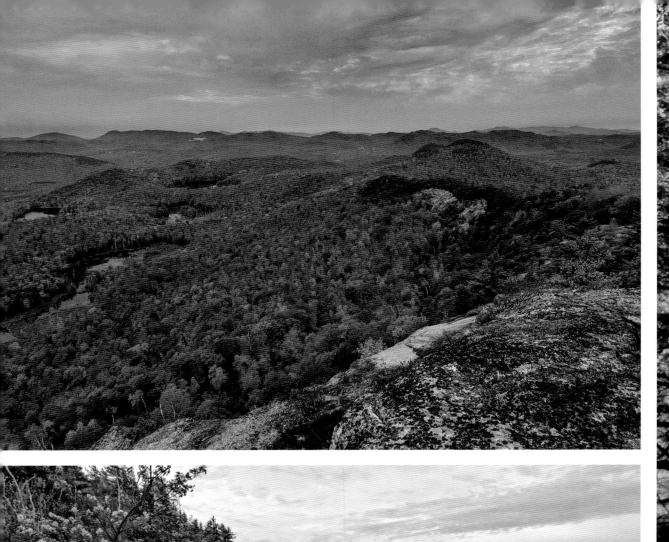

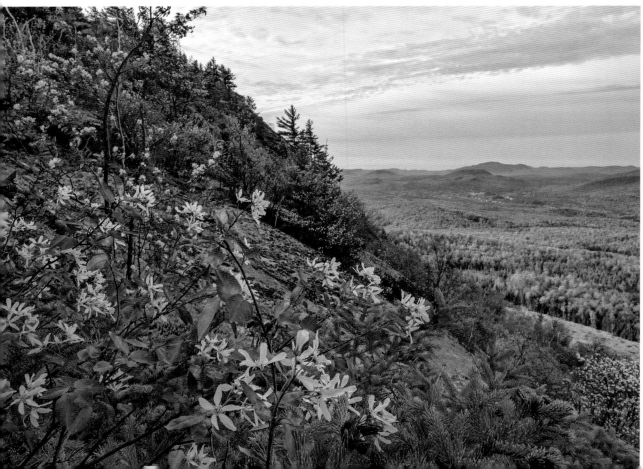

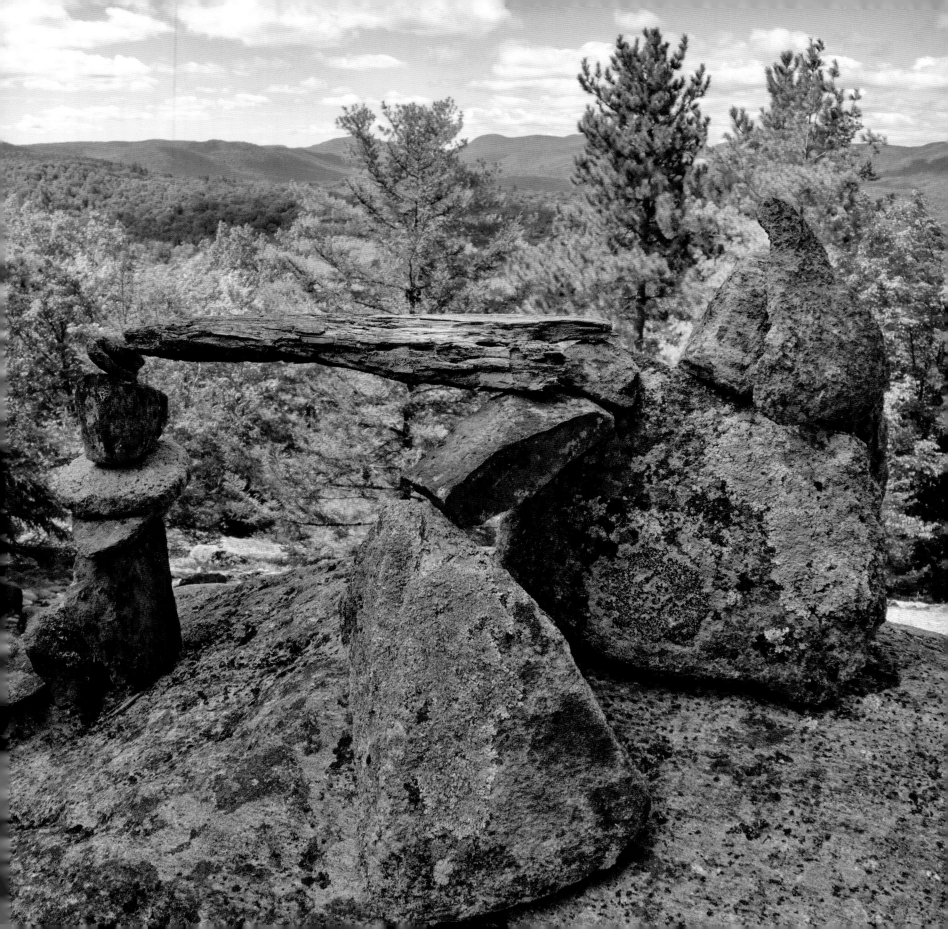

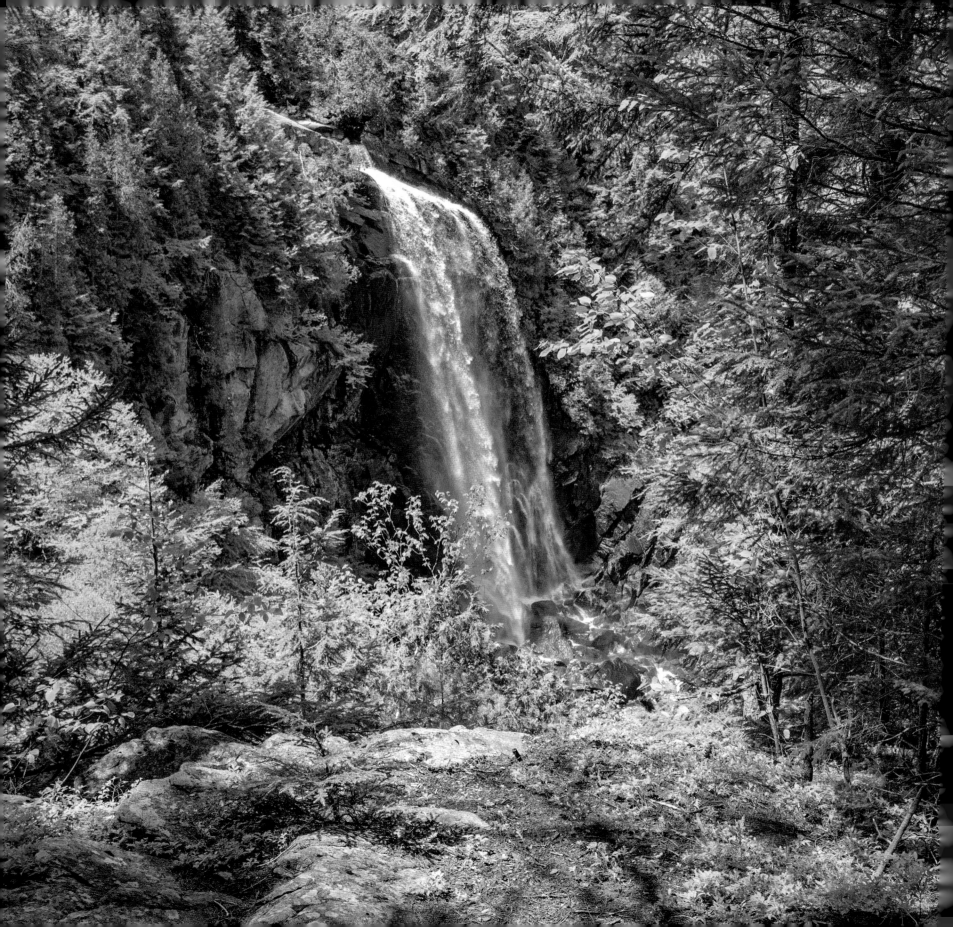

OK SLIP FALLS

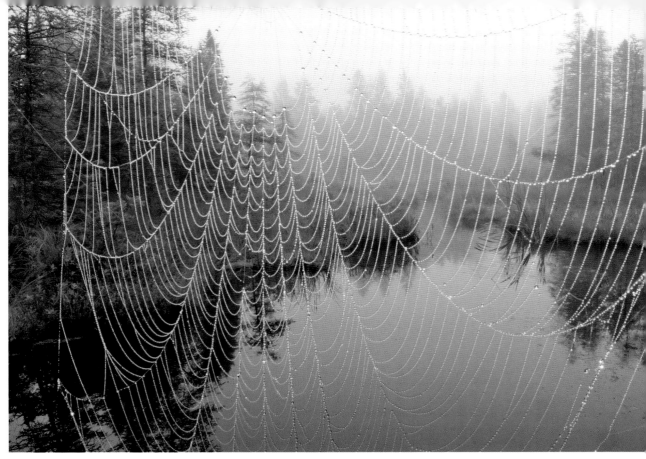

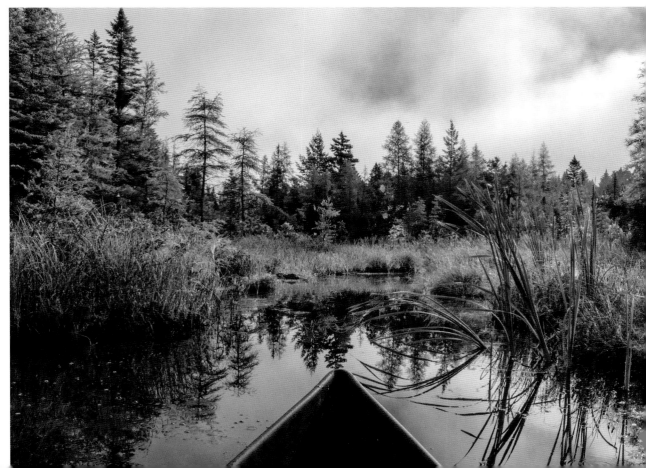

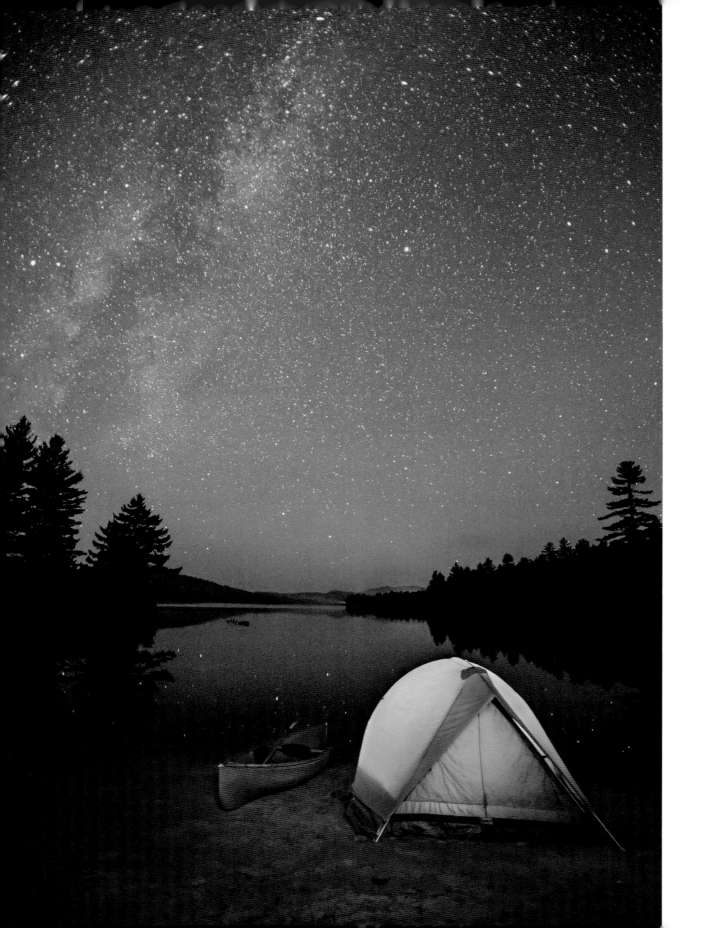

PREVIOUS SPREAD: The water flowing over OK Slip Falls drops more than 200 feet, making this one of the tallest waterfalls in the Adirondack Park (left). Helldiver Pond is one of many hiking, paddling, and camping destinations within the Moose River Plains Wild Forest complex (right, top and bottom).

LEFT: Stars and the Milky Way reflect in the calm water of Lake Durant.

OPPOSITE: A family enjoys a paddle on Lake Durant in the glow of a summer sunset.

FOLLOWING SPREAD: The full moon reflects in Lake Durant, with the last glow of color from the sun highlighting the clouds.

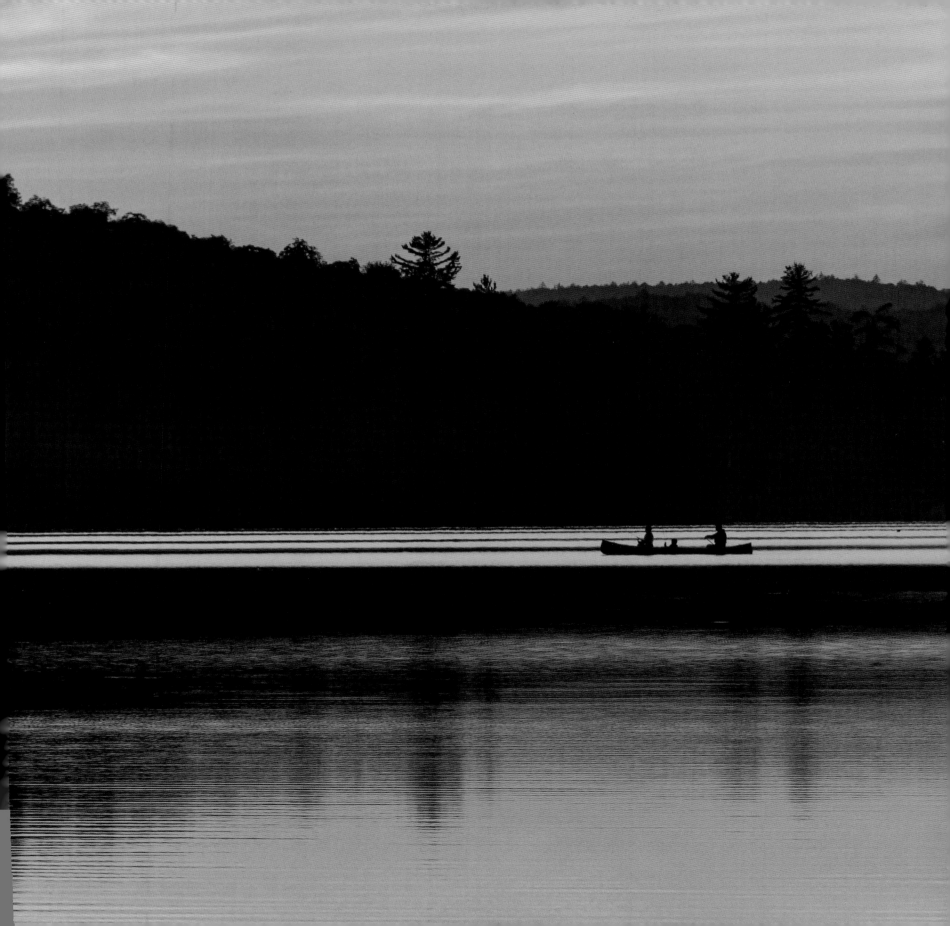

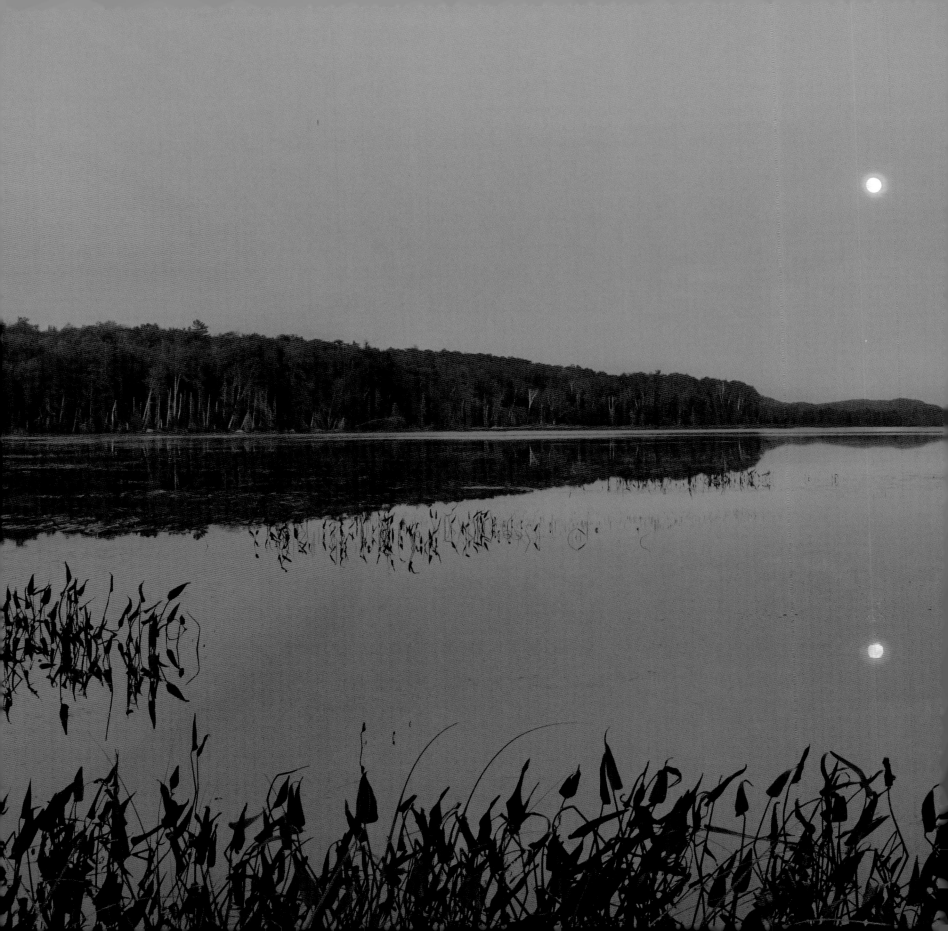

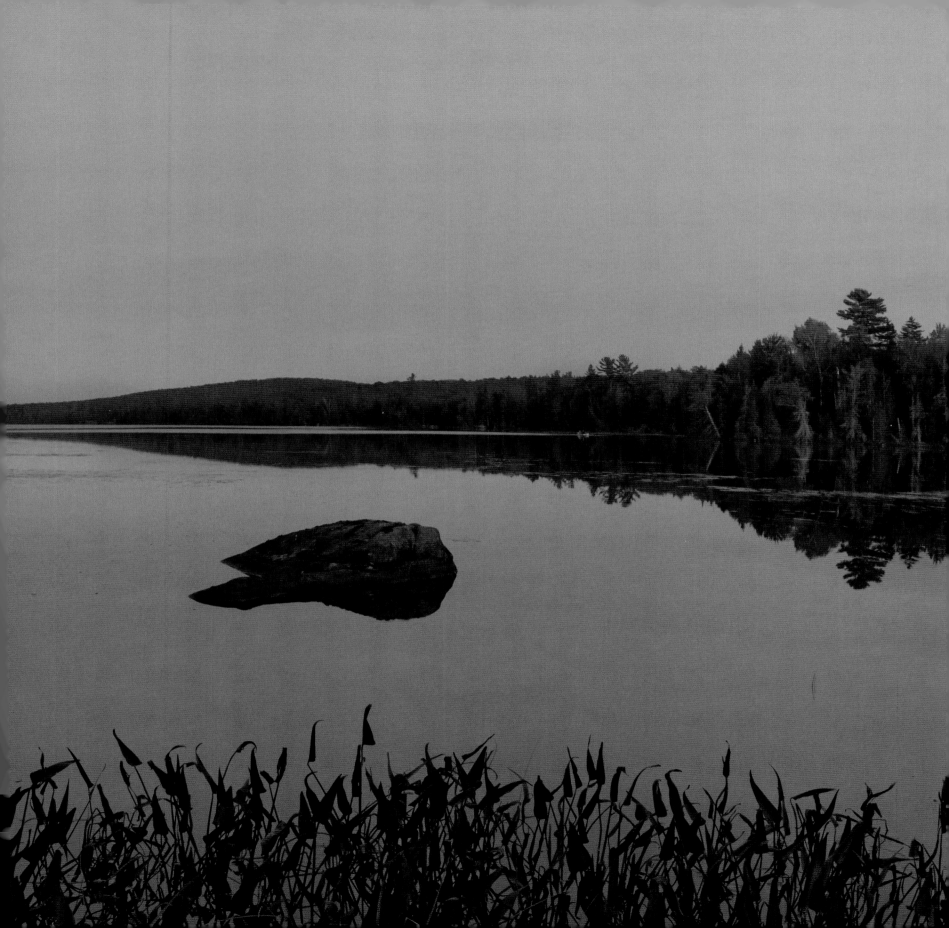

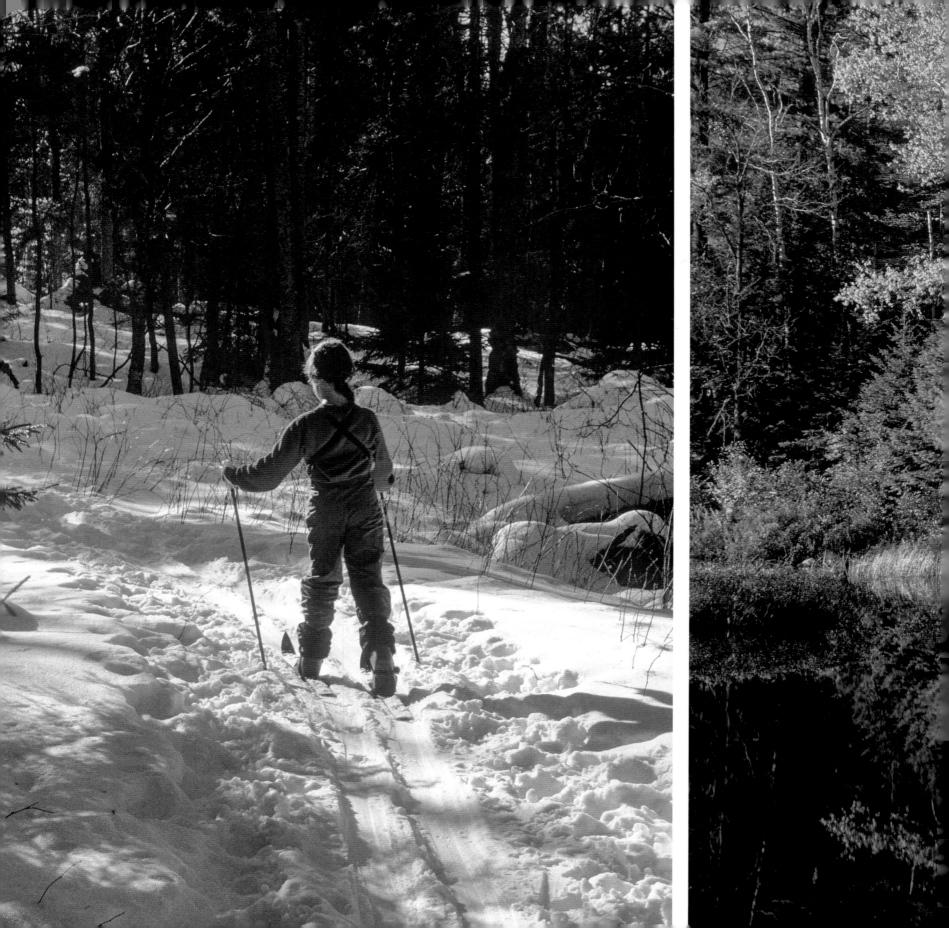

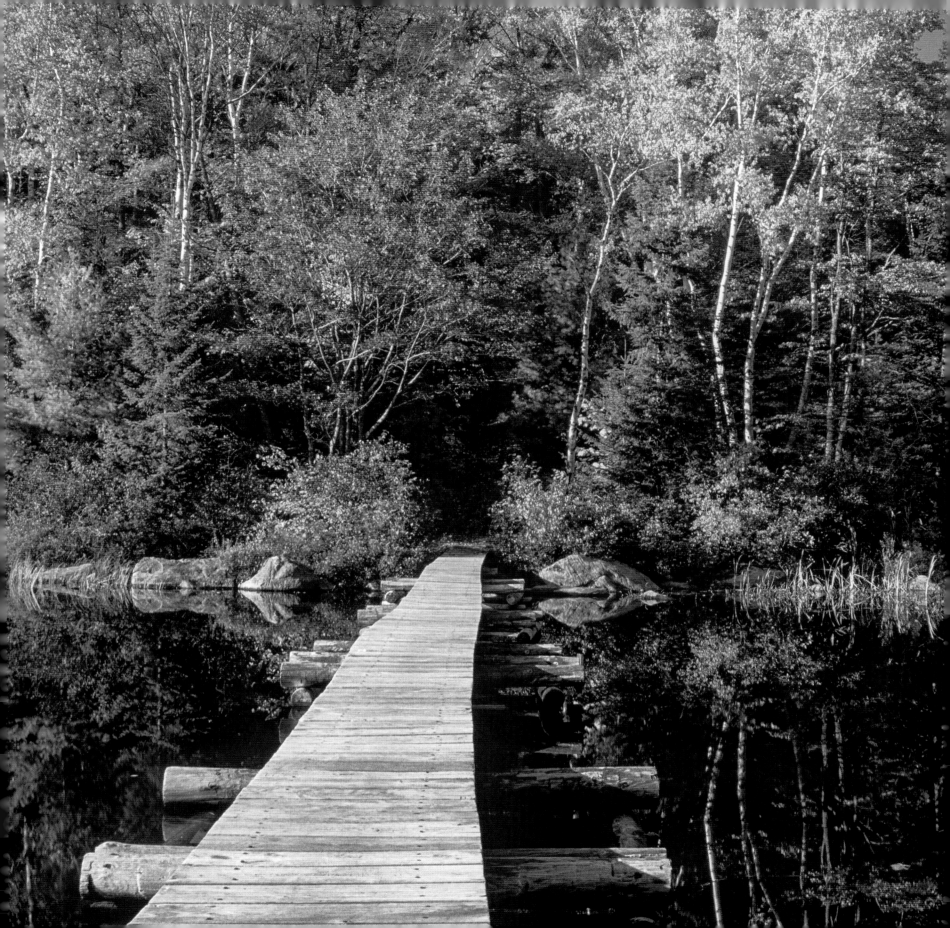

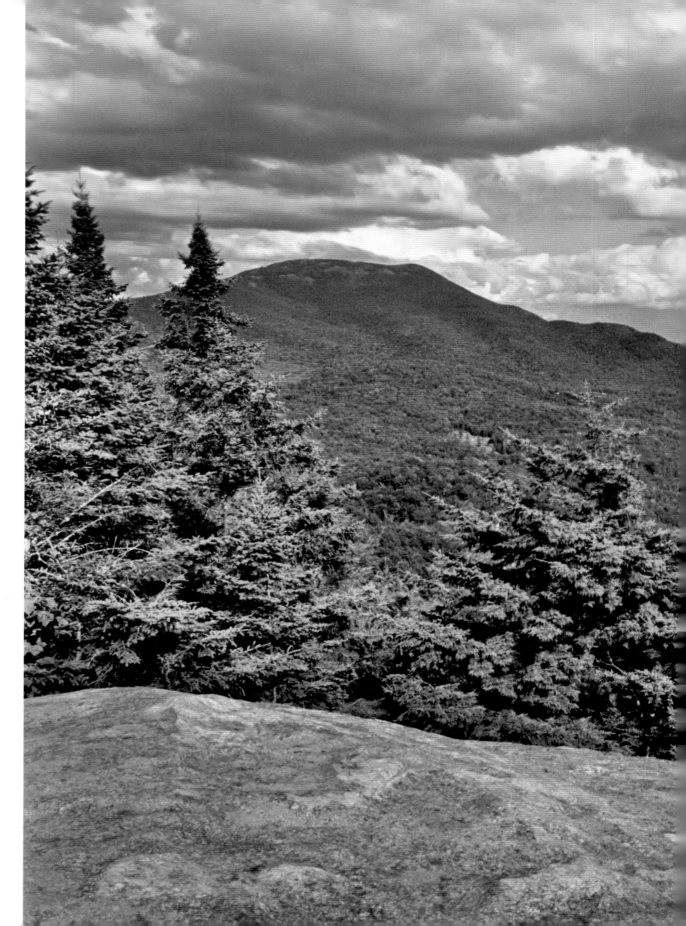

PREVIOUS SPREAD: A young cross-country skier traverses a trail near Great Camp Sagamore (left). The trail to Cascade and Stephens Ponds crosses over Rock Pond at the west end of Lake Durant (right).

OPPOSITE: Castle Rock offers a wonderful view looking east toward Blue Mountain and south toward Blue Mountain Lake.

FOLLOWING SPREAD: While the summit of Blue Mountain has a couple of open spots with shielded views, the fire tower has views in all directions. The view to the west includes Blue Mountain Lake, Eagle Lake, Utowana Lake, Raquette Lake, Forked Lake, and Minnow Pond (left). The view to the northeast includes Tirrell Pond in the foreground and the High Peaks on the horizon (right, top). In winter, the tree branches on Blue Mountain are typically covered with a foot or more of snow (right, bottom).

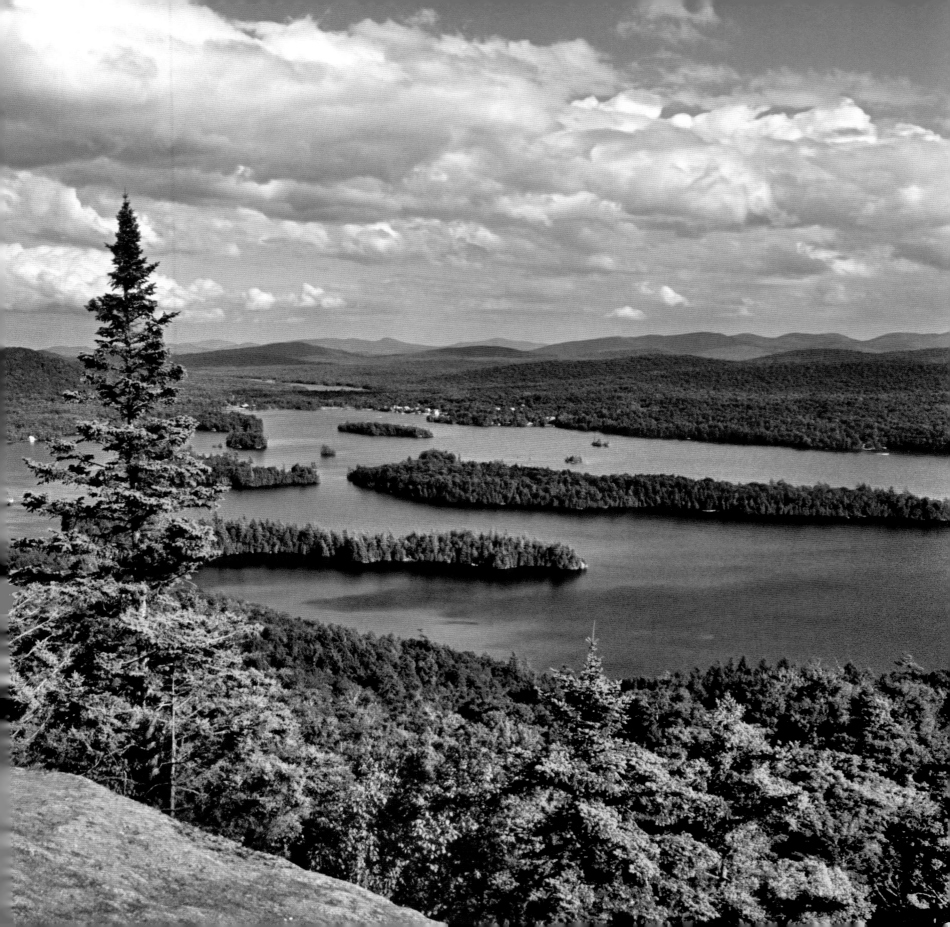

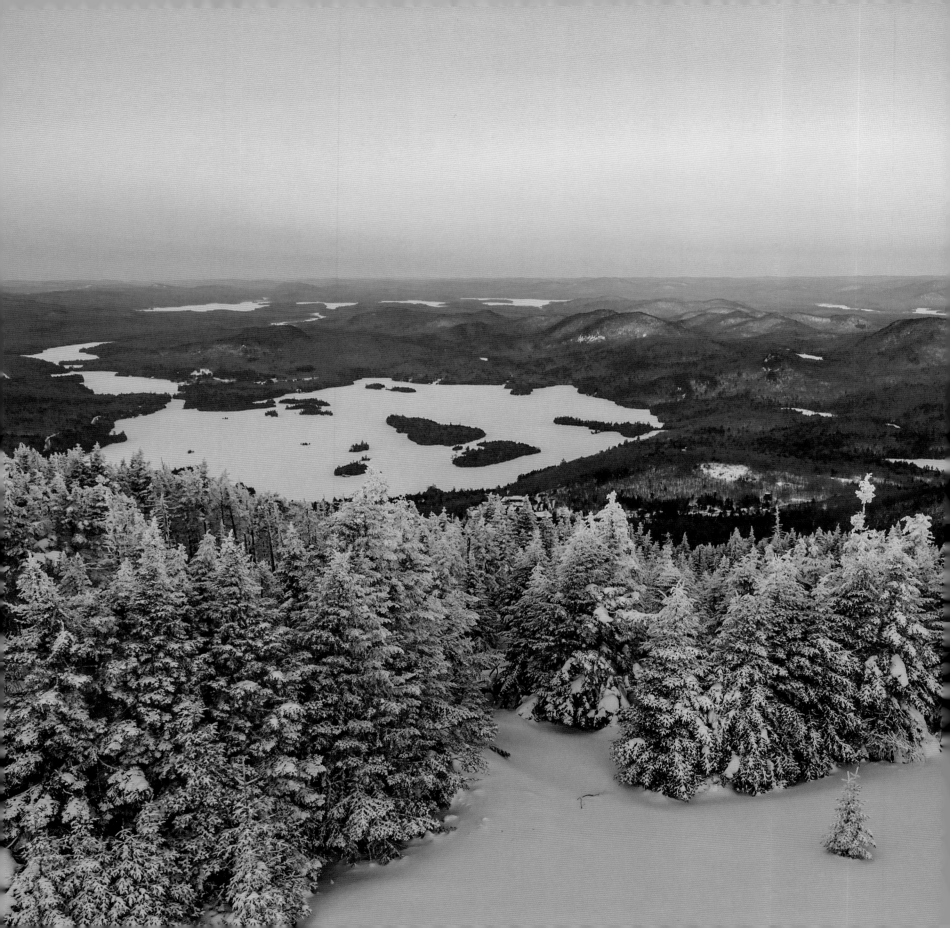

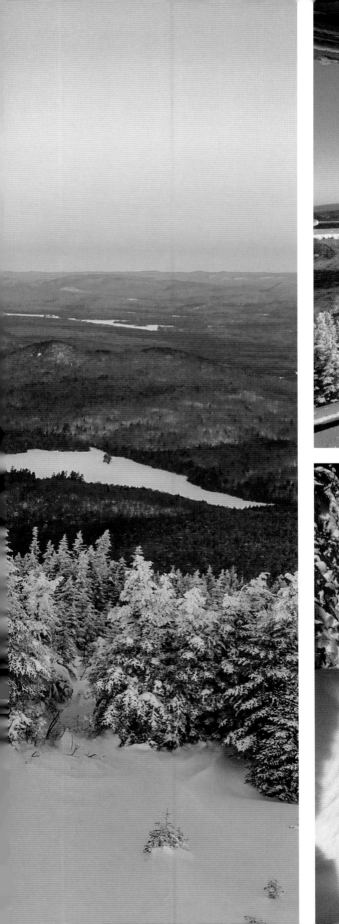
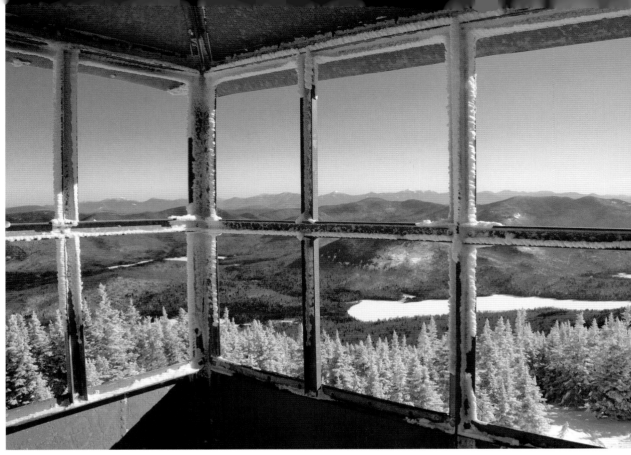

OLD FORGE, TUPPER LAKE AREA, *and* WESTERN ADIRONDACKS

It is in this part of the park where one realizes the vastness of the Adirondacks, where one can begin to see why it would be possible to fit so many small US states inside the park. One can also grasp why the first word that should come to mind in describing the Adirondacks is "woods," not "mountains." Few prominences punctuate the western Adirondacks, but a handful of those that do feature restored fire towers. Stillwater, for example, is about the easiest hike you can imagine in order to be rewarded with a great view, which exists because there's nothing to get in the way. From these lookouts it's easy to tell how well watered the western Adirondacks are—with lakes, ponds, and rivers galore. In this most-remote and least-visited section of the Adirondacks, trails take you to such intriguing destinations as Adrenaline Falls, Bald Mountain, Queer Lake, Confusion Flats, Slush Pond, Easy Street, Heron Marsh, Frost Pocket, Ledge Mountain Overlook, the Potato Patch, Russian Lake, Sunday Creek, Willys Cave, Woodhull Dam, and Golden Stair Mountain. You can walk the Mad Tom Trail, the Milk Can Trail, the Lost Pond Nature Trail (don't worry; it's well marked), the Mudhole Trail (not in mud season, though), the Arab Mountain Trail, the Eagle Cliff Trail, and the Silvermine Trail. There's no end of evocative names in this sprawling expanse of the Adirondacks, all inviting exploration.

PREVIOUS SPREAD: The sun sets at Lake Lila.

OPPOSITE: Gull Lake is one of many lakes and ponds with foot-trail access in the western Adirondacks.

FOLLOWING SPREAD: The Moose River has a mix of calm, flat water and scenic rocky sections, in addition to some sections of Class 5 white water during periods of high water flow (left). Kayakers enjoy a calm section of the Moose River near the Green Bridge in Thendara (right).

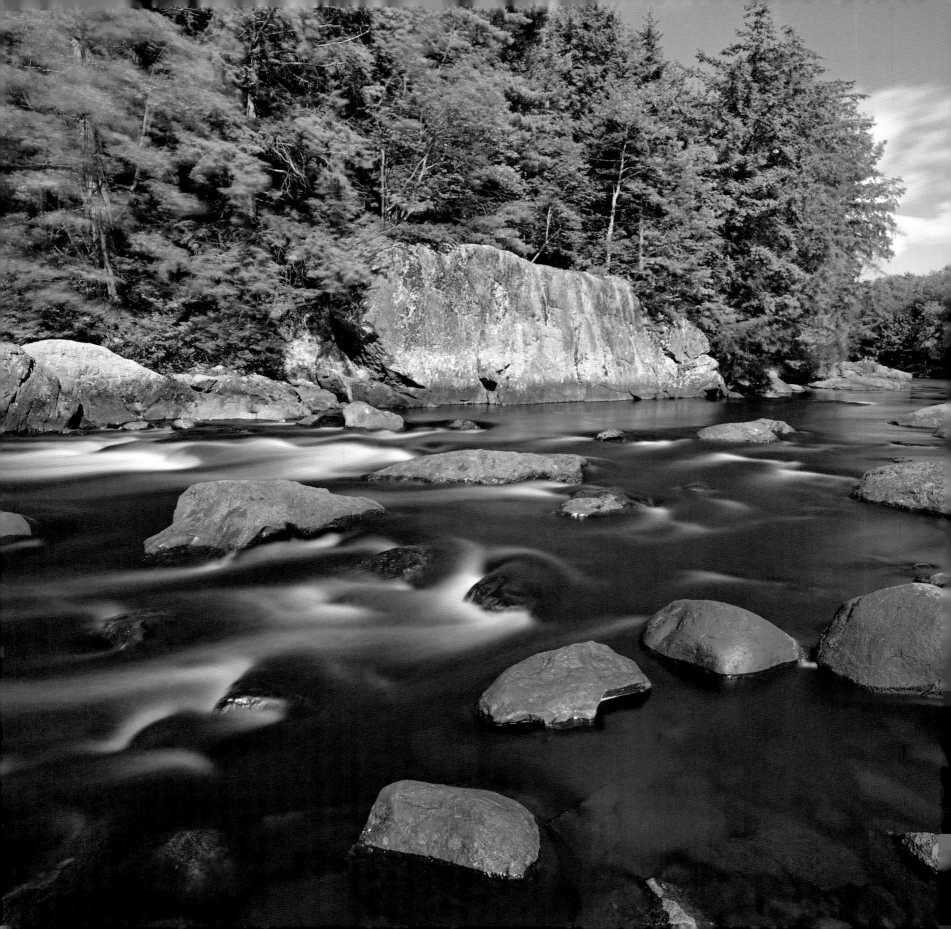

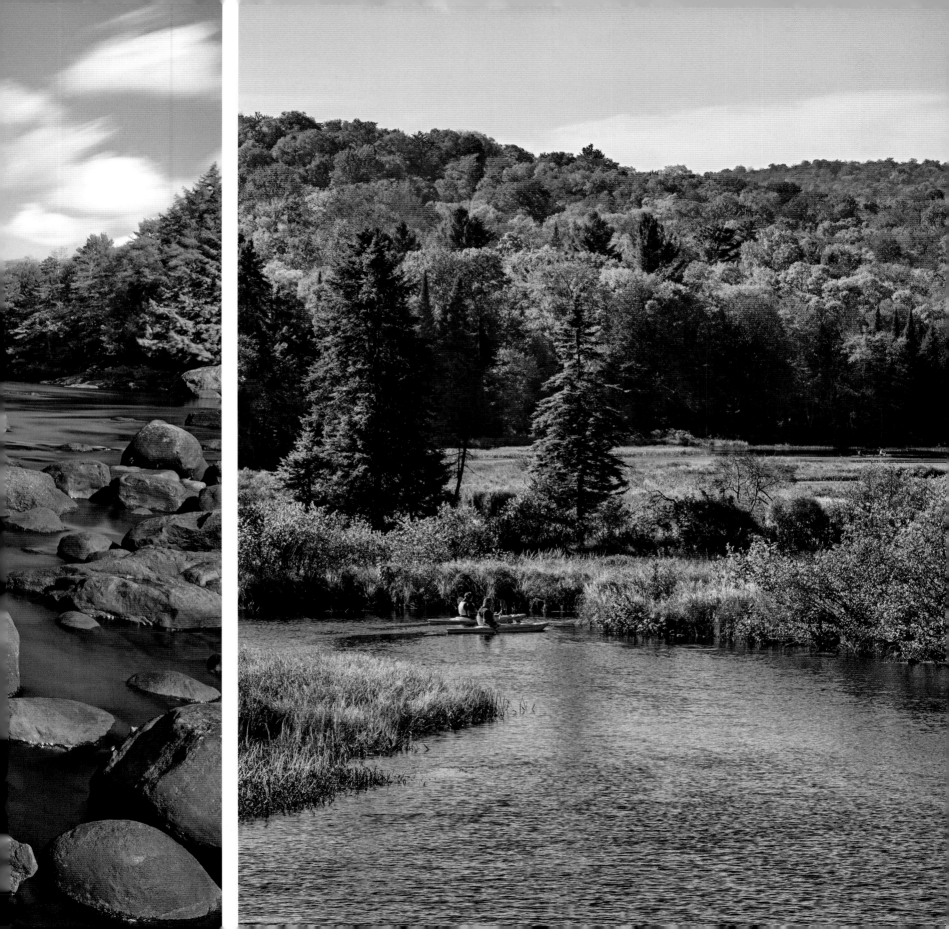

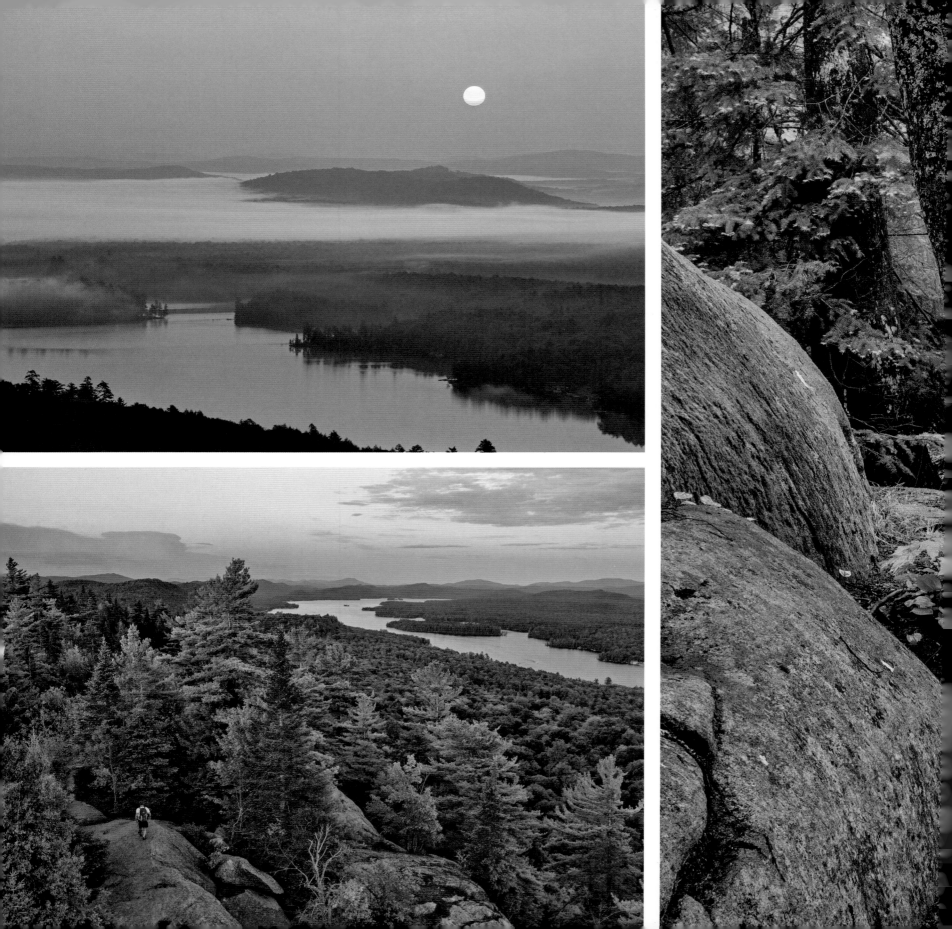

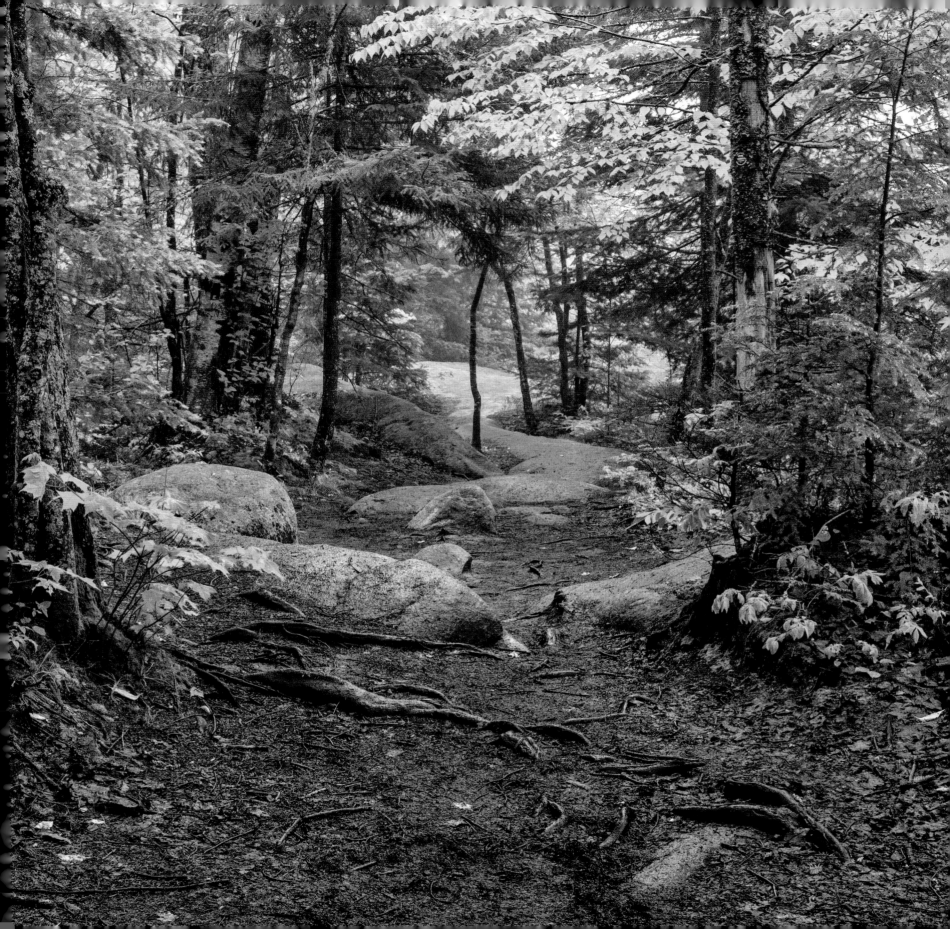

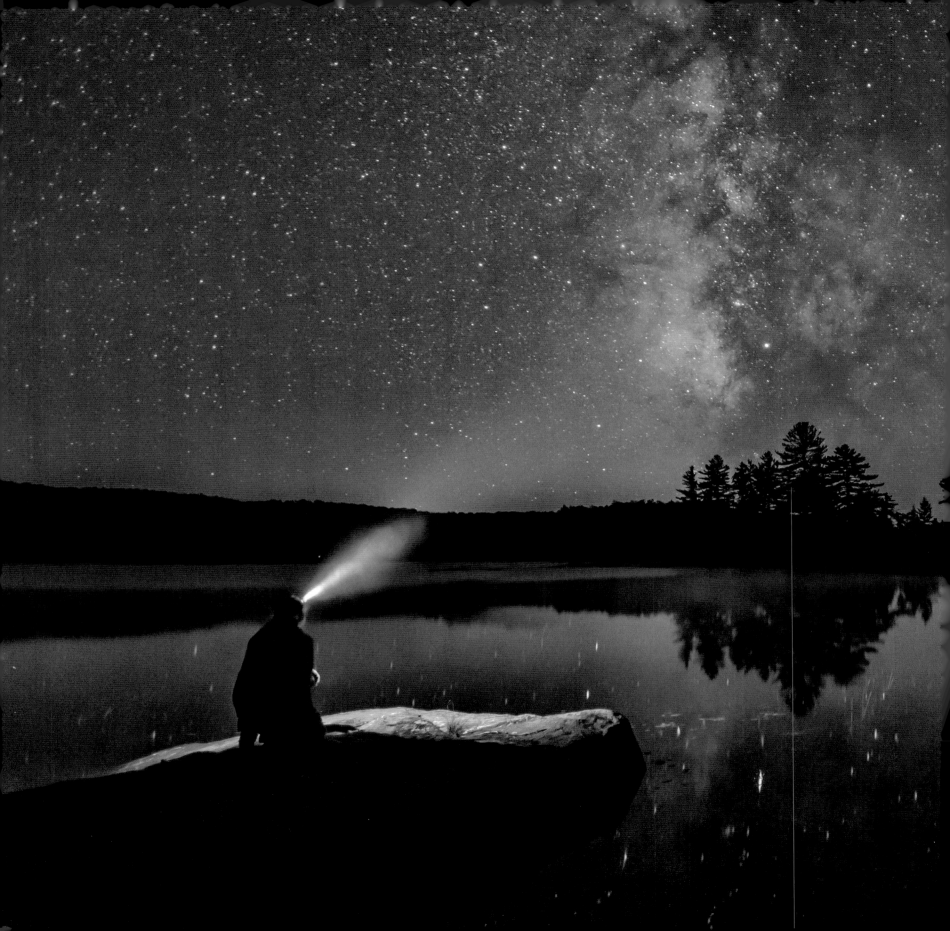

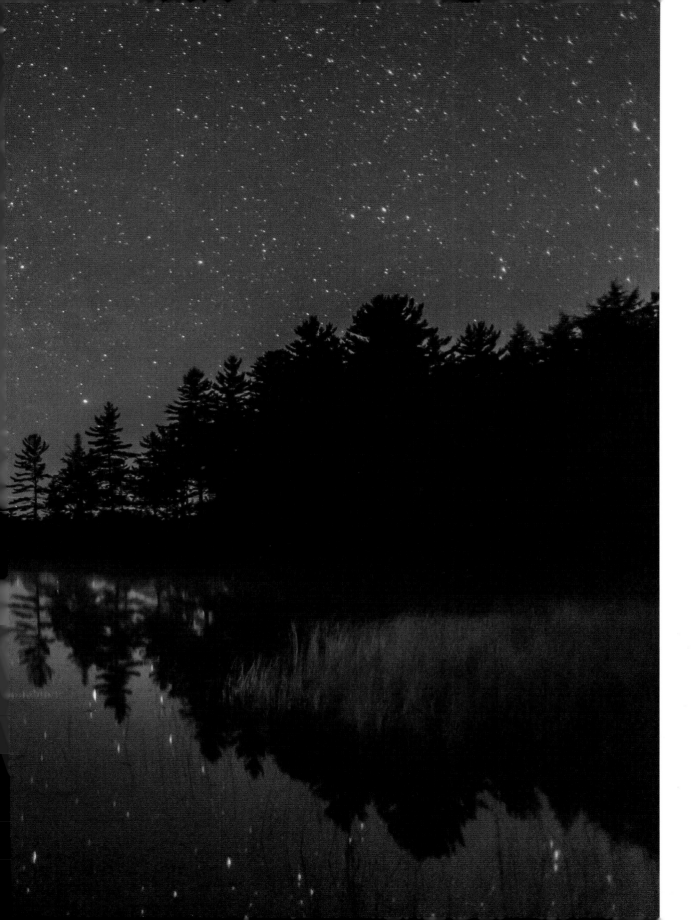

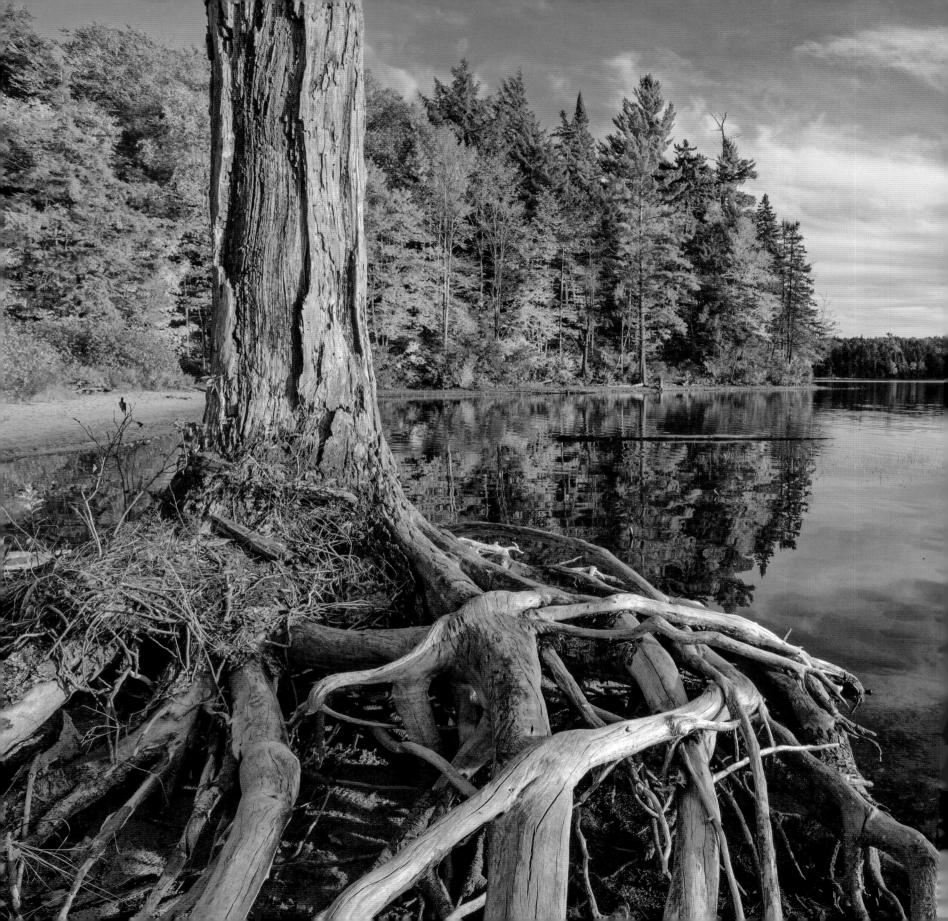

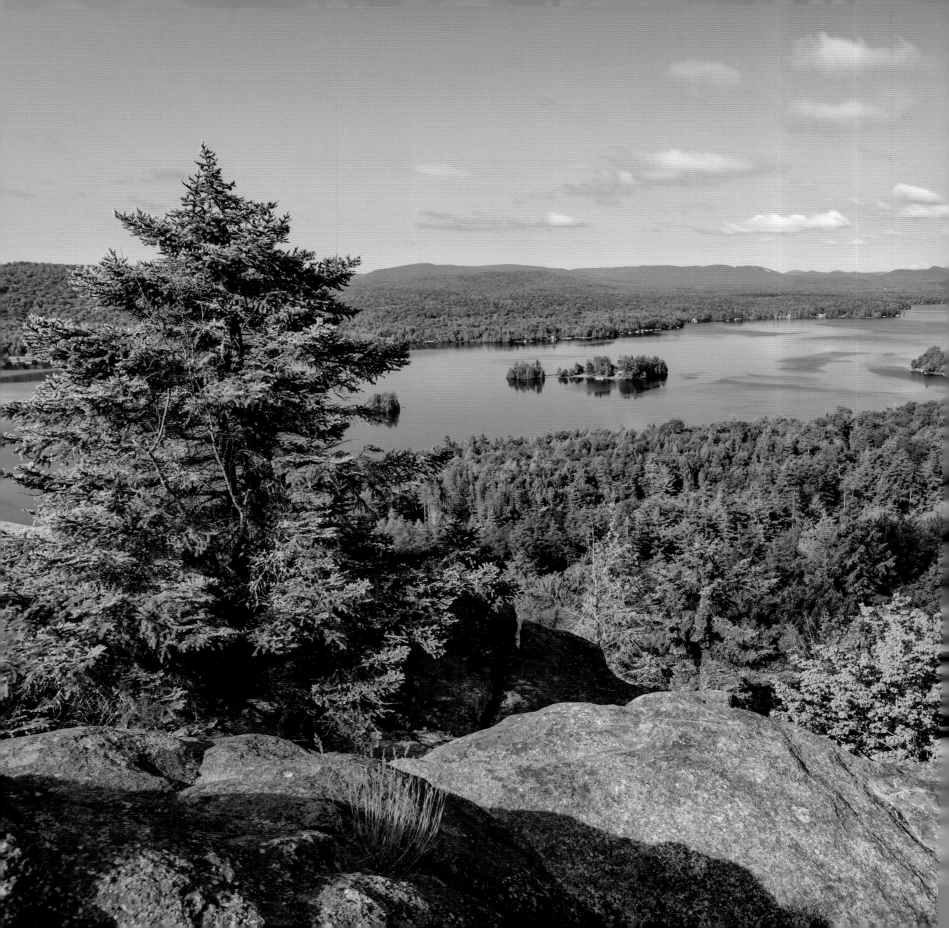

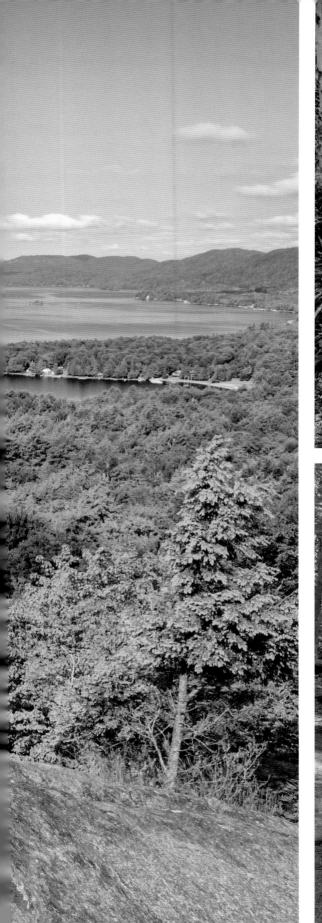

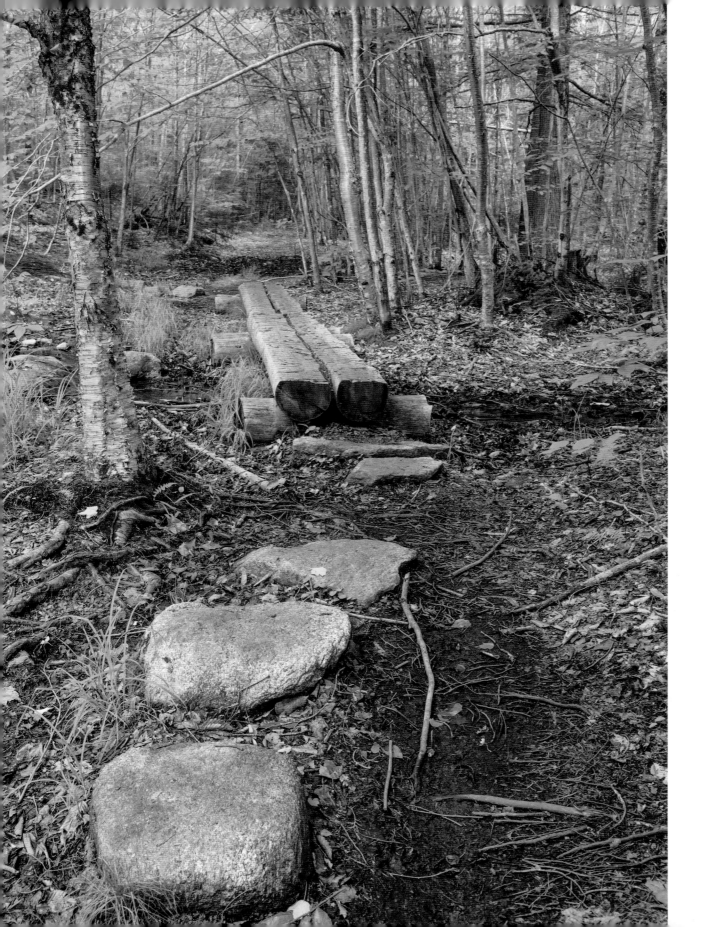

PREVIOUS SPREAD: Rocky Mountain is a popular short trail that offers fabulous views over Inlet and Fourth Lake. The top has a large open ledge to hang out on (left), and the trail is a typical Adirondack mountain hike with lots of roots and rocks along the way (right, top and bottom).

LEFT: A log bridge and well-placed stones are designed to protect the wetter soil and vegetation along some sections of the Bear Mountain Trail.

OPPOSITE: A rock cairn sits on an open rock area on top of Bear Mountain.

FOLLOWING SPREAD: This durable walkway into Ferd's Bog protects the fragile vegetation and allows people to experience the unique qualities of a boreal bog (left). An aerial view of the Stillwater Reservoir shows the surrounding lakes, with the Beaver River heading off toward other lakes and mountains on the upper right (right).

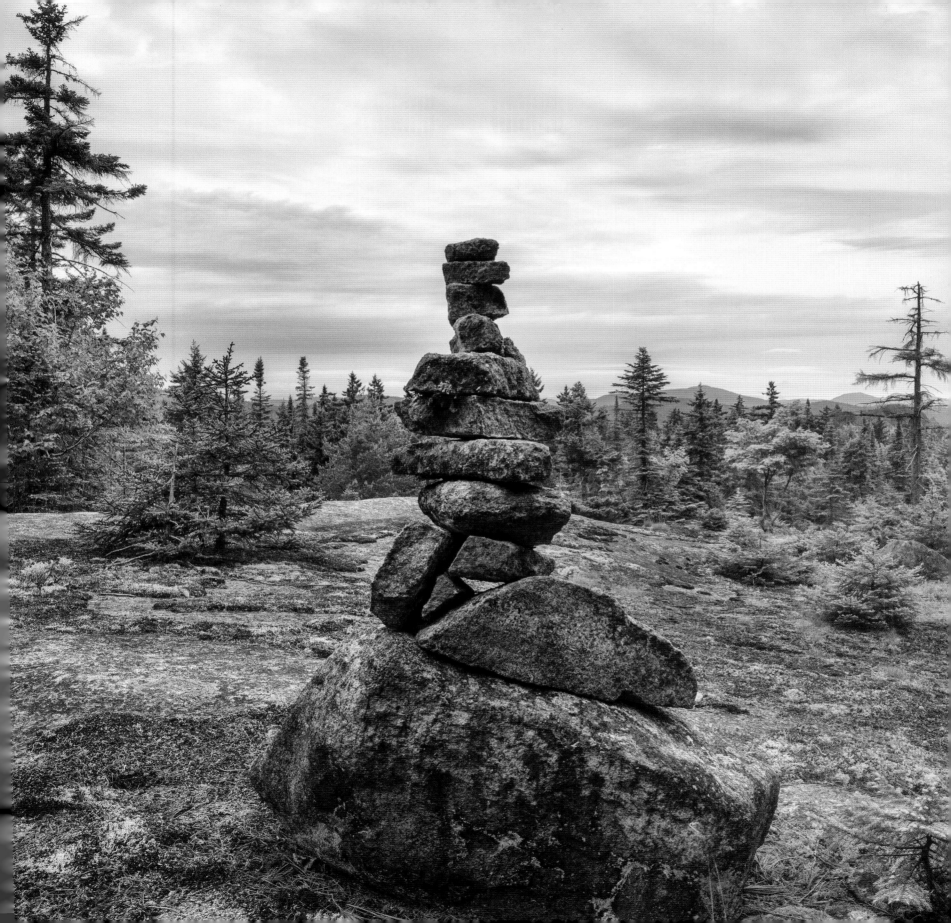

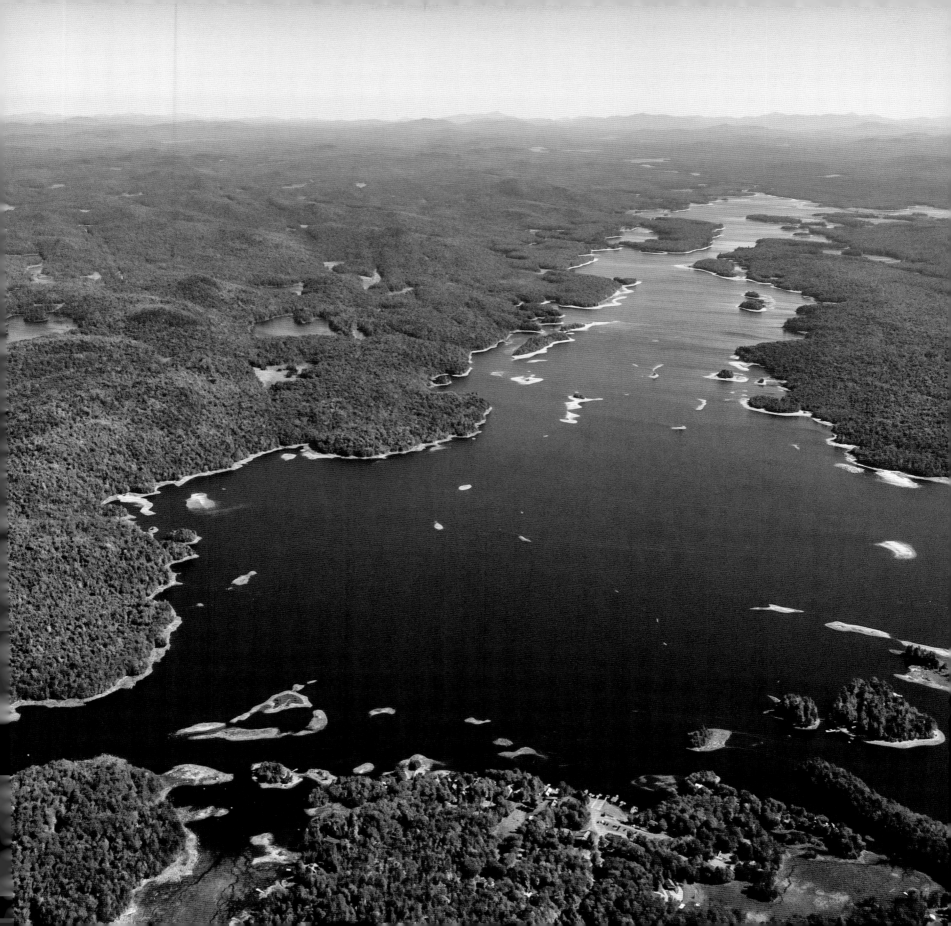

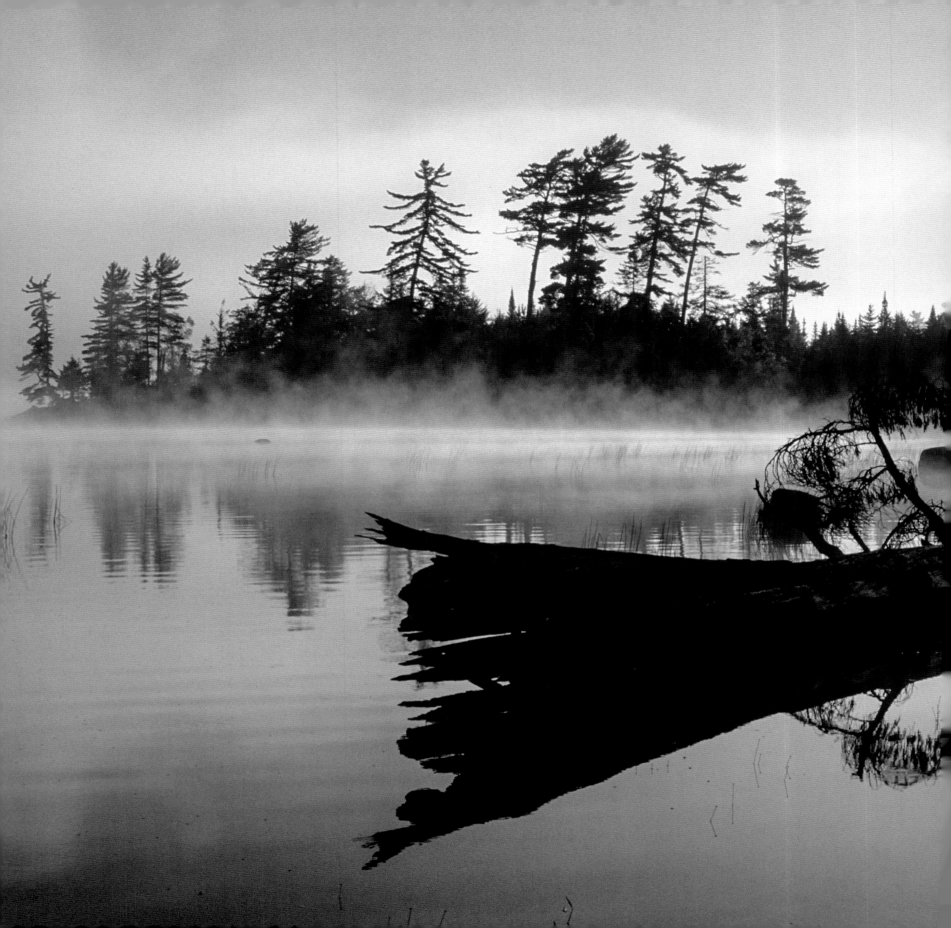

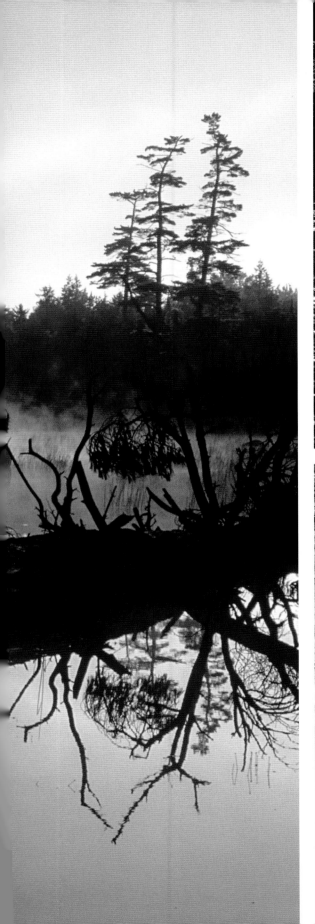
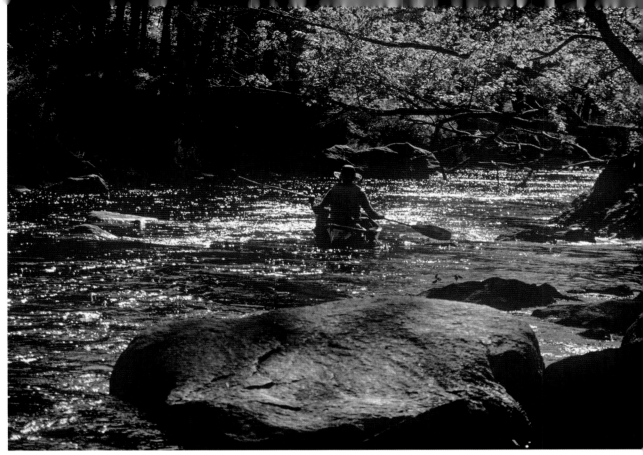
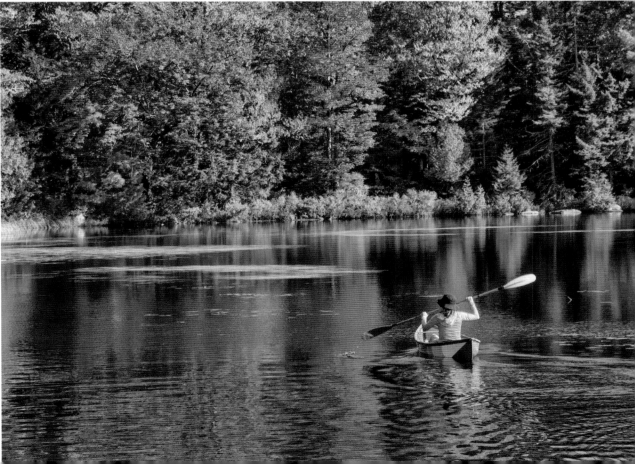

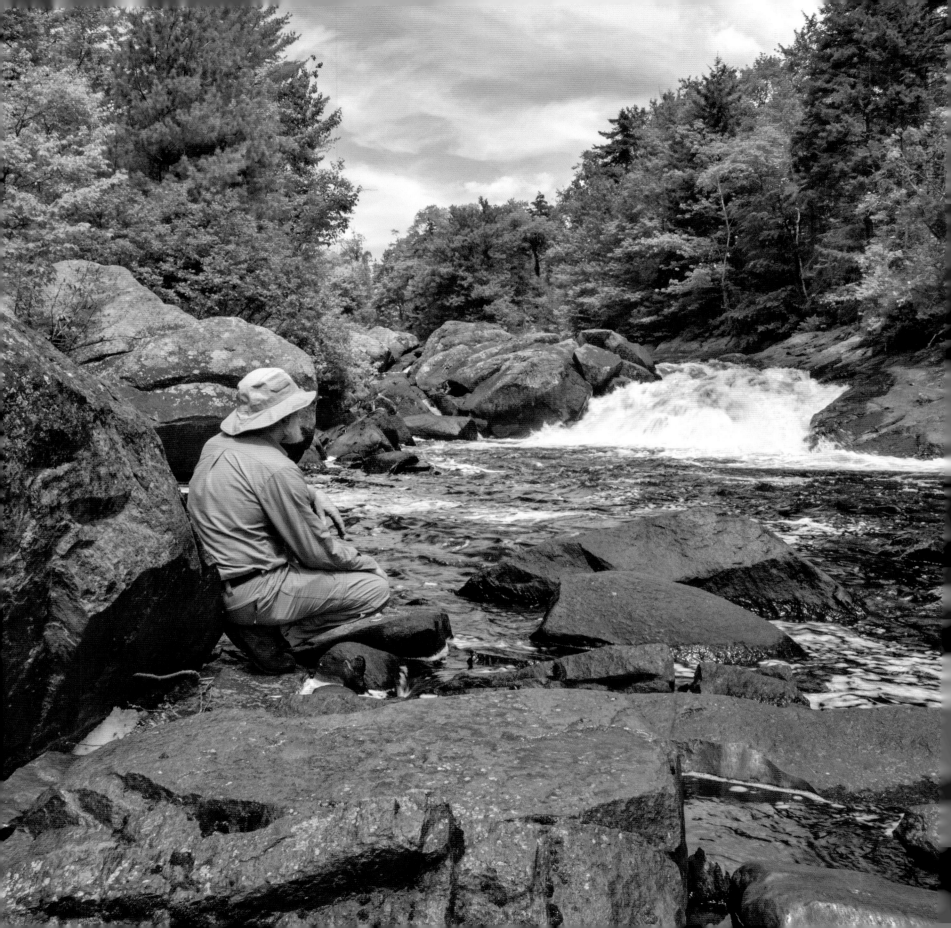

PREVIOUS SPREAD: Morning mist silhouettes the pines that tower above Lake Lila (left). A paddler canoes along one of the faster sections of the Oswegatchie River in the Five Ponds Wilderness (right, top). Another paddler in a Hornbeck canoe enjoys a beautiful fall day on Tooley Pond (right, bottom).

OPPOSITE: Tooley Pond Road near Cranberry Lake provides access to several trails that lead to waterfalls along the Grasse River. A hiker stops to enjoy this view of Bulkhead Falls.

RIGHT, TOP: This small waterfall on a stream is a short distance from Rainbow Falls.

RIGHT, BOTTOM: This is one of many cascades along the trail to Copper Rock Falls.

FOLLOWING SPREAD: The Grasse River cascades over a wide rock ledge at Basford Falls (left). Moss-covered logs, hardwoods, and cedars line the riverbanks of the Raquette River below the Forked Lake Dam (right, top and bottom).

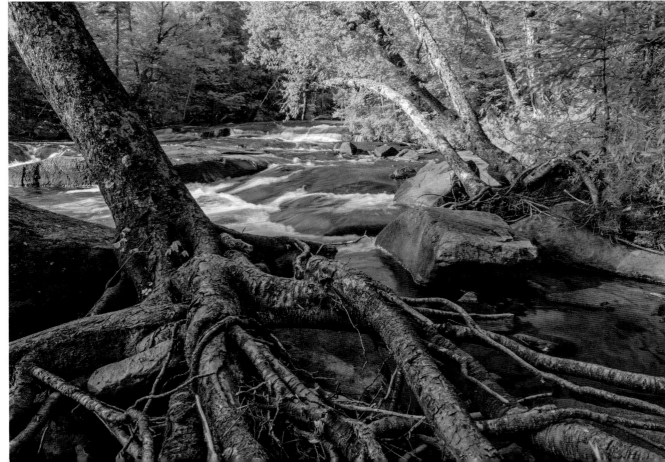

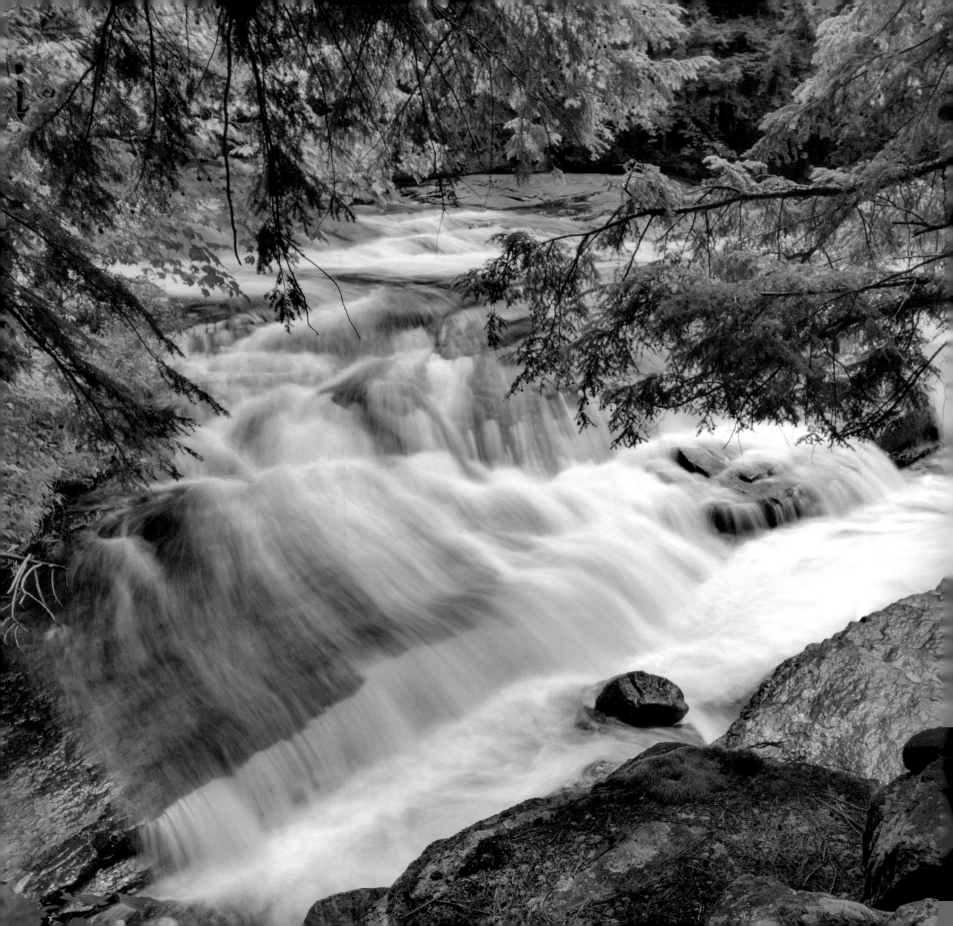

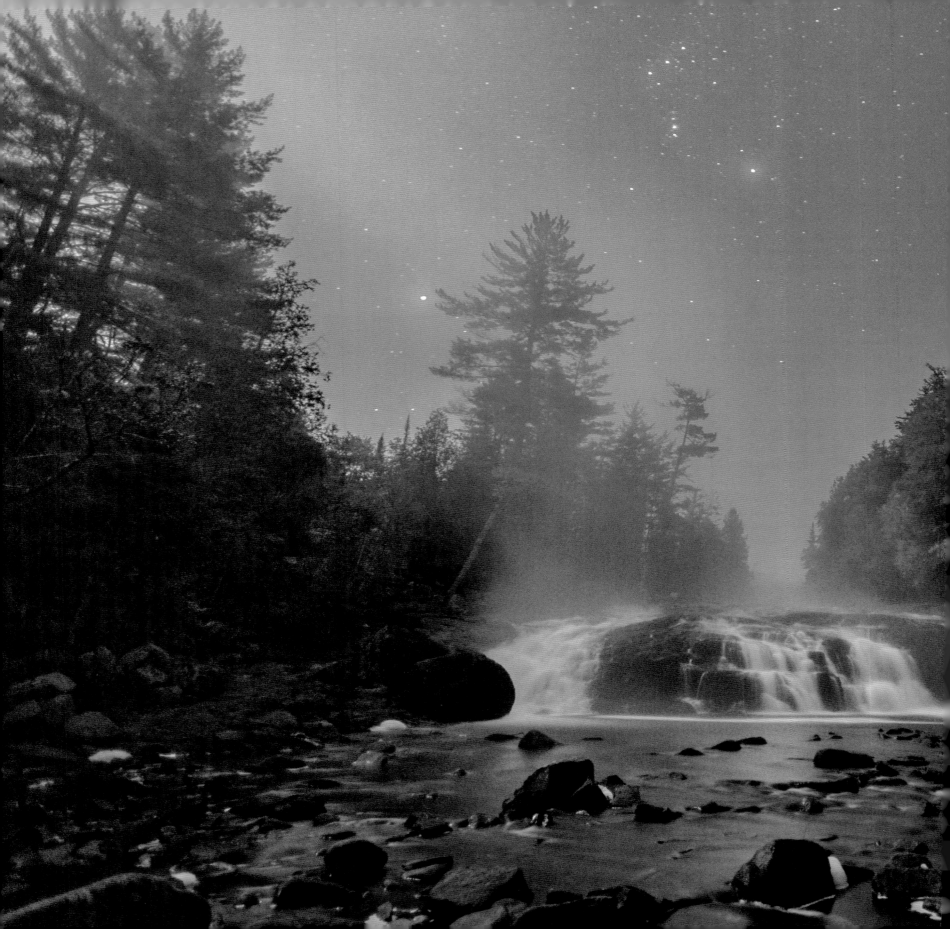

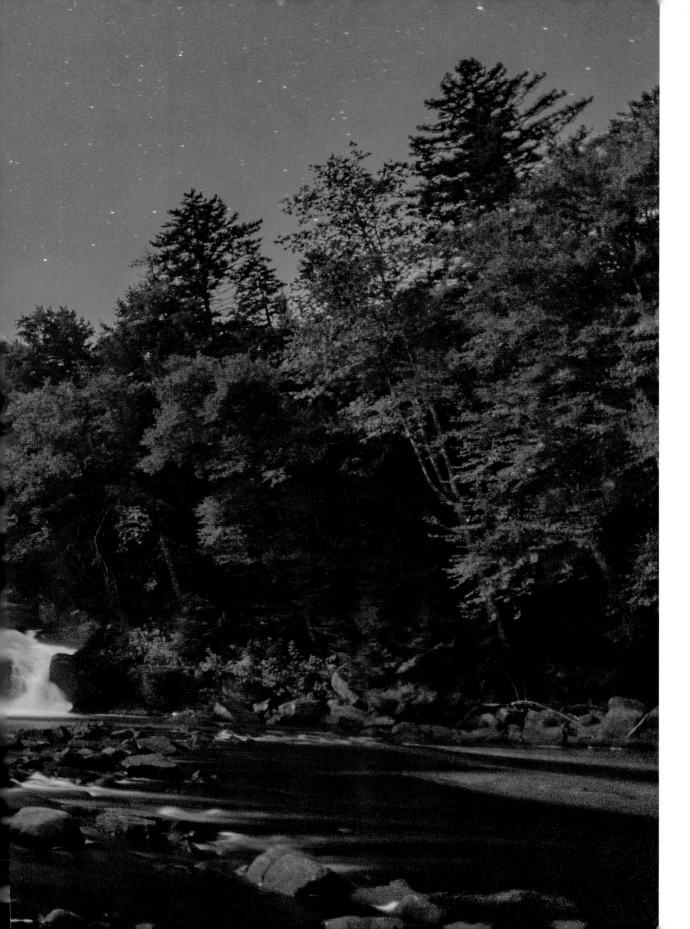

OPPOSITE: On a crisp, clear fall night, mist from Buttermilk Falls on the Raquette River rises and mingles with the stars overhead.

FOLLOWING SPREAD: The shoreline of Raquette Lake offers a beautiful view of Blue Mountain (left). The St. Regis Canoe Area has opportunities for day trips and extended trips on the myriad of ponds, lakes, and trails. Paddlers explore the St. Regis Pond end of the portage from Little Clear Pond (right, top and bottom).

273

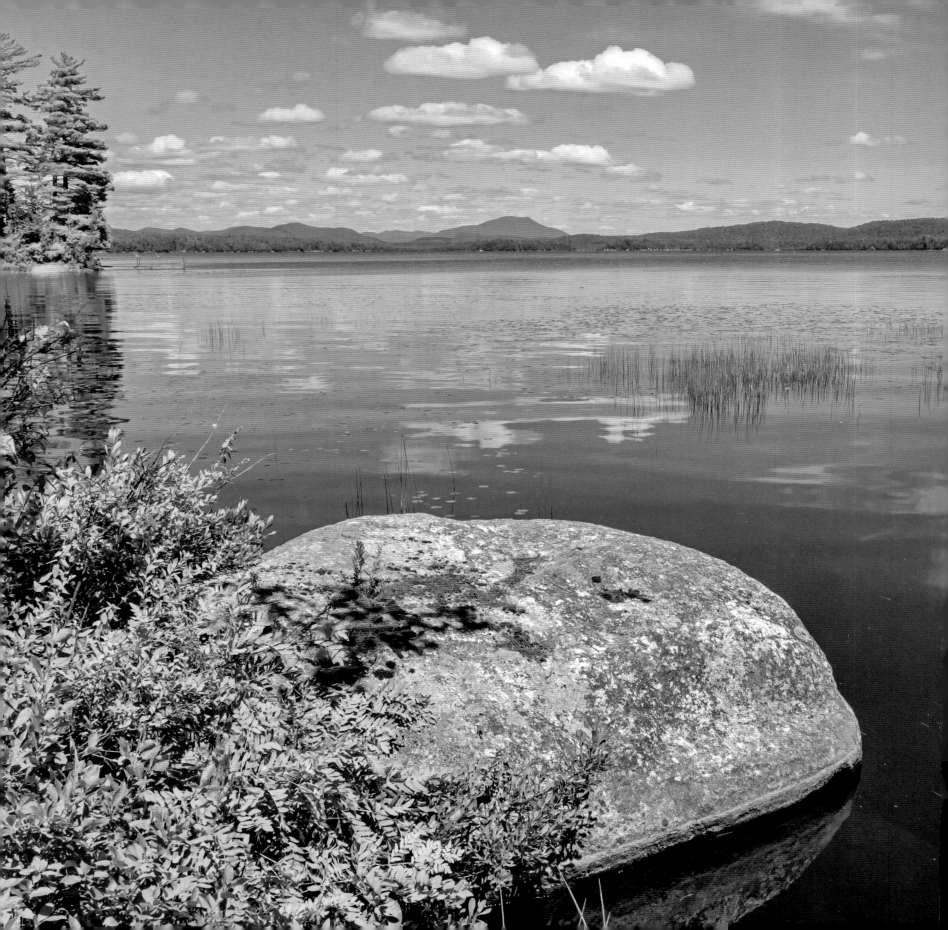

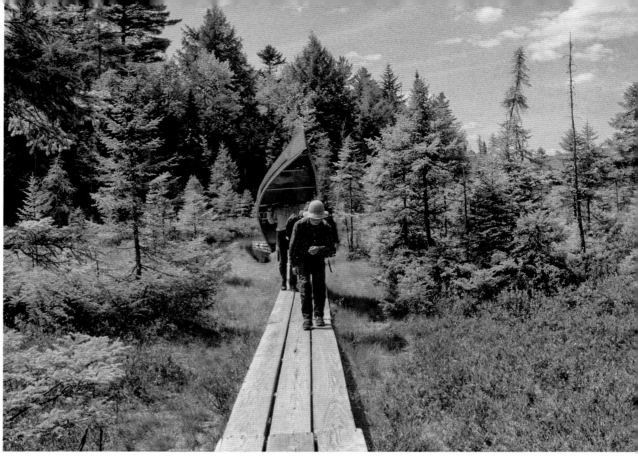
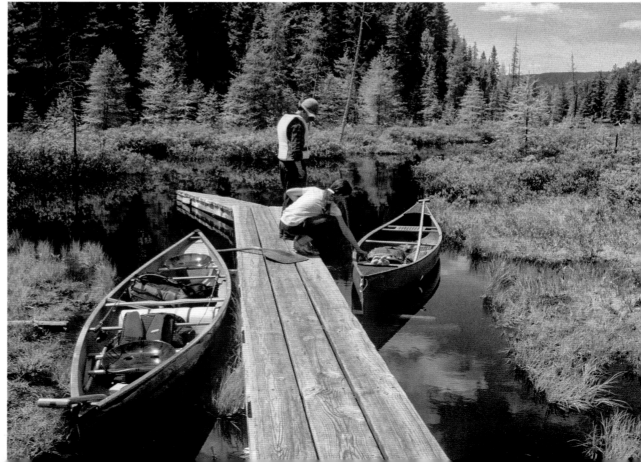

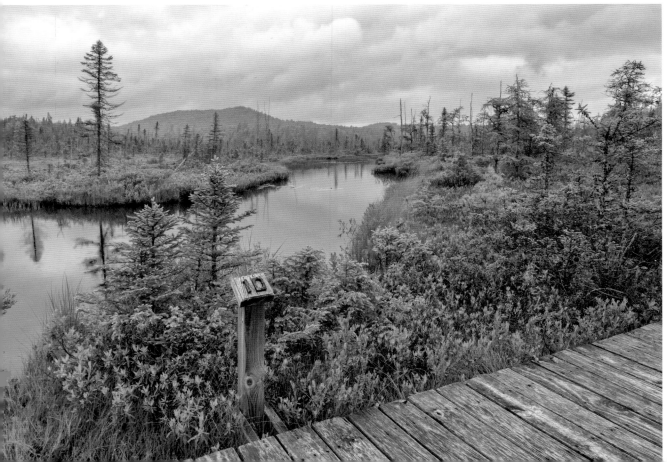

LEFT, TOP: Two benches for relaxing and watching wildlife sit along the Boreal Life Trail at Paul Smith's College Visitor Interpretive Center.

LEFT, BOTTOM: An interpretive site sits at the water's edge in the central part of the bog.

OPPOSITE: A wildlife viewing deck overlooks Barnum Pond.

FOLLOWING SPREAD: Madawaska Pond and the flow on Quebec Brook have some interesting paddling and wildlife-viewing opportunities in a boreal landscape: an active beaver lodge on Quebec Brook (left), a blue heron fishing among the lily pads (right, top), and a wide-eyed bullfrog in shallow water (right, bottom).

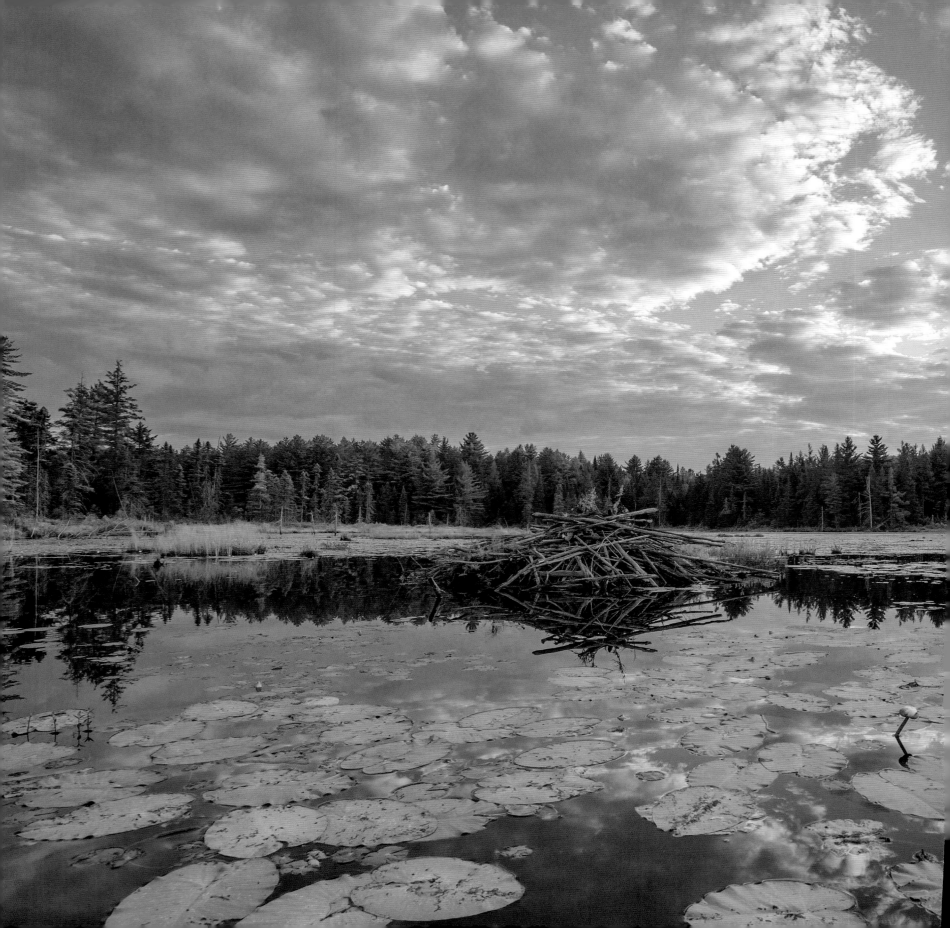

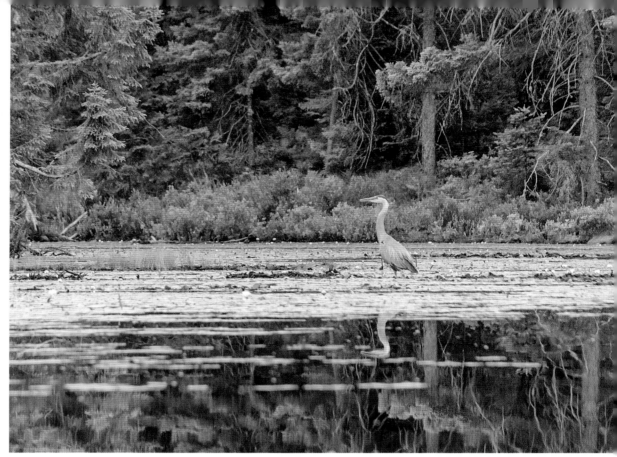
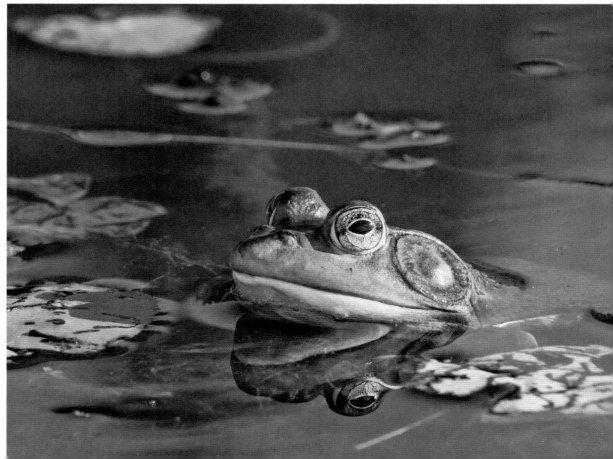

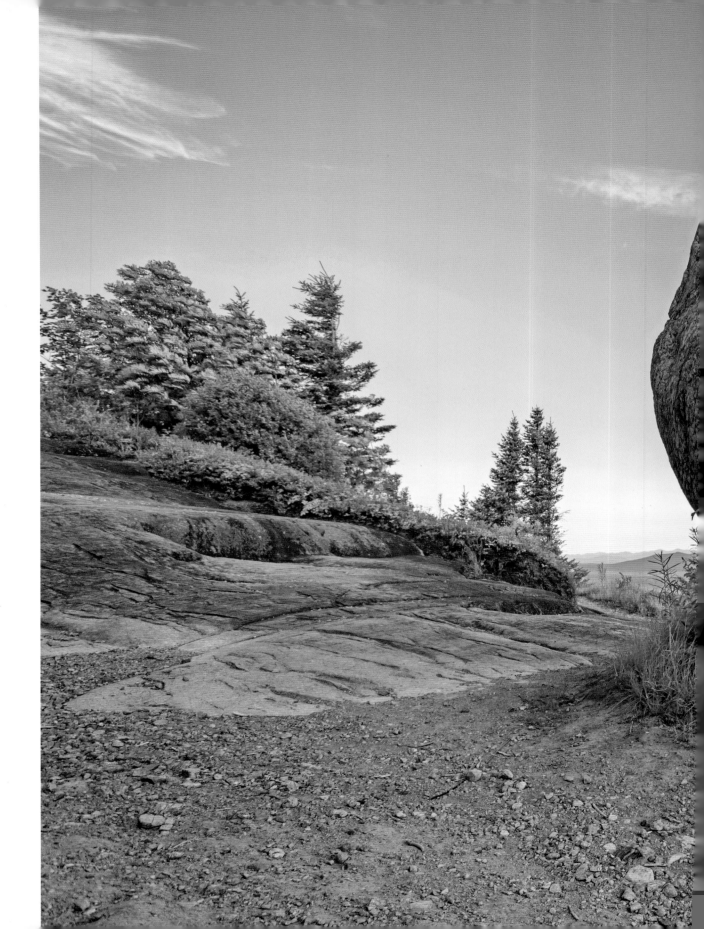

OPPOSITE: A boulder-size glacial erratic sits on the shoulder of Azure Mountain in the northwestern Adirondacks.

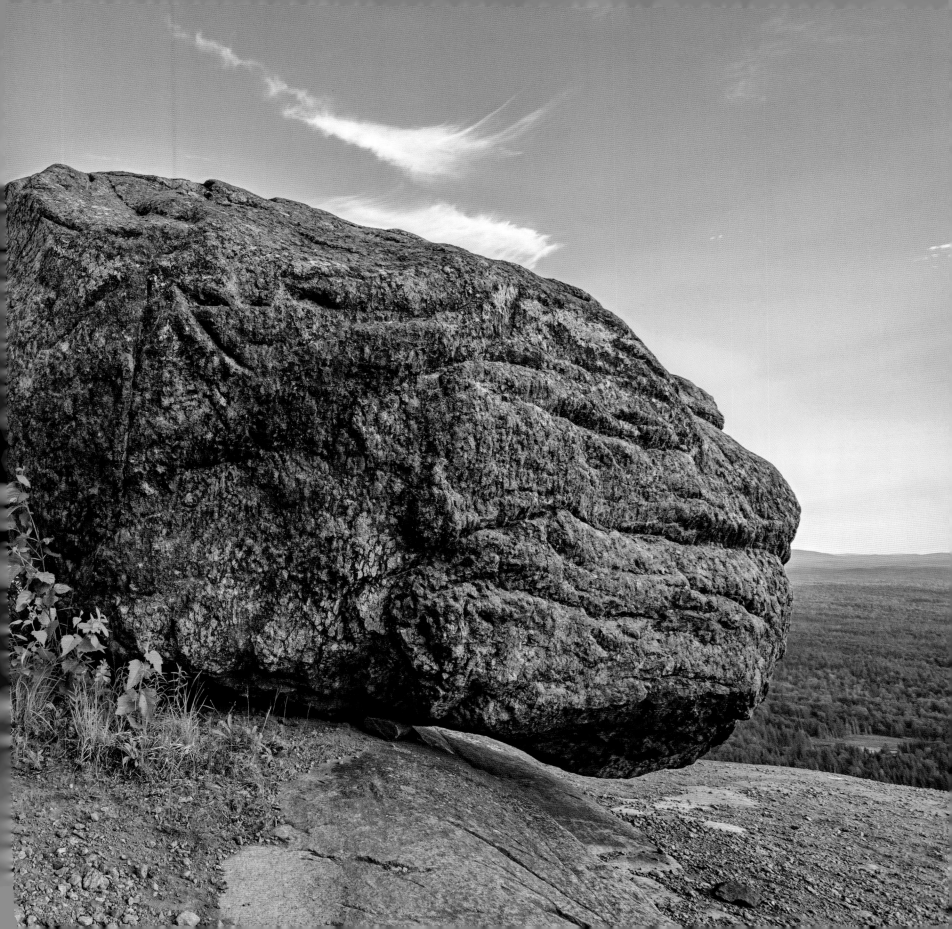

AFTERWORD

Executive Director and Counsel, Adirondack Mountain Club

You already know from the eloquent text and magnificent photographs in this book that the Adirondacks are a very unique and special place. If there is anything constant as we contemplate the future of the Adirondacks, it is change. Some change is beneficial. As the state buys more private forest lands, lakes, and mountains and adds them to the constitutionally protected "Forever Wild" Forest Preserve, a rewilding is taking place. Even industrial forests once heavily cut are benefiting from modern selective cutting and sustainable forestry-management techniques.

The Adirondack environment is now characterized by the protection and return of old-growth forests, spruce and cedar swamps, and low-level spruce and fir boreal forests at the southern edge of their climate range. The eastern wolf found in Ontario's Algonquin Park has migrated east across the St. Lawrence River and interbred with Adirondack coyotes. Small packs of these canids are hunting deer with only the alpha male and females breeding—which is unique wolf behavior—and they are nearly twice as heavy and large as coyotes. Moose, cougars, otters, fishers, and beavers have returned, as have bald eagles.

Global warming and climate change threaten the boreal habitats and the species they shelter, such as the spruce grouse and moose. Acid rain and mercury deposition from burning soft coal to generate electricity upwind of the Adirondacks have threatened the loons, trout, and food chain of many Adirondack lakes, especially in the southwestern part of the region. Legal actions brought and won in the federal courts a decade ago by the Adirondack Mountain Club (ADK) and its allies have resulted in a remarkable improvement in the acidity levels of many lakes, with a restoration of the natural food chain. These legal victories led to the closure or repowering with natural gas of many coal-powered electric-generating plants,

reducing the acid deposition and mercury emissions. It also reduced the amount of heat trapping carbon dioxide emitted by these plants.

Recently, the Trump administration's Environmental Protection Agency (EPA) began to submit new regulations that attempt to reverse the legal victories that required air-pollution technology to be installed on these power plants. These regulation changes would allow coal-burning plants to evade the requirements to reduce acid rain, smog, and mercury with the latest air pollution emission technology. Other new regulatory changes would reverse the Obama-era rules that mandated the reduction of carbon dioxide emissions in order for the nation to comply with the Paris Accord, a 30 percent reduction of carbon by 2030. The new EPA rules would lower those carbon emission targets to less than 1.5 percent. ADK will vigorously oppose these rule changes in Washington and in the federal courts.

The Adirondacks contribute significantly to the reduction of global warming gasses. The hundreds of millions of trees sequester carbon in their trunks, branches, root systems, and soils. As forests mature and even harvested trees store carbon in useful wood products, more carbon is removed from the atmosphere. With the warming of the earth and the global trade in wood products, devastating foreign insects and tree pathogens—such as the emerald ash borer, Asian longhorned beetle, oak wilt, and deadly hemlock woolly adelgid—threaten the forests of the Adirondacks. These invaders lack natural controls as they spread. ADK has worked with entomologists at Cornell University to finance, develop, and propagate in the wild unique beetles and whiteflies that can effectively control the hemlock woolly adelgid, potentially saving the stands of hemlock that comprise one tree in seven in the Adirondacks. ADK is also lobbying to secure funding to develop

282 THE TRAILS OF THE ADIRONDACKS

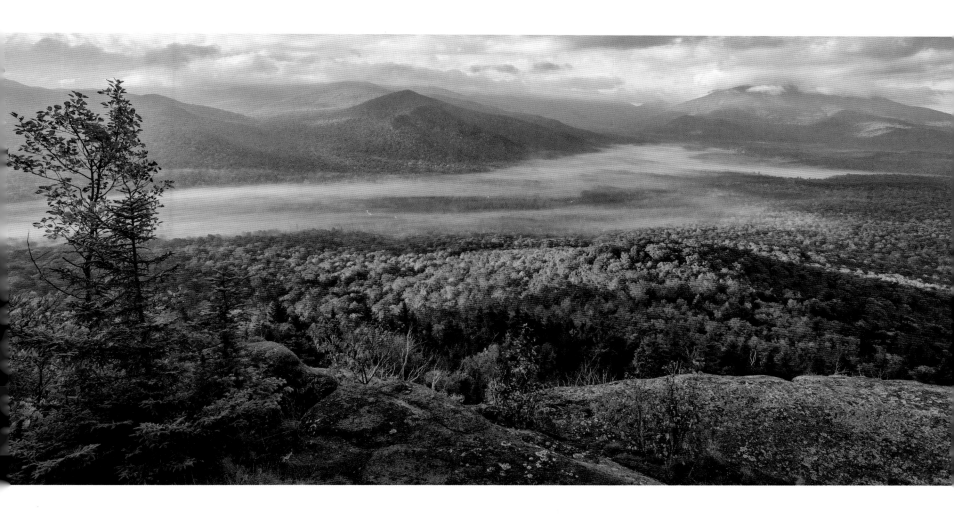

countermeasures to address the other tree-killing invasives. You can help us protect Adirondack trees by not transporting firewood into the region and buying plentiful and inexpensive local firewood.

The peerless water quality of the thousands of Adirondack lakes and ponds is also threatened by invaders, such as Eurasian milfoil, hydrilla (milfoil on steroids), water chestnut, and the spiny waterflea. The only current countermeasure to prevent the spread of these habitat-destroying aquatic invasives is ensuring that they aren't spread into "clean" lakes as hitchhikers on boats, boat trailers, canoes, and kayaks. We must ensure watercraft are thoroughly cleaned and washed before taking them from known infected lakes—such as the Finger Lakes, Lake Champlain, and

Great Sacandaga Lake—to the lakes of the Adirondacks that are largely free of aquatic invasives. ADK has worked to help finance boat- and trailer-washing stations at 12 locations on major highways around the periphery of the Adirondacks. Please wash your canoes and kayaks, especially the rudder parts. Hikers can prevent the spread of harmful plants such as wild parsnips and garlic mustard by keeping a whisk broom in their trunk and carefully brushing off their boots before hiking in another area.

I hope as you enjoy the great photographs and thoughtful text of this magnificent book that you will do your part to keep the Adirondacks in its wild and natural state through your own actions, words, and thoughts.

POSTSCRIPT

The Adirondacks have been my inspiration for as long as I can remember, as well as my home for more than 45 years. While I spent my childhood in southern Pennsylvania, I always felt like I "grew up" while hiking and exploring the Adirondack High Peaks after moving here when I was 18. I always enjoyed taking pictures, but I felt compelled to buy a 35mm SLR camera after kindling a love affair with the rugged mountain wilderness during my first High Peak climb in January 1975. I have come to feel I am as much a part of these mountains as they are of me.

My hope is this book inspires newcomers to explore and develop an appreciation for the Adirondacks, and remind those who already know and love the region how special and unique it is. I joined ADK in 1979 as a way to meet like-minded people and help support the group that maintains, protects, and looks after the trails and wilds in the Adirondack Park. I encourage everyone to support ADK and other groups that help safeguard and preserve the character of the Adirondacks for future generations.

CARL HEILMAN II

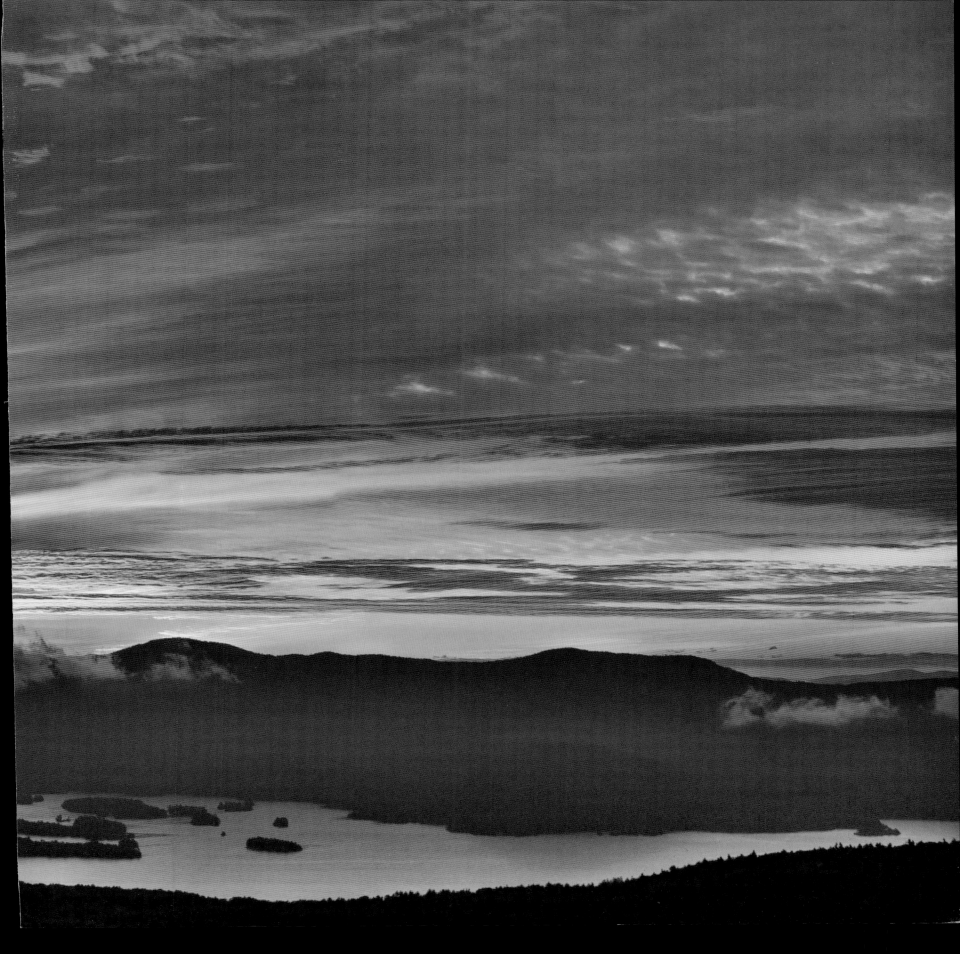

ACKNOWLEDGMENTS

First and foremost, a huge thanks to my wife, Meg, who has supported my photography endeavors in so many different ways through all our years together, and who does all she can to keep things running smoothly while I'm immersed in the many details of getting another book together. Many thanks also to my daughter Greta, who takes care of additional office work while I'm gone, and is the primary person for all high-res color work for my books and other projects. And thanks also to my son Carl, my grandchildren Gabe and Annaleigh, and my sister Mary Alice—who have all been such good sports and wonderful company on our multitude of hikes, paddles, and four-season adventures in the Adirondacks.

Thanks once again to Rizzoli for offering me this book, and taking care of the multitude of publishing details. I have especially enjoyed working with publisher Charles Miers, associate publisher James Muschett, book designer Susi Oberhelman, and editor Candice Fehrman. I appreciate their attention to detail, as well as the awesome quality of the final product. A huge thank-you also to ADK editor Andrea Masters for helping with contacts, editing details, and other thoughtful considerations, as well as ADK for its support of and help with this book.

Thank you also to the authors who have contributed to this book, especially Bill McKibben, who has done so much for the Adirondacks while working at an international level for the environment; Neal Burdick, who I had the pleasure of working with for decades as the editor of *Adirondac* magazine; and Adirondack authors Stuart Mesinger and Christine Jerome, who each paint a wonderful picture with words of how Adirondack trails, waterways, and backcountry affect those who explore the park's wild regions. Thanks also to the authors, editors, and publishers of the National Geographic maps for the Adirondacks, as well as Ann Hough, ADK art director, and the authors of ADK's guidebook series, which has helped me find new places to explore in the Adirondacks since I first started hiking here.

I would also like to express thanks to *Adirondack Life, Adirondack Explorer*, the Adirondack Chapter of The Nature Conservancy, the Adirondack Land Trust, the Adirondack Council, the Open Space Institute, and the Lake George Land Conservancy for the projects they have sent my way, which played a part in the photographs that have been included in this book. Thank you also to the advocacy groups, land trusts, and conservancies that work together toward the common goal of maintaining the rural character and wilderness of the Adirondack Park for future generations to enjoy.

I have also appreciated help from a number of folks I know who offered suggestions, directions, and other guidance for this project, including Phil Brown, Tyler Frakes, Tony Goodwin, Sarah Hoffman, Mike Lynch, Sophia McClelland, and David Thomas-Train. All were helpful in tracking down various details for photographs used in the book. In addition, I have met and enjoyed the company of many others on my hikes and travels, including folks on my snowshoeing and photo tours, and I have appreciated their thoughts and suggestions for different trips and trails.

Any project like this is a joint effort, and I greatly appreciate the efforts of everyone who has been involved in some way. Thank you!

ADK (Adirondack Mountain Club)

ADK is the only nonprofit organization dedicated to protecting and advocating for New York State's wild lands and waters while also teaching people how to enjoy natural places responsibly. Since 1922 the organization has offered people opportunities to stay and play in as well as protect, discover, and explore the outdoors. Today, ADK has 30,000 members in 27 chapters statewide and is served by a professional year-round staff. The organization is recognized as a vital voice in the commitment to environmental stewardship and ethical outdoor recreation in New York State.

PUBLICATIONS

ADK publishes 20 titles, including outdoor recreation guides, maps, and armchair traveler books. Profits from the sale of these publications help underwrite the cost of our extensive trails, education, conservation, and natural history programs.

OUTDOOR EDUCATION

ADK offers a wide variety of workshops and courses for different abilities as well as outreach programs for schools and youth groups. Courses include hiking, paddling, backpacking, wilderness skills, and a naturalist series. Other areas of ADK expertise in education are:

- **Adirondack High Peaks Summit Stewardship:** One of the Northeast's most acclaimed environmental initiatives, this program protects New York State's alpine habitat through education, research, and trail work. Summit stewards hike daily to the tallest summits in the state to educate hikers and enlist their help in protecting alpine species. The program is a partnership of ADK, the Adirondack Chapter of the Nature Conservancy, and the New York State Department of Environmental Conservation (DEC).
- **Leave No Trace (LNT):** ADK is a partner with the Leave No Trace Center for Outdoor Ethics, creators of an international program designed to assist outdoor enthusiasts with decisions about how to reduce their impacts in the outdoors. One of 10 national providers of LNT Master Educator Courses, ADK also offers LNT Trainer Courses and LNT Awareness Workshops.

TRAIL PROGRAMS

Professional and volunteer trail crews work closely with the New York State DEC to improve thousands of miles of hiking trails and paddle portages in the Adirondacks, Catskills, and elsewhere.

CONSERVATION AND ADVOCACY

ADK addresses issues involving New York's Forest Preserve, parks, and open spaces, protecting natural resources through legislative advocacy and stewardship.

LODGES AND CAMPGROUND

ADK's Adirondak Loj and Wilderness Campground at Heart Lake are open year-round and reached by car. Johns Brook Lodge, cabins, and lean-tos are backcountry facilities located three-and-a-half miles into the High Peaks Wilderness. They are accessed on foot and open year-round.

VOLUNTEER OPPORTUNITIES

ADK volunteers are found on the trails and summits, in the backcountry, as lean-to adopters, as citizen scientists, as advocates, and as workers helping maintain ADK properties.

MEMBERSHIP

Benefits of membership include enrollment in one of ADK's 27 chapters; a subscription to *Adirondac* magazine; and discounts on publications, lodging, parking, and merchandise.

For more information:

 Working for Wilderness

Adirondack Mountain Club
814 Goggins Road
Lake George, NY 12845

ADK.org

@adkmtnclub on Instagram, YouTube, Facebook, and Twitter

Membership and publication orders
(Membership Services Center): 518-668-4447

Facility reservations and education programs
(Heart Lake Program Center): 518-523-3441

Public affairs: 518-449-3870

First published in the United States of America in 2019 by
Rizzoli International Publications, Inc.
300 Park Avenue South
New York, NY 10010
www.rizzoliusa.com

All photographs © 2019 Carl Heilman II, except for the following:
Courtesy ADK Archives: pp. 34, 35 (both), 37, 41 (left), 42 (left), 51, 52, 54, 59, and 71.
© Eleanor Brown/ADK Archives: p. 38 (left).
© James Bullard: p. 32 (right).
Courtesy of Concord Free Public Library: p. 29.
Courtesy Fisheries, Game, and Forest Commission report, 1896: p. 32 (left).
© Greta Heilman: p. 275 (top).
© Odie Monahan/ADK Archives: p. 41 (right).
Courtesy New York State Department of Commerce: pp. 38 (right) and 39.
© Bob Shangraw/ADK Archives: p. 42 (right).

Text: Neal Burdick
Foreword: Bill McKibben
Map: Elizabeth Cruz
Project Editor: Candice Fehrman
ADK Editor: Andrea Masters
Book Design: Susi Oberhelman

Excerpts on pages 28, 33, 55, and 71 were taken from ADK's *The Adirondack
Reader* (edited by Paul Jamieson and Neal Burdick), third edition, and
used with permission. Excerpts on pages 56–57 were taken from ADK's *No Place
I'd Rather Be: Wit and Wisdom from Adirondack Lean-To Journals*
(by Stuart F. Mesinger) and used with permission.

www.ADK.org

ADK (Adirondack Mountain Club) is dedicated to the conservation, preservation,
and responsible recreational use of the New York State Forest Preserve and
other parks, wild lands, and waters vital to our members and chapters.

Working for Wilderness

2019 2020 2021 2022 / 10 9 8 7 6 5 4 3 2 1

Printed in China

ISBN-13: 978-1-59962-153-1
Library of Congress Catalog Control Number: 2018958405

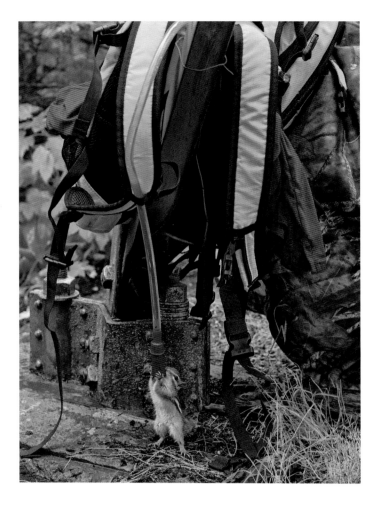

PAGE 1: In this view from Cat Mountain, evening light bathes Black Mountain, the Tongue Mountain Range, and Lake George.

PAGES 2-3: Paddlers set off to canoe on the Boreas Ponds, with a backdrop of the High Peaks on the horizon.

PAGES 4-5: This picturesque set of falls on Tenant Creek is in the south-central Adirondacks.

PAGES 6-7: Anticrepuscular rays fill the sky above Simon Pond, where the Raquette River flows into the waters of Tupper Lake.

PAGE 283: An ethereal mist covers the South Meadow valley on an exquisite fall morning, while the summits of Mount Marcy, Mount Colden, and Algonquin Peak are gently nestled in softly lit clouds.

PAGES 284-285: A spectacular sunrise over Lake George, the Tongue Mountain Range, Black Mountain, and Sleeping Beauty Mountain is visible from the ledges at the top of Cat Mountain.

ABOVE: A chipmunk drinks from a hiker's hydration pack at the base of the Snowy Mountain fire tower.